PERFORMA

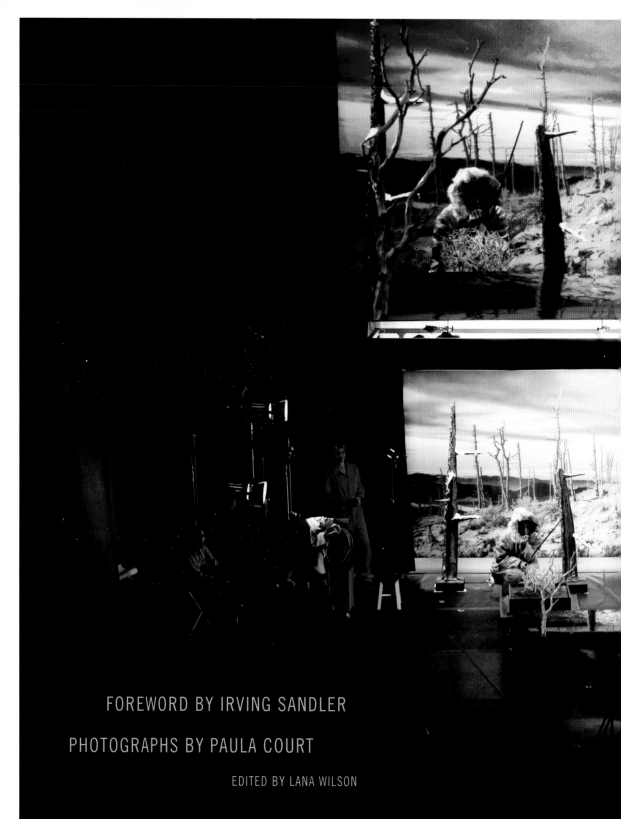

FOREWORD BY IRVING SANDLER

PHOTOGRAPHS BY PAULA COURT

EDITED BY LANA WILSON

PERFORMA-09
BACK TO FUTURISM-
ROSELEE GOLDBERG-
09

PARTICIPATING VENUES

1. 80 ST. MARK'S PLACE
2. 179 CANAL
3. 590 MADISON (THE ATRIUM)
4. ABRONS ARTS CENTER
5. ANTHOLOGY FILM ARCHIVES
6. APF LAB
7. ART IN GENERAL
8. ARTISTS SPACE
9. ASIA SOCIETY
10. BARYSHNIKOV ARTS CENTER
11. BIDOUN MAGAZINE SPACE
12. BLANK SL8
13. THE BRONX MUSEUM OF THE ARTS
14. BROOKLYN MUSEUM
15. THE BRUCE HIGH QUALITY FOUNDATION UNIVERSITY
16. CABINET SPACE
17. CASA ITALIANA ZERILI-MARIMÒ
18. CHASHAMA 679
19. CEDAR LAKE
20. THE COOPER UNION
21. CREATIVE TIME @ THE SLIPPER ROOM
22. DANCE THEATER WORKSHOP
23. DANSPACE PROJECT
24. E-FLUX
25. EL MUSEO DEL BARRIO
26. EMILY HARVEY FOUNDATION
27. EYEBEAM ART + TECHNOLOGY CENTER
28. FOREVER & TODAY, INC.
29. GOETHE-INSTITUT
30. THE HIGH LINE
31. HUNTER COLLEGE
32. GAIR BUILDING NO. 6
33. THE GRAMERCY THEATER
34. INVISIBLE-EXPORTS
35. ISSUE PROJECT ROOM
36. ITALIAN CULTURAL INSTITUTE
37. JAPAN SOCIETY
38. JUDSON MEMORIAL CHURCH
39. THE KITCHEN
40. LA MAMA LA GALLERIA
41. (LE) POISSON ROUGE
42. LIGHT INDUSTRY
43. MARSHALL CHESS CLUB
44. MARTIN E. SEGAL THEATRE CENTER
45. MUSEUM OF AFRICAN ART @ CASTLE CLINTON
46. MUSEUM OF ARTS AND DESIGN
47. MUSEUM OF CHINESE IN AMERICA
48. THE MUSEUM OF MODERN ART
49. NATIONAL ARTS CLUB
50. NEW MUSEUM
51. NEW YORK UNIVERSITY
52. ON STELLAR RAYS
53. P.S.1 CONTEMPORARY ART CENTER
54. PARK AVENUE ARMORY
55. PARSONS THE NEW SCHOOL FOR DESIGN
56. PARTICIPANT INC.
57. THE PERFORMANCE PROJECT @ UNIVERSITY SETTLEMENT
58. THE PERFORMING GARAGE
59. PS122
60. RENTAL
61. SAATCHI & SAATCHI
62. SALON 94
63. SCARAMOUCHE
64. SCULPTURECENTER
65. SEWARD PARK
66. THE STUDIO MUSEUM IN HARLEM
67. SWISS INSTITUTE
68. TAXTER & SPENGEMANN
69. TEATRO OF THE ITALIAN ACADEMY
70. TIMES SQUARE
71. TISCH SCHOOL OF THE ARTS
72. TOWN HALL
73. VAN ALEN INSTITUTE
74. WHITE BOX
75. WHITE COLUMNS
76. WHITE SLAB PALACE
77. X INITIATIVE

Performa 09: Back to Futurism is published as a record of the third Performa biennial, Performa 09 (November 1–22, 2009).

Author
RoseLee Goldberg

Editor
Lana Wilson

Consulting Editor
Nell McClister

Designer
Stacy Wakefield

Photographer
Paula Court

Indexing
Onni Nickle

Title Page
Yeondoo Jung, *Cinemagician*, a Performa Commission with the Yokohama Festival for Video and Social Technology, 2009. Photo by Paula Court.

Printing
RR Donnelley

Published by Performa Publications

Performa, a nonprofit multidisciplinary arts organization established by RoseLee Goldberg in 2004, is dedicated to exploring the critical role of live performance in the history of twentieth-century art and to encouraging new directions in performance for the twenty-first century. In 2005, Performa launched New York's first performance biennial, Performa 05, followed by Performa 07 (2007) and Performa 09 (2009).

This publication was supported by Laura Brugger and Charles Ross Sappenfield / The Capital Group Companies and Furthermore: a program of the J.M. Kaplan Fund.

Printed in China.

ISBN 978-0-615-45066-7

Performa
100 West 23rd Street, 5th Floor
New York NY 10011
T + 1 212 366 5700
F + 1 212 366 5743
www.performa-arts.org

Distributed by:
D.A.P./Distributed Art Publishers
155 6th Avenue, 2nd Floor
New York, NY 10013
1-800-338-BOOK
www.artbook.com

CONTENTS

CHAPTER THREE
THE ILLUMINATING STAGE:
139 PERFORMANCE AT THE EDGE OF THEATER

CHAPTER FOUR
165 SIMULTANEOUS AWARENESS: PERFORMANCE BETWEEN SCREENS

A NOTE ON THE CHAPTER TITLES

The chapter titles in this book are drawn from various Futurist manifestos.

Chapter Two, *Exalting the Crowds*
Quotation from "Futurist Manifesto of Lust," by Valentine de Saint-Point, 1913.

Chapter Three, *The Illuminating Stage*
Quotation from "Futurist Scenography," by Enrico Prampolini, 1915.

Chapter Four, *Simultaneous Awareness*
Quotation from "Destruction of Syntax—Imagination without strings—Words-in-Freedom," by F. T. Marinetti, 1913.

Chapter Five, *The Art of Noises*
Quotation from "The Art of Noises," by Luigi Russolo, 1913.

Chapter Six, *Lust Is a Force*
Quotation from "Futurist Manifesto of Lust."

Chapter Seven, *The Universe Will Be Our Vocabulary*
Quotation from "The Futurist Cinema," by F. T. Marinetti, Bruno Corra, Emilio Settimelli, Arnaldo Ginna, Giacomo Balla, and Remo Chiti, 1916.

Chapter Eight, *The Polyexpressive Symphony*
Quotation from "The Futurist Cinema."

Chapter Nine, *A Slap in the Face of Public Taste*
Quotation from "A Slap in the Face of Public Taste," by David Burliuk, Alexander Krudenykh, Vladimir Mayakovsky, and Victor Khlebnikov, 1917.

Chapter Ten, *Every Generation Must Build Its Own City*
Quotation from "Manifesto of Futurist Architecture," by Antonio Sant'Elia, 1914.

Foreword

BY IRVING SANDLER

I still recall the excitement I felt the first time I saw a theatrical piece by a visual artist, which happened to be *the* first work of its kind in my time. It was Red Grooms's *A Play Called Fire*, and it was staged at the Sun Gallery in Provincetown in 1958. The next year, Allan Kaprow presented *18 Happenings in Six Parts* at the Reuben Gallery. It was soon followed by the Happenings of Claes Oldenburg, Jim Dine, Robert Whitman, and George Brecht. Something fresh and avant-garde was occurring in New York School art. I was on alert.

Kaprow would provide a rationale for Happenings. I recall vividly his challenge to Abstract Expressionist painters in *their* Club in 1958. He said, "I am convinced that painting is a bore.... What doesn't bore me is the total destruction of ideas that have any discipline. I'm giving up painting and all of the arts by doing anything and everything." Pandemonium broke loose just short of chairs being thrown. As I left The Club that night, I knew that Kaprow's call for a new art that would break down the barriers between the arts and between art and life would radically change American art.

And it did. The early '60s witnessed Fluxus events. News arrived of a Gutai Group in Japan, the activities of Wolf Vostell in Germany, and much more. In 1966, Experiments in Art and Technology presented *9 Evenings: Theatre and Engineering*, held at the Twenty-Fifth Street Armory (the site of the Armory Show in 1913).

The available knowledge about the history of performance art was spotty. In 1979, RoseLee Goldberg provided a systematic account in *Performance Art: From Futurism to the Present*. She demonstrated not only that live performance art had a long and notable history, but that it was a crucial catalyst in shaping

the development of modernist art and culture. She showed that it had provided a vast open space in which artists had experimented in the past, and equally important, she claimed that this space was still open to contemporary artists.

Artists in increasing numbers agreed and created performances, but they were not reaching the audience their work merited. RoseLee decided to do something about this problem. Her solution was Performa. Those of us who watched this development were awed by RoseLee's ambitious vision and her astonishing ability to bring it to fruition. She predicted that Performa would attract a sizable and enthusiastic public, and she was right. Each Performa biennial, since the first in 2005, has extended the range and relevance of live performance art, and it is safe to predict that it will continue to do so.

Increasingly, the centrality of performance art in today's culture is being acknowledged. Growing numbers of art and cultural critics and historians are recognizing that many of the liveliest, timeliest, and most accomplished artists today are creating theatrical events and are seriously dealing with their work, its history, and its theory.

Performa, led by the inspired, passionate, and savvy RoseLee Goldberg, deserves our profound thanks.

How to Celebrate a Century

BY ROSELEE GOLDBERG

I have been waiting to celebrate the hundredth anniversary of the launch of Futurism for a long time, ever since I wrote the opening paragraph to my book on the history of performance art, first published in 1979. It was clear to me then, as much as it is now, that the twentieth century began with a series of radical propositions by the Futurists that would shift the very idea of art, transporting it from the museum and academy walls to the street and variety theater, from the painted canvas to the spoken word, from the written page to the airwaves, and from the pedestal of the sculpture studio to live bodies engaged in performed actions of all kinds. Indeed, the first Futurist Manifesto of 1909, and the seventeen Futurist manifestos that followed over almost two decades, left no part of modern life untouched; probing and provoking, inventing and challenging, they proposed and projected new ways to eat, sleep, fly, dance, and dream.

With Performa 09, the third biennial of new visual art performance, there would be no question where our starting point would be: back to Futurism. Hence our rallying cry for a twenty-first century revisit of an art movement from the early twentieth century that could show us the way to our own future. No looking back to the political '60s, the conceptual '70s, the yuppie-led '80s, the market-obsessed '90s, and the media-swamped '00s for inspiration. Instead, a review of the opening years of a century that was marked by new technologies (cars, trains, airplanes, machines) so powerful that every aspect of life would be changed forever, taken as a reference for the opening years of the next century, similarly marked by new technologies (computers, the Internet, robotic engineering, digital imaging) so powerful that every aspect of life would be forever changed.

We covered the city with banquets, exhibitions, street parades,

noise concerts, sleep-ins, film screenings, and performances, exercising a vision of urban connectedness that took history as inspiration. The Performa Hub was the starting point each day for a series of conversations that would provide a reading of both past and present, a veritable "how to" of bringing history to life. After all, in 2009 Futurism was being celebrated in major museums in Paris, Milan, London, and Rome, with exhibitions of paintings, sculptures, and drawings but only the most rudimentary nod to the manic activism—cultural, political, and social—that drove the young band of poets, painters, architects, musicians, and visionaries in the years leading up to the First World War, and that made the Futurist movement a roiling, disruptive wave of new art across England, Europe, Russia, Japan, and Mexico within weeks of its first fiery declamation. Instead, Performa chose another path, providing opportunities to experience what Futurism might have felt like, to taste the concoctions of creators in all media. We left out nothing and nobody was left out.

Architecture, and its many communities, was an important new addition to the Performa compendium of ideas. With Performa 07 we introduced new dance to our original manifesto for Performa 05—live art by visual artists—and for Performa 09, we wove an architectural net into the matrix between disciplines, starting with the Performa Hub, our first architecture commission, and from there extending up, down, and across Manhattan and its boroughs. With the Storefront for Art and Architecture, Performa presented a ten-day gathering of purposeful architects, academics, and urban scholars in a polemical crossfire of ideas and ideals. Long days and nights turned conversation into a battle call of urban activism for young architects against the stasis of real estate economies that produce the architecture with which we are forced to live. In events at the Performa Hub, the ideal performance space, street map, skyline, eye-level facade, and urban enclave were debated with PowerPoint, pencil, and posters, in a two-way exchange between experts and fans, as well as in a public school for architecture that emerged from a do-it-yourself curriculum posted online.

Poetry—or "words in liberty," as Marinetti described his—

took concrete form on the streets of Chinatown, with chalked words written onto a tarmac that quickly dissolved in the rain, or spoken, in declamations and declarations at a museum in the Bronx. Newspapers, printed fast and furiously overnight, brought the words closer to our ears, and images, still and moving, silent and with sound, captured Performa on the run each night and showed it fresh-faced to the world each morning.

Such compact illumination of the creative realities of the city that never sleeps provided context and framing for the remarkable Performa Commissions, numbering twelve, each with a proposition for a futurism all its own and each providing us with utterly original ways to view our fast-paced world. So fast did history race by these past hundred years that Performa attempted to stop time for a moment by devoting three weeks to reassess and rethink both how we experience art, and how we know and record it. For Performa was founded to reinstate the significance of artists' performance as pivotal to the history of twentieth-century art, and to show its electric charge as a place where ideas get started. Performa has demanded that we rewrite that history, a process that is well under way. Not only is performance art now being recognized, finally, by museums around the world as an essential form for exhibition, programming, and collecting, but the study of performance art in schools and universities has itself become the new art history.

PRELUDE

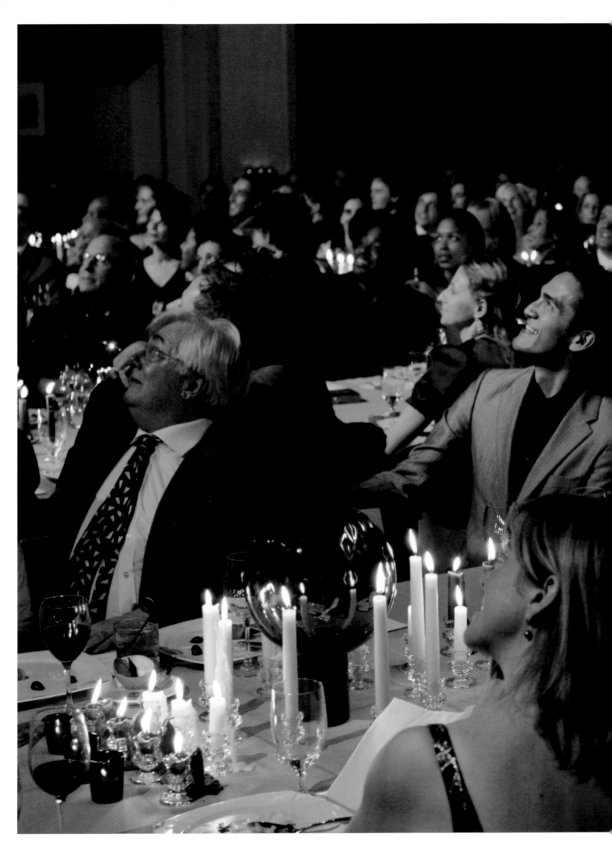

The Futurist Banquet
*as seen during "Milk
Bathed in Green Light,"
2009. All photos this
section by Paula Court.*

THE FUTURIST BANQUET

On February 20, 2009, the exact date that the Futurist manifesto was published on the front page of the Paris newspaper *Le Figaro* one hundred years before, Performa threw an extraordinary dinner party for one hundred people to commemorate its publication. *The Futurist Banquet* celebrated the Futurists' "love of danger, the habit of energy and fearlessness" and the group of young Italian poets, painters, and sculptors led by the indefatigable poet F. T. Marinetti, who wrote those words. The banquet also officially introduced the Futurist theme for Performa 09, taking the hundredth anniversary as an opportunity to fulfill Performa's mission of bringing history to life in the most original and inspiring ways.

At Inside Park, a restaurant situated in the Great Hall of the Community House at the historic St. Bartholomew's Church on Park Avenue—with its soaring thirty-foot ceiling, decorative wall stencils, and stained-glass windows still intact from the hall's original construction eighty-six years ago—renowned chef Matthew Weingarten, formerly the chef de cuisine at the celebrated Savoy restaurant in New York, enthusiastically welcomed visitors with an inventive Futurist menu inspired by Marinetti's sensational *Futurist Cookbook* of 1932.

"We must invent new foods that induce happiness and optimism and multiply infinitely the joy of living," Marinetti declared in the book's introduction, which

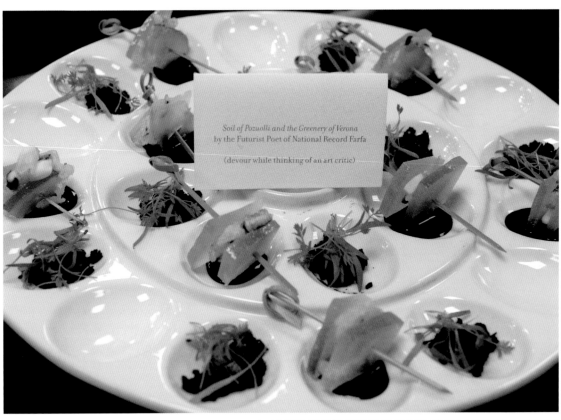

Soil of Pozuolli and the Greenery of Verona
by the Futurist Poet of National Record Farfa

(devour while thinking of an art critic)

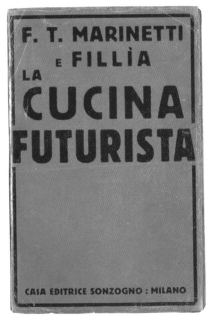

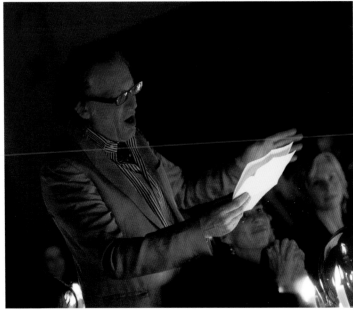

Above, left: Cover of F. T. Marinetti's Futurist Cookbook, 1932. Right: Ronald Guttman performing the poem "Folgore's Dazzling Appetizer" at The Futurist Banquet, 2009.

Opposite: Appetizers served during The Futurist Banquet, 2009. Top: "Soil of Pozuolli and the Greenery of Verona." Bottom: "Tyrrhenian Seaweed Foam (with coral garnish)."

also denounced pasta as something that "weighs you down like a ball and chain." During the 1920s and '30s, Futurist chefs such as Luigi Colombo Fillia, Giacomo Balla, and Fortunato Depero, also painters and sculptors, created wild and creatively named dishes, the serving of which was accompanied by banging gongs, dramatic lighting changes, and even special scents strewn throughout the room.

In response, Weingarten—a longtime supporter of local farmlands and responsibly sourced ingredients, as well as an admirer of the *Futurist Cookbook*—fused the theatricality of the Futurists' famous dinners with his own trademark use of seasonal ingredients and rustic cooking techniques. The evening began with cocktails featuring unusual drinks such as "Alcoholic Joust," during which time the guests were invited to locate their assigned place settings featuring their own initials made of

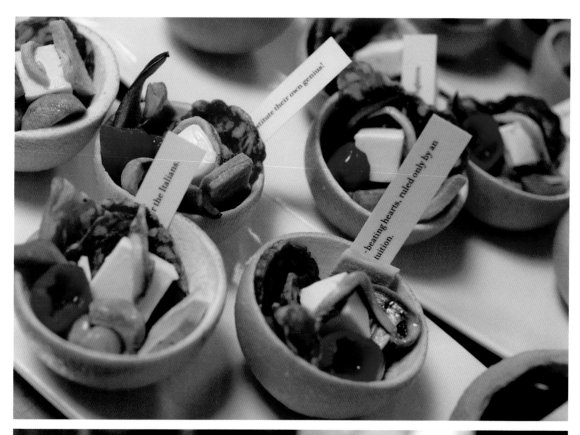

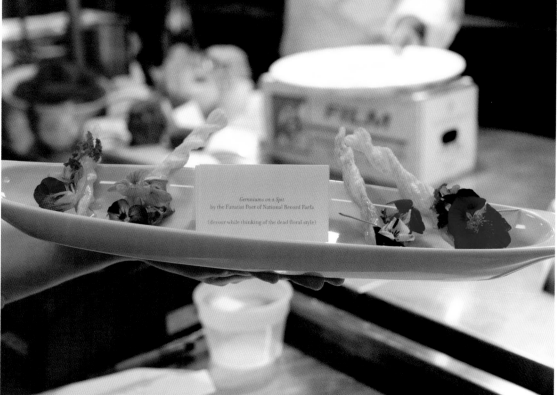

Geraniums on a Spit
by the Futurist Poet of National Record Farfa

(devour while thinking of the dead floral style)

mortadella, caramel, pastry, and cheese. The appetizers served included "Edible Alphabet" and "Cubist Vegetables," followed by courses such as "Intuitive Antipasto" (orange rinds containing Futurist rallying cries on paper, which guests were invited to stand and shout during the meal), "Aerofood" (during which guests ate while attendants sprayed perfume in front of their noses), and "Milk Bathed in Green Light" (a sweet ricotta dish that guests ate while the room was illuminated with bright green lights). Throughout, The Cangelosi Cards, a New Orleans–style jazz band, incorporated Italian avant-garde references into their repertoire.

A later highlight of the evening was a performance of Futurist poet Francesco Cangiullo's epic text *Piedigrotta* (1916), which takes the yearly Neapolitan street party as its subject and is considered to be the pinnacle of Futurist poetry, by composer and musicologist Luciano Chessa. Using onomatopoeic techniques to mimic the sounds of firecrackers bursting, street vendors shouting, a group of tenors singing, and mortars and shrapnel exploding, presenting the noise of the city as a living organism that is brought to a sudden halt when the procession of the Black Madonna takes over the stage, Chessa performed the poem shouting and running throughout the space.

The evening was capped off with a creative dessert by British artists and Jell-O maestros Bompas & Parr, who reconstructed the Futurist recipe *The Marinettian Bombe* with orange Jell-O, angelica, fresh strawberries, candied chestnuts, and Campari, served with apricots and candied lemons. A sweet finish to an unforgettable evening.

—RoseLee Goldberg

Appetizers served during The Futurist Banquet, *2009. Top: "Intuitive Antipasto." Bottom: "Geraniums on a Spit."*

P.S.1
CONTEMPORARY
ART CENTER

CURATED BY KLAUS
BIESENBACH AND
ROSELEE GOLDBERG

ORGANIZED BY P.S.1
CONTEMPORARY
ART CENTER AND
PERFORMA

100 Years, 2009. New York exhibition view. Photo by Paula Court.

100 YEARS
(VERSION #2, P.S.1, NOV 2009)

An exhibition covering each year since 1909, when the Futurists published their "Futurist Manifesto" and launched the Futurist movement, with its demands for an art of action and intervention, to 2009, when Performa celebrated the 100th anniversary of Futurism, *100 Years* is an essential introduction to the history of performance art. Organized as part of Performa 09, *100 Years* included a vast collection of material never before gathered in the same exhibition space: films, videos, drawings, notations, photographs, posters, and flyers of live art by artists coming from a range of disciplines. It also provided a vital timeline of key performance works that shaped the ideas and developments of twentieth-century art and culture.

Conceived as a "living exhibition," since it will continue to grow exponentially as it travels from venue to venue over the coming years, *100 Years* showed the extraordinary variety of performance by artists over the past ten decades. Reprints of Futurist and Dada manifestos were seen side by side with photographs of Oskar Schlemmer's *Triadic Ballet*, films of Francis Picabia's *Relâche*, and footage of Mary Wigman's *Hexentanz* in the first room, while unforgettable films (transferred to video) by Yves Klein, Carolee Schneemann, Anna Halprin, Yoko Ono, Trisha Brown, and Yayoi Kusama could be seen in the second. The exhibition led viewers chronologically through the galleries, with material by Vito Acconci, Ana Mendieta,

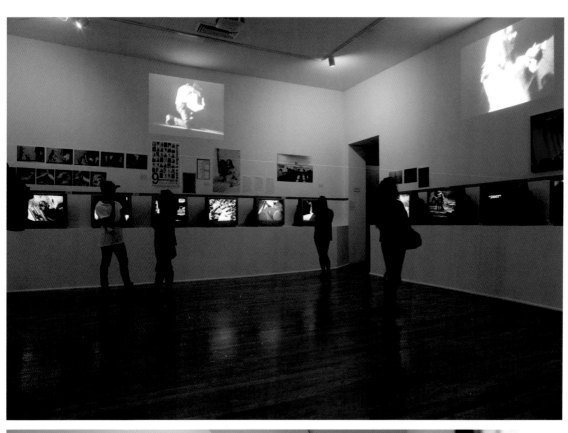

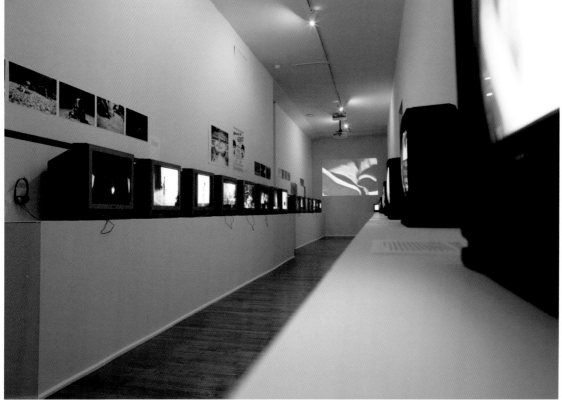

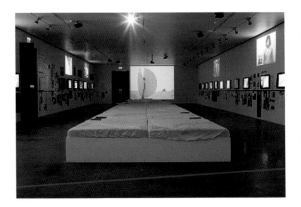

Above: 100 Years, *2010. Moscow exhibition views. Courtesy Garage Center for Contemporary Culture, 2010.*

Opposite: 100 Years, *2009. New York exhibition views. Photos by Paula Court.*

Matthew Barney, Tania Bruguera, Adrian Piper, and Michael Smith, all the way to the present day, with material by Allora & Calzadilla, Sigalit Landau, and Ryan Trecartin.

Functioning as an archive of easily reproducible material, the exhibition was also a history of the style and manner of documentation itself, and of the technology used to produce it. From grainy black-and-white films from the early 1910s to the grayish-blue of black-and-white video recordings from the '60s, and from the sepia tones of early color film and video to the sharp brightness of contemporary high-definition digital recordings, as well as a parallel history from silent footage to surround sound, and the escalation of scale made possible by today's projectors, this unusual exhibition was itself a model of the multidisciplinary range of contemporary art and technology. With additional live programs, seminars, and screenings organized each week during its four-month run at P.S.1 in New York, and a two-week performance festival accompanying the show when it was presented at The Garage Center in Moscow in June 2010, *100 Years*, which continues to tour, is an important container for a history of ephemeral art, and an exciting new model for ways to make that history palpable, and live, for new generations of viewers. —*RoseLee Goldberg*

PROVOKING THE FUTURE

PERFORMA COMMISSIONS

The Performa Commissions program, initiated by Performa Director RoseLee Goldberg to create ambitious new performances for the twenty-first century, invites visual artists—many of whom have never worked "live" before—to create new work especially for the biennial. Performa works closely with each artist from start to finish, from development and production through final presentation at the biennial, including international touring following the New York premiere. For Performa 09, these biennial centerpieces included an opening-night moving feast, a cell-phone parade, a talk show, a mysterious journey through the Lower East Side, and a musical spectacle based on high-school yearbook photos.

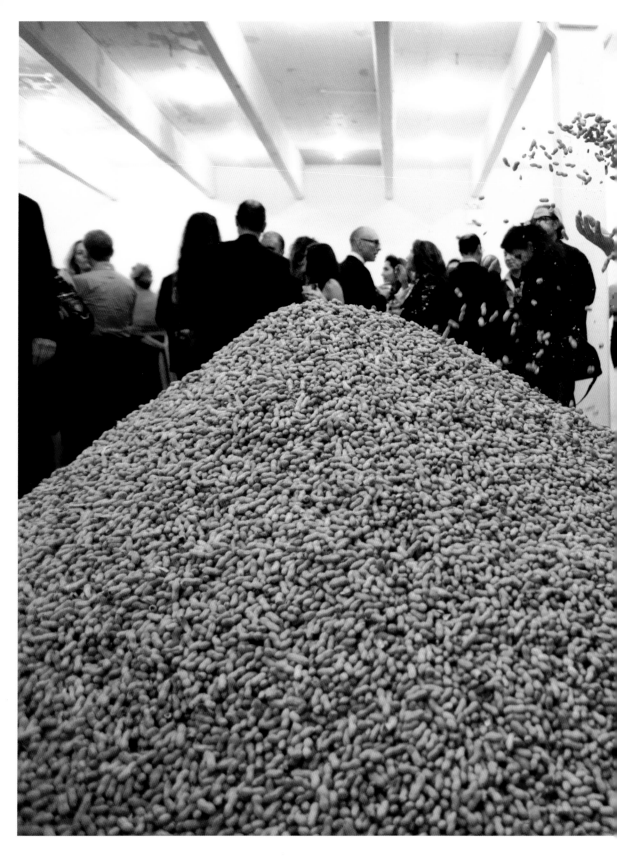

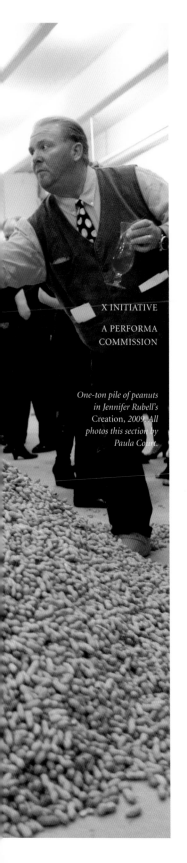

*One-ton pile of peanuts
in Jennifer Rubell's
Creation, 2009. All
photos this section by
Paula Court.*

OPENING NIGHT: CREATION
JENNIFER RUBELL

The goal of Performa's Opening Night is to set the stage for a biennial that will palpably shift the mood of New York City's cultural life, and to declare the beginning of a three-week immersion in the imagination of visual artists. It is a night in which to fully submit to the fact that art gives significance to our daily lives, not only to satiate our desires for aesthetic and visceral pleasures, but also as a means to express the complex humanism that shapes our consciousness.

For Performa 09's Opening Night, Jennifer Rubell created an event that accomplished all of the above. Startling in its scale, interactive demands, and visual metaphors, her performance-installation took place on three vast floors of a building on Twenty-Second Street in Manhattan. The elements of the evening followed the order of a typical gala reception—"cocktails," "dinner," and "dessert"—but Rubell entirely upended these conventions. Also arranged in three parts, her *Creation,* inspired by the first chapters of Genesis, provided surprises every step of the way.

The top floor, "cocktails," was Rubell's version of the "Garden of Eden," where Adam might have tilled the ground. A giant mound of roasted peanuts in their shells, 3,600 glasses on a pedestal, one ton of ice cubes, and, in the 28-foot-long elevator, an expansive table of wine, liquor, and mixers were laid out for visitors to help themselves. For "dinner," guests descended via the liquor elevator to the third floor, where the "Creation of Woman" (from Adam's rib) was represented by one ton of spare ribs atop a massive pedestal, with honey raining from above. Five long tables, each seating one hundred people, were laid with pots running down the center that contained the side dishes, forks, knives, toothpicks, and napkins. A trio of water coolers, filled with red wine, white wine, and water, were set up to the side of the space.

For "dessert," the liquor elevator opened onto the second floor, representing "Expulsion and the Fall": a space elegantly strewn with three newly felled apple trees that had been brought

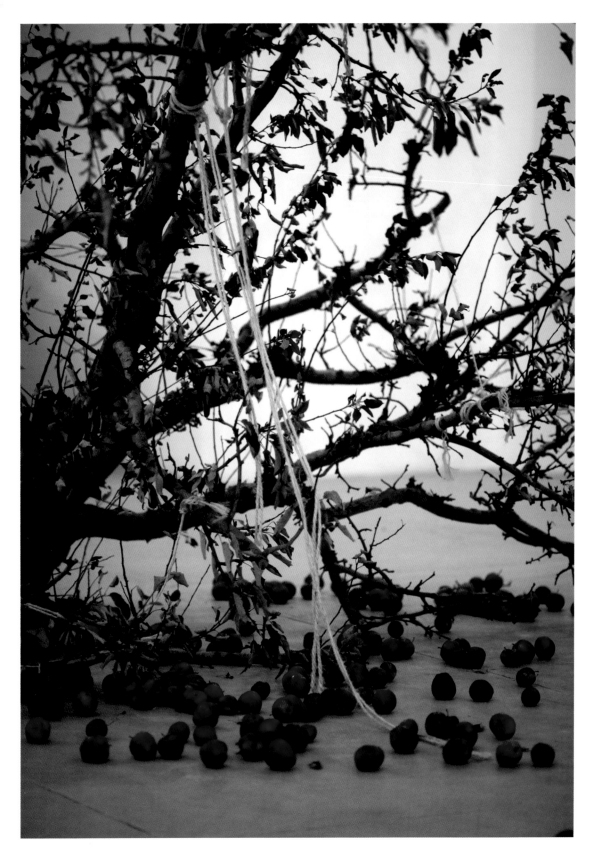

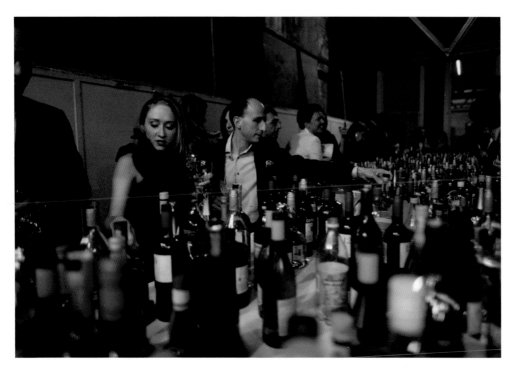

Details of Jennifer Rubell's
Creation, *2009. Left: Felled apple
tree. Above: Liquor elevator.*

*Following spread: details from
Jennifer Rubell's* Creation,
*2009. Top left: One ton of ribs
with honey dripping on them.
Bottom left: Guests seated. Top
right: Drink coolers. Bottom
right: Guest about to hammer a
chocolate replica of Jeff Koons's
Rabbit.*

in that day by a farmer on Long Island, with apples still attached
to their branches. The healthful fruit could be eaten along
with cookies plucked from three large industrial bags filled
with sugar, and morsels of chocolate, once guests took up the
hammers provided and started destroying the seven chocolate
facsimiles of Jeff Koons's famous *Rabbit* sculpture.

"The project as a whole serves many functions," noted Rubell.
"As a commentary on the artisanal, the original, the unique
and the appropriated; as an exploration of ways to engage art
history through a medium (food) virtually absent from it; as a
catalyst for a working interaction between viewers and objects,
and viewers and each other; as a meal; and as a questioning of
the boundary between art and all that exists to support it."

—*RoseLee Goldberg*

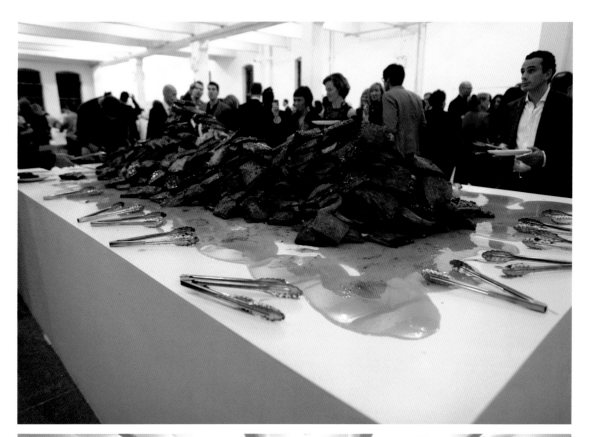

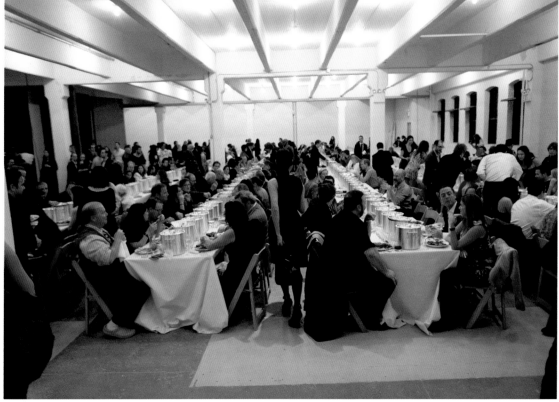

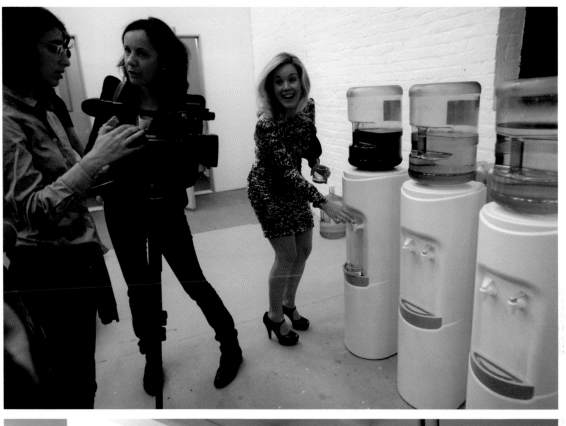

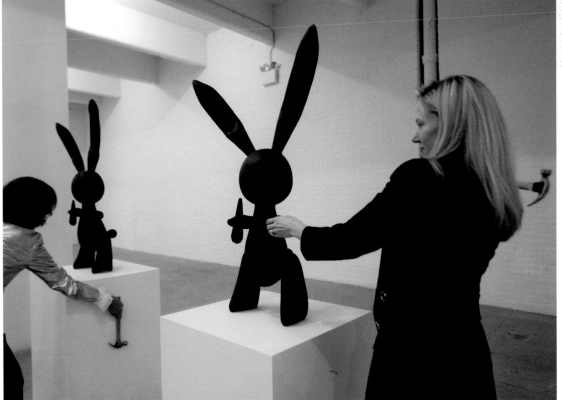

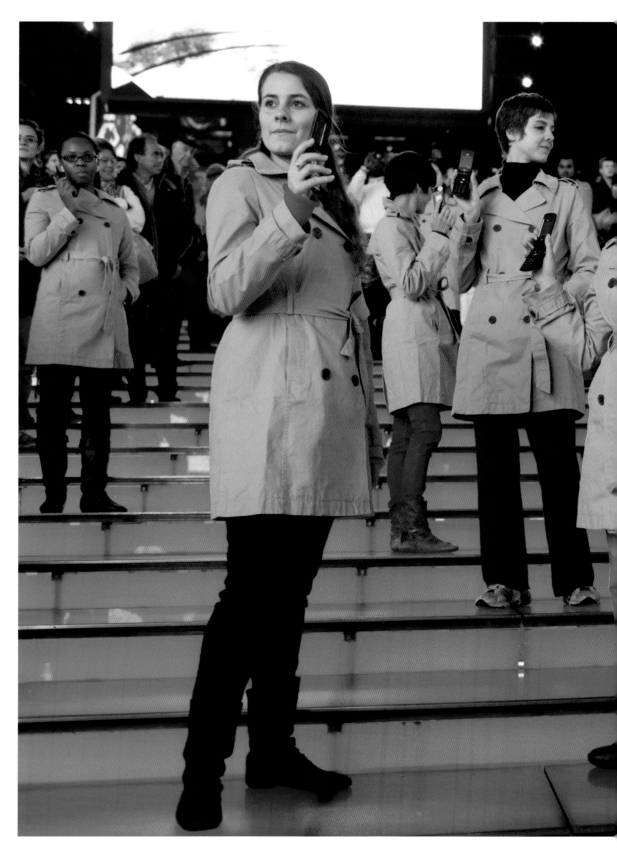

TIMES SQUARE

A PERFORMA
COMMISSION

PRESENTED IN
PARTNERSHIP
WITH THE TIMES
SQUARE ALLIANCE

Arto Lindsay,
SOMEWHERE I READ,
2009. Performance view.
Photo by Paula Court.

Right: Arto Lindsay,
SOMEWHERE I READ,
2009. Video still.

SOMEWHERE I READ
ARTO LINDSAY

Arto Lindsay, the Brazilian-raised American musician and sound artist, turned the *Carnaval* tradition of the spectacular street parade on its head with a minimalist, technology-centered approach. Instead of floats, bright costumes, and brass bands, Lindsay opted for a choreographed parade of fifty dancers wearing Bogart-style trench coats, holding cell phones to their ears that transmitted a stripped-down techno score for all to hear. Assembled on the red staircase at the northern end of Times Square near Forty-Seventh Street, among the crowd of tourists taking pictures of the light show around them, the dancers snapped to attention when the first notes of synchronized digital beats emanated from their phones. Rhythmically shaking their heads from side to side, they descended the stairs and began their "dance" (created in collaboration with choreographer Lily Baldwin)—which included a straight-legged leap, a crouch with hands rapidly beating the air around their heads, and a "funky chicken"–style walk. As they made their way slowly in single file through the square down Seventh Avenue to Thirtieth Street, over more than an hour, the public fell in line behind the performers as though following the Pied Piper, parting the late-night crowd. The result was a surprisingly focused and interactive event amid the cacophony of neon billboards, high-lumen projections, and street traffic. —*Mark Beasley*

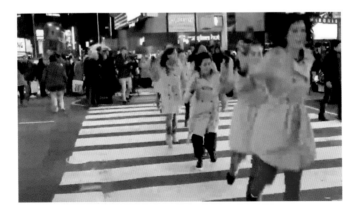

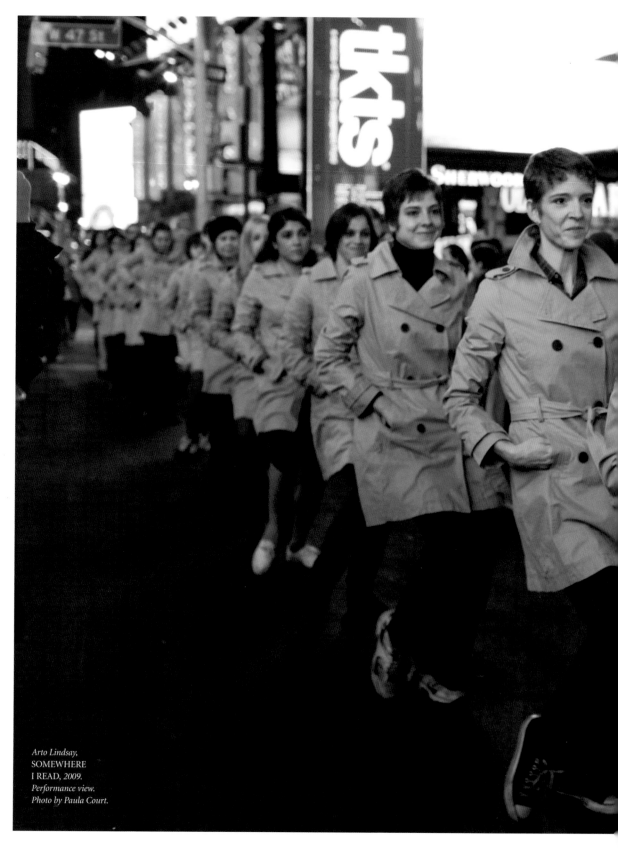

Arto Lindsay,
SOMEWHERE
I READ, *2009.*
Performance view.
Photo by Paula Court.

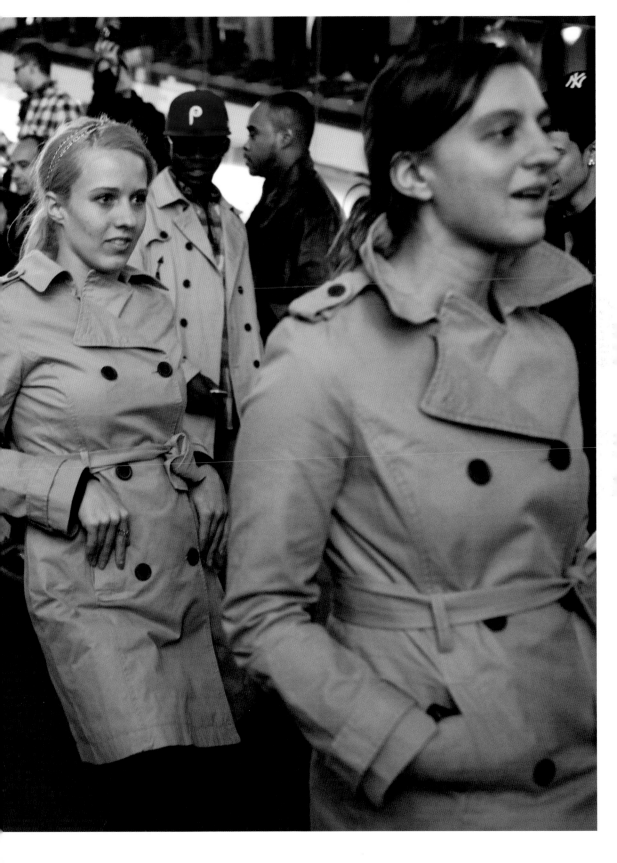

You jumped into a pool—
a man out of his mind.

For Audio Dial (888)866-9697 (minute usage may apply)

on cnn.com

**Chapel housing 9/11
victims set on fire**

CLEAR CHANNEL
SPECTACOLOR

DROP THE MONKEY
GUY BEN-NER

A PERFORMA
COMMISSION
WITH ARTIS
CONTEMPORARY
ISRAELI ART FUND

*Guy Ben-Ner, Drop the
Monkey, 2009. Times
Square exhibition view.
Photo by Paula Court.*

It was the perfect plan. What could go wrong? No stranger to dragging his personal life into his art, Guy Ben-Ner devised a way to raise the stakes while seriously working the system. For *Drop the Monkey* he proposed making a video that would document in real time his travels back and forth between Tel Aviv and Berlin, and wagered that he could complete it without any editing, post-production revising, or hindsight fixes: the videotape would never leave the camera, and what was recorded, scene after scene, would be all there is. Shot sequentially over the course of a year and the span of twenty-five flights, the eight-minute video revolves around a solipsistic dialogue, a cell-phone conversation in rhymed verse that Ben-Ner has with himself—his home self talking to his away self—that mainly concerns the self-reflexive moral, ethical, artistic, and logistical pros and cons of making the video. Each remark or response, each question or trifling retort, requires another day of travel and a five-hour flight, and the airline miles start to rack up.

Speaking with a touch of Shakespearean bravado, Ben-Ner's Berlin self explains to his Tel Aviv self that, thanks to the generous financial support of an unnamed art organization, he has concocted an ingenious way to have frequent amorous visits to his Berlin lover completely subsidized under the cover of a neat conceptual conceit. But the line between artistic game-playing and risky brinksmanship is a fine one, as Ben-Ner knows. Just a few minutes into the video, we learn that his lover has ditched him as spring turned to summer, and now he feels trapped by the contractually binding project that had ensured their regular rendezvous. As he notes with growing distress, he is obligated to his underwriters to deliver the goods as promised, and as his personal affairs unravel, the strict rules of his project force him to continue shuttling to and fro and absorb the contours of the unexpected into his life's new narrative. Ultimately the video's tone becomes more humble, parabolic, even quietly profound. It's hard to tell what shape the video would have taken if his girlfriend hadn't dumped him and his year of travel had remained

Hello friend, your voice
is ringing very sweet

Berlin

Guy Ben-Ner, Drop the Monkey, *2009. Video stills. Courtesy the artist.*

carefree. Did he sense from the start that his video would have a narrative arc that bent toward the tragic? Or did he have a mental script in his head from which life deviated? Was there always an inkling that the tale of his private jet-set escapades, destined to play out for public consumption and debut on a massive screen in New York's Times Square, would have more than a tinge of the Icarus myth? Indeed, a premonition of folly, hubris, and downfall seems present from the beginning—which is always where the smart money is. —*James Trainor*

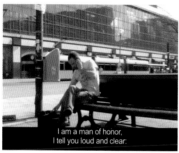

I am a man of honor,
I tell you loud and clear:

Berlin

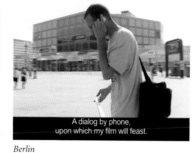

A dialog by phone,
upon which my film will feast.

Berlin

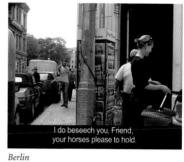

I do beseech you, Friend,
your horses please to hold.

Berlin

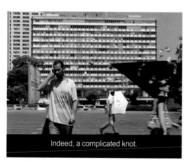

Indeed, a complicated knot.

Tel Aviv

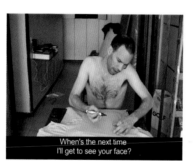

When's the next time
I'll get to see your face?

Tel Aviv

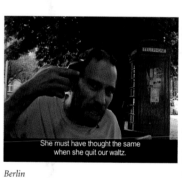

She must have thought the same
when she quit our waltz.

Berlin

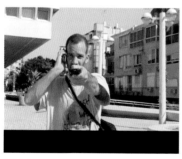

Tel Aviv

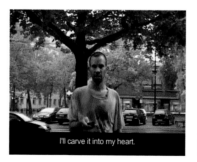

I'll carve it into my heart.

Berlin

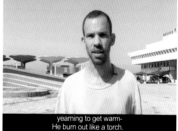

yearning to get warm-
He burn out like a torch.

Tel Aviv

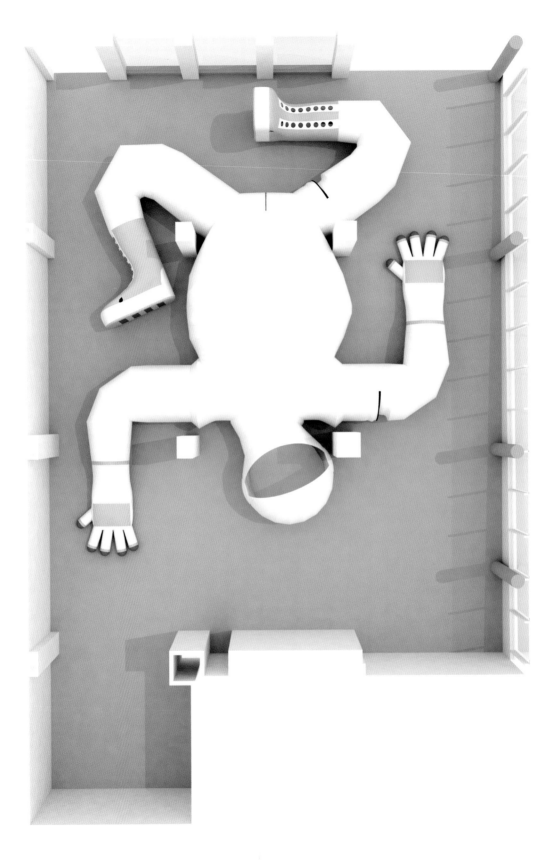

MOTHER EARTH SISTER MOON
CHRISTIAN TOMASZEWSKI AND
JOANNA MALINOWSKA

CHASHAMA 679

A PERFORMA
COMMISSION

*Christian
Tomaszewski and
Joanna Malinowska,*
Mother Earth Sister
Moon, *2009. Initial
design rendering.
Courtesy the artists.*

Through the plate-glass windows of a storefront at the corner of Third Avenue and Forty-Third Street, passersby could see a colossal white form lit from within—a giant alien worm? The tubular structure proved to be not an extraterrestrial, but a huge and wondrous space suit made of translucent Tyvek material lying on its back and supported by a skeleton of slender pipes. *Mother Earth Sister Moon*, a collaboration between Polish multimedia installation artist Christian Tomaszewski and video and performance artist Joanna Malinowska, was modeled on the suit worn by Russian astronaut Valentina Tereshkova, who in 1963 became the first woman in space, and also referred to Niki de Saint Phalle's naughty-at-the-time *Hon-—En Katedral* (She—A Cathedral, 1966), a monumental, voluptuous female figure that viewers entered through her "vagina." *Mother Earth Sister Moon* could also be entered (through the armpits and sides as well as the crotch) but was more moonlike than earthy. The installation was also the site of a performance presented four times during the biennial: A fashion show inspired by Soviet-era clothing, with space-age music by Masami Tomihisa, the work consisted of a complex tribute of sorts to women, the Russian avant-garde in general (which boasted an unprecedented number of female artists), and Constructivism in particular, with its blend of fine art, design, and craft. Inside the space suit, lit by clusters of white neon tubes (one corner fixture recalled Tatlin by way of Flavin), viewers sat cozily on the floor leaving an open runway for the models, women of various ages and shapes, who entered and exited by unzipping and zipping certain seams. The "collection" was mostly gray, black, and white, imaginatively suggesting Malevich's paintings as well as design elements of science-fiction film and Eastern Bloc literature. It was all more Soviet than New York-Paris-Milan, and Anna Wintour was not in attendance, but everyone had a good time, despite the Cold War ambience. —*Lilly Wei*

A version of this text was originally published in the February 2010 issue of Art in America.

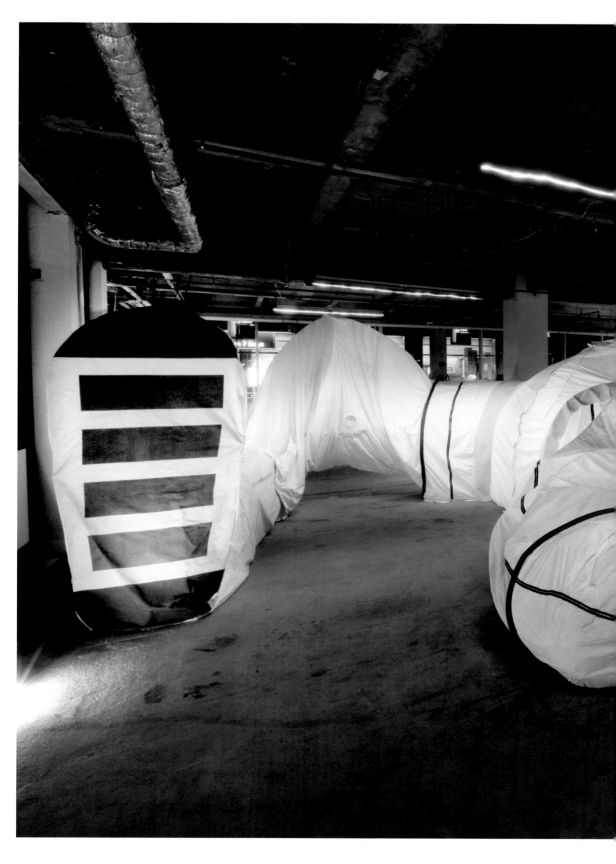

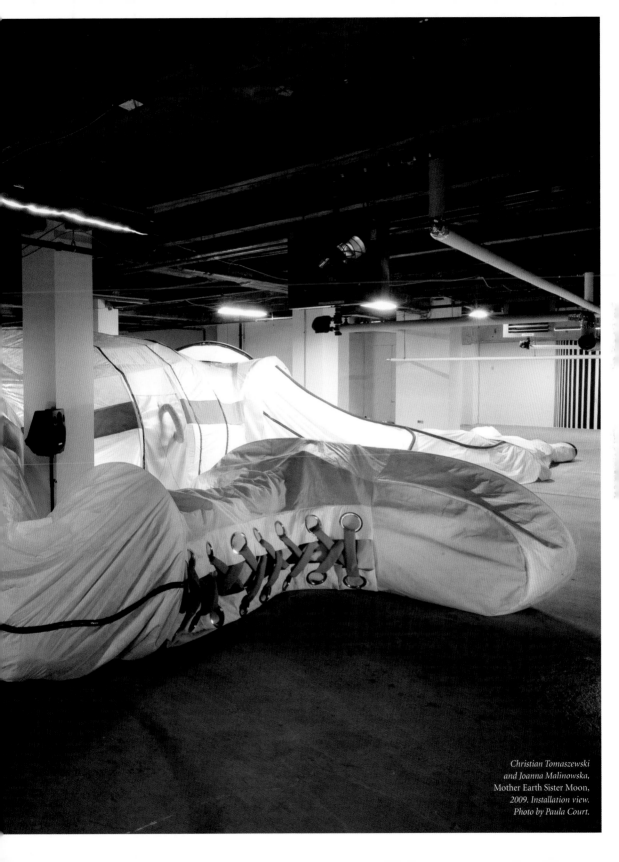

*Christian Tomaszewski
and Joanna Malinowska,
Mother Earth Sister Moon,
2009. Installation view.
Photo by Paula Court.*

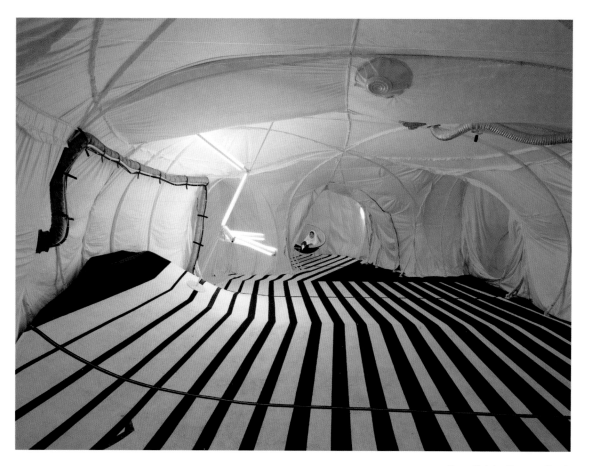

Above: Christian Tomaszewski and Joanna Malinowska, Mother Earth Sister Moon, *2009. Performance view. Photo by Paula Court.*

Opposite: Costumes from Christian Tomaszewski and Joanna Malinowska's Mother Earth Sister Moon, *2009. Photos by Nicolas Wagner.*

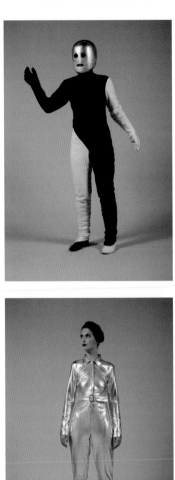
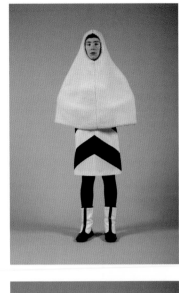
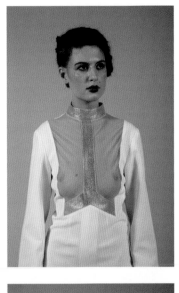
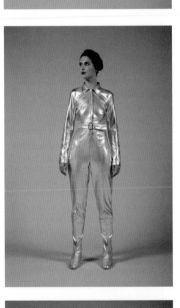

ABRONS ARTS
CENTER

A PERFORMA
COMMISSION
WITH ARTIS
CONTEMPORARY
ISRAELI ART FUND

*Set for Omer Fast's
Talk Show, 2009. All
photos this section by
Paula Court.*

TALK SHOW
OMER FAST

With *Talk Show*, Israeli artist Omer Fast accomplished a remarkable transition from video installation to live performance, with understated conceptual deftness. Known for work that examines how individuals and histories shape each other through storytelling, Fast has often mixed footage into personal and mass-media-based accounts of current and past events. In *Talk Show*, Fast organized a complex exploration of individual versus collective memory, and of how all recollections morph over time.

At first glance, *Talk Show* was exactly what it professed to be—a talk show, complete with two armchairs, an "APPLAUSE" light for the audience, and two flower arrangements (with the morbid twist of a skull nestling in each one). A middle-aged woman sat in one chair; a sixty-something man in the other. "So," the woman began. "Tell me about your brother." The man launched into a series of anecdotes about his childhood. The reminiscences were detailed, specific, idiosyncratic. Gradually it became clear that there was something unusual about his brother. The audience was gripped: he was an electric storyteller. It turned out that a few years ago, he suspected his brother of being a serial killer. He explained, candidly and clearly, the pain of having to decide whether or not to go to the police, how to tell his mother, the unwanted attention of the press, and so on. The story ended rather quietly, and he left the stage to great applause.

A younger man came onstage and took the empty seat. "So," he said to the woman. "Tell me about your brother." She began the same story. Seeming slips of the tongue and differences in the content made you wonder whether the dialogue was scripted or improvised. The tone was different too—somewhat debased, less detailed, clearly secondhand. At the end of the story, she left the stage, to more applause. A very tall man came to take her place. "So," he began.

And so the evening proceeded. Six actors appeared, each of whom, it turned out, was hearing the story for the first time

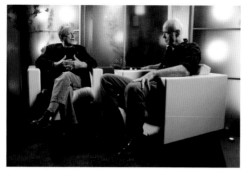

William Ayers with Tom Noonan.

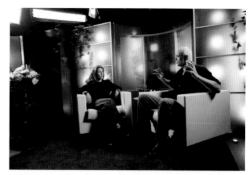

Lili Taylor with Tom Noonan.

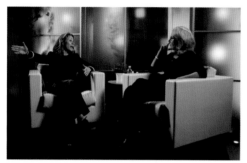

Lili Taylor with Jill Clayburgh.

David Margulies with Jill Clayburgh.

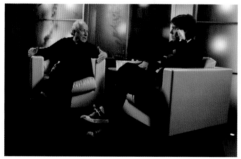

David Margulies with Dave Hill.

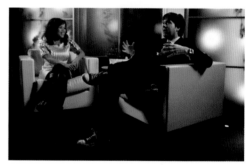

Rosie Perez with Dave Hill.

onstage, and repeated it from memory to the next guest. Eventually, our champion raconteur from the start appeared onstage again, this time as interviewer, hearing his own story told back to him. We had come full circle, but meanwhile the story had deteriorated and morphed, becoming more reductive, more entertaining, more narcissistic ("Why's everyone always asking me about my brother? Why doesn't anyone ask about me?"). These changes were incremental, perhaps alluding to

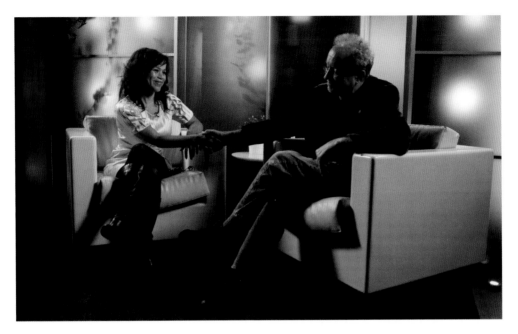

Rosie Perez with William Ayers.

All photos this spread: Omer Fast's Talk Show, 2009. Performance views.

how the mass media simplifies and degrades the most complex narratives.

Some audience members may have realized from the beginning that the original storyteller was David Kaczynski, the brother of Unabomber Ted Kaczynski. (On the two other nights of the performance, the lead storytellers were William Ayers, retired education professor and former member of the Weather Underground; and Lisa Ramaci, wife of murdered journalist Steven Vincent.) The actors—Tom Noonan, Lili Taylor, Jill Clayburgh, David Margulies, Rosie Perez, and, surprisingly, comedian Dave Hill—had no idea who the storyteller each night would be, and were kept in a soundproof area offstage until their turn came. With the extraordinary power of the stories—and their unexpected transformation into misrepresentations, half-truths, fantasies, or even jokes—Fast provided a provocative glimpse of the mutability of personal reality in the context of global events. *—Claire Bishop*

Interview

WILLIAM AYERS, OMER FAST, AND LILI TAYLOR

MODERATED BY LANA WILSON

LANA WILSON (LW): Omer, how did you come up with the concept for *Talk Show*?

OMER FAST (OF): I've made several projects that involve meeting people—people with stories, people who have lived through intense experiences, and people who have every reason to embellish, fabricate, or cover up those experiences. What's interesting to me is not only the confessional aspect of these stories, but also the ambiguity involved in recalling something. Very often the stories I'm interested in have to do with subjects that are quite loaded. They often have very personal elements to them, but they always relate directly to a much wider social fabric.

When RoseLee [Goldberg] invited me to do a Performa Commission, I knew that I wouldn't be able to do what I normally do with these sorts of subjects. I usually record conversations with people, and then spend a lot of time with that material, going deep into those little gaps, those lies, those details in the story that I find so provocative. I often amplify those aspects, sometimes adding myself into the stories as another actor or character, so that the piece ends up being about the narrating of the story, not just about unearthing a truth, as a more responsible documentarian or journalist might do.

And since I'm not a performer myself (or rather, my daily performance involves sitting in front of a computer for hours), I knew that I needed to find performers who would sit on the stage and take over that part of my work.

LW: And how did you think of Bill [William Ayers] as one of these people?

OF: I wanted to find stories connected to the local context, specifically to Manhattan, but also stories in which an individual's decision to act out of political conviction has broader consequences for the public. On the first eve-

ning, Bill talked about his involvement with the Weather Underground and the explosion at the Greenwich Village townhouse in 1970. On the second evening, Lisa Ramaci talked about her husband's fatal decision to give up a career as a New York art critic in order to go to Iraq as a freelance journalist. And on the third evening, David Kaczynski talked about his brother Ted, aka the Unabomber, who decided that society had gone in a very wrong direction and that he would act to correct it.

LW: How did you approach Bill about the project?

OF: We emailed first, and talked on the phone, and then met for a drink. We talked about what kind of story or event might be the focus of the evening. I actually didn't want to know what his chosen story would be. I didn't want to sit there like a grammar teacher correcting people's stories, imposing myself on their own recollections.

WILLIAM AYERS (WA): Omer started by saying that every story was a lie, and that really resonated with me. I've written a couple of memoirs, and my view is that memories are lies. Your memory is always editing ferociously, and you tell stories about your life, but the stories are not the actual raw chaos of living every day. And storytelling is inevitably nar-

cissistic as well; we hide things and round off the rough edges. So I thought Omer's project sounded interesting and fun.

LW: I'm surprised to hear that Omer had no idea what story you were going to tell that night. Bill, how did you decide what you would talk about?

WA: Well, I actually appreciated that Omer didn't want to hear the story. I realized that he wasn't trying to tell the perfect story—he simply wanted to see what happens when you tell a story, and other people get a hold of it and begin to play with it, and add their own first-person perspective and context to it, and I thought that was a fascinating idea. I decided to tell the story of something I've written about before—this particular love story that had tragic consequences and asked the ultimate memoir question: "How did kids like this get into a place like that?" That's the story I tried to tell in ten minutes.

LW: Omer, how was Bill's story framed for the audience? Did they understand what was going on onstage? Did they know who he was?

OF: The audience wasn't told the identities of the guests—nor were the performers, who only heard the stories for the first time when it was their turn to go onstage. That's what was

most interesting to me about this project: because the performers didn't know the stories beforehand, the focus shifted from the person telling the story—a documentary-style look at who they are and what they're talking about—to the performers, these equally real, living, breathing actors whose job is to hear the story for the first time and then recall it in front of the audience. The audience is very much "in" on what's happening, but their attention is shifted from figuring out who the storyteller is to looking at how these individuals deal with the task at hand. You start to have much more sympathy for the performers than you do for the storyteller…

LW: How did you come to think of Lili [Taylor] to be one of the performers in *Talk Show*?

OF: We invited several actors to come in for "casting," but, in the same way that I didn't ask the guests what their stories would be, I didn't "cast" by having people practice repeating a story to me. Instead I talked to them to see how they responded to the idea. I was just thrilled that Lili was interested.

LILI TAYLOR (LT): I loved the idea, and I was excited about collaborating in a different way. As an actor, collaboration is often limited to a playwright or another actor—I rarely get to cross over into different art mediums.

I loved that Omer didn't want to explain

[the piece] at all. I loved how he was like, "Let's just go with the unknown of it." So few people are willing to do that, and I think that's when the best stuff starts to happen. For me, what was most interesting was balancing the desire to entertain the audience with wanting to respect the original person's story, even if I didn't really know what it was. I think I had a very different approach than some of the other actors, like…Omer, who was that guy that was really funny?

OF: Dave Hill.

LT: Yes, Dave Hill. He can totally turn things on their head, getting a laugh but also pushing things to the very edge. It's really an exaggeration of what we all do when we tell our stories. But I wanted to try to listen really well and be as honest as possible.

LW: Bill, how did it feel to you, watching the actors?

WA: What Omer said about the performers being the people you sympathize with—that was my experience too. After I told my story to Tom [Noonan] at the start, I watched him retell the story, and at first, I wanted to jump up and correct him. But by the time it got to Rosie Perez (who, in her version, was having a lesbian love affair with her fourteen-year-old students!) I loved that it had that quality of,

as Lili said, trying to be honest and pull out some string of truth from it, but also adding yourself.

OF: Bill's a very generous person. For me, it was a hard experience, especially at the start, because I felt this contradictory responsibility to both entertain and inform the audience. I didn't want to make it a didactic evening, but at the same time I felt an ethical responsibility to the storyteller. In Bill's case, he's a very strong person, and has told this story quite a few times, so he's able to open up in front of the audience and not feel (correct me if I'm wrong, Bill) a sense of being violated or compromised. But I think on another evening, those ethical issues were much sharper. I had some questions about whether or not we crossed a line on the third night.

LT: The third night was very uncomfortable. At the end of the night, [David] Kaczynski seemed upset, and I felt confused and uncomfortable. It made me wonder whether or not this man's story had been disrespected or treated too lightly or made fun of. But what I loved about this project is that there are no easy answers to this—just lots of questions and food for thought.

LW: Could each of you walk us through your individual experiences of the first evening? Maybe starting with Bill?

WA: I went down to the theater with my son and my daughter-in-law, who are both writers and theater people. They were with me backstage, and they recognized who all the actors were, but I didn't. Omer was very nervous, so I suddenly got nervous!

Then the performance began, and I felt really odd having this conversation with Tom while everyone was watching me. As I was talking to him, I saw this knowing look come over Tom's face—I hadn't been sure if anyone would figure out who this story was about, but Tom, as I saw right in front of me, figured it out immediately. I think Lili also figured it out, and Jill Clayburgh. I don't think the others did. In any case, Tom knew, so I didn't know what to expect. After I was done I sat down with my kids in the audience, and we began to watch. Like I said, at first I wanted Tom to get it right, but by the time it got to the next performer, I had let that go. I was fascinated with what people brought to it: their own autobiographies, their own narcissisms, their own subjectivity. And also just stuff out of the cultural ether—for instance, people started talking about terrorism and bombs and all this stuff that was going on at the time of the performance. Or at one point, someone said, "We're sorry we killed all those people." But we didn't kill anybody, and that was stated in my story—so I was amazed that someone was apologizing for something that didn't happen, but realized that people were embellishing based not on things I had

said, but things they had associated in their own mind.

LW: Do you remember anything particular about Lili's retelling of your story?

WA: You figured out what the historical event was, right?

LT: Absolutely. But I had lived with the material for some time, in a way, because I narrated the documentary *The Weather Underground*.

WA: Oh, that's right! Of course!

LT: So my personal knowledge helped on your night. On the third night, for instance, I had no idea that it was David Kaczynski.

I had to truly listen, which is one of the hardest things to do. So when things started coming into my mind, like self-awareness, or, "Oh, I have a funny idea," or "Oh, that would be great," it was important to try to make it about something bigger than my little ideas of how to succeed with the audience. This was about something more. So for me, the way to do that was just to keep listening, and trust that you're getting it, and that when they leave and it's your turn, you can just open your mouth and it's going to come out.

LW: You said earlier that your goal was to be as

honest as possible. Omer, how did you prepare the actors? Did you tell them to be as "honest" as they could?

OF: For me that's such a funny idea—how performing actors, whose job it is to pretend to be someone else, are also trying to be "honest." There's a wonderful paradox in that: what does it mean to be honest, yet portray some fictional story, while the audience suspends their disbelief and their knowledge that the person they're watching is not who they're pretending to be. I don't even know what notions like "honesty" or "lying" mean once we get out of situations like the courtroom, where you have to make certain statements that then need to be examined, confirmed, denied, rebutted. This is a different, much more slippery realm.

LT: In a lot of acting classes, the thrust of what you're taught is to "get to the truth of the moment." Obviously, the character is made up, the situation is made up, every single thing is made up, and everybody knows that what's happening is make-believe, yet I, the actor, have to be as "honest" to the moment as possible. So what does that mean?

It means not being general, it means getting to something real or authentic or genuine. I *could* have a motive saying, "I want to be funny"—that's an honest motive because

it's a genuine motive that just came up, and it's true. But something deeper and more authentic than that would be thinking that it isn't *about* me being funny tonight—it's about something else, it's about this thing that Omer is doing with memory and with history and with lying, it's about this person who told his original story, it's about listening to that, and seeing if there's something deeper I can get to that's even more interesting than just being funny.

WA: Absolutely. You know, because of my work in education, I can't help listening to both of you and thinking of classrooms. It's true that in a courtroom, like Omer said, the whole point is that one narrative has to trump another narrative and win. But the beautiful thing about the best classrooms is that you don't have to have a single narrative—you can see that in every narrative there's ambiguity, contradiction, and conflict, and in this performance, that's what we're watching happen right in front of us. The original storyteller tries to tell a story that's neat and clean and says something, but everybody's riffs on that story take it somewhere else—and that's the way life is.

LW: That's beautifully put. It's revealing something that normally goes unseen, perhaps almost to a dangerous degree.

Omer, what connected the stories of these three people for you?

OF: All the stories shared a personal aspect of intense loss as well as a sense of activism—activism based on ideals that are somehow thwarted—in Bill's case, by an accident.

So each night, the audience was presented with a sense of loss and a sense of activism—and what makes it so poignant is that, as idealistic as these original motivations were, they're immediately subject to the whims of memory, the whims of the entertainment cycle, the whims of having memory erased. It's a cruel theater. The performers bore the responsibility of becoming co-authors of the work, and at the same time, the audience was like this classical Greek god—watching the struggle on the stage below, laughing and passing judgment. The cruelty of that judgment, which happens on talk shows worldwide, is, "Either tell us something new, something that's going to shock us—or entertain us, dammit!" Those were the twin pitfalls for the actors—it's like loading a gun and saying, "Start dancing," but pointing the gun at yourself! Meanwhile, the audience is also sitting there saying, "What am I going to make out of what I've just heard? Where is it going?" It doesn't always work. But when it fails, at least it fails interestingly. And if not, a new guest arrives in eight minutes.

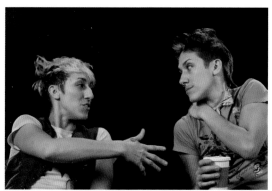

Jocelyn and Natalyn Tremblay perform "Oun"

To-Nya and To-Tam Ton-Nu perform "Sachika"

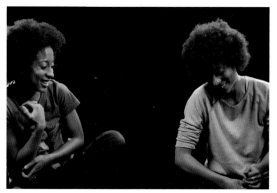

Briana and Hilary Brown perform "Shaun"

Nickolas and Robert Kimbrell perform "Star"

NEW YORK, NEW YORK
CANDICE BREITZ

ABRONS ARTS
CENTER

A PERFORMA
COMMISSION
WITH KUNSTHAUS
BREGENZ

*Opposite: Candice
Breitz,* New York,
New York, *2009.
Production stills.
Courtesy the artist.*

*Following spread:
Candice Breitz,* New
York, New York, *2009.
Performance views.
Photos by Nick Kozak.*

Candice Breitz's multi-channel video installations are mesmerizing feats of fast-paced yet highly controlled video editing; she cuts and pastes film footage, songs, facial expressions, and voiceovers so seamlessly, and with such knowledge and understanding of her material, that the final product can be read as a series of powerfully articulated ideas. For her Performa Commission, the question was, how could an artist whose work depends so thoroughly on the entire spectrum of media and editing technology, for both its aesthetics and its content, give it all up for a live improvisation, with wayward amateur actors and an unproven process?

Yet this is what Breitz did for her first live performance. *New York, New York* was an evening-length play whose set, structure, and timing were based on the formula of the television sitcom, and which involved four sets of identical twins in two separate but identical productions. Even as Breitz stepped into this new arena, *New York, New York*'s compelling themes of identity and individuality, especially as they relate to the illusory sameness of "twindom," could be tracked as an extension of her abiding obsession with "the scripted life" and the roles that nature, nurture, and the media play in constructing the fragile condition of selfhood. By extension, Breitz also hinted at the complex relationship between lives lived on- and offscreen. While the interaction of the in-the-flesh personalities added a third dimension and an emotional edge, it also served to highlight the vividly precise articulation that Breitz's videos achieve.

—*RoseLee Goldberg*

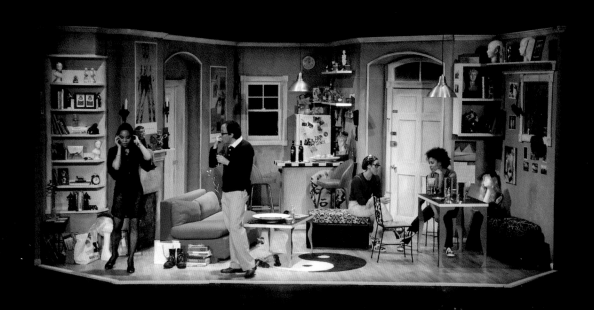

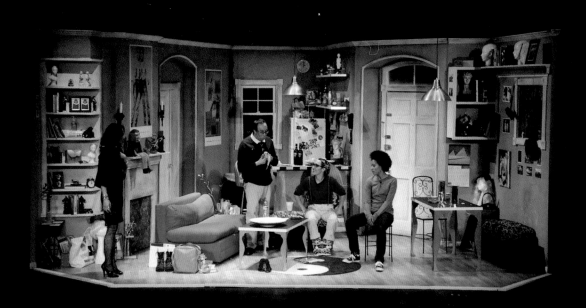

CAST A

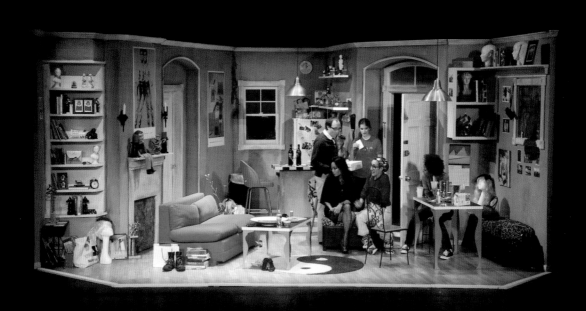

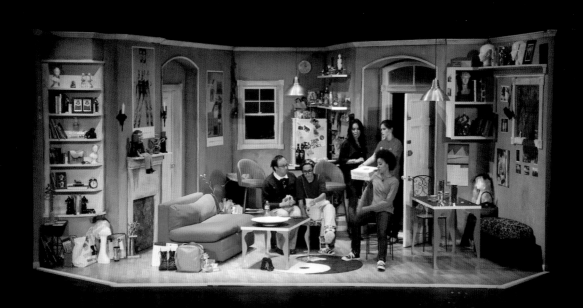

CAST B

Interview

CANDICE BREITZ

IN CONVERSATION WITH ROSELEE GOLDBERG

ROSELEE GOLDBERG (RLG): Candice, you usually work with video material, which you edit so thoroughly. So this really is an exciting and dangerous area that you have stepped into. Can you describe the process of making your first live piece?

CANDICE BREITZ (CB): Most of my video installations come out of two parallel but very different ways of working. On the one hand, there is the somewhat solitary and hermetic process involved in teasing found footage into new compositions. On the other, many of the installations result from shooting with a small crew and creating conditions in which participants are asked to improvise within certain predefined parameters. Expression under constraint interests me because it echoes our actual experience of the world. Improvisation can never be purely and absolutely improvisational, because it inevitably reflects the specificity

of the moment. *New York, New York* asked actors to step into an unfamiliar construct, to allow it to determine the boundaries of their improvisation.

RLG: So, you weren't quite using found material in the same way that you do in your film editing—you actually had to interview many different sets of twins to whittle it down to the right ones, for example. Can you describe how you found your material for this live production?

CB: Finding the twins was quite a challenge. I needed four pairs of identical twins. I wanted people who were reasonably extroverted, who could step up and perform and have a relatively self-assured presence onstage, but at the same time I wasn't interested in working with overly polished professional actors. We found most of our twin actors by word of mouth,

through friends and friends of friends. They had all had some stage experience: the Brown sisters are dancers, the Kimbrell brothers do live concerts together, the Tremblay sisters are both performance artists, and the Ton-Nu sisters are fashion designers who model their own collection from time to time. That said, I wanted to allow a margin within which theatrical conventions could be ignored or challenged, and I thought that more experienced theater professionals would be less likely to break the unspoken rules of performing onstage.

RLG: And how did the idea of making the situation resemble a television sitcom come about?

CB: What I like about the sitcom format is that it places different casts within relatively similar situations. Viewing *across* sitcoms is a bit like watching the same experiment being performed over and over again. You might have a different set of four or five main characters in a show like *Friends* than you do in *Seinfeld*, but the formula is basically the same. I also like the fact that the sitcom set is somehow suspended between the stagy conventions of the traditional theater set on the one hand, and the faux wall-free realism of the cinematic set on the other. Since I decided early on that *New York, New York* would not have a conventional

script, the set became especially important as a fictional space that needed to describe a shared set of conditions that the actors could collectively take on. It had to nevertheless remain random enough in character to allow for an unpredictable and idiosyncratic range of responses.

RLG: Could you talk about your process of inviting each set of twins to make one person out of their two personalities?

CB: After we had pinpointed the four pairs of identical twins who would make up the two parallel casts, I asked each pair of twins to spend a day with me, creating a character of their own design. Each pair sat in front of a pair of cameras that documented them as they negotiated a character that they would both be willing to play. My role was to throw biographical questions at them in relation to their emerging character. The negotiation between each pair took place over a seven to eight hour shoot, with me playing biographer. "How old is your character? Does your character get on well with her mother? What does your character eat for breakfast? What kind of literature does your character like to read? Would your character typically get drunk or not? Did your character vote for Barack Obama?" It was intriguing to watch each pair slowly unfold a

nuanced fictional character that both would be willing to become onstage.

The twins were asked to observe a couple of basic rules. Each of the characters had to be based somewhere in New York City, and they all had to be "singletons," which is what twins call non-twins. The other thing that I asked each pair, knowing full well that this could only fail, was to do their best to agree on every aspect and every detail of their character by the time they stepped onstage. Of course, they understood as well as I did that there's no way of collapsing two complex lived lives into one fictional life. We all knew that there would be considerable slippage.

RLG: As far as we understood, on opening night, these people walked onto the stage and met each other for the first time. How did you prep them before opening night? What did you tell them would happen onstage? Did they see the stage, or have a tour of it? Did you discuss the sitcom idea with them, or any other references?

CB: From a content point of view, as you said, none of the actors had met any of the other actors until the curtains went up. Each was led to the set in darkness and pushed through its front door by a backstage crew member as the performance got rolling. All that they knew

in advance was that the set was going to be a cross-section view through a New York studio apartment, and that they'd be playing within a cast of four actors. I think it's fair to say that the players each stepped onto the stage with very different ideas about whose apartment they were entering, who they might meet there, and why their character was making an appearance at the awkward gathering that was about to ensue.

RLG: That's very brave—to virtually bring them blindfolded into the theater and say, "Go!" Did you say anything to them to prepare them for that moment?

CB: I encouraged them to think of the situation as one that was very much like everyday life. Every time you leave home, you step into conditions that are familiar to some extent, but unknown and unpredictable to a much larger extent. One constantly finds oneself in new physical and social spaces, interacting with new characters for the first time. Improvisation is very much a part of being in the world, a condition rather than an out of the ordinary experience. I asked the actors to treat their onstage encounters with strangers in a strange space as an extension of the kind of chance experience that we are subject to on an average day as we move through social

space. A couple of days before the live sessions, each actor was given a set of written descriptions (without photographs) of the other characters that they were about to meet onstage, based on the biographical information that each dual character had provided. So each actor had already developed thoughts about or feelings toward the other characters before encountering them in performance, in the same way that one tends to make assumptions about strangers before actually meeting them. . . .

RLG: Brilliant. Can you describe exactly what happened during the performance?

CB: The evening started with half an hour of projected video, a selection of outtakes from each of the four character development shoots. The idea was to introduce the audience to the cast and to provide a sense of how each pair of siblings had forged their shared character. The video introducing the characters was followed by two sessions of improvisation, each with its own separate cast of four actors who represented all four possible characters. In other words, the siblings were split up into two separate casts and each actor played the character that he or she had invented in negotiation with his or her twin independently of that twin, without know-

ing how the twin would take that character to stage.

From the moment each cast of four stepped onto the set, I had absolutely no control. Each cast was left to unleash twenty-seven minutes of improvisation that felt both terrifying and thrilling from where I was sitting. During the fifteen-minute break separating the two sessions, our incredible set designer Kate Sinclair Foster reversed everything that had happened onstage during the first session, so that the second cast could enter a set identical to that encountered by the first. We wanted the second cast to be faced with the same contrived conditions that their siblings had just worked. If an actor had emptied a bottle of wine during the first session of improv, Kate replenished it. Furniture was hastily shoved back into place, and so on.

The second cast was of course made up of the identical siblings of the four actors who had been present onstage during the first session. They were dressed identically to their siblings (each pair of twins came up with their own costume for the character they had devised). This produced some amusing confusion—I later found out that many audience members did not realize, until all eight actors came onstage at the very end of the evening, that they had experienced two casts in performance. Many assumed that there were four ac-

tors and not eight. Others were perplexed by the lack of continuity between the first improvisation and the second, as well as by the often nonsensical—at moments excruciating—and admittedly very unpolished dialogue between the actors in each session, which was precisely not scripted.

That said, there were several formal devices that the actors could lean on to get themselves through the experience. Most obviously, each actor's awareness of his or her own character meant that they could fall back on this "self-knowledge" when it came to responding to unpredictable situations or conversations that arose on set. Also, each session had an identical supporting sound track, with simple audio cues that gave the cast a sense of time: a phone rings at the same moment in both sessions, for example, and the doorbell sounds at a particular moment for both casts, though of course the improvised responses to the same stimulus differed significantly from the first to the second session. The set was another device that the actors could lean on to support their performances. Instead of treating the fictional studio apartment as the home of one or another of the characters, the set designer decided to create a relatively naturalistic domestic setting that she then decorated heavily with binary references: the Cocteau Twins and Aphex Twin were on the CD racks, posters of Warhol's *Double Elvis* and Rauschenberg's *Factum* were hung on the walls, Twix chocolate bars and Doublemint gum were scattered casually in the fictional kitchen and living room, and so forth.

RLG: So Candice, as I was saying at the beginning, you are somebody who's usually so controlling in your work, and now you've gone through the experience of giving up almost all control for this live performance. What does this say about you going forward?

CB: Working on a live stage gave me the chance to really push some strategies that I've used in the past—defining the initial terms for a piece, but then giving up control, letting the actors grab the ball and run with it. It was very liberating to be forced to think in a different medium. I certainly doubt that I would have cooked up something that left so much to risk without your supportive nudging, RoseLee! Because I wasn't in my zone of comfort and I wasn't working with familiar tools, I ended up having to question a lot of the decisions that I would usually make along the way. That made the experience very exhilarating.

This interview is based on an original broadcast produced by AIR (Art International Radio), operating out of the Clocktower Gallery in New York at ARTonAIR.org.

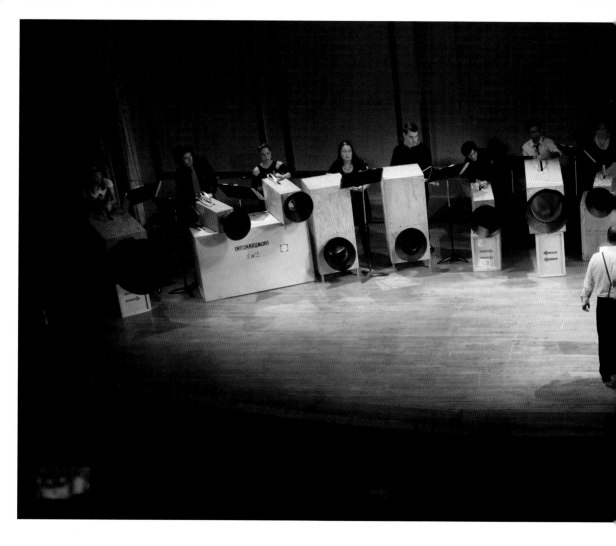

MUSIC FOR 16 FUTURIST NOISE INTONERS

The famous *intonarumori*, or "noise intoners," of the Futurists could be considered the earliest "techno music" instruments of the twentieth century, for the ways in which they provided "samples" of sounds reflecting the newly mechanized world of the time. Each instrument was custom-built as a wooden sound box with a cone-shaped metal speaker on its front; sound was produced by turning a crank, while tone and pitch were controlled with a lever.

The original intonarumori, a group of twenty-seven different instruments— an "exploder," a "howler," a "rumbler," a "whistler,"

TOWN HALL

A PERFORMA COMMISSION

CONDUCTED BY LUCIANO CHESSA

Music for 16 Futurist Noise Intoners, *2009. Performance view. Photo by Paula Court.*

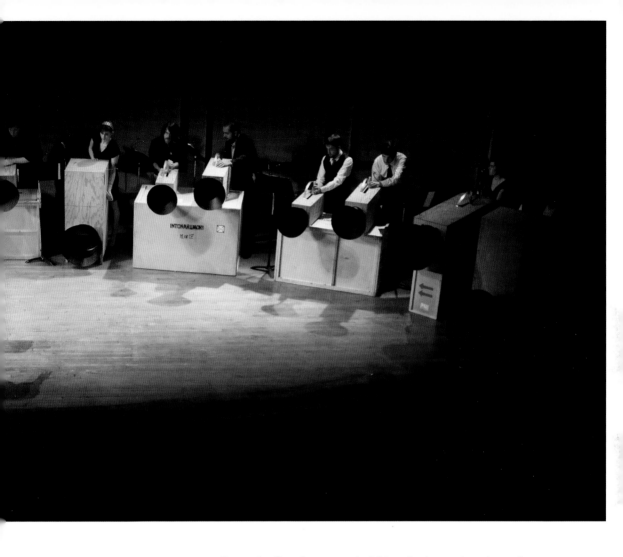

a "screecher," and so on, mimicking the humming, thumping, and pounding of the machine age—launched entirely new ideas about the kinds of sounds that would penetrate our ears and our consciousness in the future, and the ways in which we would respond to the din. "Today, noise triumphs and reigns supreme over the sensibility of men," Russolo wrote in "The Art of Noises," his Futurist manifesto of 1913, pointing out that the silence of earlier times was forever lost with the invention of the machine in the nineteenth century. "The variety of noises is infinite," he noted, predicting the exponential increase in volume in the twenty-first century. "If today, when we have perhaps a thousand different machines, we can distinguish a

L'acoustique ivresse (Les bruits de la paix)

per Minna Choi

Luciano Chessa

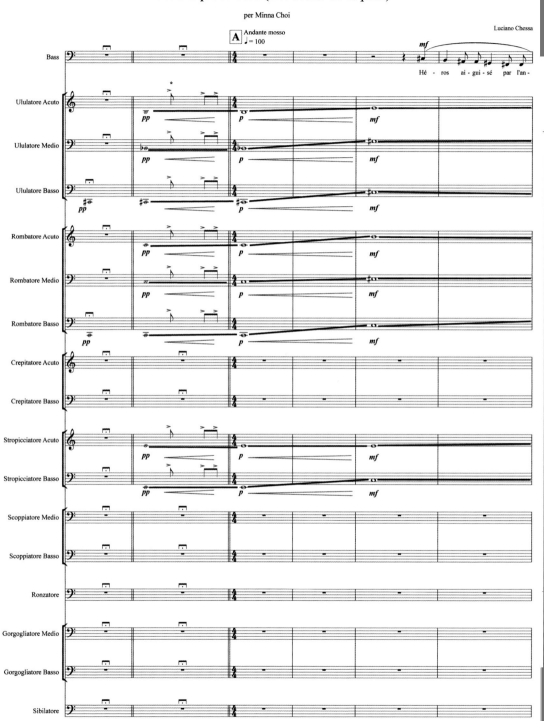

* Crank accent obtained through sudden
and sharp increase of rotation speed.

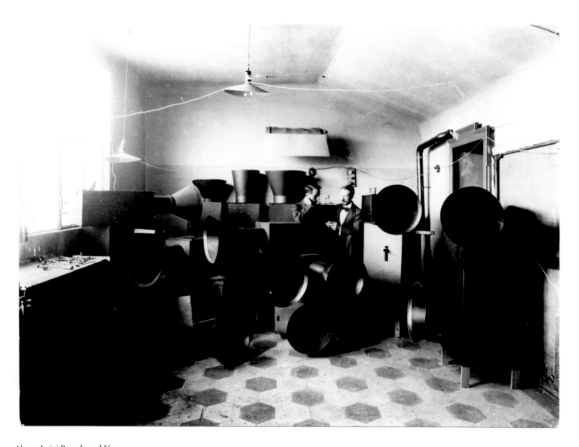

Above: Luigi Russolo and Ugo Piatti with the intonarumori, *1913. Courtesy Rovereto, Museo di Arte Moderna e Contemporanea di Trento e Rovereto, Archivio del '900, Fondo Russolo.*

Opposite: Luciano Chessa, L'acoustique ivresse (Les bruits de la paix), *2009. First page of score for the intonarumori. Courtesy the artist.*

thousand different noises; tomorrow, as new machines multiply, we will be able to distinguish ten, twenty, or thirty thousand different noises, not merely in a simply imitative way, but to combine them according to our imagination."

The first public performance of the intonarumori took place in 1913 at Modena's Teatro Storchi, and subsequent concerts were held in 1914 in Milan, Genoa, and London, and in 1922 in Paris. In 2009, *Music for 16 Futurist Noise Intoners*, commissioned by Performa and led by composer and musicologist Luciano Chessa (who also researched and oversaw the reconstruction of the machines), took place at New

York's majestic Town Hall, a venue notable as much for its design by McKim, Mead & White (in 1921) as for the radical organization that built it, the suffragist League for Political Education. In this first performance in the United States, Chessa conducted an evening of early Futurist pieces as well as specially commissioned works from legendary contemporary musicians and composers from the experimental music world: Einstürzende Neubauten frontman and Nick Cave collaborator Blixa Bargeld, vocal innovator Joan La Barbara, avant-garde saxophonist John Butcher, Deep Listening pioneer Pauline Oliveros, and Faith No More and Mr. Bungle vocalist Mike Patton. Sound and text-based performer Anat Pick, avant-garde musician Elliott Sharp, composer and vocalist Jennifer Walshe collaborating with composer and film and video artist Tony Conrad, singer and composer Nick Hallett, experimental saxophonist Ulrich Krieger, and Icelandic collective Ghostigital with Skuli Sverrison, Finboggi Petursson, and Casper Electronics added to this exciting evening of new compositions for avant-garde instruments from the past.

Music for 16 Futurist Noise Intoners is currently on a world tour that began with a concert at the Contemporary and Modern Art Museum of Trento and Rovereto (MART) in Rovereto, Italy, in September 2010. It was also presented at the MaerzMusik Festival of Contemporary Music in Berlin in March 2011.

—*RoseLee Goldberg*

Luciano Chessa conducting Joan La Barbara in a performance of her score for Music for 16 Futurist Noise Intoners. *Photo by Paula Court.*

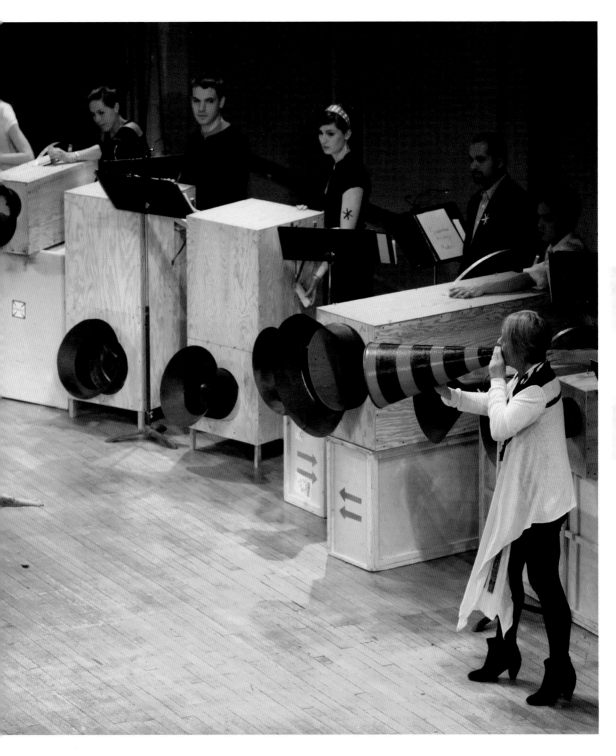

Interview

LUCIANO CHESSA

IN CONVERSATION WITH DAVID WEINSTEIN

DAVID WEINSTEIN (DW): The fabulous noise instruments that Luigi Russolo built in 1913 are something that I have dreamed about hearing and seeing for most of my adult life—and something many other people have been dreaming about for most of the last century. Today I am here with the man who has made that dream a reality: Luciano Chessa.

Luciano has a PhD in musicology from the University of California, Davis, but also earned a doctorate in piano and a masters in composition at the Conservatory in Bologna, Italy. He is now a composer and performer who, aside from being an expert on twentieth-century experimental music—look out for his book on Russolo, forthcoming from the University of California Press—is also interested in fourteenth-century music and Italian hip-hop. Which makes him the coolest guy in town.

LUCIANO CHESSA (LC): Thank you. *[Laughing]*

DW: So just to give a little background on the project—in 1913, the Italian Futurist painter and composer Luigi Russolo built an entire orchestra of noise-generating boxes that he called *intonarumori,* or "noise intoners." They were acoustic noise generators that allowed performers to create and control, in articulation and pitch, several different types of noises. The intonarumori were divided into families with different names according to the sound they produced: howling, crackling, buzzing, and so on. For Russolo, these machines were the culmination of his theories about music as expounded in his 1913 manifesto "The Art of Noises," a phrase that so many people, generation after generation, have grabbed onto.

Now, Luciano, are there any recordings of the original instruments?

LC: Yes. There is one two-sided 78 rpm consisting of two tracks: "Corale" and "Serenata." The recording was likely made in Paris in 1921, at the time of the "mixed orchestra" concerts Russolo had at the Théâtre des Champs-Élysées in June of that year, where his ensemble of twenty-six intonarumori performed with fourteen traditional instruments—so in the recording you hear strings, winds, a xylophone, and even a harp.

Russolo never loved the idea of a mixed ensemble. In his book *The Art of Noises* he says that he will always be focused on creating an orchestra of the future, which will consist *only* of intonarumori. So it's kind of a tragic irony that the only recording left is of a mixed orchestra. This was something [F. T.] Marinetti always pushed for. Marinetti wanted to find a halfway point between the radical views of Russolo and the more established world of "professional" music. For the Paris concerts, Marinetti insisted that the scores be written by more "professional" composers and conducted by a more "professional" conductor. So Russolo had to sit on the sidelines, while his brother, Antonio, who received his formal training at Milan's music conservatory and had apprenticed with Arturo Toscanini, conducted. Now, the other ironic thing about this recording is that both pieces are compositions by *Antonio* Russolo, not Luigi. In my opinion,

they're not wonderfully revolutionary compositions, but they do work as some kind of document.

DW: So none of these instruments physically survived. Do you know what became of them?

LC: It has often been said that the instruments were destroyed by bombing during the Second World War, but that is not entirely true. The bombing was probably the end of the scores, but there is an even more interesting story for the instruments.

Russolo had spent between 1913 and 1921 working with the intonarumori. After 1921, he started designing other instruments, partly because it was so difficult to deal with the intonarumori logistically—something we now understand very well! They are essentially big wood boxes: difficult to move and expensive to ship. So after 1921 the intonarumori stayed in Milan and continued to be used on and off in performances, though Russolo was no longer directly involved in that.

Meanwhile, again likely to avoid shipping costs, a slightly smaller set of intonarumori was constructed in Prague by Ugo Piatti, Russolo's assistant, and the man who appears with him in the famous photographs from 1913. Piatti, like Russolo, was a painter. (I love the idea of two painters building noise machines!)

Anyway, Piatti's intonarumori debuted at Prague's National Theater in 1923 for Marinetti's play *Il tamburo di fuoco*, accompanied by Balilla Pratella's music. We don't know exactly what happened to the Prague set, but they are definitely gone, and were likely just disposed of after the 1923 performance.

The last report we have of Russolo's original intonarumori dates from 1929, when four were borrowed by a Milanese elementary school for its modest theater productions. They were probably stored there up to the end of WWII, when it is likely that fleeing Nazi troops lodging at the school burned them for warmth during the famously cold winter of 1944.

DW: Now can you describe for us exactly what these instruments are? You've said that they're made from wood and cardboard, and are big and hard to carry around. They also use levers rather than keyboards, are "self-resonating," and have these big megaphone-type things on them that push the sound out into space.

LC: These instruments were basically the physical expansions of Russolo's theoretical writings. In his 1913 manifesto, Russolo outlined a taxonomy of sounds anybody would experience living in a metropolitan area at the turn of the century. This was a very influential taxonomy—for example, for *Williams Mix*, John

Cage worked out a classification of noises that strikingly resembles Russolo's. So that is to say that many artists working with noise feel a need to order it in some way.

DW: That's really interesting—that first came the ordering, and then came the instruments.

LC: Yeah. Russolo also had a very theoretical mind. In his manifesto, he classifies the various noises you experience in modern life into six categories or families—rumbling noises, whistling noises, gurgling noises, and so forth, up to a sixth category that included noises produced by humans or animals, like screams, laughter, cries, howls, etc. The manifesto closed stating the intention of constructing a set of new instruments that could produce the above noises, effectively replacing the traditional instruments and sounds of the symphonic orchestra with an orchestra of only noise-generating machines. So he is already laying out the next step. The manifesto was published on March 11, 1913, and right after that Marinetti announced that the first Futurist noise concert would take place at the Futurist headquarters in Milan on August 11 of the same year! So that left only five months for Russolo and Piatti to build the first set of instruments. He ended up extending the six original families into eight and thus built eight families of intonarumori, with up to three instruments in

each, for a total of the sixteen instruments that made up Russolo's first orchestra. That's the very set I rebuilt for Performa 09.

The basic model for each instrument is a parallelepiped box containing a string excited by a wheel. The string is connected on one side to a drumskin attached to a radiating gramophone-like horn, and on another to a lever that the performer can pull back and forth, varying the string tension, allowing the noise to gliss. The problem for reconstructing these instruments is that in their patent, Russolo describes and provides drawings of this basic mechanical interface, without saying much about the wheels or how the noise itself was produced.

Russolo built all of these instruments through trial and error—Galileo's spirit was in the air! Noises that match his description can be produced, provided that you have thoroughly investigated the sources, spent time in a lab where you can experiment, and had a luthier's technical assistance. This is exactly the path I followed—the luthier, in my case, was Keith Cary.

I based my reconstruction on the patent, the accompanying drawing, and the few photographs that exist—the photographs from the summer of 1913 when the first set was built, as well as photographs from live performances. All of these images, though, show only the outside of the instruments, aside from one, which shows the inside of an intonarumori Russolo called *ronzatore*.

DW: And were there any written accounts that helped you, too?

LC: Yes. There was Russolo's writing, of course, and then there were his letters. I think I read every mention of the instruments by any people who ever saw them. Stravinsky heard them, as did Prokofiev. I worked with everything I could find, like a detective gathering evidence to solve the mystery of how each instrument created its noise. This is where I think it helped that I'm a former medievalist, because when you do research on medieval music, you have very little to work with, so you use letters, poems, paintings, frescoes, anything you can find from the time that might hint at anything. Many musicologists who have worked on Russolo before have been rather dismissive of his friends' accounts of the instruments, because some of them use very poetic language, and aren't "scientific" enough, but I treated those descriptions like gold. And in the end, having rebuilt this orchestra of sixteen instruments, I would say that they all pretty much match Russolo's description.

DW: They're really remarkable. When you look inside them, they're a mixture of many different mechanical technologies—some remind me of the wheel of the hurdy-gurdy, which rubs against rosin, or the cuíca or "lion's roar," the Brazilian instrument with a string connected to a drumhead, or the harp, of course,

with the stretching of strings. And there are pitch markings on the instruments where the levers are so you can aim for a note in your placement, like with a trombone. And there's such a range of different noises—rubbing, buzzing, clicking, bird-like chirping . . . yet what's incredible is that, when they all play at once, sometimes you hear this absolutely human voice. It's remarkable.

LC: Yes, it's amazing.

DW: I've also heard that as a set, the intonarumori orchestra can be considered to be the first analog synthesizer.

LC: I think that's very accurate description. As a whole, this orchestra enacts Russolo's noise taxonomy: first conceptually, through a system that is based on the division of the entire universe of noises into families, then factually, resulting in corresponding families of devices that modulate these various noises individually. So Russolo's orchestra is *as a whole* the synthesizer, and each individual instrument is a small sound module, where each noise gets processed individually through quite elegant mechanical filtering.

DW: Can you tell us a little bit more about the different families of intonarumori, and the categories of noise they belong to?

LC: First there are the *Ululatori*, or "Howlers." They came in three ranges: high, medium, low. These are instruments that Russolo described as being somewhere between human voice, string instruments, and sirens. Their sounds are made through gut strings and wooden wheels, controlled by a crank, and are very smooth—if you sustain a steady crank speed, they can really sound like string instruments.

The next family is the *Rombatori*, or "Rumblers." They were intended to evoke the sound of thunder. They also come in high, medium, and low, and use the same basic mechanism as the Howlers, with a slightly different kind of wheel.

Next are the *Crepitatori*, or the "Cracklers," which make the sounds of metallic crackling, in two ranges, high and low. These sounds are made through indentations in the wheel. Russolo said they were supposed to sound like something between a mandolin and the sounds of a grunting pig being skinned alive. Imagine that!

The next family is the *Stropicciatori*, or the "Rubbers," which were built to make the sound of metallic friction. After a lot of experimenting, I eventually had them built with metal wheels exciting metal strings. There were two of these, so that makes a total of ten instruments for these first four families. All these instruments so far are mechanical.

The other four families are electric, which

might be surprising, but I didn't make it up. Russolo mentioned specifically in *The Art of Noises* that some of his intonarumori were electrically powered, and could either be plugged in or self-powered with a battery, which really was high-tech in 1913. These instruments use a doorbell-like mechanism, hitting either the strings or the drum.

So the first electric family is *Scoppiatori*, or the "Combusters." All the Futurists were obsessed with cars, so of course Russolo had to build an instrument that sounded like a car, and it *really* did. There were two instruments in the "Combuster" family.

There's the *Gorgogliatori*, or "Gurglers," which also came in two ranges, medium and low. They were built to sound like water moving through pipes and gutters. Here too the noise is incredibly well "synthesized."

Then we have the *Ronzatore*, or the "Hummer." I actually prefer the translation "Buzzer," because I think that that is a more accurate rendering of the original Italian. This is the only instrument we had the photo of the inside of, but what's interesting is that this photograph had for a long time been reproduced in books horizontally, and so historians have written about it and tried to make sense of it as an instrument meant to lie horizontally. A major breakthrough in my research was to realize that this instrument could only make physical sense if it stood on its shorter end,

vertically.

Finally there is the *Sibilatore*, or "Whistler," whose main sound was like the whistling of the wind.

Now, all these names may sound funny to you, even cartoonish, but they were for me an essential piece of the puzzle. I studied in Bologna with Umberto Eco in 1991, the year when the course he offered became his marvelous book *The Search for the Perfect Language*. He taught us about the notion, coming from Scholastic philosophy, that in a perfect language there had to be a metaphysical correspondence between names and the items they designate. I took the Italian names of these instruments very seriously, with the conviction that Russolo, especially as he was so well aware of Marinetti's theory of onomatopoeias to quote it at length in the *Art of Noises*, would have not adopted these names lightly. The onomatopoetic Italian names of the intonarumori really guided my reconstruction choices. In the end I built instruments that *had* to fully fit their names as they sound in the original Italian.

DW: It has been a pleasure to have these instruments in our gallery and to hear them every day. The entire staff has achieved semi-ecstasy having them around. So, thank you for that.

This interview is based on an original broadcast produced by AIR (Art International Radio), operating out of the Clocktower Gallery in New York at ARTonAIR.org.

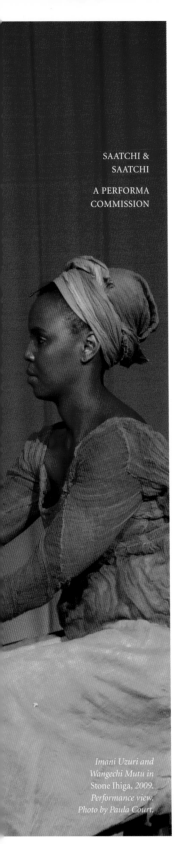

*Imani Uzuri and
Wangechi Mutu in
Stone Ihiga, 2009.
Performance view.
Photo by Paula Court.*

STONE IHIGA
WANGECHI MUTU
IN COLLABORATION WITH IMANI UZURI

Images focusing on contemporary world politics and post-colonial African issues reveal how fashion pictures, pornography, and ethnographic photography merge and collide in complex ways in Wangechi Mutu's seductive large-scale montages. In *Stone Ihiga*, these elements were given three-dimensional form and sound. Through heavy velvet curtains, the audience entered a carpeted performance space flanked by several of Mutu's *Thrones*—simple wooden chairs with elongated legs—which emitted a haunting blend of overtone singing, guttural chants, and other song and speech created by composer-vocalist Imani Uzuri. This immersive soundscape, inspired by the secluded, tree-surrounded "hush arbors" where African American slaves prayed and voiced their pain through music, was alluring and eerie. Mutu and Uzuri entered in exquisitely draped skirts and headwraps and waded through the sea of people, drawing the audience's attention with their smiles, subtle greetings, and knowing glances; they followed the women to the brightly lit set of two chairs at the far end of the room. Over the next twenty minutes, Mutu and Uzuri sat before the audience in an anticipatory state simmering with humming, small repetitive bits of song, snippets of ariettas, recitations in Gikuyu, foot tapping, standing, fidgeting, and exchanging entreating glances. A meditative tension built as it dawned on the audience that these women were under a death sentence, waiting to be stoned.

Performance is always an appointment with expectation. In *Stone Ihiga*, Mutu and Uzuri used this underlying principle to complicate expectation and politicize presence itself. As the title suggested ("stone" in English and Gikuyu), the performance refers to the form of public capital punishment for women in certain cultures who have been found guilty of adultery or promiscuity. "I originally conceived of this piece as a way to think about a universal problem in which women, and particularly women considered to be unchaste, impure,

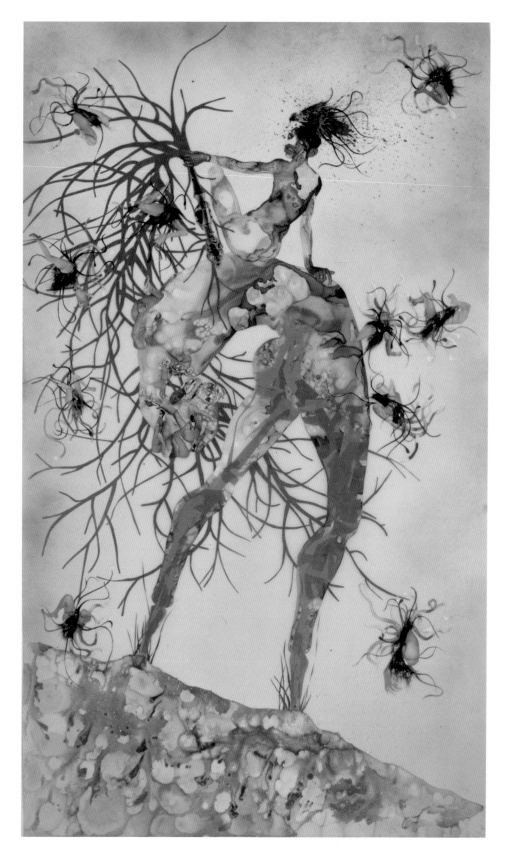

Above: Wangechi Mutu, preparatory
sketch for Stone Ihiga, 2009.
Courtesy the artist.

Opposite: Wangechi Mutu, You
tried so hard to make us away,
2009. Courtesy the artist.

promiscuous, or adulterous, are targeted. I wanted to create
a multisensory space where the audience's attendance could
be turned into a formal device for describing complicity and
collusion in this type of violence against our bodies." The
waiting—both the women's anticipation and the audience's
complicit "standing by"—was at the heart of the performance,
representing both the real experience of women around the
world subjected to this cruel punishment and the political
inertia that must be transformed.

—Trajal Harrell

EXTRACURRICULAR ACTIVITY PROJECTIVE RECONSTRUCTION #32, PLUS

MIKE KELLEY

JUDSON
MEMORIAL
CHURCH

A PERFORMA
COMMISSION

*Mike Kelley,
Extracurricular
Activity Projective
Reconstruction #32
(Horse Dance of the
False Virgin), 2005.
Courtesy the artist.*

Inspired by hundreds of photographs from American high-school yearbooks and the holiday pageants, band performances, pep rallies, and Halloween scare parties that they capture, Mike Kelley's darkly funny film and large-scale video installation *Day is Done* (2005) comprised a series of elaborate vignettes showcasing what Kelley calls "common American performance types." The inherent theatricality of these teenage folk rituals and the extra theatricality that Kelley gave them on film suggested yet another rendering: a live performance of *Day is Done.* Commissioned by Performa, Kelley translated his filmed material into *Extracurricular Activity Projective Reconstruction #32, Plus,* fourteen highly energetic scenes of music and psychodynamic drama staged in the basement gym of the Judson Memorial Church, chosen for its historic associations with minimalist "pedestrian" dance of the Judson Dance Theater era.

Kelly's high-school drama began appropriately with performers playing a fast basketball game to a pulsing drum score, "Cowgirl Beat," performed by Kelley's band of LA-based musicians. Kelley played coach, moving around the court in a gym vest and loose pants, blowing fiercely on his whistle as he refereed the game. Then the lights dimmed, an eerie blue glow filled the room, and a flower-crowned "Virgin Mary" in a floor-length gown circled the gym to the opening theme of the supernatural television show *One Step Beyond.* "The Judson Church Horse Dance" followed: two pairs of women in street clothes ambled into the gym in the classic "horse" formation, the front person of each pair walking upright, the second bent over and holding the first around the waist. They pranced around the space, occasionally extending a back leg in arabesque, and finally both bowed low in the center of the space. Later on, they repeated the dance in full costume, wearing large horse heads and skirts, which reinforced the implication that the earlier performance in street clothes was an homage to postmodern

Mike Kelley, Extracurricular
Activity Projective Reconstruction
#32, Plus, *2009. Performance views.*
Photos by Paula Court.

dance—thus conflating the populist spectacle of the halftime
show of high-school sports mascots with a revered movement
in dance history.

"Motivational Speech" opened with a drumroll and fanfare
of trumpets. Kelley, wearing a flowery bonnet like a granny at a
summer fête, flounced around the room, welcoming everyone
with giddy waves and blown kisses, part town mayor and part
court jester. He then performed "CODA," a minimal noise work
that he first performed in 2007 as part of the original sound
track for *Day is Done.* Kneeling, he scraped and slammed
wooden blocks together and blew into water with a length of
pipe, kicking off a highly amplified noise music section of the
evening in keeping with his long-term involvement with bands
and experimental music throughout his career. "Structuralist

Mimes" was performed on two differently pitched drum sets placed at opposite ends of the gym, creating a rhythmic call and response that Kelley said was "derived from the click track used as a timing guide for video editing." "Mary," a "warped snippet" of Broadway songwriter George M. Cohan's "Mary Is A Grand Old Name," was sung in the style of a barbershop quartet, and was followed by the musical high point of the evening, "The Offer," an electrifying Mardi Gras–style parade of twelve brass horn players who climbed to the top of an outsize ladder placed in the center of the room by four muscle-bound naked men, and then climbed back down, all the while blasting a rhythmic composition that supported the fierce vocals of their ringleader.

This noisy, colorful, and altogether ferocious performance closed with the brooding synthesizer, crashing cymbals, and swirling red and green spotlights of "Empty Gym," which, in Kelley's mind, was "a sensitive evocation of the lonely unpopulated gymnasium of lost youth." —*Mark Beasley*

Above: Source material for Mike Kelley's Extracurricular Activity Projective Reconstruction #33 (The Offer), *2009. Courtesy the artist.*

Opposite: Mike Kelley, Extracurricular Activity Projective Reconstruction #32, Plus, *2009. Performance view. Photo by Paula Court.*

FUTURIST LIFE REDUX

Film sequence from
Love Story of the
Painter Balla and
the Chair, *a segment
of* Vita Futurista
(Futurist Life), *1916.*

The only official "Futurist" film ever made, *Vita Futurista (Futurist Life)* was devised in 1916 by a committee of Futurist artists including Arnaldo Ginna, Giacomo Balla, Remo Chiti, Bruno Corra, and F. T. Marinetti. Comprising eleven independent segments conceived and written by different artists—with the whole film shot, edited, and generally overseen by Ginna—*Futurist Life* took up several ideas proposed in the "Futurist Cinema" manifesto written earlier that year, contrasting the spirit and lifestyle of the Futurist with that of the ordinary man in a series of humorous sketches (including "How the Futurist Walks" and "Love Story of the Painter Balla and a Chair"), many of which used experimental techniques such as split screens and double exposures. The forty-minute film premiered at the Niccolini Theatre in Florence in 1917 as part of a program with four *sintesi* (very short plays) by Emilio Settimelli and Corra and live poetry readings by Settimelli and Chiti of the works of several Futurist writers. But it was a failure with the audience, who threw stones and other objects at the screen, and was generally forgotten soon after. The only known copy of the film was lost several decades ago, and now all that remain are Ginna's written accounts, a review in the journal *L'Italia Futurista*, and a few still images.

For Performa 09, eleven contemporary film and video artists were invited to reimagine the scenes from *Vita Futurista* for an omnibus film that would be an all-new *Futurist Life Redux* for the twenty-first century. We held a lottery to determine which artist would do which scene. Each of the participants was then mailed a white envelope containing a single-sentence description of their assigned scene, copies of the few images that remained from the original film, the promise of a small stipend, and—in true Futurist style—a deadline only four weeks away. The resulting films and videos, although made in a wide variety of styles, from stop-motion animation to video-game-inspired special effects, were all full of energy and verve.

Legendary underground filmmaker George Kuchar's video featured his San Francisco art school students in fantastical costumes playing with a range of bizarre props (a fake foot, a

George Kuchar, Acid Redux

Shannon Plumb, Matinee

Ben Coonley, Why Cecco Beppe Does Not Die

Shana Moulton, The Sentimental Futurist

Matthew Silver and Shoval Zohar (The Future), The Path to Enlightenment

Aïda Ruilova, How the Futurist Sleeps (Half of 'Cerebral Ballzy')

Michael Smith, Futurist Lunch

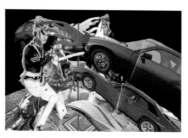

Martha Colburn, One and One is Life

Trisha Baga, Love Story of the Painter Balla and a Chair

chameckilerner, Conversation with Boxing Gloves Between Chamecki and Lerner

Lynn Hershman Leeson, Customized Marinetti

disco light, a gorilla mask) to a pulpy Hollywood score. The Future (American filmmaker Matthew Silver and Israeli video artist Shoval Zohar) created an entire psychedelic epic, using dozens of video layers to tell the story of a man and woman trying to "kill" the Future, and culminating in a dance of girls in tinfoil costumes (the "dance of geometric splendor" that the original Futurist scene had prompted them to create). Female choreographer duo chameckilerner restaged the "Discussion with Boxing Gloves Between Marinetti and Ungari" as an elegant superimposition of the pair, gradually morphing from a fight into a rhythmic dance. Ben Coonley's reworking of "Why Cecco Beppe Does Not Die" was a crowd favorite, casting Etsa the Cat as Beppe (a former Italian minister of culture reviled by the Futurists) and twin toddlers dressed in skeleton suits as "proto-Futurists" who try to kill Beppe, but end up fleeing his terrible stench. Other artists used Futurist themes, rather than specific storylines, as their point of entry. In "Futurist Lunch," Michael Smith, decked out as Santa Claus, marched in front of a black-and-white montage of machine and industrial footage; in Lynn Hershman Leeson's "Futurist Walk," actors ran while violent, kinetic scenes from the popular video game Grand Theft Auto exploded behind them; and in Martha Colburn's collaged 16 mm animation, the Futurists' "Introspective Research into States of Mind" became a portrait of Wonder Woman flying through landscapes of automobiles and factory debris. Other contributions included Shannon Plumb's humorous, silent-film-inspired vignettes of unusual movie theater patrons, Aïda Ruilova's rapidly cut imagery of a boy tormented in his sleep, and Trisha Baga's depiction of the marriage between an abstract painting and a chair. Despite the fact that female artists were the primary makers of this new version of the lost Futurist film (an intentional choice on our part), the Futurists themselves probably would have loved *Futurist Life Redux*—for its dynamism, imagination, and general sense of mayhem.

Film and video stills from Futurist Life Redux, *2009. Courtesy the artists.*

—*Lana Wilson and Andrew Lampert*

Participating artists: Trisha Baga, chameckilerner, Martha Colburn, Ben Coonley, George Kuchar, Lynn Hershman Leeson, Shana Moulton, Shannon Plumb, Aïda Ruilova, Matthew Silver and Shoval Zohar (The Future), and Michael Smith.

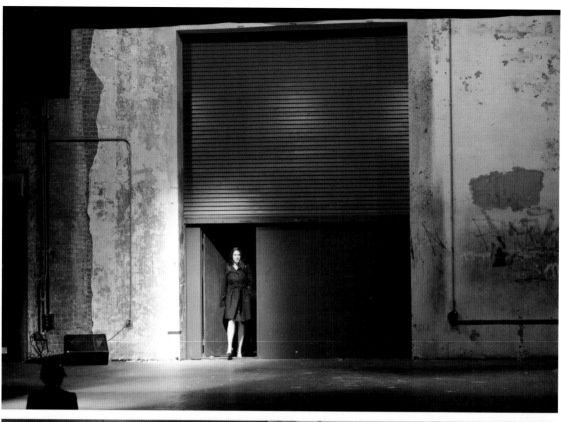

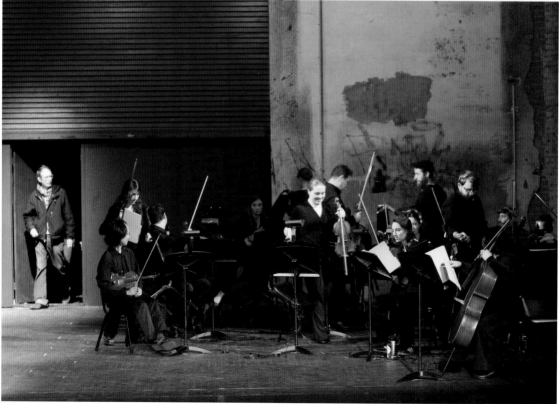

K.62 AND K.85

DOMINIQUE GONZALEZ-FOERSTER AND ARI BENJAMIN MEYERS

K.62

ABRONS ARTS
CENTER

A PERFORMA
COMMISSION

K.85

LOCATIONS
UNKNOWN

PRESENTED BY
PERFORMA

*Dominique
Gonzalez-Foerster
and Ari Benjamin
Meyers, K.62, 2009.
Performance views.
Photos by Dale Jabagat.*

K.62:

I had planned to attend *K.62* with a group of friends. That day, however, one of them sent me a text message: "Do you know where you're going tonight? I'm going to a gallery and Mitch is going to a barbershop." I had no idea what that meant, so I called my friend, who told me that when she purchased her tickets she was instructed to call Performa for the address of the performance. I had received no such instructions, but I called Performa to see where I should go, and they said, "You have a ticket to *K.62*— would you like to go to *K.85* instead?" "Aren't they at the same time?" I asked. "Yes, but if you'd like to go to *K.85* we have two tickets left." I said no thanks. I called my friend back and told her that we had accidentally gotten tickets to different performances, and we agreed to meet up later on.

When I presented my ticket at Abrons Arts Center on the Lower East Side, I was directed to a small practice studio upstairs. I noticed that the ushers were sending the other audience members to three different places, even if that meant separating couples and friends. The practice studio was bare aside from a few folding chairs and a violin player warming up. After about twenty minutes, an usher came in and announced that we were in the wrong room and had to move to the main theater. We arrived to find the stage empty and the house lights on. A dozen stagehands were standing around talking into headsets, shuttling several "Ks" among a variety of locations. After fifteen long minutes of this, a door at the back of the stage suddenly opened and a man walked out. For a second, I thought, wow—that actor looks so much like my friend Mitch. Then I realized it *was* Mitch. Then I thought, wait—my friend is *in* this performance and wanted it to be a surprise . . . and then I saw his confused expression and knew that his being in the performance was a surprise to him as well. These moments of confusion were sublime, and it was uncanny to eventually watch four of my friends come through that door. Since I

PERFORMERS

An oboe player in the blue room. 7:35 p.m.

A violin player in the yellow room. 7:35 p.m.

Audience enters the main theater. 7:50 p.m.

AUDIENCE

Reading the twenty questions. 7:55 p.m.

A violin player in Katz's Deli. 8:00 p.m.

A Jenny checking the information board. 8:10 p.m.

K'S

K ticket at Katz's Deli. 8:10 p.m.

First K arrives. 8:15 p.m.

K takes a taxi. 8:25 p.m.

knew the "character" of each friend, there was a kind of double meaning in their presence: the idea of who I knew them to be, and the idea of who they could become when transformed by the stage. I could see their multiplicity, their possibility, their fear, their acceptance. Imagining these twenty people arriving at the theater one at a time, and thinking of what they might have seen before they arrived, left me with a pleasant enigma I will not soon forget. —*Melissa Dubbin*

Another K arrives. 8:45 p.m.

Orson Welles crosses the stage. 9:10 p.m.

A magic trick is performed on stage. 9:25 p.m.

A volunteer from the audience. 9:25 p.m.

Musicians on stage. 9:40 p.m.

Young girls run through the theater. 9:45 p.m.

Last K arrives. 9:50 p.m.

Audience waiting to enter After. 10 p.m.

Audience at After. 10:25 p.m.

Dominique Gonzalez-Foerster and Ari Benjamin Meyers, K.62 and K.85, 2009. Performance views. All photos by Paradise Gonzalez except "An oboe player in the blue room" and "Audience enters the main theater," both by Dale Jabagat, and "A violin player in Katz's Deli," "K ticket at Katz's Deli," and "Audience waiting to enter After," courtesy the artists.

K.85:

On November 18, I found myself standing on the main stage at the Abrons Arts Center, blinded by stage lights, dimly aware of a gently playing string quartet and a full house halfheartedly applauding my arrival . . . and wondering what exactly I was expected to do next. As I circled toward the strings, a woman standing downstage beckoned me forward. "Are you K11?" she asked. "Yes, I'm K11!" To my relief, she led me into

the auditorium, where I gratefully accepted a seat in . . . row K.

Such was my entry, in medias res, to Dominique Gonzalez-Foerster and Ari Benjamin Meyers's *K.85*. But the performance had actually begun hours earlier, when Performa had called me offering a "solo" ticket to *K.85* or a "group" ticket to *K.62*. I leaped for the solo option. A subsequent phone call instructed me to go to Performa Hub at exactly 8 p.m., which I did, whereupon I was handed an envelope labeled "K11." A violinist was there, playing her part of what was clearly a larger score. Inside the envelope was an invitation to "After" (a party on the corner of Grand and Pitt Streets) and twenty dollars for the cab ride home. Uh-oh. So this was the "solo" option: one audience member getting to watch one violinist playing one part for ninety minutes. Avant-garde difficulty writ large.

But I was wrong. A cab parked outside had "K11" on the windshield, so I got in. I soon realized that I was being driven to the corner of Grand and Pitt, i.e., the back of Abrons, which bore a neon sign reading "AFTER." I took my place in a line with three other Ks. From time to time, the bouncer talked to someone on a radio and let one of them in. By my turn, I had guessed that entry into the building was going to mean entry onto the main stage. And so it did.

On either side of the stage were whiteboards on which the movements of each K were being mapped in relation to the five movements of music that were played onstage. Shortly after my arrival, the audience was played an audio sample of Orson Welles's 1962 film adaptation of Kafka's *The Trial* (1925), and the next K to arrive gave a short speech responding to the excerpt. At this point, it became clear that Gonzalez-Foerster and Meyers were creating for us an experience of controlled subjugation akin to that experienced by Josef K at the end of *The Trial*: to walk into a situation but not know the reason you are there or the logic of the gathering. The other point of reference was Martin Scorsese's *After Hours* (1985), in which a man is stranded in SoHo when his last twenty blows out a cab window (and which also contains dialogue lifted from *The Trial*).

Such a wonderfully dense web of references took the tropes of avant-garde dispersal, transparency, and fragmentation to a new

*Dominique Gonzalez-Foerster
and Ari Benjamin Meyers, K.62,
2009. Performance view. Photo by
Paradise Gonzalez.*

extreme. The work's elegantly inscrutable structure suggested so many things—chief among them the possibility that, sometimes, the behind-the-scenes maneuvering that goes into making a performance, the other audience members at the performance, and even your own trip to actually get to the performance might all be more interesting than the performance itself.

—Claire Bishop

Since its premiere at Performa 09, this project subsequently toured to the Kaaitheater in Brussels in March 2011, under the new title K.62/K.73/K.85, and to the Hebbel Theater in Berlin in September 2011.

CINEMAGICIAN
YEONDOO JUNG

ASIA SOCIETY

A PERFORMA
COMMISSION WITH
THE YOKOHAMA
FESTIVAL FOR
VIDEO AND SOCIAL
TECHNOLOGY

When cinema was invented at the end of the nineteenth century, the sight of moving pictures on a wall seemed like a magic trick to its first audiences. Magicians at the time saw the camera as another tool for their illusions, a way to use the magic of film to enhance their own acts. Through the combined talents of magicians, machinists, and prop builders, some of the very first film "tricks" were created through techniques that form the foundation of movie special effects today. One of the major early cinema pioneers, former cabaret illusionist George Méliès, soon became famed as the first "cinemagician" because of the ingenious effects he originated. Yeondoo Jung's first-ever live performance, *Cinemagician*, took Méliès as inspiration for creating a whimsical dual reality, showing illusions on a screen while unveiling the techniques behind them on stage at the same time.

In Asia Society's auditorium, a cast of fifteen real-life film crew members, clad in bright orange jumpsuits, arranged a bevy of film lights, props, and other technical equipment surrounding a painted backdrop of snowy mountaintops while, directly in front of the camera, while a videographer captured a series of actions performed by the star of the show, South Korean celebrity magician Eungyeol Lee. A live feed from the videographer's camera was projected onto a screen hanging above the stage, so that the audience had the privileged perspective of seeing both the seamless, magical world of images on screen as well as the actual mechanics and behind-the-scenes stunts involved in creating them on stage. "I am bringing the experience of shooting the movie into the theater, so the audience sees the results of what I am making while at the same time they are also very involved in the process of making it," said Jung in an interview.

The series of vignettes that unfolded included Lee appearing to go ice fishing inside the painted backdrop, erasing trees from his sketchbook that simultaneously disappeared from the landscape, and blowing at a white tablecloth that then

Yeondoo Jung, Cinemagician, 2009. Performance view. All photos this section by Paula Court.

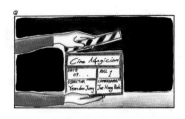

Above: Yeondoo Jung, preparatory drawings for Cinemagician, *2009. Courtesy the artist.*

Opposite: Yeondoo Jung, Cinemagician, *2009. Performance view.*

flew into the air, hanging itself neatly on a hook. To achieve these effects, the film crew arranged props, moved breakaway doors and walls, spray painted, blow-dried, lit, and otherwise manipulated all of the set elements on stage, in ways that were framed out or otherwise concealed from the gaze of the camera. One key character—the "shadowman," a ninja-like figure dressed in black clothing and a face mask—regularly interfered with the action, helping to complete many of Lee's tricks (in a manner humorously unbeknownst to Lee), and another special figure—a single snare drummer—was also on stage, using her drumbeat to amplify the level of tension involved in completing the illusions on stage.

In *Cinemagician,* Jung—whose dreamy photography, film,

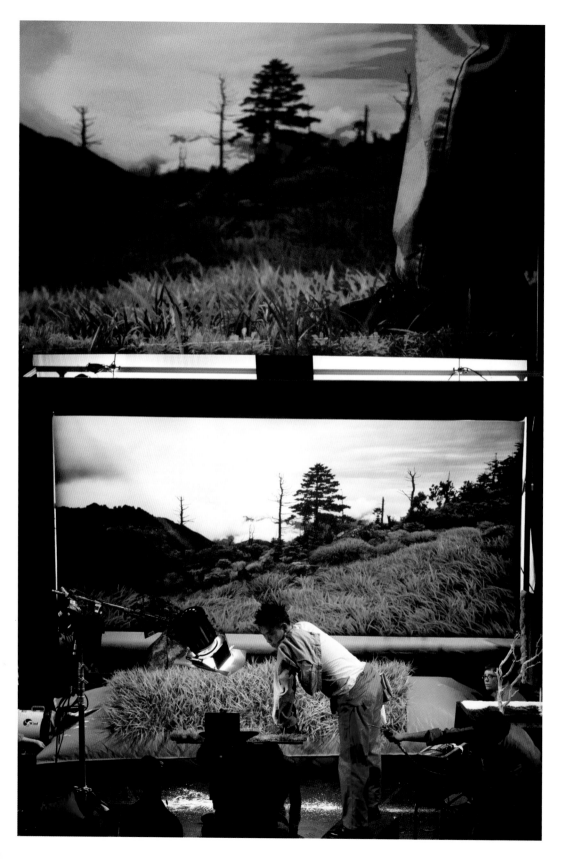

Yeondoo Jung,
Cinemagician, 2009.
Performance views.

and video work often plays with the idea of transformation by revealing the art-making process, as in his acclaimed 2008 film *Documentary Nostalgia,* which used a single take to capture scenes from the artist's life, turning a foyer into a street corner into a rice paddy—not only brought the experience of shooting a movie into the theater, but also used his carefully choreographed trompe l'oeil to show how reality can be transformed through cinematography, alluding to the tenuous authenticity of mediated images, and leaving the audience to oscillate between reality and magic, action and illusion.

—*Defne Ayas*

EXALTING THE CROWDS

PERFORMANCE AS SPECTACLE

During Performa 09, artists staged spectacles large and small at venues, indoors and out, throughout New York City, ranging from Fischerspooner's outrageously glam concert and Davide Balula's sixty-person human clock to Stuart Sherman's miniature tabletop performances and Nikhil Chopra's daily journeys to Governor's Island to create an epic drawing of New York's skyline. The biennial ended with two late-night events that took place amid the permanent spectacle of Times Square: Santiago Sierra's enormous *NO* mounted on a truck, and Loris Greaud's projections of exploding fireworks on the square's famous JumboTrons.

YOG RAJ CHITRAKAR: MEMORY DRAWINGS IX
NIKHIL CHOPRA

NEW MUSEUM

CURATED BY
EUNGIE JOO

*Drawing by Nikhil
Chopra from* Yog Raj
Chitrakar: Memory
Drawings IX, *2009.
Courtesy the artist and
the New Museum.*

In his *Memory Drawing* series, begun in 2007, Mumbai-based artist Nikhil Chopra appropriates the Victorian-era history, dress, and demeanor of his grandfather, an amateur landscape painter and draftsman, to become the shape-shifting character Yog Raj Chitrakar, who sets out on daily drawing expeditions in cities around the world in search of the "perfect vista." As part of his exhibition at the New Museum, Chopra used costumes (designed by Loise Braganza) and props to transform the lobby gallery into Chitrakar's living quarters for five days and nights in full view of visitors. Inspired by the 1920s, a time of significant changes caused by immigration, architecture, and labor between two world wars, Chopra-as-Chitrakar traveled through Chinatown, Lower Manhattan, and, eventually, Ellis Island. For three consecutive days, he woke, washed, dressed, ate breakfast, and cut a large piece out of an unprimed canvas hung across the back wall. This he bundled into a rucksack and took to Ellis Island, where he spread it on the ground and proceeded to draw the skyline of New York in thick black charcoal. He returned to the museum in the afternoon and hung the canvas on its space on the wall. Visitors were encouraged to return throughout the course of the piece to watch the progress of the mural and the artist's metamorphosis from artist to cartographer to dandy to empress to explorer to soldier to elegant abstraction.

Following the performance, remnants of Chopra's occupation of the space remained on display as an installation until late February 2010. Documentation from three previous performances were also on view in this exhibition—*Memory Drawing II* (Mumbai, 2007), *Yog Raj Chitrakar visits Lal Chowk* (Srinagar, 2007), and *Memory Drawing VI* (London, 2008)— suggesting the many ways in which the history and reality of a location impact the artist's execution of characters through costuming, gesture, and action. —*Travis Chamberlain*

Nikhil Chopra, Yog Raj
Chitrakar: Memory Drawings
IX, *2009. Performance views.*
Courtesy the New Museum.

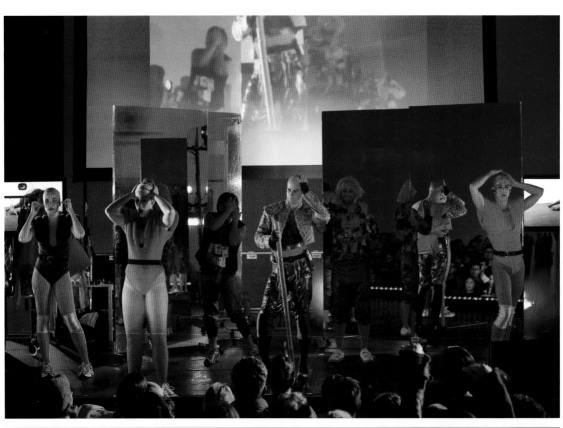

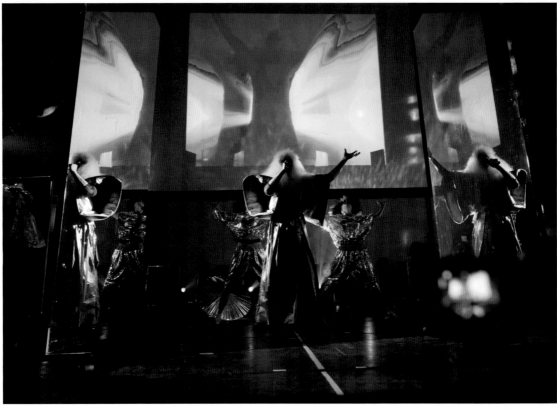

BETWEEN WORLDS
FISCHERSPOONER

THE MUSEUM OF
MODERN ART

ORGANIZED
BY KLAUS
BIESENBACH
AND JENNY
SCHLENZKA

Fischerspooner,
Between Worlds, 2009.
Performance views.
Top: Photo by Matthu
Placek. Bottom: Photo
by Paula Court.

Fischerspooner's five-hour high-gloss art cabaret, driven by song sets and video from their latest album *Entertainment* (2009), drew on an image bank of disparate worlds, from Noh theater to the US space program to the Wooster Group's production of *Hamlet* (2007). Viewers could circle a specially constructed platform in MoMA's vast Donald B. and Catherine C. Marron Atrium, watching the action both backstage, where performers primped in front of makeup mirrors, made costume changes, and were harassed by a stage manager, and onstage, where energetic dancers, wearing costumes made by more than a dozen designers (including Elise Fife-Martinelli, Peter Soronen, and Yves St. Laurent), were led by front man Casey Spooner. Electroclash music, a flickering light show, and synchronized choreography were peppered with Spooner's running commentary on clichés of pop life and mainstream culture. For video artist and performer Spooner and his collaborator Warren Fischer, a classically trained musician, *Between Worlds* was yet another example of work that "began as a piece *about* entertainment but that ultimately became entertainment."

—*Jenny Schlenzka*

CAMP KID FRIENDLY

MIKE KELLEY AND MICHAEL SMITH

SCULPTURECENTER

Mike Kelley and Michael Smith, Camp Kid Friendly, *2009. Performance view. Photo by Paradise Gonzalez.*

Designed as a live complement to the installation *A Voyage of Growth and Discovery*, which showed video and performance artist Michael Smith's well-known character Baby IKKI (the middle-aged Smith dressed in a diaper, frilly bonnet, and suspenders, stamping around with a pacifier in his mouth) on his journey to the notorious Burning Man festival in Nevada's Black Rock Desert, *Camp Kid Friendly* was a family-oriented happening that drew a diverse crowd of all ages and created a psychedelic, high-energy atmosphere that was equal parts rave, commune, and playground gone wild.

Smith, as Baby IKKI, drummed on a giant gong, pranced around the space, and created a "secret recipe" snack for the audience made from chocolate cake, brown sugar, and Atomic FireBall candies, while Bec Stupak projected hyper-colorful videos on six screens and remixed dance beats by Scott Benzel and Smith's collaborator, artist and musician Mike Kelley. A dozen performers from Malcolm Stuart's hula-hoop troupe Color Wheel, in wild fluorescent unitards, danced acrobatically, performed tricks with flame-covered hoops, and climbed on a Buckminster Fuller–inspired geodesic dome that had been turned into a playpen and filled with stuffed animals. Kelley (apparently dressed as Pocahontas) could be seen off to the side grinding to the music or, later, curled up inside the dome. Mixing over-the-top aesthetics and the utopian aspirations of Burning Man with a playful, child-like regression, *Camp Kid Friendly* poked fun at the impulse to organize experimental tribes, addressing a collective yearning for alternative lifestyles but ultimately critiquing escapist attempts to create such hallucinatory fantasies.

—*Kristen Chappa*

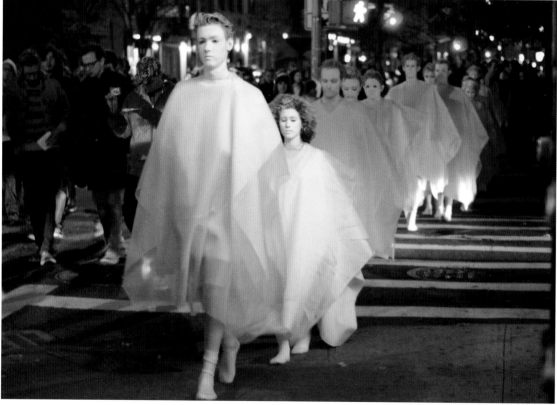

SAAQIOU, LECTURE, AND SILENT MARCH
TERENCE KOH

SAAQIOU

BROOKLYN
MUSEUM

LECTURE

NATIONAL
ARTS CLUB

SILENT
MARCH

TOMPKINS
SQUARE PARK

PRESENTED BY
PERFORMA

Terence Koh, Silent
March, *2009.*
Performance views.
Photos by Andrew
Russeth.

Saaqiou:

As a mysterious DJ mixed pulsating beats at the Brooklyn Museum's Saturday-night performance series, a strobe suddenly lit up Rodin's *Burghers of Calais* (1889), a circle of bronze sculptures. Everyone started jumping, further evoking the club culture that is a frequent theme for Canadian artist Terence Koh (formerly known as asianpunkboy). Black-clad performers then entered the circle: two who jumped and danced, then one (Koh himself?) who echoed the sculptures' postures. Like a black hole dropped into Brooklyn Museum, *SAAQIOU* ended with the performers fading back into the crowd. With no explanation given, the spectacle was pure punk. —*Sarah Giovanniello*

Lecture:

Following a surreal buffet of hors d'oeuvres crawling with ants, Terence Koh took the lectern at the National Arts Club to impart a rapid-fire art history lesson. For forty-five minutes he gesticulated toward projected images that began with the ancients and ended with Mapplethorpe, Goldin, and Hirst, touching on beauty, war, queer politics, sex, religion, AIDS, and performance art itself. Though the lecture was delivered in complete and emphatic gibberish, it made perfect sense to its appreciative audience. As one wag put it, "Nice to know we've reached the end of art." And survived to tell about it. —*Linda Yablonsky*

Silent March:

At 7 p.m. on November 21, a crowd congregated in Tompkins Square Park, as a note circulated by Terence Koh had specified. Soon ten figures in white fabric and face paint appeared marching silently in a line. Two neighborhood kids ran alongside, shouting, "Are you zombies?" As the figures shuffled north, pedestrians stared: "What are they protesting?" The group made its way to the Phoenix bar, leaving a series of cinematic impressions in their wake. —*Andrew Russeth*

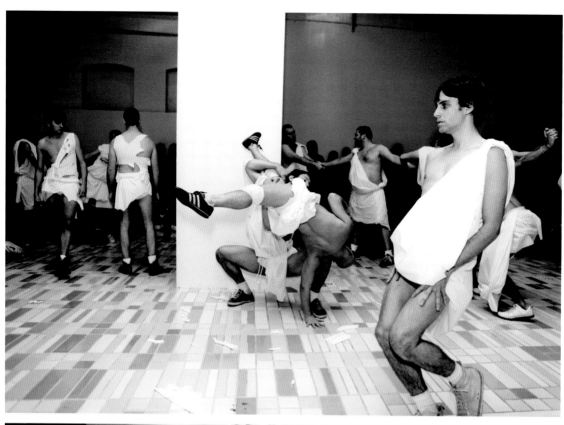

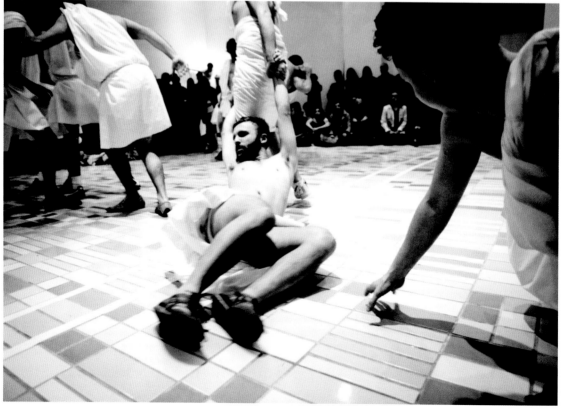

ECKS ECKS ECKS – AKA – SACRED BAND OF THEBES – AKA – IN MEMORY OF ROBERT ISABELL – AKA – ANY FAG COULD DO THAT

RYAN MCNAMARA

X INITIATIVE

Ryan McNamara, Ecks Ecks Ecks – AKA – Sacred Band of Thebes – AKA – In Memory of Robert Isabell – AKA – Any Fag Could Do That, 2009. Performance views. Photos by Kevin Tachman.

Inspired by the accomplishments of the Sacred Band of Thebes—a small brigade of homosexual lovers that crushed the Spartan army in 375 B.C.—and the haute-glamour of the late Robert Isabell—the innovative event planner who once flooded Studio 54 with four tons of glitter—*Ecks Ecks Ecks* was a half-hour-long extravaganza performed by forty toga-clad young men who enacted McNamara's vision of the ancient Band mixed with iconographic imagery from contemporary gay culture.

For artist Ryan McNamara—obsessed with what he calls "the emotive power of pop music" and the flashy stylishness of early MTV videos such as Michael Jackson's *Thriller*—*Ecks Ecks Ecks* was an assault on the indifference of history to gay culture and achievement. His camp-infused performances, which since 2005 have taken forms including a stage musical, a TV variety show, and a public dance-training workshop in galleries throughout New York, expanded in this work to mix ideas of clubbing and war. A flute-accompanied procession, led by McNamara, began the piece; performers sashayed and snapped their way into the space and, in choreographed pairs, demonstrated classic combat moves, which evolved into feigned erotic acts and disco dancing, performed to a techno house beat. Following a writhing climax the performers collapsed to the floor, leaving a field of immobile bodies amongst which audience members had to tiptoe to reach the exit.

—*Kevin McGarry*

HONOR AMONG THIEVES
(CHAPTER 1: THE TOWER AND THE STAR)
GLENN KAINO AND RYAN MAJESTIC

Inspired by the "Tower" tarot card, which represents catastrophic ruin or disillusion as well as the changes and revelations that can follow, *Honor Among Thieves*—a collaboration between Los Angeles–based artist Glenn Kaino and renowned magician Ryan Majestic—featured a precarious stack of fifty decks of cards. Majestic removed the deck from the top, asked an audience member to think of a card, and then turned the correct card face up. Without missing a beat, he then went through the same routine with another audience member. As the trick was repeated over half an hour, the audience was caught in a cycle of anticipation, deception, and disillusion. If an illusion is repeated, is it less magical? And if we have multiple opportunities to uncover the truth, does our failure to do so transform us? *Honor Among Thieves* suggested that for Kaino, there is no easy answer. —*Shane Brennan*

THE SLIPPER ROOM

PRESENTED BY CREATIVE TIME

Glenn Kaino with Ryan Majestic, Honor Among Thieves (Chapter 1: The Tower and the Star), *2009. Performance view. Photo by Meghan McInnis.*

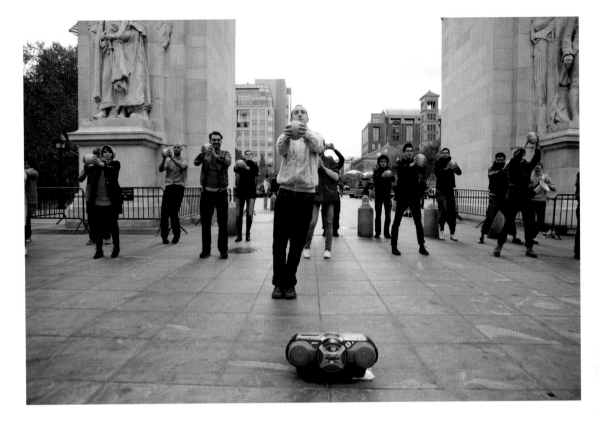

THE ANTS STRUGGLE ON THE SNOW
(LE FORMICHE FANNO FATICA SULLA NEVE)

MARCELLO MALOBERTI

WASHINGTON
SQUARE PARK

CURATED
BY BARBARA
CASAVECCHIA
AND CAROLINE
CORBETTA

*Marcello Maloberti,
The Ants Struggle
on the Snow (Le
formiche fanno fatica
sulla neve), 2009.
Performance view.
Photo by Paula Court.*

Italian-born artist Marcello Maloberti calls his performances "moveable feats." Beginning with loose planning and some props, he develops exercises in surprise and improvisation where representation and reality intersect. *The Ants Struggle on the Snow* took place on a Thursday afternoon by the iconic archway of Washington Square Park and featured hilariously amateurish choreography to Romanian techno music; a boy dressed in a Futuristic Depero-inspired costume (designed by Antonio Marras) driving a toy motorbike; and the twenty performers (friends, strangers, and the artist himself) parading around the arch carrying Maloberti sculptures and an American flag with a thirty-foot silver tail. Performed in a loop over four hours, *Ants* offered an animated tableau vivant of New York life, concentrated in one small area of the city for a few hours.

—*Barbara Casavecchia and Caroline Corbetta*

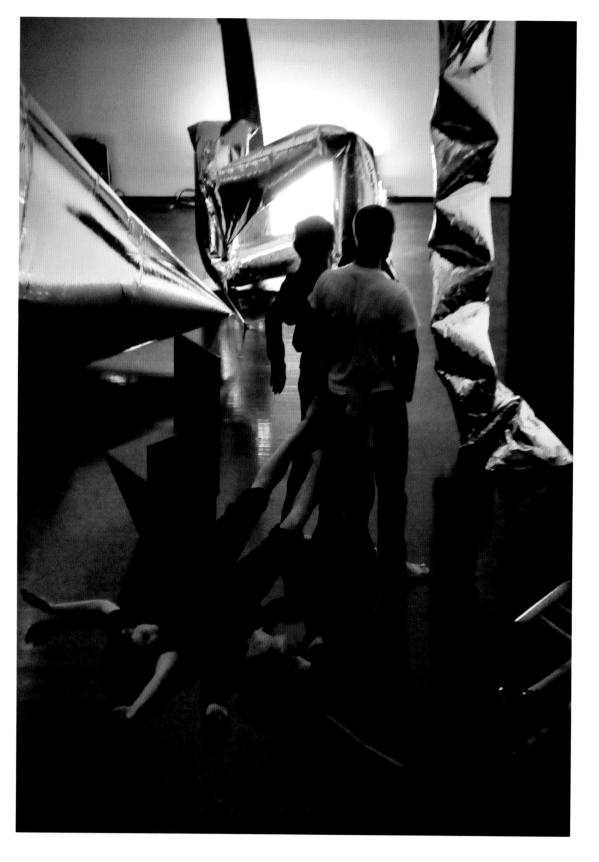

GIRLMACHINE
CARLOS SOTO AND CHARLES CHEMIN

TEATRO OF THE
ITALIAN ACADEMY
AT COLUMBIA
UNIVERSITY

PRESENTED BY
THE ITALIAN
ACADEMY AND
THE DEPARTMENT
OF ITALIAN,
COLUMBIA
UNIVERSITY

*Carlos Soto and
Charles Chemin,
GIRLMACHINE,
2009. Open rehearsal
at the Watermill
Center. Photo by
Sherry Dobbin.*

Performance directors Carlos Soto and Charles Chemin took the Futurist ambivalence toward women as their subject in *GIRLMACHINE*, an evening-length performance held in the Teatro of the Italian Academy at Columbia University that kicked off the two-day conference *Beyond Futurism: F. T. Marinetti, Writer* (see p. 291). In the words of Soto and Chemin, the Futurists "feared and loathed" women, "reducing them to a pure object, a pleasure tool"—but were also "secretly enraptured and entrapped by the feminine." In *GIRLMACHINE*, a text compiled from diverse sources—including writings by Marinetti, French playwright and filmmaker Sascha Guitry, and New Wave science-fiction author J. G. Ballard—formed the basis for a gradually unfolding series of tableaux. Eight black-clad performers moved through the space, enacting slow, sometimes mechanical, sexually charged choreography beneath monumental silver Mylar inflatables, specially designed by architect Christian Wassmann to transform the neo-Renaissance-style Teatro with their moving, reflective shapes. The ongoing scripted dialogue mixed Marinetti's odes to violence with Ballard's techno erotics, hinting at a series of lovers' quarrels and the fragmentation that results. In this associative journey through poetry, novels, manifestos, obsessions, and stereotypes, *GIRLMACHINE* revealed the many layers of the Futurists' conception of gender identity and its relation to contemporary ideas.

—*Performa*

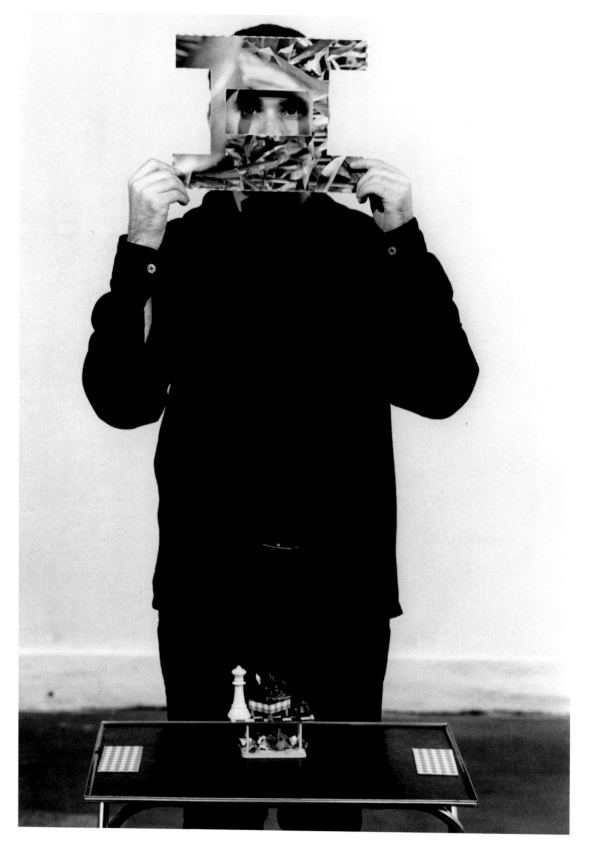

STUART SHERMAN: NOTHING UP MY SLEEVE

PARTICIPANT INC.

CURATED
BY JONATHAN
BERGER

*Stuart Sherman,
Eleventh Spectacle,
1978. Performance
view. Copyright ©
Babette Mangolte (all
rights of reproduction
reserved).*

Over a thirty-year period, the remarkable artist Stuart Sherman compiled an immense body of work in performance, film, video, writing, sculpture, and drawing until his death in 2001. He devoted much of his time to the creation of "spectacles," small tabletop performances in which everyday objects were manipulated atop one or more folding TV dinner tables. Performed by a pokerfaced Sherman, the spectacles occupied a uniquely awkward hybrid space, moving among references to comedy, illusion, minimalism, surrealism, melancholia, foreign language, and vaudeville.

Focusing on artists who constructed alternate realities through illusion and deception, challenging the idea that "the truth" is fact and instead engaging it as a wholly subjective form, the exhibition *Stuart Sherman: Nothing Up My Sleeve* included video and photographic documentation of Sherman's spectacles as well as the few surviving objects from those performances; work related to magic and death, such as artifacts related to Harry Houdini and the gold suit from James Lee Byars's *The Death of James Lee Byars* (1994–2004); a small room devoted entirely to the life and career of the actor Andy Kaufman, displaying his childhood record collection, his transcendental meditation materials, documentation of Kaufman undergoing psychic surgery in the Philippines, and the first draft of his novel *The Huey Williams Story* (published as a book in 1999); and other re-imaginings of different personas and the past. In conjunction with the exhibition, a concert was staged at Santo's Party House featuring Vaginal Davis's legendary rock band P.M.E. (Pedro, Muriel, and Esther) and longtime Kaufman collaborator Tony Clifton, often rumored to be Andy himself, who took the audience through a wild and raunchy five-hour set that ended only when the venue turned the power off.

—*Jonathan Berger and Lia Gangitano*

Participating artists: Nancy Barton and Michael Glass with Allison Somers and Eric Van Speights, James Lee Byars, Carol Bove, Matthew Brannon, Katarina Burin, Tony Clifton, Vaginal Davis, Eileen Gray, Harry Houdini, Andy Kaufman, KIOSK/Alisa Grifo and Marco Romeny, Little Switzerland, Babette Mangolte, P.M.E. (Pedro, Muriel, and Esther), Stuart Sherman, SITE Projects, SUPERSTUDIO, Stefanie Victor, Hot Keys/Jeff Weiss, and Richard C. Martinez.

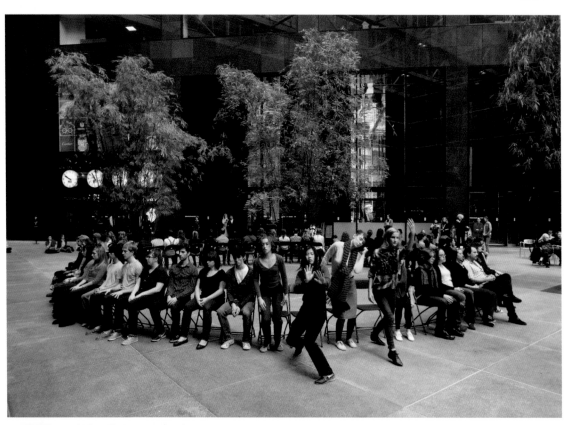

THE ENDLESS PACE
(VARIATION FOR 60 DANCERS)
DAVIDE BALULA

590 MADISON
AVENUE (THE
ATRIUM)

PRESENTED BY
FAKE ESTATE

Davide Balula,
The Endless Pace
(Variation for 60
Dancers), *2009.*
Performance views.
Photos by Paula Court.

Davide Balula's *Endless Pace (Variation for 60 Dancers)*, a "live clock" of sixty dancers, was an extension of his sound installation *The Endless Pace (Invisible Clock for 12 Speakers)*, commissioned by Tonspur for Vienna's MuseumsQuartier in 2008, which featured a single sound for every second. Seated on chairs in a large circle in the atrium lobby of a Madison Avenue skyscraper, the dancers echoed the rotation of the second hand of a clock, with each member of the circle performing a unique movement as his or her turn came, so that there was one move per second, creating a continuous wave of motion that lasted for one hour. (Balula worked in collaboration with choreographer Biba Bell to develop the movements.) An energetic force seemed to propel this wave, as movement passed swiftly from one dancer to another, making the performers appear to merge into a single entity. But each dancer was also given the chance to briefly become an individual, to act as the "minute hand" of the clock by stepping outside the circle for sixty seconds to jump, gyrate, curl, crouch, or just stand still and reentering the circle once a full rotation was made, to be replaced with the next dancer in line. Inspired in part by Busby Berkeley's synchronized swimming spectacles, but replacing the decadence of those showstoppers with a simple but equally satisfying geometry, *Endless Pace* was a lively and elegant acknowledgement of the passage of time.

—*Julie Trotta*

TWIRL

JEN DENIKE

In the middle of the crowd at the Brooklyn Museum's First Saturday series, Jen DeNike—a performance artist whose work is inspired by the ways in which architecture affects movement and the choreographic traditions of classical ballet—surprised viewers with a guerrilla spectacle of sound, movement, and color. At exactly 6 p.m., a blue sequin–bedecked majorette appeared and performed a series of impressive baton tricks, her sparkly prop soaring dangerously close to the pavilion's glass ceiling. Suddenly, horns and drums could be heard in the distance, and within minutes a sixty-five-member high-school marching band from Weehawken, New Jersey, in full uniform, entered the pavilion playing the theme from *Star Wars,* followed by a color guard of girls waving giant red flags in a tightly synchronized routine. As quickly as this vision came together, it disappeared, with the band and guard marching out of the building, soon followed by the lone majorette, the brief extravaganza vanishing into the darkness outside. —*Sarah Giovanniello*

BROOKLYN
MUSEUM

Jen DeNike, Twirl,
*2009. Performance
view. Courtesy the
Brooklyn Museum.*

NO PLACE: A RITUAL OF THE EMPATHICS

SAYA WOOLFALK

THE STUDIO
MUSEUM IN
HARLEM

*Saya Woolfalk, No
Place: A Ritual of
the Empathics, 2009.
Rehearsal view. Photo by
Saya Woolfalk.*

For an artist with multiple cultural identities (black, white, and Japanese), Saya Woolfalk's performances, videos, and paintings are driven by the creation of utopian worlds that bear unmistakable resemblances to our own, blending craft traditions with elements of science fiction to display an anthropologist's understanding of ideals across cultures. Her thirty-minute performance in the small theater of the Studio Museum brought these threads of fantasy and empathy to life. In the dimly lit space, Woolfalk began the work giving a Power Point–accompanied lecture from a podium in the role of an "Ethnographer," describing the origins of the "Empathics" from a fictional land called "No Place." The subject matter of her talk, the Empathics themselves, then appeared: five dancers in bright monochrome body suits, who presented a funereal ritual that spoke of future societies, future rituals, and the ethnography of a civilization that has yet to exist. —*Naomi Beckwith*

THE SNORKS, A CONCERT FOR CREATURES [TRAILER]

LORIS GREAUD

TIMES SQUARE

A PERFORMA
PREMIERE

COMMISSIONED
BY PERFORMA

PRESENTED IN
COOPERATION
WITH THE TIMES
SQUARE ALLIANCE

Loris Greaud, The
Snorks, A Concert for
Creatures [Trailer],
*2009. Exhibition view.
Photo by Paula Court.*

The dark abyss of the ocean—the place on earth that we know the least about—is populated by bioluminescent creatures that flicker to the rhythm of the environment's sound frequencies to produce undersea "light shows." It is this curious phenomenon that inspired French artist Loris Greaud's ambitious project *A Concert for Creatures*, developed in collaboration with Performa, the MIT Sea Grant College Program, and Carnegie Mellon University.

A cross-disciplinary artist whose fields of interest and activity range from architecture to experimental film, quantum mechanics to electronic music (he has founded both a movie studio and a record label), Greaud typically works in collaboration with scientists, musicians, writers, athletes, and other experts as the starting point for serial projects that often travel to multiple venues in different forms. For Performa 09, he indulged his fascination with the depths of the ocean and the pyrotechnics of the sky in an exciting period of research that culminated in a bold two-part "exhibition." *A Concert for Creatures* was launched over the desert in Abu Dhabi, in the form of a giant fireworks display designed by acclaimed international pyrotechnicians Groupe F to mimic the amoebic glow-in-the-dark ballets of deep-sea creatures, and continued two weeks later at midnight in Times Square, New York, where a crowd watched video documentation of the fireworks on the enormous Panasonic, NASDAQ, and Reuters LED screens, towers of light that normally display advertisements but took on a hint of the aquarium. It was a conceptually and visually rich beginning to an ongoing project that includes growing a culture of diatoms of the undersea species in an MIT laboratory in Boston, and producing a film with a sound track by the experimental hip-hop band Antipop Consortium. —*RoseLee Goldberg*

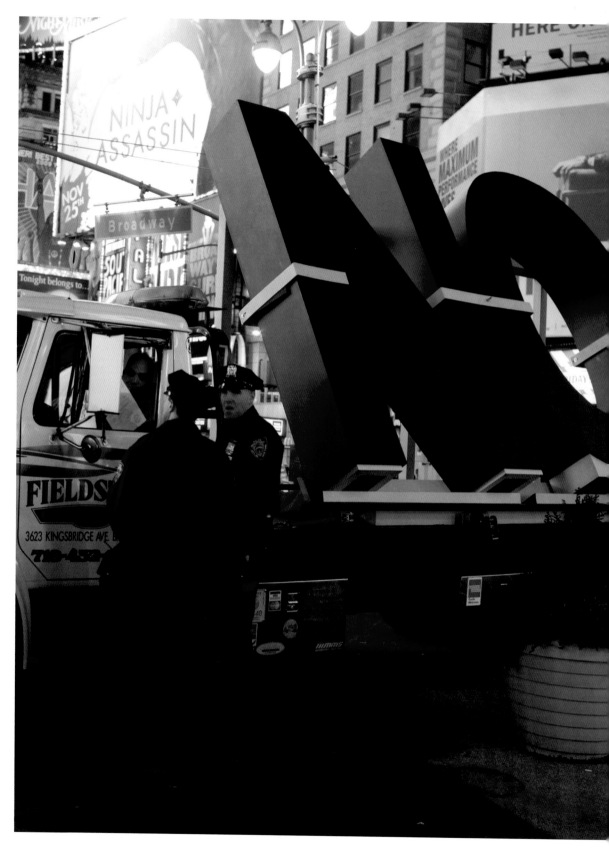

*Santiago Sierra, NO,
2009. Performance
view. Photo by Paula
Court.*

NO
SANTIAGO SIERRA

For twenty-four hours in November 2009, pedestrians in Manhattan might have spotted a truck carrying a metal structure supporting two ten-foot-tall, three-dimensional capital letters made out of plywood painted black. Two letters, one uncompromising proclamation: NO.

Santiago Sierra is known for his controversial actions and political interventions, such as paying Brazilian prostitutes with drugs to have a line tattooed on their back (2000) and building a gas chamber in a former German synagogue (2006). This sign defined his fundamental position as an artist and as a human being, asserting the inalienable right to dissent and to take a political position in the face of social and political realities.

Departing the Studio Museum in Harlem at noon, *NO* set out on a planned route through Manhattan past politically charged sites such as the United Nations and the National Debt Clock on Forty-Fourth Street. Parked below the clock, the sign attracted the attention of tourists and passersby, who posed for photographs in front of *NO* while the gross national debt rocketed upward. The truck then continued through Chelsea and Wall Street and back up to Times Square, where it was parked until noon the following day.

NO's appearance in Manhattan was part of Sierra's most ambitious project to date, *NO, GLOBAL TOUR*, which launched in Europe in Summer 2009 and continued in North America in October 2009, appearing in Toronto, Detroit, Cleveland, Washington, DC, and Miami, in contemporary art contexts as well as settings with particular historical significance. The tour is ongoing, and a complementary "road movie" is recording the journey of the truck and the landscapes it passes through. *NO* literally stops people in their tracks, asking them to think about the creative potential of dissent as a powerful force for change.

—*Silvia Sgualdini*

Chapter Three

THE ILLUMINATING STAGE

PERFORMANCE AT THE EDGE OF THEATER

A series of performances by artists at the temporary exhibition space X Initiative brought together works that showed a conceptually driven fascination for conventions of the stage. One group reworked an outrageous play written by Picasso, and another duo gave a twenty-minute lecture-demonstration on the history of body art, while the multi-night "conceptual social club" of *The Prompt* at a Lower East Side lounge drew inspiration from the Futurist Variety Theater. The role of the audience was frequently explored as well, whether by having viewers watch exaggerated versions of themselves (Emily Mast) or by giving them a welcoming environment to become part of the performance themselves (Oliver Herring).

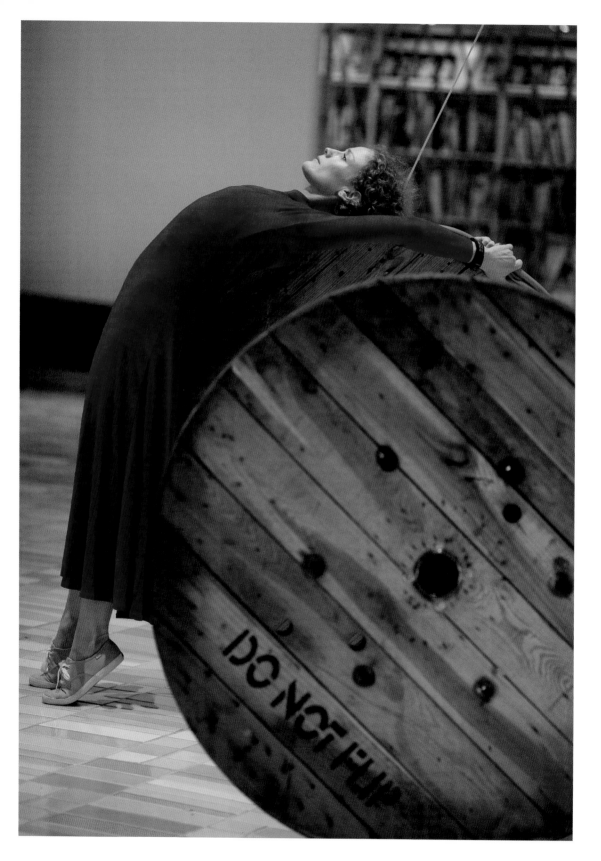

EMPTY IS ALSO
TAMAR ETTUN AND EMILY COATES

X INITIATIVE

COMMISSIONED
BY PERFORMA

PRESENTED BY X
INITIATIVE

Tamar Ettun and Emily Coates, Empty is Also, *2009. Performance views. All photos this section by Paula Court.*

Encouraged to collaborate for the first time by Performa director RoseLee Goldberg, performer and Yale theater studies lecturer Emily Coates and up-and-coming artist Tamar Ettun (then at the Yale School of Art) created the performance-installation *Empty is Also.* Since people often view sculpture as enduring and dance as fleeting, Ettun (a sculptor) and Coates (a former ballerina) decided to reverse these expectations. By attaching ordinary "found" objects—each with their own individual history—together to create new sculptural forms, Ettun suggested an entirely new story hidden within the original "memories" of these items. Crutches and red yarn became a large dream catcher (a hoop-shaped Native American protective charm) that remained stationary throughout the performance, while Coates, in a striking red dress, moved a painter's scaffold laden with dozens of objects affixed by Ettun (including a broom, a sheet, and a garden hose) around the gallery space. In this way the sculpture became mobile, changeable, and suggestive of different identities: a boat, a flag, a treehouse. The viewers became a part of the impermanence of the work as they walked in and around the performance space. In contrast, by incorporating famous sequences from the work of choreographers George Balanchine and Yvonne

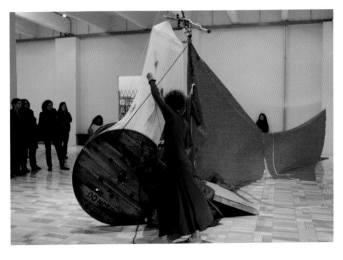

The following words appear within the drawing: tree house, light, telescope, Mosquito net hang from the ceiling, Sail I, Sail I, height depends on the room, rope with a pillow, sails can open and close, 2 meter, Wood 1.5 meter, mini objects, fence, 4 m, bucket, bags, bags of dust, wood pieces, table

Above: Preparatory drawing by Tamar Ettun for Empty is Also, *2009. Courtesy the artist.*

Opposite: Tamar Ettun and Emily Coates, Empty is Also, *2009. Performance view.*

Rainer, Coates's dance seemed stable, instantly identifiable, and timeless. The grace of the dance was periodically interrupted by Coates's efforts to return the sculpture installation to its original design—without success—as saxophonist Jane Ira Bloom played John Phillip Sousa's "Stars and Stripes Forever" in the background. The question loomed throughout: Which art form is more ephemeral now? —*Carol Hsin*

80 ST. MARK'S
PLACE

PRESENTED BY
PERFORMA

IN ORDER OF APPEARANCE
YOURI DIRKX AND AURÉLIEN FROMENT

Presented in a small East Village theater from the 1920s, Aurélien Froment's solo performance *In Order of Appearance* was set on a stage resembling a white-cube gallery. Scrolls of paper unfurling from the ceiling onto the floor formed movable white walls, while actor Youri Dirkx arranged and rearranged pedestals and objects in the shape of triangles, circles, and squares—the classic elements of the sculptor's vocabulary—on the floor. As the props became chairs, screens, or sculptures, the visual "picture" of the stage oscillated between decorative and functional, stage prop and art object.

In Order of Appearance was an extension of Froment's longtime interest in the ways in which theatrical and cinematic spectatorship affect the interpretation of images. The work's playful sensibility—its structure as a gradual accumulation of colorful objects on a blank canvas, and Dirkx's childlike preoccupation with the props—echoes the game-like qualities of several of Froment's previous works, such as *Froebel Suite* (2009), in which visitors were given the chance to play with a variety of colorful shapes, and *Who Here Listens to BBC News on Friday Night?* (2008), a set of illustrated playing cards that visitors were encouraged to use. *In Order of Appearance* took these ideas one step further, revealing the way in which objects and information are "staged" in the contexts of both theater and visual art.

—*Armelle Pradalier*

Youri Dirkx and Aurélien Froment, In Order of Appearance, *2009. Performance view. Courtesy the artist.*

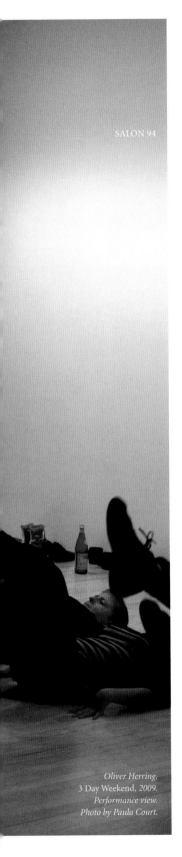

Oliver Herring,
3 Day Weekend, 2009.
Performance view.
Photo by Paula Court.

3 DAY WEEKEND
OLIVER HERRING

I began my project *3 Day Weekend* by issuing an open call for participants. From the submissions we received, I selected five, using the applicants' personality, body type, and age as the criteria for building a group that was wholly diverse aside from one shared trait—no one should have previous dance experience. Of the chosen five, three traveled long distances, one from as far as Columbus, Ohio. Before the long weekend over which the performances would take place, we got together three times to develop "seed-choreography," a kind of rough sketch that served as our guideline and safety net during the performances.

Day one (an open house from 6 to 8 p.m.) was packed. As the audience sipped cocktails and milled around, without any announcement I started giving choreographic instructions to my group, which they attempted to follow. It took about ten minutes for the audience to figure out what was going on and settle in as "viewers." Then I added what, to me, is the quintessential ballet music of all time, Sergei Prokofiev's "Dance of the Knights" from the ballet *Romeo and Juliet.* I repeated this music over and over throughout the performances. For the most part, I improvised my directions. The participants performed drops and acrobatic lifts, arranged themselves in complicated configurations, and threw themselves off furniture, while I adjusted their poses and filmed them with a video camera. The audience seemed to really get into it, which in turn emboldened us.

On day two (another two-hour block of time), I decided to include volunteer audience members in the performance, shaping the choreography around what they were able and willing to do. By the end of day three's performance, everyone, old and young, artist and non-artist, was participating, except for a single person who remained as the official "audience." By that time, a group of people with absolutely no experience in dance—including myself—had built an elaborate, athletic, inclusive, sometimes ridiculous, and rather unlikely ballet.

—*Oliver Herring*

RABIH MROUÉ'S GIFT TO NEW YORK
RABIH MROUÉ

PS122

CO-PRESENTED
BY PS122 AND
PERFORMA

ORGANIZED BY
DEFNE AYAS

Rabih Mroué, Rabih
Mroué's Gift to
New York, *2009.
Performance view.
Photo by Paula Court.*

"My name is Rabih Mroué. I'm glad to be here with you tonight. This is my first visit to New York; as a matter of fact, this is the first time I've set foot in the United States."

Having accepted an open invitation that Performa issued in 2006 to present one of his signature satiric lecture-performances, which use actual and constructed "evidence" to recount Lebanon's bloody and fragmenting history of civil war from 1975 to 1990, artist, playwright, and theater director Rabih Mroué planned to participate in Performa 09—but could not appear in person, due to visa delays. Aware of the challenges that New York audiences might face in understanding his work because of Lebanon's complicated political context, Mroué decided, instead, to send an intimate letter to New York as a "gift" that would reflect on his presence onstage through his physical absence. Four videos were also shipped—*I, the Undersigned* (2007), *On Three Posters* (2000), *With Soul, with Blood* (2003), and *Face A/Face B* (2002)—to be screened to the audience at PS122 following a reading of the letter.

At the show's two presentations, Mroué's letter was read by an actor (Jim Fletcher or Okwui Okpokwasili) standing alone under a soft spotlight in the dark theater. The reader's task was to guide the spectators through a Borgesian labyrinth, telling the story of "making it to New York City" through a series of surreal conversations with a variety of US citizens. Mroué's own doubts—as he talks to US consulate officials in Brussels, border police officers at JFK airport, a New York taxi driver on the way to his hotel, and a journalist from the *New Yorker*—elicited a mixture of sympathy, disbelief, laughter, and profound sadness from the audience. *Letter to New York* demonstrated how Mroué, whose work regularly questions the definition of theater, is especially interested in how the performer relates to the audience; in this case, he used storytelling and his own absence to build a relationship of remarkable empathy with those in attendance.

—*Defne Ayas*

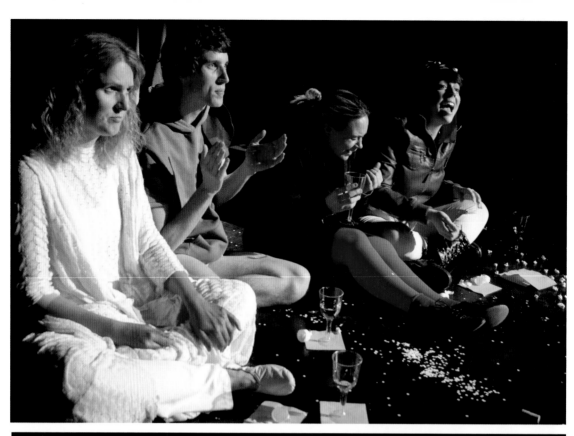

EVERYTHING, NOTHING, SOMETHING, ALWAYS (WALLA!)

EMILY MAST

X INITIATIVE

Conceived in the tradition of *commedia dell'arte*, which uses masked "types" instead of complex characters, Emily Mast's *Everything, Nothing, Something, Always (Walla!)* featured four actors—the Articulator, the Wonderer, the Enthusiast, and the Doubter—performing a single script nine times over the course of three hours. The content of the play was a conversation-*cum*-argument on the nature of theater, with each "mask-character" representing a different aspect of the artist's psyche. Additional actors sat in chairs in front of the small stage, impersonating an "audience" given to exceptionally strong reactions. The actual audience members were invited to stand on all sides of the installation so that they were watching not only a play but also another "audience" watching a play, all the while looking through the play at one another. By giving the audience the freedom to view the piece from all sides, Mast transformed the idea of "theater" into a live sculpture of sorts that could be contemplated much like an object in an exhibition.

"Right now, you are you because you were written that way," the Enthusiast told the Wonderer early in the performance. This seemed less and less certain, as in one version the stage actors spoke very loudly, in another they held a pretend picnic, and in yet another an actor in the "audience" provided a perfect voiceover of all the scripted lines while the four "mask-characters" ran about on stage miming the accompanying actions. Mast filled her script with melodrama, cliché, and caricature, bringing humor to the existential dilemmas encountered in the process of artistic production. In this way, she not only depicted a self that contained many different "characters" but also turned the creative process inside out for the viewer's examination.

—Tyler Coburn

Part of this essay was originally published as part of a longer article in ArtReview 39 *(March 2010).*

F FOR FAITH
LECTURES / PERFORMANCES
GUILLAUME DÉSANGES

X INITIATIVE

Guillaume Désanges, A
History of Performance
in 20 Minutes, *2009.*
Performance views.
Photos by Paula Court.

In *F for Faith, Lectures / performances*, Guillaume Désanges—a French art critic and curator who has recently begun to present his lectures and conferences as artworks in their own right—performed two sets of three presentations consecutively in an eight-hour "marathon" on three days. In the first lecture, *A History of Performance in 20 Minutes*, Désanges sat at a table on the left side of a small stage, reading a text summarizing the history of the body's representation in art in a quiet, monotonous voice. He identified several "pivotal gestures," such as "Appearing," "Receiving," "Holding Back," and "Escaping," while next to him, in front of a white screen, performer Alexandra Delage, wearing a business suit, demonstrated these movements—sometimes quite aggressively—as he called them out. At one point, she bent forward with her eyes closed and attempted to catch tennis balls, as in Vito Acconci's *Blindfold Catching* (1970); at another, she acted out being shot in the arm, as in Chris Burden's *Shoot* (1971). In the second lecture, *Vox Artisti, his masters' voices*, Désanges turned to a history of the voice and its relation to the visual arts. In the darkened room, he played a surreal dialogue pieced together from hundreds of snippets of performances, conferences, interviews, and documentaries from sound archives around the world. As the audio track played, Désanges sat silently at his computer, typing notes that were projected onto the screen. *Signs and Wonders*, the final lecture, took the form of a shadow play: while Delage placed objects (pieces of paper, seeds, drops of water) on the glass surface of an overhead projector, Désanges explained the relationship of their basic forms to works by Donald Judd, Hans Haacke, and Robert Smithson, using the recurrent "signs" of Minimal and Conceptual art (the cube, the circle, and the spiral) to transition from one artwork to the next.

—*Cecilia Alemani*

DESIRE CAUGHT BY THE TAIL
SCOTT KEIGHTLEY AND TOM O'NEILL

X INITIATIVE

Artist Scott Keightley and experimental theater-maker Tom O'Neill restaged Pablo Picasso's 1941 play *Desire Caught by the Tail,* which the painter wrote over the course of three days in Nazi-occupied Paris, as an "assault on the audience" in the form of "an overflowing stream of absurdity" that echoed Dadaist theater in the number of ideas it threw against the wall, refusing to be limited by realism, cause-and-effect, or sheer practicality. Whereas Picasso's tragicomedy was first presented as a reading in Michel Leiris's apartment in 1944, with a cast including Simone de Beauvoir, Albert Camus, Jean-Paul Sartre, and Picasso himself, Keightley and O'Neill rehearsed their cast of eleven actors (many of whom were fellow students in the theater department at NYU) in studios and apartments and on rooftops all over the city, at one point selling cookies in Central Park to raise funds for the production. On the night of the show, seated in front of a semicircular stage in the center of a large room, the audience could see tables overflowing with an assortment of objects—carrots, cigarettes, cell phones, loose change, fruits and cheeses, bottles of wine, an upside-down ladder, a pig's head—which would be used in a chaotic series of tableaux vivants, with music, shouting, and loud cheering throughout. The challenge was to take Picasso's script, which often calls for actions practically impossible to perform onstage, and translate it using the props at hand. As Keightley explained, "For example, an actor jumping through a window in the script was represented by building a table out of glass windows and throwing the heaviest thing we had lying around, which happened to be a pig's head." Characters undressed and pretended to make love onstage; a large fish was used as a weapon; a lottery wheel was spun; a character known as "Le Onion," wearing waders and goggles, laughed maniacally while twirling his mustache. One audience member later told Keightley that at dinner after the show she had suddenly felt like taking off her clothes, sweeping the contents of the table onto the floor, and screaming: for Keightley, "an ideal reaction."

—*RoseLee Goldberg*

on spot: Great Egret
(Ardea alba)

Westport woods 2nd App!

keep out

Saeso Bowl

V75 Jagsiro 28/3
① 3, 6,9 11 Jacke
① ② 15 V
① 1 5
①
① 5,7,9 1
① 1 3 5 8 2
① ④ 6 V
① 2, 3, 7 8 1
· 2ratt Frida 1 142 601

therapy TODAY

he used to graffiti penises
on lifeguard stand —
once he made faces out of them
we knew he was cured

2.Bundesliga.de
Oberhausen : FCK 1:1
Osnabrück : 60
Aachen : Fürth 1:0
Wiesbaden : Pauli 3:1
Rostock : Frankfut 2:0
FCK : Ushan 2:0

take the bags
and don't
come home
before 5:30

rock

dock

ADOPTION OPTIONS
The UK chapter of Westport
charity warns against Ma-
donna's Malawi adoption.
Despite the condemnation
of Save the Children,
which has a head quater
in nearby Westport —
pass by and have a
look at their sculpture
program in the front yard «

Every time my dad goes
there he asks for
"Do you pumpernickel
Bagels"
in the hope one day
they will

If you feel pain
after showering
in the upper back
your bathrobe
might be to
heavy!

[we wonder how
Christine Gattmeyer
keeps her upper back
muscles in such a
form]

What did you get
tonight?

I bought a pair
of one cup espresso
maker for a fiver

Police Blotter ..
BRIAN ESPOSITO, 25, OF
BRIDGEPORT, was charged
with breach of peace
and given a court date
April 2.

I'M
GRUMPY

New Haven's police
say a 2nd arrest has
been made in the
theft of art work
made by the victim
of the Unabomber
David Gelernter.
The art was stolen
from the Joseph Slifka
Center for Jewish Life
at YALE

wrote the cat on a postit and
glued it to her back

Soaking in Irish Steel cut Oats
overnight reduces the cooking
time imense — and then
put peanut butter in at the very last end.

888
women
under
influence
[part375]

86 Porsche 911 Cab.
Pristine, new top and lift
motors, brake restora-
tion, guards red with
black top, 78K mi. Sum-
mer use only. $26,500
860-859-1030
opportunity

But if you still can't stay
away from it

CVS WESTPORT CT

has an excellent adjusted KODAK
direct print machine & the mana-
ger is a foto expert himself who
sleeps with his CANON G9 . . .
if I wouldn't have a reason this could be one

Guests arriving

[next morning:]

Pastries
P-A-S-T-R
IES were
served —
something
never was
served, when
we were alone

Gary's Garements:

"A Feast for the eyes
— you don't have to
think about it." Hommgwac

CARLOT
2004
$12
X X X

Acorn
4750
PACON

AMERICAN SOLDIER
THEATER SOCIETAET (BERND KRAUSS AND
MICHAEL THOMAS)

"Walsch. *W* as in war, *A* as in Alamo, *L* as in Lenin, *S* as in science fiction, *C* as in crime, and *H* as in hell." So Ricky, the protagonist of Rainer Werner Fassbinder's *American Soldier* (1970), spells a name to an operator, revealing much about his dark worldview and obsession with Hollywood gangster movies. For Performa 09, Bernd Krauss and Michael Thomas of the German art collective Theater Societaet presented a live adaptation of the film (coinciding with Krauss's related exhibition *iSLAND kEEPER*): a bare-bones performance—essentially an illustrated script reading—that emphasized the emotional and sexual subtexts of Fassbinder's challenging film.

In the Goethe-Institut's intimate downtown space, with the performers inside a small circle formed by a metal railing that the audience closely ringed, Thomas played Munich-born Ricky, who returns to his hometown after fighting on the American side in the Vietnam War and falls in with corrupt policemen and an unsavory gang, and Krauss played all the other characters (and sometimes Ricky as well). With DIY costumes and props and minimal lighting, they focused on pivotal scenes, such as an emotional dialogue between Ricky and his mother—both of whom Krauss played, putting on and removing a single costume item to signal the character change. Such performative and aesthetic restrictions reflected Fassbinder's cinematic vision, emphasizing the simplicity of his means in creating a stark and unforgettable work. —*Laura Barlow*

MANNEQUINS' BALL
BRUNO JASIEŃSKI

MARTIN E.
SEGAL THEATRE
CENTER AT THE
CUNY GRADUATE
CENTER

CO-PRESENTED
BY THE POLISH
CULTURAL
INSTITUTE IN
NEW YORK

CURATED BY
DANIEL GEROULD
AND FRANK
HENTSCHKER

*Janusz Warminski's
production of Bruno
Jasieński's* Mannequins'
Ball *(1930) at the
Ateneum, Warsaw,
1974. Performance
view. Courtesy the
Martin E. Segal Theatre
Center at the CUNY
Graduate Center.*

The often-overlooked Polish Futurists, based in Krakow and Warsaw in the '20s, were a talented and colorful group of artists and writers who made a significant contribution to the international Futurist movement, and Bruno Jasieński's *Mannequins' Ball* (which was published in Russian in 1931 and premiered in Prague two years later) was the most celebrated Polish Futurist drama of its time. Jasieński's satirical two-hour play about a group of mannequins in a Paris fashion house staging a revolt against their capitalist exploiters—a grotesque fantasy featuring vignettes such as a politician's head being cut off with a pair of giant scissors—was never before professionally performed in the Americas, and was conceived for Performa 09 by British director Allison Troup-Jensen with more than fifteen actors from her Counterpoint theater company, twenty mannequins, and two costume designers.

Mannequins' Ball has served as an inspiration for many contemporary Polish artists, including theater curator Joanna Warsza, who, as part of the same event, presented excerpts from performances she produced, including *Virus in the Theater Performance* (2006), an intervention in which audience plants stormed onto the stage partway through a play and eventually incited the rest of the crowd to come up and join them, and *Boniek!* (2007), a one-man reenactment of the spectacular Poland-Belgium face-off at the 1982 World Cup—two humorously confrontational actions that would have been right up Jasieński's alley.

—*Daniel Gerould and Frank Hentschker*

Claim that you have left
your cell phone at hom...
and need to make an...
call to a loved one in...
Japan, try and convi...
someone to lend yo...
phone. Say that thi...
part of the game.

...a negative sentence.
...with positive statement... a
...tion, if they ask you a ques-
...respond with another
...anyone asks you a ques-
you want. But then if
...alk to people. Start as

T

...t least one
...conversation,
...them a highly
...and tedious
...of your journey to
...t.

D o the opposite of
whatever you were doing
before receiving this card.
Think for a minute about
what this means, if
anything.

S peak without using any
...verbs. Think for a moment
about what this implies.

T alk with peop...
...riences with ...
...of the day."

...al
...ion w...
...sue then
...n an attem...
...ue your previ...
. If not, ask some...
at the time is.

A sk someone a series of
typical gambit-style ques-
tions. What do you do?
Where do you live? What
music do you like? etc. but
take no apparent interest in
the replies.

W rite a short burst of
rap-style lyrics on the
rhyme 'ate' and sing it to
someone claiming that it's
the latest Eminem single.

...ceiving this
...walking. When you b...
into someone, try and
sweet talk them into a
conversation about the
meaning of life and love,
nothing much happens,
close your eyes again and
set off once more.

G o to the bar and order a
'Streamliner' cocktail –
describe what's in it, how
to make it and where you
discovered it. If there's no
...r, make imaginary
...cktails a subject of
...conversation.

THE PROMPT (A NIGHT CLUB)

WHITE SLAB
PALACE

COMMISSIONED
BY PERFORMA

PRESENTED IN
CONJUNCTION
WITH
KUNSTVEREIN NY

CURATED BY
SARINA BASTA
AND MICHAEL
PORTNOY

*Cards designed by Ian
Monk for* The Prompt
(a night club), *2009.
Courtesy the artist.*

A five-night "social club" inspired by the Futurist Variety Theater, *The Prompt (a night club)* comprised a conversation-starting object, a rule governing etiquette and conversation between guests, a short film, a commissioned score or playlist, and a series of short performances.

The venue—the back room of a popular downtown restaurant and bar—was designed to look like a cabaret, with a small stage and candlelit tables. Michael Portnoy, the "Director of Behavior," hosted each evening. Along with filmmakers and writers Jamie and Sarah Francoise Hook, Portnoy circulated as an errant maître d', introducing guests under false pretenses, barging into and modifying conversations, and awarding points on "behavioral scorecards."

The conversation-starting objects ranged from artist Mark Dion's stuffed hedgehog to a high chair designed by theater director Robert Wilson. Rules of etiquette included a card game created by Ian Monk ("When speaking, always try and start by using the last three words of what the last person just said"). Especially memorable performances included Aki Sasamoto dancing a lecture about doughnuts and string theory and taking directions from artist/musician Momus via Skype from Berlin; Marianne Vitale's short film *Patron*, which commanded the audience to perform a poetic barrage of impossible actions; and Reggie Watts bringing down the house with his trademark mixture of beat-box music, hybrid accents, and next-wave comedy.

Featuring work by more than twenty artists, while also encouraging the public to perform themselves, *The Prompt* proved to be an unforgettable social experiment.

—*Sarina Basta*

Participating artists: Rita Ackermann, Fia Backström, the Bruce High Quality Foundation, Joan Juliet Buck & Cassie Terman, Joshua Kit Clayton, Patrick Cleandenim, CORO, Dexter Sinister, Mark Dion, Sylvie Fleury, Joseph Grigely, Jamie Hook, Rashid Johnson, Gabriel Lester, Paul Etienne Lincoln, Momus & Aki Sasamoto, Patrick Meagher, Haley Mellin, Ian Monk (OULIPO), Charlemagne Palestine, Adam Pendleton, Falke Pisano, R. H. Quaytman, Jimmy Raskin, Gavin Russom, Salter and Snowden, Dana Sherwood, Dina Sieden, Guy Richards Smit, Mindy Vale & Danny McDonald, Ben Vautier, Marianne Vitale, Reggie Watts, and Robert Wilson.

Defence							
					Response Aggressive		
speak	write	q/r	mem	rev	def	flash	Pic

Keywords **don't worry, power, me**
Region Pinjarra
Source Written When Spoken
Year 2009

Quotation Reference Spoken:

"Don't worry, you don't have that much power over me" - Noam, Friend, 2010

Quotation Reference Written:

"Don't worry, you don't have that much power over me" - Noam, Friend, Phone, 2010

Elaborating and Prefixes							
					Statement Conventional		
speak	write	q/r	mem	rev	def	flash	Pic

Keywords **worse, much**
Region Perth
Source Remembered
Year c. 1988 - 2010

Quotation Reference Spoken:

"Could be worse, it could always be much worse" – Doreen, Grandma, c. 1988 - 2010

Quotation Reference Written:

"could be worse, it could always be much worse" – Doreen, Grandma, Various Environments, c. 1988 - 2010

THE QUOTE GENERATOR, PHASE TWO

DANIELLE FREAKLEY

In *The Quote Generator,* Australian artist Danielle Freakley spoke entirely in quotations for a set period of time—sixteen months for *Phase One,* one year for *Phase Two,* and six months for *Phase Three.* Her sources included films, advertisements, books, magazines, and social exchanges, which she recorded on her iPod, memorized, and presented in a variety of formats, reflecting the various professional and personal situations she found herself in: at an interactive performance in a gallery; in conversation with friends, family, and strangers; as a guest at a dinner party. For the premiere of *Phase Two,* she stood in a large white space at X Initiative amid scattered seating for the audience and began a yearlong project of speaking only in phrases collected from her own conversations over the previous sixteen months. —*Rob Teeters*

X INITIATIVE

Quotation cards from Danielle Freakley's
The Quote Generator,
Phase Two, *2009.*
Courtesy the artist.

HEAR IT HERE
SHANA LUTKER

*Shana Lutker,
Hear it Here, 2009.
Performance view.
Photo by Michelle
Proksell.*

Combining public political speech with Happening-like instruction-based performance, Shana Lutker's *Hear It Here* complicated the roles of audience and performer. The artist invited audience members to speak into a microphone; their words went directly to headphones worn by two actors onstage, who then repeated the lines, while an accordion player added emphasis and atmosphere. The open format produced all kinds of unexpected material—political statements, sentimental reflections, jokes, requests, even reprimands—that eventually coalesced into a public forum on free speech, ending with serenades to the accordionist and concrete poetry.

Hear it Here is an ongoing performance, and was previously presented in Miami, Orange County, Santa Barbara, and Zurich. Since its content is informed by the local conditions of each setting, it is entirely different with each staging. Lutker is recording and transcribing each performance, building an archive of public statements for reference in future projects. —*Anne Ellegood*

SIMULTANEOUS AWARENESS

PERFORMANCE BETWEEN SCREENS

The Futurists' obsession with "simultaneity"—the layering of many different ideas, sounds, actions, or images in a single moment—is nowhere more evident than in multimedia performance, which has the capacity to combine live performance, imagery, light, and sound in ways that provoke and inspire. From William Kentridge's autobiographical monologue, with its coinciding representations of the artist himself, to Joan Jonas's intricate collage of performance, video, drawing, and text, the multimedia events in Performa 09 provided rich views into many new worlds.

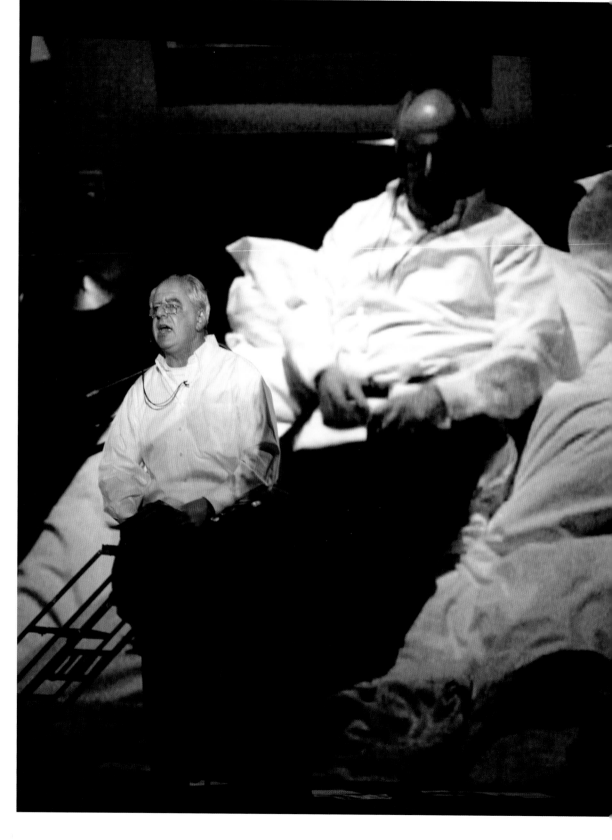

William Kentridge, I
Am Not Me, the Horse
Is Not Mine, *2009.*
Performance view. All
photos this section by
Paula Court.

I AM NOT ME, THE HORSE IS NOT MINE
WILLIAM KENTRIDGE

Early in his career, in the mid-1970s, William Kentridge performed with the Junction Avenue Theater Company in Johannesburg, while also running a printing press and producing posters for the struggling trade unions in apartheid-era South Africa. Later, he would use a full arsenal of artistic media—drawing, etching, painting, film animation—to respond to the political context that imposed curfews, house arrests, solitary confinement, and unlawful detention on its citizens, and to articulate the emotional and psychological effects of such oppression. Even so, he would return to the physical exercises of the actor as a yardstick for measuring and controlling his material: "I learned a huge amount about what it is to be an artist from the theater school," he once said. "How you modulate the energy of a performance, how the energy of one moment—no more, no less—has to be sufficient to give the spark for the next moment."

I Am Not Me, the Horse Is Not Mine, Kentridge's first live performance on his own stage, puts such precisely modulated energy into action. As both performer and narrator, director and interviewer, he asks and answers questions of himself, and explains how and why he made this solo performance using many "selves"—in the flesh, on film, and sometimes projected in triplicate—to do so. *I Am Not Me* provides background on the thought processes that would go into the designs and concept for his production of Russian composer Dmitri Shostakovich's satirical opera *The Nose* (1930), based on the

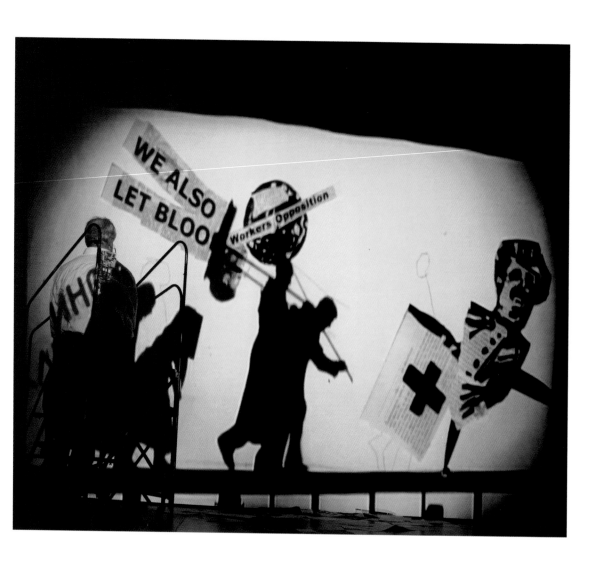

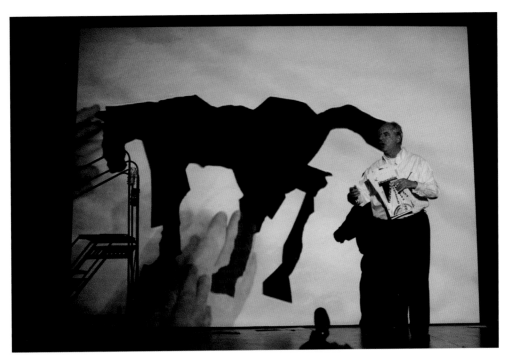

William Kentridge, I Am Not Me, the Horse Is Not Mine, *2009. Performance views.*

Nikolai Gogol short story of the same name, which would be Kentridge's directorial debut at the Metropolitan Opera in New York in March 2010. The absurd story of a man searching for his nose, which ends up more powerful than he, and its implications in a society ruled by Soviet totalitarianism, or for that matter, one ruled by apartheid's race laws, provided Kentridge with rich seams, both visual and historical, to explore. In his profoundly touching and riveting performance—part monologue, part lecture, and part animated film—Kentridge communicated his deeply held humanist views of the world. Even its title, *I Am Not Me, the Horse Is Not Mine*, a Russian peasant expression used to deny guilt, shows him taking full responsibility for the artist's role to inform and inspire. —*RoseLee Goldberg*

William Kentridge, I
Am Not Me, the Horse
Is Not Mine, *2009.*
Performance views.

READING DANTE
JOAN JONAS

THE
PERFORMING
GARAGE

A PERFORMA
PREMIERE

*This and following
spread: Joan Jonas,*
Reading Dante, *2009.
Performance views.
All photos this section
by Paula Court.*

Published in Venice in 1555, Dante Alighieri's *The Divine Comedy*, an allegorical vision of the afterlife that was considered by the Futurists to be a precursor to their obsession with simultaneity, was the starting point for Joan Jonas's contemporary rendering of heaven and hell. *The Divine Comedy's* 14,233 lines (written in Italian rather than Latin, making it available to a much broader readership) describe Dante's journey from one side to the other, climbing over obstacles and fending off attacks by wild animals representing the sins of humankind. Jonas links Dante's epic poem to the writings of late-nineteenth and early-twentieth-century art historian and cultural theorist Aby Warburg (whose material was the centerpiece of a 2006 performance by Jonas titled *The Shape, the Scent, the Feel of Things*): both Dante and Warburg "had an overarching world view," and both "represent characters that are on a journey through life that involves thinking about the world as a whole, not just what's immediately around them." Jonas goes on, "The medieval era of Dante and the first half of the twentieth century were both periods of extraordinary change, and I think the same could be said of today."

A sixty-minute collage of film, drawings, and projections, amid objects and props including a child's chair, a chalkboard,

Opposite and above: Joan Jonas,
Reading Dante, *2009. Performance
views.*

and an easel, as well as large animal heads worn from time to
time by the two performers (Jonas and Ragani Haas), and with
a soundscape of traffic noises, falling trees, and recorded frag-
ments of Dante's text read by Jonas and also by children, *Read-
ing Dante* represented Jonas's quotidian and highly personalized
rendering of her own eccentric "infernal paradise." Composed
and structured around film footage from several periods of her
life—1970s New York, the Canadian woods where she spends
summers, a ruin surrounding a lava field in Mexico City that
she visited with an artist friend, a shadow play conducted dur-
ing a workshop in a church in Italy—*Reading Dante* further il-
lustrated Jonas's sophisticated and highly visceral approach to
technology, philosophy, daily life, and live performance, and her
blending of mediums and meanings in the process.

—*RoseLee Goldberg*

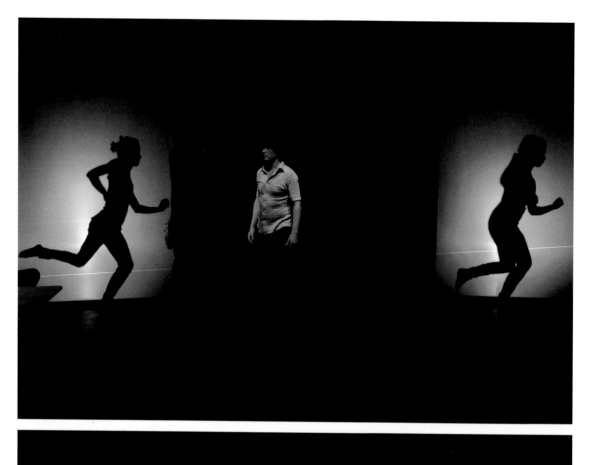

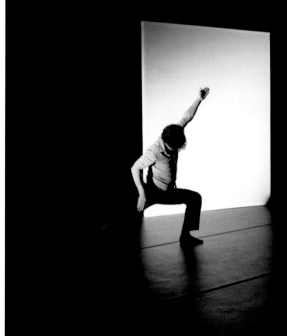

HISTORY IN THE MAKING,
OR THE SECRET DIARIES OF LINDA SCHULTZ
KEREN CYTTER

A PERFORMA
PREMIERE

PRESENTED
BY THE KITCHEN
AND PERFORMA

COMMISSIONED BY
IF I CAN'T DANCE,
I DON'T WANT TO
BE PART OF YOUR
REVOLUTION

CO-PRODUCED
BY HEBBEL
AM UFER, IF I
CAN'T DANCE...,
PERFORMA, AND
THE TATE MODERN

Keren Cytter, History
in the Making, or
The Secret Diaries of
Linda Schultz, *2009.
Performance views.
Photos by Paula Court.*

In her first live piece, Keren Cytter chose to throw nearly every performance-based medium—drama, dance, live video, spoken word, musical theater—into a fractured and disjunctive mix alongside what she calls her own "kitchen sink existentialism." As in her video and film work, linear narratives and causal relationships fell by the wayside, as actors shifted or exchanged roles, flubbed their lines, and stepped in and out of character; scenes were repeated with subtly proliferating mutations, with beginnings becoming endings and endings becoming midpoints. Working with her troupe Dance International Europe Now (or DIE Now), Cytter shuffled and genres (science fiction, melodrama, screwball comedy, political thriller) and performance forms (shadow plays, first-person confessional monologues, slo-mo action sequences, light projections, pantomime). At its core, *History in the Making* imagined a world in which, one day, everyone wakes up to find they have been transformed into a member of the opposite sex. The transformation spreads like a virus from outer space, a gender-bending *Invasion of the Body Snatchers.* But the work was also a fantasy of political and psychic revolution, in which fixed social roles come unmoored, and transmutation—of souls, identities, sexes, jobs, dreams, emotions—becomes the order of the day. —*James Trainor*

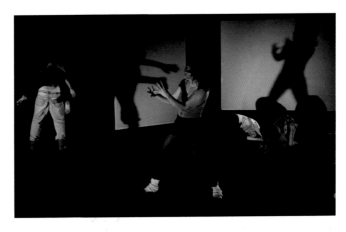

DESNIANSKY RAION

CYPRIEN GAILLARD AND KOUDLAM

THE KITCHEN

Cyprien Gaillard and Koudlam, Desniansky Raion, 2009. Performance views. Photos by Paula Court.

Dynamite explosions erasing the last remaining fragments of an elegant country estate, noisy American tourists having drinking contests at a historic Mayan site, a young man diving into a shallow lake before an abandoned postmodern tower block, and breaking his nose—these images of disintegration and disorder could be found in the collection of five short videos that French artist Cyprien Gaillard projected on a large screen as part of his one-night-only performance at The Kitchen. Gaillard's longtime collaborator, electronic musician and composer Koudlam (French slang for "knife stab"), stood to one side mixing fragments of electro, psychobilly, and tropical music with his signature vocal wailing. Taking architecture, and those forced to inhabit its grimmest designs, as both a metaphor for decay and a symbol for the disappearance of culture, Gaillard consciously navigates between the histories of art and of urbanism in his efforts to rehabilitate "the ruins" as a point of departure for his own creativity. The centerpiece of the evening was Gaillard's notorious twenty-nine-minute video *Desniansky Raion* (2007), a powerful triptych featuring a battle between hooligans in a Russian suburb; a spectacular lightshow and the subsequent demolition of a tower block near Paris; and a ring of Ukrainian projects reminiscent of a much more monumental Stonehenge. The warehouse-style architecture of The Kitchen lent Gaillard and Koudlam's joint composition, performed in New York for the first time, another layer of raw urbanity.

—*Virginie Bobin*

BRODY CONDON
WITHOUT SUN AND CASE

WITHOUT
SUN

THE MUSEUM OF
MODERN ART

CASE

THE NEW MUSEUM

COMMISSIONED
AND PRESENTED
BY RHIZOME AT
THE NEW MUSEUM

ADDITIONAL
SUPPORT
PROVIDED BY
THE PERFORMA
COMMISSIONING
FUND

Brody Condon,
Without Sun, *2009.*
Video still. Courtesy
the artist.

Without Sun:

Presented as part of MoMA's Modern Mondays series, which showcases experimental work by cutting-edge contemporary filmmakers and moving-image artists, Brody Condon's *Without Sun* comprised two fifteen-minute sections: a video screening immediately followed by a live performance. In the video, an edited compilation of YouTube footage, young men and women documented their psychedelic trips, while in the performance, actor Russell Edge and dancer Linda Austen reenacted the scenes from the video on a small stage in front of the blank screen.

Condon's work stems from his fascination with community subcultures, art history, and participatory fantasy games of all kind—including the curious live events that take place on the Live Action Role Playing (LARPing) scene, which he documents and uses as source material. In *Without Sun*, Condon reversed his usual process: The "found performances" became a template for a live performance. Condon titled his piece after Chris Marker's personal-essay film *Sans Soleil* (1983), with its themes of memory, technology, and travel, and its connections to the video/performance's subject matter of mind and body control. Deceptively simple in form, *Without Sun* probed the mysteries of the subconscious on a hallucinogenic journey. The video provided a disturbing narrative all its own, while the re-performance of the video parsed and de-emotionalized the actual experiences, reaching for a deeper understanding of the representation of reality in video documentation, and of the viewers' voyeuristic complicity. —*Sally Berger*

Case:

William Gibson's 1984 novel *Neuromancer*, considered a classic of the "cyberpunk" literary genre, tells the story of Case, a fallen super-hacker whose glory days have long since ended, leaving him in a drug-addled state that lifts when a mysterious entity offers him a second chance. Kaleidoscopic and

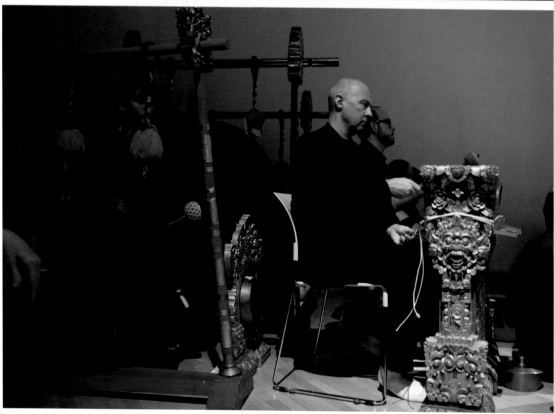

prescient, the novel wrestles with virtual reality, artificial intelligence, and a rapidly globalizing world through the intricacies of Case's story.

As a boy, artist Brody Condon was given a copy of *Neuromancer* by his stepfather, Midwestern activist and hell-raiser Ray "Bad Rad" Radtke. Thus *Case* began with a series of interviews with Radtke, which Condon mixed with text from the book to form a preliminary script. Premiering as a six-hour performance installation in the basement theater of the New Museum, *Case* comprised a series of scenes from the novel—performed by a cast that included Radtke, notorious porn star Sasha Grey, and legendary sound artist Tony Conrad—interspersed with comments from Radtke about "a life lived on the fringes of society." The performance was presented in the style of a rehearsal: audience members came and went throughout the afternoon; the set was a landscape of sculptural, movable props; and the actors read their lines from printed scripts in a deadpan tone (occasionally accompanied by a twenty-piece Indonesian gamelan ensemble, the Dharma Swara). With its wide range of references—including Bauhaus master Oskar Schlemmer's 1920s performances using sculptural objects as props, which Condon sees as "a key moment in twentieth-century techno-fetishist art"—*Case* constituted an investigation into the ways in which we see and feel time and space, and a continuation of his inquiry into the over-identification with fantasy in contemporary culture.

—*Lauren Cornell*

Brody Condon, Case, *2009. Performance stills. Photos by Paula Court.*

THE GOOD LIFE
MICHEL AUDER

EMILY HARVEY
FOUNDATION

CURATED BY
LIUTAURAS
PSIBILSKIS

*Video stills from
Michel Auder's* The
Good Life, *2009.
Courtesy the artist.*

Since he first began recording video in 1969, Michel Auder has amassed a vast collection of footage. A video art pioneer and longtime member of the New York art scene, he has shot thousands of hours of video throughout the city and around the world, creating work spanning the entire development of consumer video formats, from black-and-white reel-to-reel tape to full-color high-definition digital files. Often acting as a voyeur, Auder takes images from a variety of real-life situations and later, sometimes many years later, assembles them into artworks.

In 1979 Auder had spent several days in Amsterdam at an international gathering of poets—including Kathy Acker, William Burroughs, John Cooper Clarke, Ira Cohen, Gregory Corso, Jean Jacques Lebel, Michael McClure, Ron Padgett, and Adriano Spatola—observing and recording their reading/performances, many of which were fiery and dramatic, with the poets taking strong political stances and sometimes even seeming to improvise. To make *The Good Life*, which premiered at the Emily Harvey Foundation, Auder edited his footage into two channels and set up side-by-side projections, lending the video a remarkable presence—as though the two projections were themselves performing a raw, forceful poetry reading for the audience.

—*Liutauras Psibilskis*

THE NEW MUSEUM

Sung Hwan Kim, One from In the room, 2009. Rehearsal still. Photo taken by Insung Kang under Sung Hwan Kim's direction. Courtesy Sung Hwan Kim and Wilkinson Gallery.

ONE FROM IN THE ROOM
SUNG HWAN KIM

One from In the room was the latest iteration of Sung Hwan Kim's ongoing In the room series (2006), which he began developing in Korea (where he grew up) and the Netherlands (where he went to school) to explore how one form of storytelling can be transformed into another by juxtaposing cultures, genres, genders, and generations. In the room recalls the work of Kim's mentor Joan Jonas in its combination of video projections, music, text drawn from a range of sources, and live performance.

Kim has said, "I thought of a room as a box, from which a story vibrates." One from In the room tells some of the same tales as In the room 3 (dog I knew) (2007)—brief anecdotes mixing absurdist humor with ghost stories. One was of a woman who had an ear on top of her head, which she had to plug when it rained; another was inspired by Kim's childhood memory of electricity shut-downs in his village, rumored to be instigated by an affair between the president and a famous actress who lived there. In the dimly lit basement theater of the New Museum, Kim repeated these stories in a hushed monotone, occasionally illustrating his narrative with surreal, childlike drawings that were projected on a screen behind him.

A haunting score performed live by Kim's regular collaborator dogr (David Michael DiGregorio)—thickly layered harmonies of voice, samples, and various instruments—interwove with Kim's soft-spoken storytelling. At one point, the lyrics dogr was singing were picked up by Kim to become the words of one of his characters; at another moment, the music overwhelmed Kim's spoken text, turning his story into song. A third performer, former Korean pop star Byungjun Kwon, moved through Kim's delicate set installation like a phantom, at one point grabbing an acoustic guitar to sing a ballad before vanishing into the darkness. Stitching together many vignettes with music, pictures, and movement, One from In the room painted a portrait of a creative mind quietly contemplating our fragmented, fantastical universe. —Travis Chamberlain

INNOCENCE IN EXTREMIS
AMY GRANAT

At the Emily Harvey Foundation, a second-floor space on Broadway in SoHo, the windows are typically shut tight against street noise. But for *Innocence in Extremis*, a performance created by filmmaker, photographer, and projection artist Amy Granat in collaboration with dancers Felicia Ballos and Flora Wiegmann and guitarist Lanny Jordan Jackson, the windows were thrown wide open to admit the rhythmic sounds of traffic. While four video projectors flashed white light mixed with 16-mm film footage of skiers and skaters inscribing geometric patterns in snow and ice, Ballos and Wiegmann performed slow, controlled movements in unison, with Jackson adding a haunting guitar solo. By introducing a layer of pulsating, immersive sound to her flickering cinematic environments, Granat amplified her exploration of the experiential richness of everyday urban life. —*Liutauras Psibilskis*

EMILY HARVEY
FOUNDATION

CURATED BY
LIUTAURAS
PSIBILSKIS

Amy Granat in collaboration with dancers Felicia Ballos and Flora Wiegmann, Innocence in Extremis, 2009. Performance still. Photo by Liutauras Psibilskis.

POSTGRAVITY ART :: SYNTAPIENS
DRAGAN ŽIVADINOV, DUNJA ZUPANČIČ,
AND MIHA TURŠIČ

EYEBEAM ART +
TECHNOLOGY
CENTER

Dragan Živadinov,
Dunja Zupančič,
and Miha Turšič,
Postgravity Art ::
Syntapiens, *2009.*
Performance still. Photo
by Christine A. Butler.
Courtesy Eyebeam Art
+ Technology Center.

For the Slovenian collective Dragan Živadinov, Dunja Zupančič, and Miha Turšič, "postgravity art" will be produced in the future, in space, in zero-gravity environments. In *Noordung 1995–2045*, the artists imagine a journey into space and the artwork that they will produce en route, to be transmitted to earth via satellite. Their performance at Eyebeam—which took place for fifty consecutive hours amid a complex audiovisual setup—introduced their research on postgravity art, which they pinpoint as originating with Russian Constructivists Kazimir Malevich and Edvard Stepančič and Austro-Hungarian cosmonautic pioneer Herman Potočnik. Five performers in matching cosmonaut uniforms presented projections, lectures, movement, and hourly "informances" describing *Noordung*, many of which were streamed live across the globe. —*RoseLee Goldberg*

PERFORMING THE WEB

JODI AND JEFF CROUSE AND AARON MEYERS

How can social media, typically used by people sitting alone at their computers, become a source for truly shared experience? In *Performing the Web*, three leading "net artists" convened for a lively evening spent examining this question.

JODI, the Netherlands-based duo of artists Joan Heemskerk and Dirk Paesmans, performed *The Folksomy Project*, a deconstruction of YouTube. Paesmans mixed YouTube samples live while Heemskerk uploaded video "fan mail" and audience members added their own clips via webcams. Meanwhile, Eyebeam Fellows Jeff Crouse and Aaron Meyers staged an episode of their popular game show *The World Series of 'Tubing*, a cross between Pokémon and a poker tournament. Competitors "played" with real playing cards on which a webcam and visual-recognition software superimposed a YouTube clip, the total effect visible to the audience via a large projection screen. —*Paul Amitai*

EYEBEAM ART +
TECHNOLOGY
CENTER

Jeff and Aaron Meyers,
The World Series
of 'Tubing, *2009.*
Performance still. Photo
by Christine A. Butler.
Courtesy Eyebeam Art
+ Technology Center.

ERRATIC ANTHROPOLOGIES
GUY BENFIELD, SHANA MOULTON, AND
RANCOURT/YATSUK

ART IN
GENERAL

Drawing on sources ranging from hippie communes to suburban tract houses, the three performances that accompanied the exhibition *Erratic Anthropologies* portrayed "alternative" individuals in order to explore the psychology of contemporary American society.

The performances were presented in a consecutive set on two occasions. The evenings began in Art in General's back gallery with Shana Moulton's *The Undiscovered Antique*, which centered around hypochondriac suburban dweller Cynthia's pilgrimage to the American Southwest to determine the "antique" value of her household decorations, and her discovery that they are mass-produced consumer products. In a stream-of-consciousness remix of this narrative, the artist projected a colorful video featuring cut-and-paste-style animations in front of which she performed posture exercise–inspired dances and a confessional acceptance speech in a hooded white cotton robe. Then, in the front gallery, the art duo Rancourt/Yatsuk (Justin Rancourt and Chuck Yatsuk) presented a DIY version of a model Florida-swampland home and yard; realtor "Don Donavucci," wearing an absurd pharaoh headdress, aviator sunglasses, and gold cape, and accompanied by machete-wielding sidekick "Brady," burst onto the scene to describe the features of this real estate and take visitors, two at a time, on a tour of their extravagant unfinished construction. Finally, Guy Benfield, at ground level in the darkened storefront space, created an intimate "psychedelic funk" environment for groups of four or five. Throbbing electronic music, colored lights, and the haze of a fog machine set the atmosphere. Over the course of an hour, Benfield shuttled ceramic pots and vases in and out of a polyhedral "kiln," scrolled through archival images of commune culture on several monitors, and at the climax of the performance, clumsily stuffed himself into the kiln, struggling until he broke through the back to reveal a bright white light that cut through the disco ambience. —*Nina Horisaki-Christens*

PSEUDO-FUTURIST VIDEO GAME IMPROVISATION EXTRAVAGANZA
EVA AND FRANCO MATTES AKA 0100101110101101.ORG

SECOND LIFE
AND THE
PERFORMA HUB

*Eva and Franco
Mattes, aka
0100101110101101.org,
Pseudo-Futurist Video
Game Improvisation
Extravaganza, 2009.
Performance stills.
Courtesy the artists.*

You didn't need to be in New York to attend Eva and Franco Mattes's *Pseudo-Futurist Video Game Improvisation Extravaganza,* because it was set in an artist-run space in Second Life, an online virtual world that anybody can enter via an avatar. When I logged in from Italy, the Matteses were performing a piece called *Medication Valse,* named after (and accompanied by) Jack Nitzsche's oppressively demure orchestral theme for *One Flew Over the Cuckoo's Nest* (1975). The Matteses' avatars looked just like them—young and good-looking. Franco was sitting, naked, in an office chair, his body controlled by a computer script that made him slowly twist with the music. His figure soon floated free from the chair; he then embarked on a trippy airborne duet with Eva (also naked), their bodies intersecting—a hand reaching through Eva's back, an ankle sliding through Franco's thigh—as the "camera" spun around them. The Matteses were simultaneously performing, recording (the documentation was immediately posted on YouTube), and communicating with the audience in real-time chats. After *Medication Valse* and a short *entr'acte* came the closing performance, a bizarre "bed-in": the audience could join the naked artists and perform, all together, any imaginable sexual position.

The event lasted about forty minutes, and was projected live onto a screen at the Performa Hub. Toward the end, members of the Second Life audience started spontaneously creating objects, activating special computer scripts, and improvising performances of all kinds in an uncontrolled, Dada-like atmosphere. The "pseudo-Futurist" extravaganza had turned into a truly Futurist night. The Matteses have restaged seminal performances from the 1960s and '70s in the form of video games and online performances, but here they went even further back, to the roots of experimental performance: the early-twentieth-century avant-garde. Even more than performing, what Eva and Franco Mattes do online is test out heretofore unknown ways of living—and isn't that what the avant-gardes were doing, after all? —*Domenico Quaranta*

THE ART OF NOISES

MUSIC, RADIO, SOUND

"In the nineteenth century, with the invention of the machine, Noise was born," wrote Luigi Russolo in his famous 1913 manifesto "The Art of Noises." The exploration of noise as a phenomenon unto itself was one of the Futurists' most radical propositions, and one that Performa 09 fully embraced. Aside from reconstructing the iconic *intonarumori* (or "noise machines"—see page 72), the biennial also presented a festival of noise music, a radio program, sound installations, band concerts, and an opera singer under hypnosis. All this in the midst of the cacophony of New York City, whose ongoing sound track provided a backdrop of sirens, automobiles, machinery, and crowd noises.

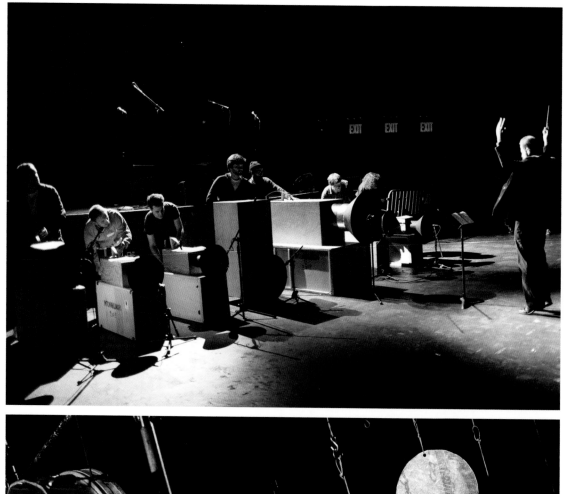

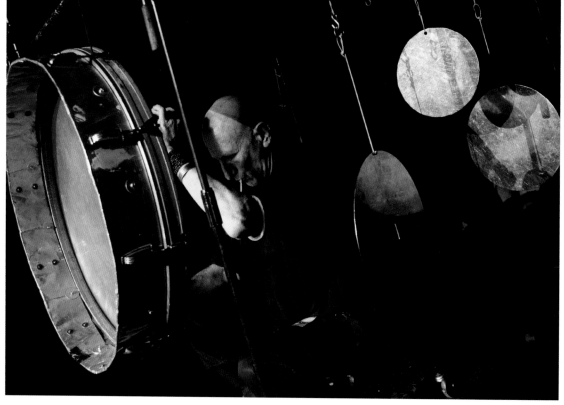

A FANTASTIC WORLD SUPERIMPOSED ON REALITY: A SELECT HISTORY OF EXPERIMENTAL MUSIC AND NOT FOR SALE: NOISE PANEL

THE GRAMERCY
THEATER

PRESENTED AND
PRODUCED BY
PERFORMA

CURATED BY MIKE
KELLEY AND MARK
BEASLEY

A Fantastic World
Superimposed
on Reality, *2009.*
Performance views.

*Top: Luciano
Chessa conducting*
Risveglio di una città
*(Awakening of a city,
1913).*

*Bottom: Z'EV. All
photos this section by
Paula Court.*

From Futurism and the classical avant-garde of the '20s, through Fluxus and the Los Angeles Free Music Society of the '60s and '70s, to the downtown New York No Wave scene of the '80s, the two-day festival *A Fantastic World Superimposed on Reality* showcased the trajectory of experimental music in the twentieth century. Curated by visual artist Mike Kelley—who grew up on the Detroit music scene of the '60s and '70s, which spawned bands like Iggy and the Stooges and MC5—and Performa curator Mark Beasley, *A Fantastic World* presented over twenty live performances at New York's iconic Gramercy Theater by artists who began using experimental sound art forms long before "noise music" became a recognized category. In this way, *A Fantastic World* revealed the historical DNA of what was once an improper kind of sound evolving into a respected musical subgenre—a proper improper form.

The festival kicked off its first night with a rendition of Luigi Russolo's *intonarumori* score *Risveglio di una città* (Awakening of a city, 1913), then leapt forward in time to present two classic works—minimalist composer Steve Reich's *Pendulum Music* (1968), an assault of feedback created by microphones and speakers; and an intuitive ensemble score by Karlheinz Stockhausen called *IT* (1968). *Stick Figures* (1987), Fred Frith's score for treated guitars, rounded out the minimalism for the evening. A series of lively improvised works included a saxophone solo by avant-garde composer John Zorn; a trio selected by Sonic Youth's Thurston Moore, with Moore on guitar, Ryan Sawyer on drums, and free jazz saxophonist Daniel Carter; and American poet and musician Z'EV, an industrial music pioneer, who performed an improvised percussion set in the center of the concert-hall floor. Arto Lindsay, one of New Wave's key improvisational guitarists and a longtime champion of Brazilian music, performed a short set fusing the vibrant chaos of electric guitar with the haunting melancholy of his singing. The voice was also key to Jad Fair, founder of the lo-fi alternative band

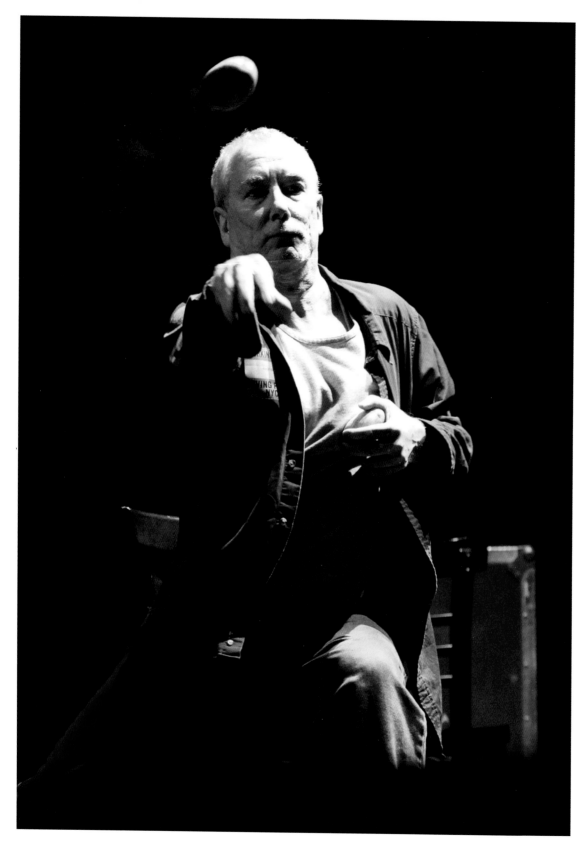

Jad Fair with Lumberob

Christian Marclay and Shelley Hirsch

Thurston Moore and Ryan Sawyer

Arto Lindsay

Tony Conrad

Tom Chiu performing George Brecht

John Zorn

Daniel Carter

Dana Lyn performing Bruce Nauman

Above: A Fantastic World
Superimposed on Reality, *2009.*
Performance views.

*Opposite: Mike Kelley performing
Rodney Graham's* Lobbing
Potatoes at a Gong *(1969)
as part of* A Fantastic World
Superimposed on Reality, *2009.*

Half Japanese, who brought down the house, accompanied by the musician/athlete/human beat box Lumberob. A moment of deadpan satire came with visual artist and musician Rodney Graham's *Lobbing Potatoes at a Gong*, a self-explanatory action performed by Kelley and dated "1969" in the program, as a joking comment on the festival's historical format.

The last act to take the stage was Thee Majesty, an expanded poetry project combining the sung and spoken lyrics of Genesis Breyer P-Orridge (the former leader of experimental British group Throbbing Gristle) with the music of artist and singer Bryin Dall on guitar and Morrison Edley on percussion. The evening closed with a presentation of Rhys Chattham's relentless and room-clearing epic *Two Gongs* (1971), in which the instruments are methodically banged at various dynamics for sixty minutes.

On the following night, Max Neuhaus's seminal acoustic

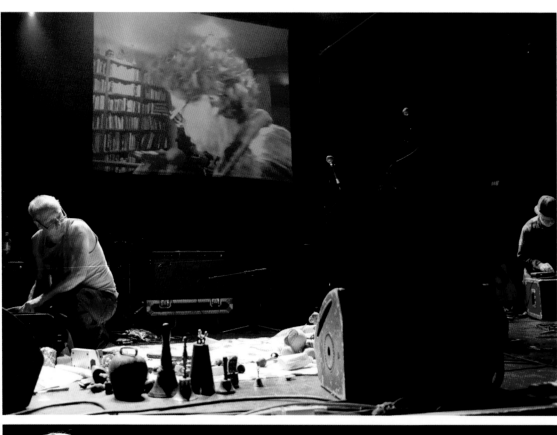

feedback composition *Fontana Mix Feed—John Cage* (1965), a piece using contact mics and kettle drums that laid the foundation for the feedback-heavy sound that developed in late-'60s rock and roll, was followed by two key works of the Fluxus movement showing how those artists rethought the aural qualities of everyday domestic objects, Alison Knowles's *Nivea Cream Piece* (1962) and George Brecht's *Solo for Violin* (1962), in which the instrument is simply polished with oil. Another violin performance was given by Tony Conrad, whose improvised piece recalled his seminal drone work *Four Violins* (1964) through its highly amplified strings; two major female vocalists then took the stage with Joan La Barbara's *October Music: Star Showers and Extraterrestrials* (1980) followed by singer Shelley Hirsch performing with Christian Marclay on turntables. An unnerving conceptual score, John Duncan's *The Grateful*, threw the theater into darkness while audience plants began emitting a carefully orchestrated series of screams. Finally, two highly influential groups rounded out the evening: an improvised set by Airway, a seven-person ensemble (led by Le Forte Four member Joe Potts) that was part of the Los Angeles Free Music Society in the early '70s; and members of the influential Detroit band Destroy All Monsters—Kelley, Cary Loren, and Jim Shaw (live via Internet broadcast)—giving their first New York presentation using psychedelic guitar, improvised vocals, and a modified toy orchestra. *A Fantastic World* closed with a restaging of Bruce Nauman's *Violin tuned D.E.A.D.* (1968), in which three musical notes—D, E, and A—are played simultaneously on a violin, over and over again, in brusque strokes that ironically translate death into the most simple beautiful sound.

—*Mark Beasley*

A Fantastic World Superimposed on Reality, *2009. Performance views.*

Top: Destroy All Monsters. Bottom: Alison Knowles's Nivea Cream Piece *(1962) as reconstructed by Alex Waterman.*

Not For Sale: Noise Panel, *which took place at Artists Space over the same weekend, featured artist and musician Tony Conrad; Professor of Modern and Contemporary Art at Columbia University and author of* Beyond the Dream Syndicate *Branden W. Joseph; composer, musician, and author of* A Power Stronger Than Itself: The AACM and American Experimental Music *George Lewis; and Performacommisioned artist, musician, and experimental composer Arto Lindsay in a conversation moderated by Mark Beasley.*

Interview

MIKE KELLEY AND LEE RANALDO

MODERATED BY MARK BEASLEY

MARK BEASLEY (MB): In 1977 the composer and writer R. Murray Schafer described "noise" as any unwanted or unmusical sound. What do the terms "noise" and "experimental music" mean to both of you?

MIKE KELLEY (MK): I've always thought of experimental music as music where the outcome isn't predetermined. Like in a scientific experiment when you have an idea about something and then you see if that idea plays out in practice, but you don't really know what's going to happen. Whereas noise, traditionally, would be something outside of music, a sound that's considered unpleasant. And it's also generally considered transgressive.

LEE RANALDO (LR): The term "noise" is a funny one, because when Sonic Youth was first getting started in 1980 and '81, club owners were using the word in a derogatory sense to describe the downtown scene. One club owner was quoted in the *SoHo Weekly News* as complaining, "You

know, that downtown scene is all just noise." I would say that "noise" is not really a very effective descriptive term when applied to music. Maybe it means something more dissonant, or unpleasant, or un-harmonic . . . but if you take as your basis that music is all about various textures and how they're structurally arranged, noise is just another element that one can use.

MB: So Mike, how did you first become interested in this kind of music? On the *Noise Panel* at Artists Space, didn't you say that you weren't allowed to take vocal classes in Catholic school because they thought you had a bad voice?

MK: Yes, they wouldn't let me sing—even in the classroom. There were no music classes, so occasionally students would sing religious or folk songs in a regular class, but I wasn't allowed to sing because I did not have a "harmonious voice." And then later, when I switched to public school in ninth grade, I wanted to take music but wasn't allowed to because I

didn't have any background in it. And it was the same when I went to CalArts to attend graduate school. I wanted to study with Morton Subotnick, but because I had no music training, I wasn't allowed to take music theory courses. So basically, my whole life, whenever I've tried to get involved in music, I've been institutionally denied.

LR: It's a Catch-22: you have to be trained before you can study music, and you have to study music before you can be trained. That's why one might turn to experimental music—because you don't need any qualifications, really. Anyone with an idea is in.

MB: So how did you first become interested in these kinds of music?

LR: I was exposed to a lot of music at home. My mother was a pianist, and I sang in choruses all through grade school and high school and played guitar and piano. But when I started to get serious about the idea of making music myself, it was separate. I was more inspired by what was coming out of the radio: first AM radio pop music, and later rock and roll music. Yet even at that time there were certain formal codes and structures to making rock music, which—in my limited capacity as a player—I was unable to hit. So I was forced to branch out to try to create my own language.

MB: Do you think there was a generational discord, or moment, when the meaning of "noise" changed?

MK: Well, I think that in the beginning, electric rock music was considered noise music because of the volume and the distortion; the whole point of electric rock was to be noisy, so there was a generational split right there.

LR: That's true. All amplified music was once seen as transgressive by a large section of society, especially as it got louder and weirder. "If it's too loud, you're too old!"

MK: Exactly. Then things started to go in a more psychedelic direction. And once you hear someone like Jimi Hendrix, with all of the feedback and distortion, it's not a big leap to start playing the electronics themselves. For anyone who grew up in an industrial area, these sounds were already very common; for me, coming out of Detroit, it was natural to go in that direction.

LR: A lot of people have talked about noise music being heavily influenced by environment, saying that of course noise came up in New York and Tokyo because those are big loud cities with lots of noise everywhere, and it's true. There are times when I walk around New York, and if there's a lot of construction

going on—with the sounds of pile drivers and whatnot echoing off the buildings—you start to hear these amazing rhythm tracks.

MK: Definitely. William Burroughs's tape experiments were very influential on me because they started with recordings of environments. To him, sound was a kind of weapon.

MB: The art historian and theorist Branden Joseph has written about the political dimension of noise—for example, some have argued that noise control guidelines have been abused to control African American neighborhoods like Harlem and Brownsville, to prevent more housing developments from being built—the idea being that noise is this scary force to white middle-class people in urban areas. Living in Detroit, Mike, did you feel that noise was used politically in any way?

MK: Not politically in a conscious way. In poor areas, loud motorcycles, cars, and boom boxes are statements of identity—they function as a kind of audio graffiti. Similarly, raucous popular music generally functions as the voice of disenfranchised people—including youth.

MB: What were the politics of Destroy All Monsters?

MK: We developed out a specific late-'60s Detroit music scene where noise—loud rock music—was used in a confrontational manner and linked to the politics of the New Left. Concerts organized by the anarchist White Panther Party mixed populist rock and experimental music in an attempt to radicalize local youth. But that scene died at the end of the decade with the collapse of the local economy.

Destroy All Monsters addressed the failure of that utopian dream by doing a more nihilistic version of it. We were very exploratory— we didn't have "one sound." I lived in a house with jazz and rock musicians, and often our recordings were jam sessions with very different kinds of players, just exploring sounds without any particular focus.

MB: And Lee, what politics do you think were informing Sonic Youth?

LR: Well, I'm actually thinking pre–Sonic Youth, when I was a teenager starting to play rock music. At that time the socio-political element was basically that you didn't like your parents' music. Young people were looking for more challenging stuff to listen to. By the time I left high school, my interest in rock had changed into an interest in twentieth-century music of all sorts, from the Futurists through John Cage, Karlheinz Stockhausen, and Henry Cowell. There was also the influence of the later, more experimental tracks by the Beatles, for example, which pushed the boundaries of what the listening experience could be. I think young people wanted to feel like the field was wide open, so that you could do whatever you wanted.

MB: Then, to connect your and Mike's practices—I understand that Sonic Youth provided the sound track for Mike's piece *Plato's Cave, Rothko's Chapel, Lincoln's Profile* at Artists Space in 1986. How did that collaboration come about?

LR: I think Mike and Kim [Gordon] had become friends in LA. Mike was coming to New York to do this piece at Artists Space and asked us if we would work with him.

MK: That's right—I knew Kim in LA before she moved to New York. At that time she was not yet a musician; she was a visual artist. I watched the development of Sonic Youth, and I liked the music and I liked them as people. In that particular performance I wanted to have a live sound element modeled on kabuki theater, where there are musical sections that play off the language in a quite disjointed way. I also wanted to play with the idea of rock staging. A lot of the audience was there to see Sonic Youth specifically, because at that point they were a known band, so I had some parts where the band was really foregrounded and others where they were completely hidden— behind a curtain, for instance.

MB: Moving forward in time, would you say that noise could be described as a transgression that changes with each generation?

MK: Definitely. I'm hearing a lot of music now that's obviously a reaction against the noisiness of punk and post-punk—like psychfolk. That's a generational transgression.

LR: There's a whole category of what I call "noise-icians"—people who are dedicated to playing pure noise music—that started getting attention in the '90s with Japanese bands like Violent Onsen Geisha and Boredoms. So today there's a whole group of younger people for whom this is their background—it's like their Beatles. When Sonic Youth was developing, we were integrating pop structures with very abstract, or noisy, sounds, trying to figure out ways to meld them both. We were children of AM radio, and grew up listening to pop music, but also being exposed to all sorts of avant-garde movements like I was talking about earlier, so we didn't want to abandon one for the other.

These days there are so many young people who are specifically noise musicians that it almost puts them into a ghetto. It's become a genre, so for young people it's not transgressive anymore: you're just into it or you're not.

MK: Exactly. I was really surprised when I first went to Japan with Destroy All Monsters—we played in front of an auditorium packed with teenagers. They're so fascinated with obscurities there. To them noise music was like punk was for American kids—but they were mixing, like, John Cage with hardcore. It was all exotic music to them, outside of their culture, so they

didn't have the same inherited inhibitions about crossing these musical borders. I was so shocked by this, I found it hard to believe that noise music could be popular teen music.

LR: When Destroy All Monsters was around, did you feel like you guys existed in a kind of void? Now noise bands can go out and get tours all over, but then, it was either being part of the established music scene or nothing.

MK: Yeah, we couldn't even play in a club. They'd kick us out.

LR: Sure. It was the same thing when Sonic Youth was starting out—we had a hard time getting gigs because people didn't understand the music.

MB: Were you accepted by the art world? Could you play in galleries?

MK: No—we weren't accepted by the art world or the music world, so we operated in a kind of guerilla way. We would crash house parties and play there; or we'd play at loft parties for three or four people, after the rest had fled. We existed in more of a conceptual way, rather than as part of a scene. But that really changed with the rise of punk. When I moved to California, I tried to move into the punk scene with my band the Poetics, which included Tony Oursler and John Miller. Some of the musicians associated with the Los An-

geles Free Music Society (LAFMS) were attempting to do the same thing, but it was a very odd marriage. All of my attempts to fit into different music scenes didn't work. At a certain point, I lost interest and decided to do solo work that was specifically geared toward the performance art audience, keeping out of the music world entirely.

LR: I had a band in college called Black Lung Disease, a kind of psychedelic abstract music combo, that reminds me of what you're saying about Destroy All Monsters. You guys only played a few gigs the whole time you were around. I remember that we played a lot—but we didn't play for a lot of people. It was almost like we were alone in a laboratory experimenting, and the laboratory happened to be someone's living room, or wherever you could set up a drum kit. Only an incredibly tiny group of people—the players and a few friends—*ever* heard us. It wasn't a scene; it certainly wasn't a profession or a career.

Once it gets to the level of these noise bands today, touring all over and playing in clubs, it's hardly even experimental anymore. There's something very codified about it at that point: audiences coming to see it know exactly what it is. Maybe experimental music is something you're only afforded the opportunity to create—when you're trying stuff purely for your own edification, to see where it goes.

MB: Mike, it was an honor and an education

to work with you on the noise music festival. Could you tell us about creating *A Fantastic World Superimposed on Reality* for Performa 09?

MK: Sure. The noise festival was a dream come true. I had the opportunity to put together, on one bill, a selection of performers that I really admire. I kept it to a particular generation to provide focus, but I also wanted to include the kind of classical avant-garde pieces that influenced these people. So, it was a mix of musicians and artists primarily associated with the downtown New York scene of the late '60s and '70s along with improvisational and experimental musicians of the same generation from other locales—especially Los Angeles.

MB: And what about your take on the West Coast scene that you came out of?

MK: A good history of American improvisational music of Lee's and my generation has yet to be written. The West Coast scene, in particular, is poorly documented. There are many written histories of punk, but no one has written about the art band phenomenon. When I moved to Los Angeles in 1976 I became acquainted with the LAFMS—improvisational artist/musicians my age who were producing their own records. The West Coast was one of the most important centers for what has come to be known as "industrial"

music, with artists like Boyd Rice and John Duncan, and "synthpunk" groups like The Screamers. The Screamers were very popular in Los Angeles, but they refused to release studio recordings of their music. Few recordings exist of many of these groups. That's why I felt it was important to include groups like Airway in the festival. It was the first time, to my knowledge, that any LAFMS-related band had played in New York, and the first time that Destroy All Monsters played in New York.

MB: Which is incredible. Lee, what did you think of the festival?

LR: I performed [in the re-creation of Steve Reich's *Pendulum Music*] and watched everything on the first night. I loved the fact that it was drawing on a very specific time period because I think that if it had extended further, it would have moved into a place that was much better known to the crowd that was there. In a way, it was like Mike's diary of musical pieces from that period that had an influence on him, which I thought gave it this really nice sense of focus.

MB: Yes, it was woven together by Mike's personal narrative. And it was also provocative in suggesting that at a certain point, true "noise" ceased to be—it's something that future generations will have to define anew.

NUMMER ELF: THE KING'S GAMBIT ACCEPTED, THE NUMBER OF STARS IN THE SKY & WAITING FOR AN EARTHQUAKE

GUIDO VAN DER WERVE

MARSHALL
CHESS CLUB

PRESENTED BY
PERFORMA

CURATED BY
DEFNE AYAS WITH
MARK BEASLEY

Guido van der Werve, Nummer Elf: The King's Gambit Accepted, The Number of Stars in the Sky & Waiting for an Earthquake, *2009. Performance views. Photos by Paradise Gonzalez.*

Marcel Duchamp, Francis Picabia, and Man Ray are among the many artists who have been fascinated by the game of chess. For Dutch artist and filmmaker Guido van der Werve, who is also a trained pianist, it was the parallels between chess playing and musical composition that led him to create a film, a score, an instrument, and a live performance all inspired by the iconic game.

The parlor floor of the renowned Marshall Chess Club's elegant brownstone on West Tenth Street—a former haunt of Duchamp and Man Ray and once the stomping ground of world champion chess player Bobby Fischer—was the setting for van der Werve's three-part film *Nummer twaalf* (2009), which features the artist playing chess with grandmaster Leonid Yudasin while nine string players perform a score written by van der Werve. The Marshall Chess Club was also the venue for a live concert for Performa 09 featuring a strings ensemble plus van der Werve's own "chess piano"—a chessboard with its squares attached to strings, so that every time a piece is moved, a chord is struck on a mechanical piano—performing the composition from *Nummer twaalf.* With nine members of the Manhattan Chamber Orchestra arranged behind the table where the "opponent" (the artist's friend Benjamin Boil) was already seated at the chess piano, van der Werve entered the room and made his first "move" by pressing down a square on the board, which emitted a note to which the musicians tuned their instruments. As in any chess match, which has an opening, a middle, and an end game, van der Werve's composition was in three movements: "The King's Gambit Accepted," "The Number of Stars in the Sky," and "Waiting for an Earthquake." The game began with the King's Gambit, a popular opening move in chess for over three hundred years, called dangerous by some (including Fischer) for the mistakes that can come out of it. The concert concluded, fittingly, with a stalemate. —*Defne Ayas*

Alex Waterman, A Ballad
of Accounting 2009:
Composition for Cello
and Brooklyn Queens
Expressway, *2009. Production
still. Photo by Jason Schmidt.*

RIOT RADIO BALLAD

JAMES HOFF, KARIN SCHNEIDER AND MATTIN, NICK RELPH, AND ALEX WATERMAN

Riot Radio Ballad was a series of events over three days presenting the work of several visual artists who engage spoken-word, audio, and radio material.

Artist and musician James Hoff is a cofounder of nonprofit art publisher Primary Information and recently co-curated the traveling exhibition *Hungry For Death*, featuring material culled from the archive of avant-noise band Destroy All Monsters. In Hoff's installation at Artists Space, *How Wheeling Feels When the Ground Walks Away*, a soundscape assembled from recordings of historic riots, rowdy protests at concert halls and music venues, and modern warfare, twenty people at a time were admitted into a circle of speakers and enveloped in a tumultuous, relentless audio panorama.

Brazilian artist Karin Schneider, whose work playfully examines the functional status of art, and her collaborator, musician and Basque artist Mattin, who mostly works with noise and improvisation, issued a series of spoken commands to audience members as they filed into the main gallery at Artists Space: directives ranging from tapping on the walls to screaming abruptly. The noise level rose as more and more people arrived and participated. Writer Dan Fox, sitting at a table in the middle of the room, recorded the choreographed chaos, which was also aired live on AIR (Art International Radio). Following this stage of the event, British artist and filmmaker Nick Relph played a series of spoken-word vinyl records (by writers from W. H. Auden to Quentin Crisp) that three roller skaters used as a score, dancing to the

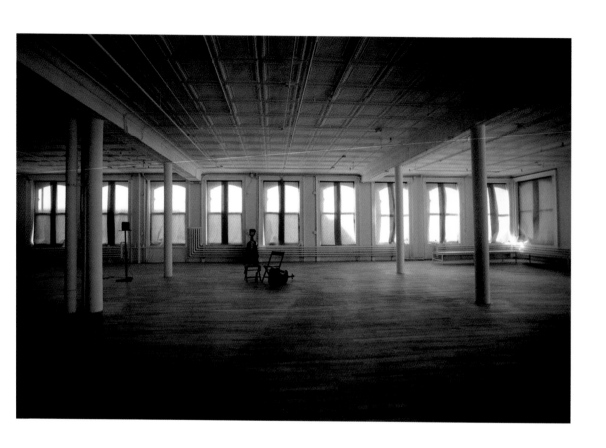

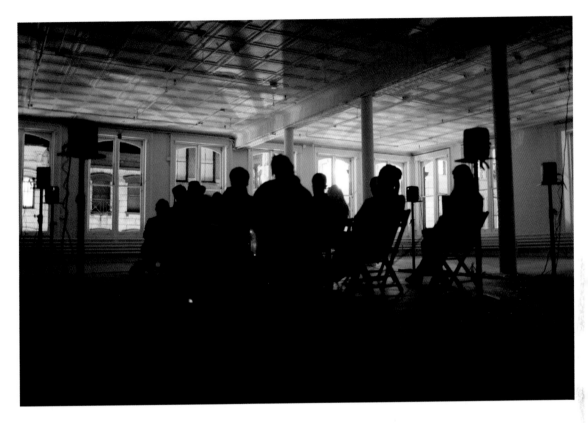

Above: James Hoff, How Wheeling
Feels When the Ground Walks
Away, *2009. Performance view.
Photo by Dale Jabagat.*

*Opposite: Setup for the performance
of Alex Waterman's* A Ballad of
Accounting 2009: Composition
for Cello and Brooklyn Queens
Expressway, *2009. Photo by Dale
Jabagat.*

cadence of the recorded voices. At the end of the evening, Mark
Beasley read Fox's descriptive and somewhat satiric text aloud.

New York–based musician, scholar, and composer Alex Wa-
terman performed a live cello recital accompanied by a 16-mm
film by Elizabeth Wendelbo that showed Waterman playing un-
der a concrete flyover ramp of the Brooklyn Queens Expressway
in Red Hook, Brooklyn, keeping time with the traffic as it swept
into Manhattan's downtown financial district.

—*Mark Beasley*

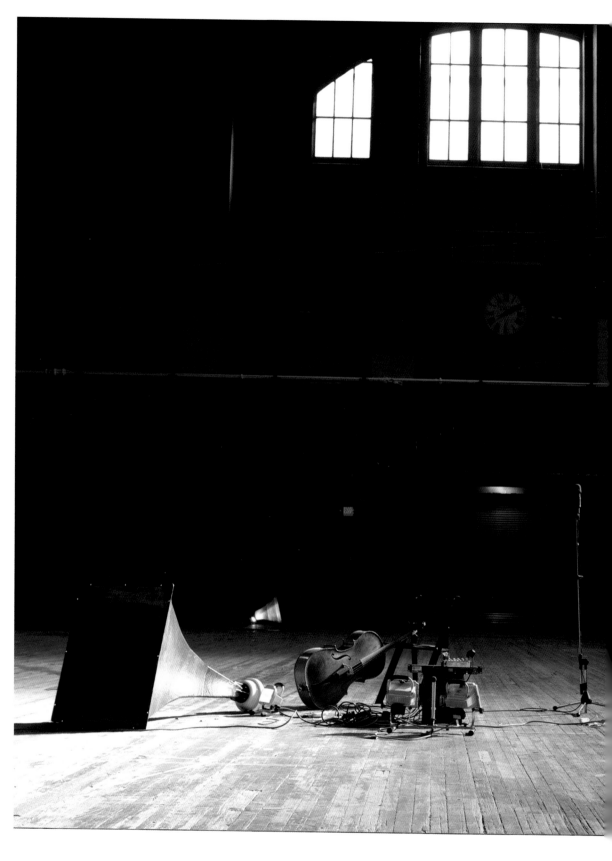

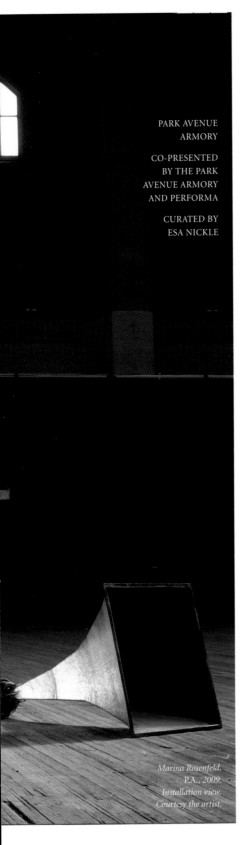

Marina Rosenfeld,
P.A., 2009.
Installation view.
Courtesy the artist.

P.A.

MARINA ROSENFELD

Walking into the cavernous drill hall of the Park Avenue Armory, the hundred-person crowd that had gathered to see Marina Rosenfeld's *P.A.* entered a mystifying, strangely gripping atmosphere. There was no central focus in the darkened space, but rather several small areas of light, where tiny lamps illuminated installations of large public-address speaker systems salvaged from sports arenas. The horns, pointed in different directions, projected a multilayered composition of electro-acoustic sound, fragmentary vocal utterances, and field recordings that Rosenfeld had made previously in the space, documenting the Armory's various functions over time (a military rehearsal space, an art-fair site, a homeless shelter). Each audience member had a unique experience of the piece, as the speakers were broadcasting sections of a larger score in different directions, and everyone moved through the space differently, while the Armory's particular architecture reflected and distorted the soundscape differently from every vantage. About twenty minutes after the audience was allowed in, Rosenfeld and cellist Okkyung Lee entered one of the lit areas near the center of the space and activated two final speakers. Rosenfeld then read from a compilation of quotations, mostly from films, in which characters "announce" themselves, and Lee accompanied her on cello, weaving the live performance into the pre-recorded soundscape. A crowd began to form around them, but the performance ended almost as soon as it began, and the crowd gradually dispersed again, wandering through the space and allowing the sound to unfold around them.

—*Esa Nickle*

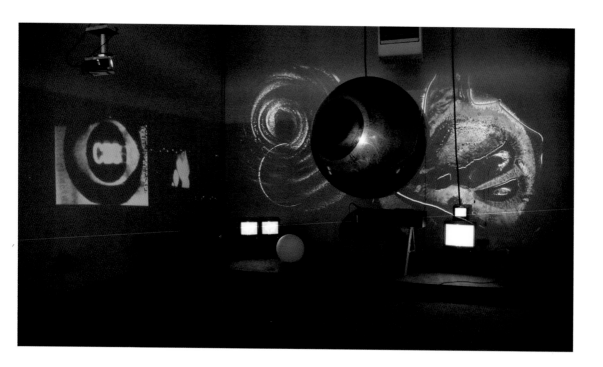

BLACK ZERO
ALDO TAMBELLINI

At a time when the art scene was made up mostly of white artists and their white followers and was centered on venues such as Andy Warhol's Factory, *Black Zero* (1965–68) brought a group of black poets, musicians, and intellectuals to the heart of the downtown art world, translating the energy and urgency of the Civil Rights movement into a night of experimental film, music, poetry, and politics. Masterminded by Italian American artist and filmmaker Aldo Tambellini, *Black Zero* was first performed in 1965 at the Astor Place Playhouse as part of the Film-Makers' Cinematheque's New Cinema Festival—a showcase for avant-garde films and performances that eventually grew into Anthology Film Archives. The sequence of events that night included activist Ben Morea and other members of Tambellini's "Group Center" collective making noise compositions with grinders and kitchenware, blasts of improvisation from jazz bassist Alan Silva and trumpeter Bill

WHITE BOX

CURATED BY
CHRISTOPH
DRAEGER

Above: Aldo Tambellini,
Black Zero, *2009.*
Installation view.
Courtesy Christoph
Draeger.

Opposite: Aldo
Tambellini in front of
his Black Zero, *2009.*
Performance view.
Courtesy Christoph
Draeger.

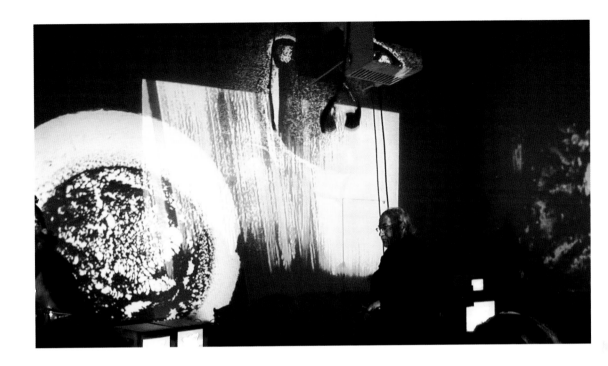

Dixon, live readings by poet Calvin C. Hernton (a member of the Lower East Side African American poetry group UMBRA), and Tambellini projecting his own black-and-white, chemically and mechanically assaulted films and slides onto a slowly inflating black weather balloon.

Ben Morea told me about *Black Zero* when I met him by chance outside a Manhattan thrift shop in 2008. The following year, I helped Tambellini re-create the performance, nearly half a century after its inception, for Performa 09. Assisted by Tambellini's partner Anna M. Salamone, the Performa evening once again included Morea making noise music, this time with power tools; bassists William Parker and Hill Greene; and Tambellini himself, now eighty years old, orchestrating the same black-and-white projections from so many years ago, using the original slides and projection equipment. After thirty-five minutes, Tambellini ended the celebratory evening when he took out his pocketknife and burst the overinflated weather balloon that had hung over the proceedings.

—*Christoph Draeger*

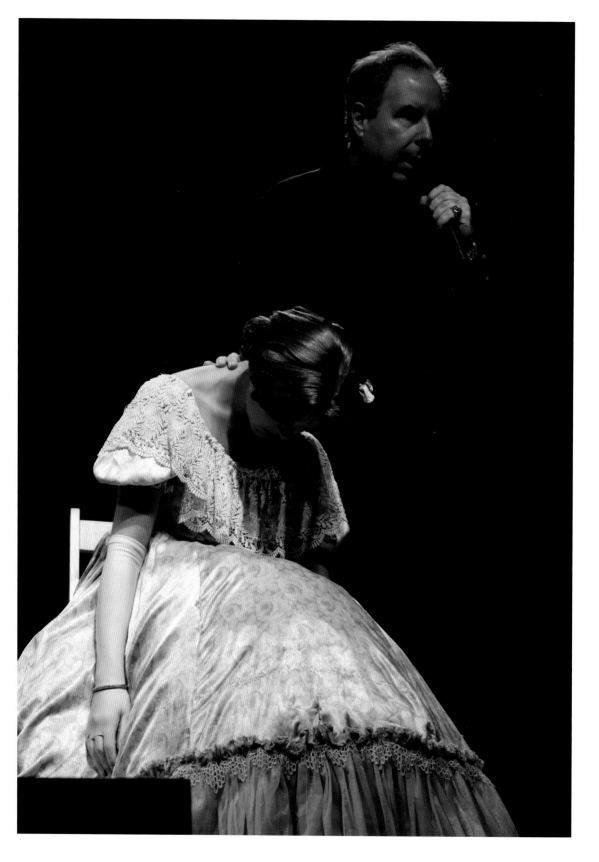

THE PERVASIVE ECHO
RUTH SACKS

BATTERY PARK

PRESENTED BY
THE MUSEUM FOR
AFRICAN ART

CURATED BY
LISA BINDER

*Above: Drawing of
Jenny Lind. Courtesy the
Museum of African Art.*

*Opposite: Ruth Sacks,
The Pervasive Echo,
2009. Performance view.
Photo by Paula Court.*

On the evening of November 2, at the entrance to Castle Clinton, near the water's edge on the southernmost tip of Lower Manhattan, an event that was part operatic concert and part hypnotist act took place on an outdoor stage. Hypnotist John Healerchi began by explaining the significance of the site: it was the exact spot where, in 1850, popular Swedish opera singer Jenny Lind had given her first performance in the United States. Healerchi then invited soprano Kathleen Berger onto the stage. Wearing a floor-length gown, very much like one that "the Swedish Nightingale," as Lind was known, might have worn 159 years earlier, Berger sat on a chair, and Healerchi, with one hand on the back of her neck, put her into a trance and prepared her to sing as Jenny Lind. Berger then rose and gave a compelling performance of Lind's signature song, the "Norwegian Echo Song," accompanied by Cathy Venable on piano. The hypnotist pulled Berger out of her trance during the applause.

My intention with this performance was to restage a Jenny Lind concert in such a way as to convey some of the complexities of Lind's persona and the media story that grew around her during her lifetime. She was usually portrayed as a shy, almost reluctant performer whose demure femininity stood in contrast to the robust qualities usually associated with female singers. Contemporary readings of Lind suggest that this seemingly passive stage persona was a facade created to serve the larger purpose of a successful stage artist whom the public would accept as being fully in keeping with the behavioral mores of women of the day. By using a hypnotist—a reference to the infamous Svengali of George Du Maurier's bestselling 1890 novel—I wanted to suggest that the methods used by the media in dictating the public persona of individuals is comparable to that of hypnosis. While a person undergoing hypnosis may appear to be entirely controlled by outside forces, the process could not have begun without the active complicity of the subject.

—Ruth Sacks

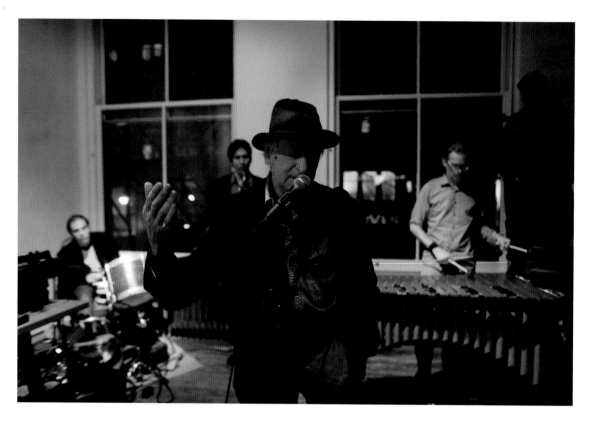

JONAS MEKAS AND NOW WE ARE HERE

Lithuanian-born underground-film legend Jonas Mekas's performance with the band Now We Are Here in a packed downtown loft had the energy and warmth of a cross-generational reunion. Mekas, who began his career in the city in the 1950s and is now in his late eighties, has a huge and enthusiastic following among twenty-somethings. The band opened the concert on its own, improvising on a wide range of instruments and mixing the buoyant sounds of free jazz with polyphonic ethnic rhythms. Mekas soon joined them, rapping his own spontaneous poetry about the pleasure of the particular moment and shouting liberation slogans in support of Palestinians, while extracts from some of Mekas's film diaries were projected on the wall. Mekas's powerful physical presence, and the potency of his words against the dense sound, made everyone in the room feel part of a celebration of the history and the future of art and culture in New York. —*Liutauras Psibilskis*

EMILY HARVEY
FOUNDATION

CURATED BY
LIUTAURAS
PSIBILSKIS

*Jonas Mekas and Now
We Are Here, 2009.
Performance view.
Photo by Paula Court.*

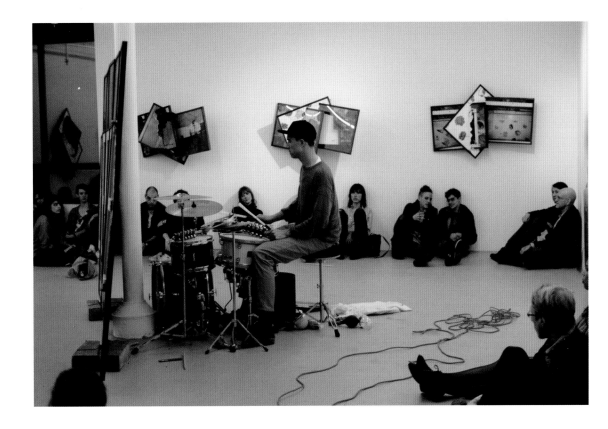

BRENDAN FOWLER

RENTAL

Brendan Fowler,
Brendan Fowler, *2009.*
Performance view.
Courtesy Rental.

On a Sunday afternoon, as part of Brendan Fowler's solo show of photographs, silkscreens, and sculptures at Rental gallery, the artist performed on the drums for five straight hours. He began by simply playing a drum set situated behind one of his sculptures, but gradually moved on to more aggressive actions, throwing pieces of the drum kit and its stool around the gallery, seemingly unaware of the people watching him. A public performance that also felt oddly private, it signaled Fowler's return to performance after a hiatus of several years during which he concentrated on his visual art, and also marked his reclaiming of his identity as a performer under his own name, rather than the stage name BARR, which he had previously used for his concerts and albums. His two practices, as musician and as visual artist, thus came together to share the space of the gallery. —*Joel Mesler*

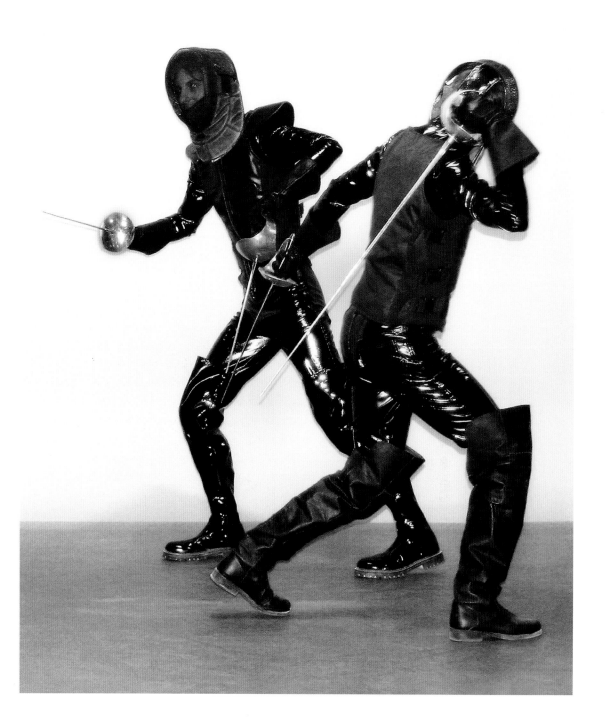

WHITE NOISE III: PANDORA'S SOUND BOX

WHITE BOX

CURATED BY
LARA PAN

*Michaël Aerts and
Vadim Vosters, Refence,
2009. Performance
view. Courtesy Michaël
Aerts.*

Performa's third installment of its sound art exhibition and performance series at Chelsea's White Box gallery, *White Noise III: Pandora's Sound Box* consisted of an exhibition in the main space, rotating installations in the WBX PROJECTS space, and two performances. The show's subtitle, inspired by Georg Wilhelm Pabst's 1929 film *Pandora's Box*, which explored the fear of female sexuality, referred to sound works addressing contemporary alarm about war, terrorism, and immigration. In Tanja Ostojic's *Misplaced Women*, performer Valentina Medda carried a large suitcase through the streets, frequently stopping to unpack and repack it, enacting the kind of everyday displacement experienced by transients, migrant workers, and disaster refugees against the aural backdrop of New York street noise—traffic, sirens, and voices—representing the city's obliviousness to the plight of this woman. Artists Michaël Aerts and Vadim Vosters's *Refence* featured a five-minute fencing tournament in which the performers, wearing glossy black leather and latex costumes, battled each other to a specially composed sound piece by DJ duo Jef Permans and Johan Vanoeckel. Works in the exhibition included Oswaldo Macia's sound installation *Darfur*, in which the sounds of two hundred barking dogs are heard on twelve channels, suggesting a world that refuses to listen to or act on the suffering of others, and Davide Bertocchi's video *Exhaust*, which compiles YouTube excerpts of the "sound tests" performed on automobile exhaust pipes, highlighting the pointless expense and pollution involved. Together the sound works explored the noise that permanently surrounds us in everyday life—a cacophony that we have trained ourselves to ignore.

—*Lara Pan*

Participating artists: Michaël Aerts and Vadim Vosters, Pierre Bismuth, Olaf Breuning, Diango Hernandez, Agnieszka Kurant, Matthieu Laurette, Robert Lazzarini, Oswaldo Macia, Tanja Ostojic, and Carlo Zanni.

AIR (ART INTERNATIONAL RADIO)

CLOCKTOWER
GALLERY

Listeners from all over the world can tune in to hear artist interviews, live performances, historical recordings, and experiments in sound and radio on AIR (Art International Radio), an arts and culture radio station available exclusively online. Since the first Performa biennial in 2005, AIR has been Performa's official radio partner, allowing the wealth of material produced during the Performa biennials to be experienced by the widest-possible audience. During Performa 09, more than forty radio programs—including rehearsals, performances, discussions, and interviews—were broadcast at ARTonAIR.org. Hosts and producers from AIR's staff joined Performa curators and artists at the Performa Hub, at the AIR studios in Manhattan's historic Clocktower Gallery, and all around town, in galleries, performance venues, and on the streets of New York.

The artists and projects included in this collection of programs ranged from satirical video artist Kalup Linzy to contemporary dance icon Meg Stuart, and from a visit to Performa's opening-night dinner to a stop for lunch at Marije Vogelzang's *Pasta Sauna.* Of course, sound and music events made for particularly compelling broadcasting. Mike Kelley's two-day "noise festival," *A Fantastic World Superimposed on Reality,* yielded wonderful performances and interviews with the seminal musicians participating, including Arto Lindsay, Joan La Barbara, and Genesis Breyer P-Orridge. Another program followed a walking tour through downtown New York in search of the diverse, notoriously loud sirens of ambulances and police cars. In yet another, music historian, composer, and Futurist expert Luciano Chessa demonstrated the workings of the hundred-year-old *intonarumori* and explained the historical relevance of these instruments during a rehearsal at the Clocktower. Recordings of these and many other Performa 09 radio programs can be found online at ARTonAIR.org.

—*David Weinstein*

TRAP
KABIR CARTER

BRONX
MUSEUM OF
THE ARTS

*Kabir Carter, Trap,
2009. Video still.
Courtesy the Bronx
Museum of the Arts.*

Trap, a sound installation by artist Kabir Carter, followed a panel discussion about the opposition of the idealistic Russian and dystopian Italian Futurist movements. Marjorie Perloff presented Velimir Khlebnikov's "Radio of the Future," an essay predicting radio's potential to disseminate news to the masses; Richard Sieburth discussed Ezra Pound's "Canto LXXII," a poem describing a fictitious meeting with Marinetti in radio hell; and poet Charles Bernstein performed a dramatic reading of sections of Marinetti's manifesto and Russian Futurist poems. Carter then positioned himself before an array of radio scanners, analog synthesizer modules, and audio mixers. Muffled voices, sirens, fuzzy static, and high-pitched beeps picked up by the scanners came together in a tangled whir, as Carter turned knobs and switched wires. As the composition reached a powerful crescendo, a phrase from "Radio of the Future," "a silver shower of sounds," perfectly described the moment. —*Jeanne Gerrity*

A version of this text originally appeared on Rhizome.org *on November 19, 2009.*

LUST IS A FORCE

THE LUST WEEKEND

Avant-garde dances, sensual songs, mysterious avatars, and intimate confessions: with *The Lust Weekend*, Performa paid tribute to Futurist poet and dancer Valentine de Saint-Point, author of the "Manifesto of Lust" (1913) and the only Futurist ever to perform in New York, with a packed program of events at University Settlement and a variety of galleries on the Lower East Side. Curated by Tairone Bastien and Virginie Bobin, *The Lust Weekend* activated an entire neighborhood: over the course of its two days, crowds could be seen wandering the streets from one event to another, finding femininity, in all its forms, around almost every corner.

ITALIAN
CULTURAL
INSTITUTE

CURATED BY
ADRIEN SINA

Opposite: Photo collage of Valentine de Saint-Point performing La Métachorie: Poems of War and Love, *Théâtre Léon-Poirier, Paris, 1913–14. Courtesy Adrien Sina Collection.*

Below: Original printing of Valentine de Saint-Point's "Futurist Manifesto of Lust," 1913. Courtesy Adrien Sina Collection.

Inspired by Valentine de Saint-Point, a radical and visionary figure of the Futurist Movement, *Feminine Futures* was a historical exhibition focused on early twentieth-century feminine and performance-based contributions to the European and American avant-gardes. Over 360 paper-based works were presented on two floors in thirty-two specially designed Plexiglas boxes and four showcases. This selection of rarely seen or previously unknown items included original photographs, handwritten letters, drawings, printed manifestos, first edition books, and ephemera. Through both imagery and text, these documents vividly underlined the fundamental role these experiments played in the birth of performance as a discipline, establishing for the first time the artist's body in a conceptual action as a work of art. Their presentation during Performa 09 was aimed at opening an entirely new perspective on Futurism.

The ground level was centered on French aristocrat Valentine de Saint-Point (1875–1953), the first and only female artist to be part of the "Direction du mouvement futuriste"—the executive board of the Futurist movement—and the only Futurist artist to perform in New York, at the Metropolitan Opera House in 1917. In her "Manifesto of the Futurist Woman" (1912) and "Futurist Manifesto of Lust" (1913), she theorized broadened territories

Manifeste futuriste
de la
Luxure

RÉPONSE aux journalistes improbes qui mutilent les phrases pour ridiculiser l'Idée;
à celles qui pensent ce que j'ai osé dire;
à ceux pour qui la Luxure n'est encore que péché;
à tous ceux qui n'atteignent dans la Luxure que le Vice, comme dans l'Orgueil que la Vanité.

La Luxure, conçue en dehors de tout concept moral et comme élément essentiel du dynamisme de la vie, est une force.

Pour une race forte, pas plus que l'orgueil, la luxure n'est un péché capital. Comme l'orgueil, la luxure est une vertu incitatrice, un foyer où s'alimentent les énergies.

La luxure, c'est l'expression d'un être projeté au-delà de lui-même; c'est la joie douloureuse d'une chair accomplie, la douleur joyeuse d'une éclosion; c'est l'union charnelle, quels que soient les secrets qui unifient les êtres; c'est la synthèse sensorielle et sensuelle d'un être pour la plus grande libération de son esprit; c'est la

of artistic activity, linking questions of flesh, desire, gender, and war to political and civilization-based issues. These ideas were the components of the "Feminine Action" that she initiated as a new cross-disciplinary field. Valentine de Saint-Point's thoughts on "lust" and "flesh-work" enriched, influenced, and interacted with dueling visions of modernity established by two Italian challengers living in Paris: Ricciotto Canudo's "Cerebrism" was conceptual, eroticized, and sensual, while F. T. Marinetti's "Futurism" was more provocative, destructive, and energetic. The importance of this heated love triangle in the emergence of the avant-gardes still remains underexplored. Valentine de Saint-Point's "Art of Flesh" research encompassed the history of tragedy, dance, and performance, and culminated with her most important conceptual quest—as she declared, "We must make lust into a work of art." Following the strands of her many intellectual partnerships, the exhibition dedicated a large section to Marinetti, then moved on to other main figures in Futurism, including Luigi Russolo, Enrico Prampolini, Ardengo Soffici, Anton Giulio Bragaglia, Mario Castagneri, Nelson Morpurgo, Armando Mazza, and Enif Angiolini Robert, looking at these artists through the lenses of theater, performance, war, eroticism, and other Futurist loves influenced by Valentine de Saint-Point.

The second floor of *Feminine Futures* traced a wider scene of radical experiments, featuring artists responding to the psychology of desire, the creation of feminine mythologies, and the construction of political power, all of which persisted in performance art until the 1960s and beyond. Material related to Loïe Fuller, Isadora and Anna Duncan, Ruth St. Denis, Mata Hari, Gertrude Hoffman, Anna Pavlova, Vera Fokina, Ida Rubinstein, Josephine Baker, Giannina Censi, Mary Wigman, Gret Palucca, Hedwig Hagemann, Valeska Gert, Ruth Page, Myra Kinch, Martha Graham, and many more comprised this part of the exhibition, which was completed by a film program of mostly unseen early performance films.

Breaking with the Futurist rhetoric of violence, Valentine de Saint-Point lived in exile in New York during World War I, developing "la Métachorie," a new form of art mixing dance,

Photos of Isadora Duncan and Anna Duncan, 1904–1927, as displayed in Feminine Futures. *Courtesy Adrien Sina Collection.*

Why New York Must Become the New Paris

Mme. de Saint-Point, French Poet and Dancer, Who Finds Fifth Avenue Ridiculous, Describes "La Metachorie," New Art

MME. VALENTINE DE SAINT-POINT, poet, painter, dramatist, and philosopher, believes that New York is to be the Paris of the future. She has begun to make it so.

Such was the feeling of the representative of THE NEW YORK TIMES who recently talked with this brilliant Frenchwoman in her sumptuous studio on Thirty-sixth Street. Curtains of colored silk drawn across the windows shut out every glimpse of the New York afternoon. The studio is a long room, decorated chiefly in the Oriental spirit, with Chinese tapestries hung on the walls, tall brown and golden jars and vases about, and a huge flat earthen bowl, filled with many-colored tropical fruits, in the centre of the floor. A little hemlock tree stands in a pot near one of the windows, and in its branches, on the day that THE TIMES representative called at the studio, clambered Mitzi, Madame's pet marmoset. This may not have been Paris, but it certainly was not New York.

Madame herself, clad in rich blue draperies, with many jewels and a golden anklet, reclined on a great couch. On cushions at her feet sat Rudyard Chenniviere and Vivian du Mas. M. Chenniviere is one of Madame's musical collaborators, writing the music which accompanies her dances. M. du Mas is a painter, and designs the light and color schemes of her dances.

Mme. de Saint-Point is the founder of a movement to which she has given the name La Metachorie. This is a combination of Greek words meaning "beyond the dance." La Metachorie, or Metachory, as it may be called, has to do with poetry, painting, the drama, music, the dance; indeed, with all forms of creative art. In her dances the purpose is to express not emotions but ideas—that is the object of the music, of the poem which the dance interprets, which is read before the dance, of the light and color effects. The lights are so arranged that the dancer is in a colored atmosphere, her body being luminous. The color is varied according to the idea of the dance. In addition, a scent is scattered, appropriate to the idea to be expressed. The dancer's face is veiled, and the draperies are used to simplify the lines of the figure.

The theories of Metachory attracted much attention in Paris before the war—the fact that their originator was a grandniece of the great Lamartine and a granddaughter of the Marquis de Glans de Cessiat being much in their favor. Many of the most famous of the modern French composers wrote music to accompany Mme. de Saint-Point's dances, among them being Claude Debussy.

With great animation, accompanied with many expressive gestures, Mme. de Saint-Point told of the tragic passing of the artistic life of Paris, and of her hope for the establishment in New York of a new artistic and literary capital of the world—a dream which she hopes to help make a reality. She talked sometimes in French, sometimes in English, and from their cushions on the floor M. Chenniviere and M. du Mas listened, now and then eagerly joining in the conversation.

"Artistic life in Paris," said Madame, "has been stopped by the war. The galleries are closed, many of the revues have ceased publication. The young painters and poets and musicians have gone to the war, and many of them have

been killed. Charles Peguy is dead, Charles du Mas is dead, Jean Milliere is dead. These are only a few names from the long list, the frightful toll which the war has taken from the genius of the world. Mario Maunier is a prisoner in Germany. And of course all the world knows the tragic and noble story of the death of the composer Magnard.

"In Paris people have no time or inclination to think of the arts. They are too busy with the terrible actualities of the war. And although with the coming

Mme. Valentine de Saint-Point.

of peace there will come a return to the ways of peace, a resumption of painting and music and the rest, yet many of the artists will be dead. Paris will have to wait for a new generation of artists to grow up. It is the little boys now in school who must make the poems and pictures that will be France's next contributions to the world's treasury of art.

"And the war's effect on literature and art must be retrogressive. In general, the artists of France were intellectual before the war. After the war the artists of France will be emotional, sentimental. It will take a long time for art in France to regain its old healthy condition.

"And so," said Madame, with sudden fervor, "it is America's turn! America must now do the work of France, New York must do the work of Paris.

"But when I think of America—mon Dieu! America has never done anything at all! America has produced nothing, has utterly failed to contribute to the beauty of the world. America has never provided a place for her artists—she has forced them all to go to France. She has never done anything to attract the élite of the world; she has never provided anything new and beautiful to attract them."

"Madame does not like," said M. du Mas, "the way in which the American millionaires copy the things of Europe."

"No," said Madame, with a forceful gesture. "The American millionaires annoy me by their worship of tradition. They never seek to develop new art with their money, but always to acquire and to copy the old art. They spend their

millions in buying from Europe old paintings, old furniture, even old buildings. When they build a house or a public building, they copy some famous thing they have seen in Europe. There can be no progress in art in these conditions. America must not take old things from old countries. America must develop her own new art.

"When a millionaire wishes to spend some of his millions on a new home, he should summon young American architects, artists, designers, and tell them

to give him something new and American—to follow the bent of their own natural genius. Instead, he says to them, 'Here is a picture of some Greek building, or some Renaissance building. Copy it exactly!' And, of course, by this means American art cannot develop."

"Fifth Avenue," said Mme. de Saint-Point, in tones of solemn conviction, "is ridiculous! The only beautiful things I have seen in New York are the Woolworth, Singer, and Flatiron Buildings, and the group of municipal buildings. They are original expressions of American art; they are not imitations of Europe.

"The trouble is, as I said, that Americans worship tradition more than Europeans ever did. The effort seems always to be to import and imitate traditions. I hear that some millionaire has bought Madison Square Garden and intends to turn it into an academy of the Greek dance. That's it! Toujours la Grecque! His money is not to go to develop the art of the dance, but to imitate the dancing of bygone centuries!

"But now America must take the place of France. And I think New York can easily become what Paris used to be. Think of all the money that America has made out of the war! Think of the fortunes that have been made in munitions! How are they to be spent? In filling America with the relics of civilizations that are dead? No! That cannot be! That money must be used for new galleries, new theatres, new institutions of every sort that will help to develop art!"

"But just how is New York to become the new Paris?" asked the reporter. "Is this money to be used to support the artists?"

"The support of the artists," said Madame warmly, "is to be taken for granted! That is a matter of secondary importance. The important thing is for the money to be used in making New York a real artistic centre, in filling it with theatres and galleries that will attract the artists and aid in the development of art. Every city in which there is money becomes a magnet to attract ideas. And ideas are what New York needs.

"I find America in a state of absolute chaos. Every one lives for himself. There are no ideals, there are no ideas! In art the only plan is to copy the art of other nations. Even in mechanics this is true; I see that, for example, the automobiles in the street are in form copies of French and English models. New ideas must be developed, and for their development money is necessary. The war has given America the money, and the war has taken from the artists of the world their home in Paris. Ten centuries ago Paris began creating traditions. Now let America begin to create traditions, now let New York begin!

"My impression of New York is that of enormous energy going to waste. That energy must not be wasted! New York must become a true cosmopolitan city, the natural home of the artists of the world, and it must do this by developing its own individuality. This imitative period through which New York is going is a phase of its childishness. As a child imitates grown people, so New York imitates the capitals of Europe. But now New York's childhood should come to an end; it is time for New York to develop its own individuality and to cease to imitate."

Mme. de Saint-Point thinks of Metachory as a new tradition, and she thinks of New York—the new Paris—as an appropriate place for its development. Europe, she believes, has already enough traditions, and in Europe at present no new artistic and literary theories can receive a hearing.

"I can see New York," she said, "becoming the artistic centre and influence that Baireuth was in Wagner's lifetime. I come here dreaming—and not only dreaming, but planning—a great institution in New York which shall be a centre of dramatic and pictorial and literary art. A world style might be developed from such a centre. This institution must not be controlled by the Government nor by any wealthy man or group of men—that would kill it! It must be free to express the spirit of art."

Mme. de Saint-Point's vision is tremendous in its scope, and she speaks with impressive enthusiasm. This great institution of which she speaks seems to be already in her mind a reality, and New York to be even as she talks becoming the artistic centre of the world.

"The American millionaires," she said, "waste their money and their time because they have no ideas. The American artists have ideas, but they are neglected here—they get no attention at all. So they go to Paris, and America loses the much-needed power of their genius. In the world there are two forces—the force of finance and the force of the intellect. For the development of art these two forces must work together. And when these two forces work together, then will America become the leader of the world's art, then will New York become the new Paris."

Above: Photos of Ruth Page and Harald Kreutzberg, 1934, by Maurice Seymour and Maurice Goldberg, as displayed in Feminine Futures. *Courtesy Adrien Sina Collection.*

Opposite: Original printing of "Why New York Must Become the New Paris" in the New York Times, *February 4, 1917. Courtesy Adrien Sina Collection.*

theater, music, and poetry. She then spent the last twenty years of her life in Egypt and the Middle East. While most of the Futurists supported Fascism, she committed herself to defending the rights of women and minorities, fighting European colonialism and its destructive hegemony. Focusing on the many achievements of this key figure in the intellectual life of her time, *Feminine Futures* at long last illuminated Valentine de Saint-Point's profound influence on the larger worlds of radical performance and early modern dance."

—*Adrien Sina*

SOLOSHOW

MARIA HASSABI

PS122

CO-PRESENTED
AND PRODUCED
BY THE PORTLAND
INSTITUTE FOR
CONTEMPORARY
ART, PS122, THE
FRENCH INSTITUTE
ALLIANCE
FRANÇAISE, AND
PERFORMA

Maria Hassabi,
SoloShow, *2009.*
Performance view.
Photo by Paula Court.

The first thing you might have noticed about Maria Hassabi's *SoloShow* was a paradoxical detail in the evening's program: Hassabi's solo would be performed by two dancers—Hassabi and Hristoula Harakas—who would take turns performing the six scheduled showings. In this way, the idea of refraction—viewing the same thing from slightly different angles—was built into the structure of the performances as it was into the performance itself. This theme of refraction was further echoed in the fact that *SoloShow* was the second part of a "diptych," the first part of which, *Solo,* an entirely different work, had been presented a month earlier in another venue.

SoloShow, a startling and meditative sixty-minute performance, was set on a large black platform, part stage, part pedestal, just a foot off the ground. Bathed at first in extra-bright spotlights, which faded to black by the end, Hassabi moved very slowly through a series of poses based on representations of women in art history and pop culture—from Rodin's *Iris* (1893–94) and Maillol's *The River* (1939–43) to Brigitte Bardot and Lil' Kim—morphing from one to another, and sometimes turning to repeat a pose so that it could be seen from the back or in profile. Hassabi's painstaking attention to the smallest details of her body, and the tension that it took to sustain every shape, made it sometimes feel as though one were watching her entire nervous system at work. Sometimes the transitions were lyrical and satiny; at other times the distortions were brutal—Mendieta? Bacon? Polanski? In the end, *SoloShow* was a highly charged exploration of the female body, and in particular the dancer's body, for, as poet Stephane Mallarmé wrote, "a dancer is not a woman (she is a metaphor and an ideal)." —*Performa*

Above, left: Maria Hassabi,
SoloShow, *2009. Performance view.*
Photo by Paula Court. Right: Jane
Fonda. Source image for SoloShow.
Courtesy Maria Hassabi.

Opposite, top: Maria Hassabi,
SoloShow, *2009. Performance view.*
Photo by Paula Court. Bottom:
Aristide Maillol, L'Air, *1939. Source*
image for SoloShow. *Courtesy*
Maria Hassabi.

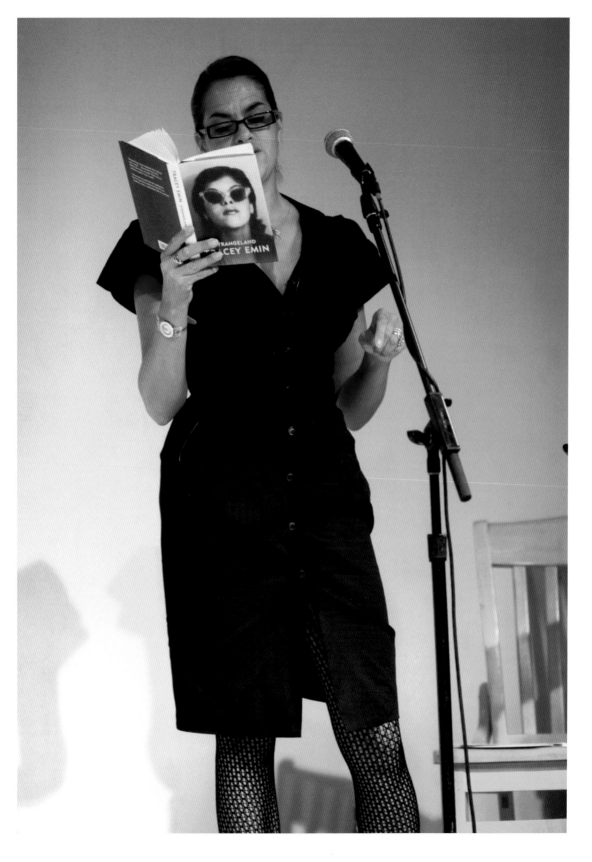

READING FROM *THOSE WHO SUFFER LOVE* AND *STRANGELAND*

TRACEY EMIN

THE PERFORMANCE PROJECT @ UNIVERSITY SETTLEMENT

PRESENTED BY LEHMANN MAUPIN AND PERFORMA

Tracey Emin, Reading from *Those Who Suffer Love* and *Strangeland, 2009. Photo by Paula Court.*

Following spread: Questions from the audience for Tracey Emin's Reading from *Those Who Suffer Love* and *Strangeland, 2009. Courtesy the artist.*

For Tracey Emin, sex always seems to be at the top of the agenda. "I don't like this microphone," she said at the start of her reading at the Performance Project @ University Settlement. "It feels like I'm giving someone a really weird blow job." During the hour-long performance, the British art star, in town for the opening of her fourth solo show at Lehmann Maupin Gallery, "Only God Knows I'm Good," read searing and tender stories from her new book of poetry, *Those Who Suffer Love* (2009), and her acclaimed memoir *Strangeland* (2005), which details her adolescent adventures with the randy boys who slagged (and raped) her in Margate, the seaside resort town where she grew up. "Sex was something you did after fish and chips," she explained. "And it was free."

Sex, lust, and longing are recurring subjects in Emin's provocative art as well, and she has never been shy about putting herself in it. (As one of her more memorable neon signs puts it, "People like you need to fuck people like me.") Yet at her reading, the forthright Emin, who is famous for putting a debauched bed stained with unidentified effluents in a museum and surrounding it with bloody underwear and used condoms (*My Bed,* 1999), was too embarrassed by the inebriated sensations of an old New York diary entry to get through it in public. "See how much I've changed?" she said, laughing. "I just wrote the book. I didn't read it." But after reading the excerpts she had selected, Emin switched gears and gave unflinching answers to written questions from the audience probing her attitude toward feminism, sex addiction, the afterlife, and the difference between men and women. "Women having sex come all the time," she said. "Men have one big ejaculation and it's over. It's the same in art. Male artists peak at forty to forty-five. For women, it's about longevity." —*Linda Yablonsky*

Excerpted from an article in the November 13, 2009, issue of New York Magazine.

WHAT IS YOUR FAVORITE CITY IN THE WORLD?

Do you like Picasso ??? Why did you say "fuck Picasso"?
I love the "inspired by Picasso" story !!
 Skyshi xx
P.S. Do you have any favourite people in the audience

I think you're wonderful → Do you consider yourself
 ♡ Bon a sex addict? Do you
 Jane feel you need to objectify
 yourself to maintain
 your value?

Are you a feminist?

Do you believe in life after death?

ISN'T IT
A LONELY
LIFE TO BE
AN ARTIST?

Why do you choose neon lights as a medium?

Are you still thinking of
THAT Interview (Turner prize)

HAVE YOU EVER DATED AN INDIAN?

WARHOL OR BEUYS?
OR
WHAT DID YOU HAVE FOR BREAKFAST?

KALUP LINZY

In an intimate Chelsea gallery setting, Kalup Linzy performed an intense eight-song set as drag-queen diva Taiwan, a character from his satiric soap-opera video series, *Conversations wit de Churen* (2003–), which focuses on the melodramatic lives of a Southern black family comprising Taiwan, Labisha, Jada, and Nucuavia, all played by Linzy himself. The popularity of *Conversations* (which is available on YouTube) is due in part to the artist's ability—as writer, director, producer, and editor—to develop entertaining yet emotionally complex characters that move effortlessly between video art, live performance, and music, caught in hilariously overwrought storylines that skewer black, queer, and art-world stereotypes.

In a long black wig, a pale flower behind his ear, and a black leotard custom-designed by Proenza Schouler, Linzy, as Taiwan, sang soulfully about loss, love, and desire, accompanied by a single acoustic guitarist (Mike Jackson). The lyrics to the songs introduced and elaborated on some *Conversations* storylines; in "That's Wassup" and "Asshole," Taiwan lambasted men "who've done him wrong." Other songs were rewrites of well-known standards, such as "(Sittin' On) The Edge of My Couch"—based on Otis Redding's 1968 classic "(Sittin' On) The Dock of the Bay"—or straight-up covers, like one of "Strokin'," a hilariously raunchy 1985 song by soul musician Clarence Carter.

—*Tairone Bastien*

IDEAL VIEWER
EINAT AMIR

SCARAMOUCHE

CURATED BY
DAVID EVERITT
HOWE

Einat Amir, Ideal
Viewer, *2009.*
Performance view.
Photo by Paula Court.

An obese young woman sat on the floor of Scaramouche gallery, sobbing. Before her lay a broken television, on top of which was a portable DVD player showing a recording of her in the same situation, crying. Whenever passersby entered the small Lower East Side storefront gallery, a man in a suit standing behind the crying woman began explaining her story. She had been left by her boyfriend, he said, hence the tears. An angry young man leaning against the gallery wall—the boyfriend, it turns out—then told his version of the breakup, while the first man turned to watch promotional videos of himself on a small screen hanging on the wall.

For this sad tale of indifference, Israeli artist Einat Amir used Craigslist to find three professional actors, and asked them to improvise a problematic love story at close quarters on two consecutive afternoons, and to interact directly with the audience. For Amir, this dissection of the roles people play applied to the art world. The Crying Woman embodied "the artist," in a moment of crisis that was both cathartic and an ironic take on narcissism; the Ex-Boyfriend implied a critique of how female artists are often expected to include intimate biographical elements in their work, whether they influenced it or not; and the Interpreter, a recurrent character in Amir's performances, was there to tell the truth. "A lot of my work is trying to include all the roles that are involved in the art experience—the artist, the object, the audience, the viewer, the critic," explains Amir. As described on business cards available at the gallery, individuals could contact the artist to have one of the three characters perform "a one-hour service free of charge" in the privacy of their own homes, using their "special skills" (such as crying "believably and continuously for long periods of time") for whatever use the individual desired.

—Virginie Bobin

THE PRESENT DOESN'T EXIST IN MY MIND, AND THE FUTURE IS ALREADY FAR BEHIND
LILIBETH CUENCA RASMUSSEN

THE PERFORMANCE
PROJECT @
UNIVERSITY
SETTLEMENT

PRESENTED BY
SCULPTURECENTER

*Lilibeth Cuenca
Rasmussen,* The
Present Doesn't Exist
in My Mind, and the
Future Is Already
Far Behind, *2009.
Rehearsal views. Photos
by Brian Close.*

Filipino-Danish artist Lilibeth Cuenca Rasmussen's multimedia one-woman show at University Settlement drew on the writings of Valentine de Saint-Point and British-born avant-garde poet Mina Loy, both of whom were affiliated with the Futurist movement only to later reject it. The thirty-minute performance began with Rasmussen ensconced in a cream-colored geometric costume designed by Lise Klitten, standing erectly on stage while slowly dictating collaged excerpts from Loy's 1923 anthology of poems, *Lunar Baedecker,* to an operatic score by composer/musicians Pete Drungle and Brian Bender. Flickering geometric shapes, crudely linear architectural forms, and a descending misty backdrop, created and compiled by artist Brian Close, were projected on Rasmussen's body and the dark screen behind her. Rasmussen's labored movements and restrictive attire viscerally suggested the masculine confines in society. As the bravura of the musical score slowly waned, the artist gradually shed the shell of her costume to reveal a sleek white bodysuit. In a rapid transition to performing her own poetry, Rasmussen threw on a white afro and sunglasses and began rapping "Fuck the F-word"—a song featuring the catchy chorus "Fuck the F, relight the fire / Let the granny feminist retire!" Bringing playfulness and biting humor to the intricacies of identity politics, Rasmussen's rich symbolic imagery and jarring sensual contrasts provided a refreshing exploration of the legacy of Futurism and its continued influence on contemporary feminism.

—Persis Singh

A SOLDIER'S LUST

KATIA BASSANINI

FOREVER &
TODAY, INC.

*Katia Bassanini,
"Seven Ways to
Victory" from* A
Soldier's Lust, *2009.
Performance view.
Photo by Forever &
Today, Inc.*

During each of the two afternoons of *The Lust Weekend*, a group of intrigued passersby and Performa fans blocked the sidewalk at the wide-open doors of Forever & Today, Inc., where Swiss artist Katia Bassanini performed five short pieces upon request by visitors, who selected from a framed menu on the wall. In "Coffee Talk," you could spend five minutes chatting with Bassanini over a cup of coffee; in "Noisy Food," she would bite into fruits and vegetables close to your ear, creating an unusual piece of musique concrète; and in "Seven Ways to Victory," "Faces of Conquest," and "Tricks for Intercourse in Public Spaces," she acted out a series of gestures mimicking domestic tasks or sexual activities. Throughout the performances, collectively titled *A Soldier's Lust*, Bassanini appeared as "Madam D," a tribute to the Greek goddess Diana, known for hunting animals and men with equal talent, and to Valentine de Saint-Point's celebration of the creative power of female sexuality. From time to time, Bassanini removed her black wig or parts of her all-white ensemble, revealing a bald head or a corset, respectively, and stepped into a bathtub filled with Styrofoam flakes. *A Soldier's Lust* wittily wove references to historical avant-gardes, cultural history, and a range of female archetypes, from goddess to pseudo-feminist artist to sitcom housewife. Sadly, it would be this promising artist's final performance; Bassanini passed away from cancer in July 2010.

—*Virginie Bobin*

COLD WATER

LA MAMA
LA GALLERIA

PRESENTED
BY LA MAMA

CURATED BY
JUSTIN BOND
AND HILTON ALS

Cold Water, *2009.*
(Caden Manson, SOS
Party Gods, *2009,*
in the foreground).
Installation view.
Courtesy La MaMa La
Galleria.

When I was asked to curate an exhibition by La MaMa's La Galleria, I wasn't sure where to begin, having never organized an art show before. I started by thinking about why I'm a performer: to give the audience a glimpse into my worldview, as a queer gender-variant feminist pagan who is constantly inspired by other performers in my community, by their courage and brazenness to make live work celebrating their identities in the face of a homogenized culture.

For any artist, the first step in making work is "going within"—sitting down, usually alone, to create something new. For performers, this process comes with the idea that the creation will ultimately be presented to a large group of people. In *Cold Water* I wanted to look at something else: artwork that was never intended for the public at all. Specifically, I wanted to look at visual art made by performers. I had noticed that many performing artists privately make visual art, as though in need of a hidden space of their own, in contrast to their life that is lived publicly, onstage. I myself am also a painter, but I can't, for instance, come home from performing in a nightclub and sit down to paint—I have to be in a completely different state of mind, one that is divorced from my performing self. As works made in a liminal space, when one isn't in the heat of the "live" mode, I think of my paintings as being made in "cold water."

At the time, I was working with theater critic Hilton Als and fashion designers Rodarte on a photo-essay homage to one of our mutual idols, transgender icon Jackie Curtis. As I posed in front of a poster of Curtis at La MaMa, I told Hilton about the show, and he started coming up with one great idea after another. I was thrilled when he agreed to join me in this adventure, suggesting the title and adding videos by Thurston Moore, Tilda Swinton, Leslie Thornton, and Darryl Turner to my initial list. It was fascinating getting to know the visual works of so many performing artists and the variety of impulses behind them. Rufus Wainwright, for instance, had a fairly utilitarian perspective on his artwork, which mostly consists of commissioned portraits and pieces made for his own album covers. Chris Tanner,

Justin Bond, Nick, *2009. Courtesy the artist.*

Rufus Wainwright, Jörn Weisbrodt, *2008.*
Courtesy La MaMa La Galleria.

Tilda Swinton, We Will Wake, *1997. Video still.*
Courtesy La MaMa La Galleria.

Assorted works by Kate Bornstein, 1974–1980. Courtesy La MaMa La Galleria.

who has been a fixture on the downtown performance scene for decades, is also a successful painter. And Kate Bornstein's drawings, made between 1974 and 1980, when she was "still a boy, and a member of the Church of Scientology, which was down on sexual perversion," were, she said, her way of saying, "Can you see me now?" —*Justin Bond*

Participating artists: Kate Bornstein, Theo Kogan, Caden Manson, Thurston Moore, Jemma Nelson, Lady Rizo, Tilda Swinton, Chris Tanner, Leslie Thornton, Darryl Turner, and Rufus Wainwright.

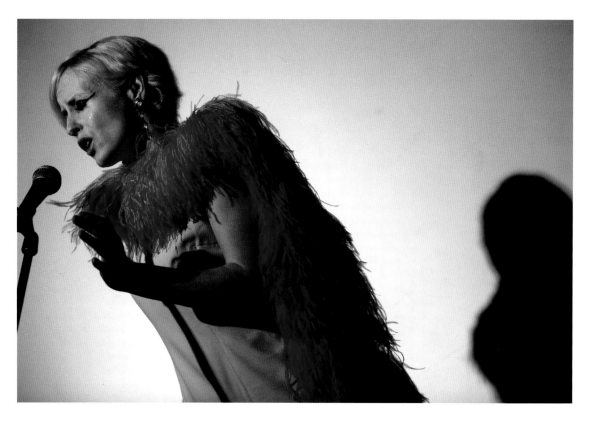

~~PERFORMAT~~

MARCELLA VANZO, JENNIFER WALSHE, AND LUCIE FONTAINE

Inspired by seminal works of 1970s feminism, Italian artist Marcella Vanzo created a traveling performance by "Lucie Fontaine," a cover name for multiple people and practices in the art world. For the two performances in New York, Vanzo worked with composer and vocalist Jennifer Walshe to write a loose "script" for an appearance by Fontaine (played by Walshe) on two consecutive evenings, just before performances by Discoteca Flaming Star and Nils Bech, respectively. Paying tribute to 1960s Italian pop music—which, to Vanzo, represented the "first attempts at sexual liberation for women in that country"— Fontaine appeared in a pink gown, feather boa, and Twiggy-esque eye makeup and performed a virtuoso six-minute a cappella composition with great aplomb, just before the curtain rose on the evening's main event. —*Virginie Bobin*

THE PERFORMANCE PROJECT @ UNIVERSITY SETTLEMENT

Marcella Vanzo,
Jennifer Walshe,
and Lucie Fontaine,
~~PERFORMAT~~, *2009.*
Performance view.
Photo by Paula Court.

INGRID (INZWISCHEN)
DISCOTECA FLAMING STAR

THE
PERFORMANCE
PROJECT @
UNIVERSITY
SETTLEMENT

PRESENTED BY
PERFORMA

Discoteca Flaming Star,
Ingrid (Inzwischen),
*2009. Performance
view. Photo by Irene
Gómez Barrio.*

Art collective and rock band Discoteca Flaming Star (German-born Wolfgang Mayer and Spanish-born Cristina Gomez Barrio) construct visual and aural collages that welcome chance, improvisation, collaboration, and play. In *Ingrid (Inzwischen)*, inspired by the confrontational tactics of the NO!art movement's Boris Lurie, the duo addressed the social disenfranchisement of nonconformists through pop songs and collaged performance. With a black lace banner running through the audience, and the room bathed in amber light, the show included percussionist James Galbraith; dancer Maren Mauer; recordings of letters written by "conceptual ventriloquist" Ingrid Rabel to a fictional advice columnist, the alter ego of artist Rita McBride; and Barrio and Mayer singing songs ranging from Latin alternative artist Manu Chao's "Lagrimas de oro" to Belgian cabaret singer Jacques Brel's "Le Moribond." —*Tairone Bastien*

BEDROOM W TV AND WOMAN LAYS W AIDE
YEMENWED

FAKE ESTATE

Yemenwed, Bedroom
w TV and Woman
Lays w Aide, 2009.
Performance view.
Photo by Paula Court.

New York–based art collective Yemenwed, best known for their 'zines, installations, and videos, staged their first live performance, *Bedroom w TV and Woman Lays w Aide*, in the loftlike gallery space of 179 Canal Street, which had been transformed to look like an apartment in the LaGuardia Houses, a public housing project on the Lower East Side. Dimly illuminated by a table lamp hung from the ceiling, the surreal set, built by Shawn Maximo and Paul Kopkau, afforded a voyeuristic glimpse into a domestic interior inhabited by a cast of women—one seated in an impossibly tall chair, one wearing a lampshade as a hat, and one framed by a curving row of wooden window blinds—who collectively created a "tableau vivant" of still bodies and objects that seemed to mesh with one another in a flat, fused environment. Each character took turns coming to life through choreography based on gestural movement and awkward angles. For Gloria Maximo, who wrote the script, the performance was an extension of her paintings: "As in Egyptian sculpture, or the relief style in general, my figures and the interior architecture are physically equal, as if carved from the same stone." An eclectic mix of music, including the operatic voice of Shannon Funchess, the gothic synthesizer of Fatima Al Qadiri, and the rolling percussion of Tim Dewitt, propelled the twenty-minute performance, with the musicians hovering in the background like a Greek chorus. The show culminated with a synchronized dance by Shaw Maximo and Megha Barnabas—a high-energy routine infused with ethnic pop moves, somewhere between Bollywood and Beyoncé. —*Julie Trotta*

LOOK BACK 2
NILS BECH AND LINA VISTE GROENLI

Nils Bech, a classically trained singer, and Bendik Giske, a saxophonist, performed a set of melancholic torch songs amid sculptures by fellow Norwegian artist Lina Viste Groenli (whose show *Effigies* was concurrently on view at Art Since the Summer of '69, a small gallery on the Lower East Side) that made reference to the lore surrounding female performers, from Isadora Duncan to Joan Armatrading. The bent wooden shape of *Armatrading*, for instance, was inspired by Gerrit Rietveld's famous zigzag chair on the iconic cover of Armatrading's 1980 album *Me Myself I*. After opening with two songs that seemed to bracket the wide range of his influences and interests—"Asleep" by 1980s indie band The Smiths and "Dido's Lament" by seventeenth-century Baroque composer Henry Purcell—Bech performed a series of songs co-written with Giske, often turning and singing directly to the sculptures, as if they were the subjects of the music. —*Tairone Bastien*

THE PERFORMANCE PROJECT @ UNIVERSITY SETTLEMENT

PRESENTED BY ART SINCE THE SUMMER OF '69

Nils Bech and Lina Viste Groenli, Look Back 2, *2009. Performance view. Photo by Paula Court.*

SNÖFRID RUBY DISTILLERY

YLVA OGLAND

SWISS INSTITUTE

CO-PRESENTED
BY SWISS
INSTITUTE AND
PERFORMA

Ylva Ogland, Snöfrid
Ruby Distillery, *2009.
Installation view.
Photo by Rodrigo
Mallea Lira / Johan
Hjerpe. Courtesy the
artist.*

For the week preceding *The Lust Weekend*, Ylva Ogland presented *Snöfrid Ruby Distillery*, in which the artist made her own vodka at Swiss Institute by cooking the alcohol out of high-quality champagne and filtering it through crushed rubies—"the mineral of Lust," according to Ogland.

A sign on the door said the gallery was closed, but an attendant directed those who knew the password ("*Snöfrid*") to the dimly lit gallery upstairs. The distilling equipment was arranged at separate workstations on large pieces of black paper taped to the floor; each object was carefully placed on a detailed drawing of it in white chalk. Visitors were able to watch Ogland and several assistants minding their alchemist's tools. On the final day of the distilling process, artist Emily Sundblad sang a Swedish song, and then she and a group of friends carried the vodka to a loft on Canal Street, where it was shared with revelers at *The Lust Weekend*'s closing party, *Betterraves Club*.

—*Tairone Bastien*

DEMONSTRATION
LISA KIRK

SEWARD PARK

PRESENTED
BY INVISIBLE-
EXPORTS

Lisa Kirk,
Demonstration, 2009.
Performance views.
Photos by Paula Court.

On the Saturday afternoon of *The Lust Weekend*, if you happened to be walking on the Lower East Side, you might have seen people here and there carrying picket signs with individualized variations of the same declarative phrase: "I am _____." Unlike picketers or protestors, however, they were not walking together, they didn't share a common message, they ranged from toddlers to senior citizens, and most of them seemed not to know one other at all.

Demonstration was a collective action in which artist Lisa Kirk manipulated the language and aesthetic of "protesting" to her own ends. The project had begun weeks before as an open call circulated through email and Facebook to join a demonstration, in which people were asked to complete the phrase "I am _____." Their statement was then emailed back in a large format to be printed, along with instructions on how to make a picket sign and when and where to show up.

After marching the streets, first individually, and then in progressively larger groups as they came upon and joined one another, the protestors finally arrived at Seward Park at the corner of Essex and Canal Streets. The park is named after William Henry Seward, a former New York State senator (1849–1861) and later Abraham Lincoln's secretary of state, who was known as an independent thinker, often far ahead of public opinion, and an outspoken opponent of slavery. Once at the park, the protestors started to walk in a large circle that grew as others arrived. At last the whole group coalesced into one unit. After about fifteen minutes, the novelty of the circling wore off, and one by one, the protestors dropped their signs in the center of the circle and walked away. The resulting pile of abandoned proclamations was a monument to their shared endeavor.

—*Tairone Bastien*

BETTERAVES CLUB
EMILY SUNDBLAD AND MARGARET LEE

179 CANAL STREET

PRESENTED BY 179 CANAL AND PERFORMA

The finale of *The Lust Weekend* began at the Swiss Institute, where Ylva Ogland's *Snöfrid Ruby Distillery* was wrapping up production, and continued at 179 Canal Street in Chinatown, with a party hosted by artists Emily Sundblad and Margaret Lee in a fifth-floor walk-up. With DJ-ing by White Columns director Matthew Higgs, Swedish songs performed by Sundblad, and ample vodka by Snöfrid, the celebration of Valentine de Saint-Point's spirit and the eclectic atmosphere of her Futurist soirées in the Paris of a century ago floated in the smoky air.

—*Virginie Bobin*

4 HOUR FUNDAMENTAL
PROFESSOR EILERS

ON STELLAR RAYS

Professor Eilers is the alter ego of artist Debo Eilers, himself a fictional creation, and a member of a growing community of New York artists who produce imaginary personal narratives. Eilers's output includes performance, sculpture, video, painting, and the construction of ever more numerous personalities.

For *The Lust Weekend*, Professor Eilers invited several of his Columbia University art students to produce projects based on Valentine de Saint-Point's "Futurist Manifesto of Lust." Sara Ziff hired a Captain Jack Sparrow impersonator to encourage passersby to venture down the narrow steps into the basement, where Eilers (wearing a gas mask and loincloth) directed visitors to stations around the room manned by his students: Cory Stanton hawked handmade T-shirts, Phyllis Ma offered "one night stands" and counterfeit drugs, and Manuel Scheinweller tried to sell "stolen" Lawrence Weiner books. Juan Carlos Olivares and Ziff lay sleeping in the corner, while Eilers kept track of his students' earnings by drawing large fluorescent-green dollar signs on the wall with a giant stick. It was a disturbing mix of funhouse and flophouse, populated by perverse characters from a collectively imagined underworld. —*Tairone Bastien*

RADIO BROADCAST
BROADSIDE

Musician Emily Bellingham and visual artist Alex Fleming founded BROADSIDE in 2003 as a platform for pursuing joint projects in art, activism, and publishing. For *The Lust Weekend*, BROADSIDE organized a daylong (9 a.m. to 9 p.m.) feminist-inspired broadcast for East Village Radio, including readings, performances, discussions, and live and recorded music. Among the many projects were artist Wendy Vogel introducing Louise Lawler's famously ironic sound work *Bird Calls* (1972), in which the artist squawks, chirps, and warbles the names of twenty-eight male artists; art historian Barbara Schröder discussing Ulrike Müller's *Herstory Inventory* (2009), the world's largest collection of art material by and about lesbians; Sonic Youth's Thurston Moore presenting rare recordings of women's experimental music from the 1970s, and artists Jen Kennedy and Liz Linden calling random numbers in the New York phone book and asking people one question: "When I say the word 'feminism,' what is the first thing that comes to mind?"

—*Lana Wilson*

THE UNIVERSE WILL BE OUR VOCABULARY

ON LANGUAGE

Language was woven through many parts of Performa 09—beginning with Dexter Sinister's broadsheet newspaper, which was distributed by hand and on public "readers" throughout the city, and encompassing readings by poets Charles Bernstein and John Yau, expansive lecture performances by Alexandre Singh, Twitter-inspired street chalking, and even texts about speed being recited by people running on treadmills in a gym—creating a multifaceted look at the power of the written and spoken word. Historical looks at Marinetti's writing, the Futurist manifestos, and the role of women in Futurist literature rounded out the offerings.

SINISTER TO ESTABLISH "FIRST/LAST" NEWSPAPER AT PORT AUTHORITY

PORT AUTHORITY — Recently described as "salient panto," DeXTER SINISTER are set to produce a newspaper twice a week for three weeks this fall under the umbrella of PERFORMA 09, New York's well-regarded biennial festival of performance art. Together with a hastily assembled staff of international writers and photographers, the Lower East Side "pamphleteers" will occupy a disused, street-level space in New York's Port Authority bus terminal on the corner of 8th Avenue and 41st Street directly opposite the new New York Times building. According to sources close to Sinister, The First/Last Newspaper (TF/LN) will be "so much about the current state of news media as anything else." Last night, they hosted a public opening of the workspace on item 6:30pm and screened Farewell Etaoin Shrdlu, a 1980 documentary narrated by Times Linotype operator Carl Schlesinger. Schlesinger offered a brief introduction. TF/LN will appear twice a week for the next three weeks, to be distributed in various formats yet to be announced. Likewise, events open to the public will be arranged during their three-week operation. In Sinister's own characteristically melodramatic words "You don't want to start quantifying things or you're dead."

NEWSPAPER TAX LEVIED: FEW CAN AFFORD DAILY 6 PENCE

NEW YORK CITY — Text takes time. It takes time to read, it takes time to write, and it takes time to reproduce. Through-out the history of text production, people have been searching for ways to distribute the costs of producing text — financial, temporal — most evenly across a system. This search led history goldsmith Johannes Gutenberg to develop and refine his system of movable type by the 1450s, which eliminated the laborious book-copying process used previously by monastic scribes. And with Gutenberg's system in place, Venetian publisher Aldus Manutius was able to quickly popularize printed books by the late 1400s.

As text becomes easier and cheaper to produce, more copies of it get made. While Gutenberg's Bible was printed in a small edition of 180, Manutius's books now printed by the thousands. More copies and more readers and more readers like their text to be portable. While Gutenberg's heavy Bible was best read in a library table, Manutius's slim editions could be easily slipped in a saddlebag or vest pocket. You want to Gutenberg's books, but Manutius's books went with you. As increasingly numerous and increasingly portable copies of texts found their way into the world, they found new readers to buy them and they spread literacy with them.

In the next two hundred years, text continued to get stiffer, more portable, more widely distributed, giving rise to a new form for the late 1600s and early 1700s: the news-paper. By now firmly established in Europe and North America, the newspaper's growth was spurred by a flowering of global trade. Access to this sensitive political news and financial information was increasingly important, and publishers strived to invent new technologies to meet demand. By the early 1600s, as a result of the industrial revolution, the Times of London boasted a press that could print a daily broadsheet of 1100 pages a minute, with a circulation to match. By 1840, presses could print on both sides, using paper, and the "penny press" was born, offering a product that cost 1/6 of the competition's price. Once again, more copies, cheaper copies, smaller copies meant better distribution of costs, and, as a result, even more readers.

As the cost of mechanically reproducing text fell, the cost of circulating printed texts fell. According to television N.N. Feltes, the fruits of the industrial revolution "spread reads, fast crutches, outside, and eventually..." made it easier to deliver printed texts to their intended audiences. Around the same time, those that were known as "booksellers" shifted away from selling each other's books and instead re-established other selves as something known as the "publisher." Where today, wholesaling their own books, but not, Feltes points out, "anybody else's." This concentration of efforts along a single product line did the trick. After all, it does no good to deliver more printed texts to read-ers if the demand from those readers isn't stimulated at the same time. Some of the same forces of industry that cheapened the cost of circulating texts were used to drive up demand: travelling salesmen were dispatched bearing cheap printed prospectuses and catalogs to hawk a publisher's wares to a near-geographically dispersed audience. On those same trains and ferryways new newspapers, streaming from the center of cities and fostering paid advertisements for books and, in-creasingly, the fine publicity of literacy itself.

Books were cheaper than ever to print, and they were cheaper, faster, and easier to distribute. Readers were increasingly aware of new books on the market, and, because of the new industrial age, they were increasing-ly able to find leisure time to read them, all of which set the stage for a flourishing of the Victorian appreciation and consumption of literature. Costs fell, distribution climbed, demand grew, but one variable was not supporting. It still took sixteen a long time to produce a text, and, even given their best efforts, there was no guarantee to publishers that an author's work would ignite the pas-sions of an ever-anxious public.

Again, it was the newspaper to the rescue, or, rather, the technology developed for the newspaper industry. When a greedy and disappearing British government levied a tax on the newspaper industry starting in 1712, it grew over the next century to a peace. Printers began producing pamphlets instead. Through a loophole in the tax law, pamphlets, which were longer than newspapers, weren't taxed and were only marginally more expensive than newspapers to print. While few people could afford the daily cost of it price for 4/5 or 3/page newspaper, the ac-casional cost of a 12-pence (1-shilling) pam-phlet of 48 pages seemed justified. Printers naturally gravitated toward pamphlets and today, the additional space required with new advertising, fiction, and other mis-cellaneous content.

Some printers realized that this new content was more popular than their news cov-erage and began recruiting proven authors to publish exclusively in the pamphlet format.

MUSEUM PIECE

Review

Farewell etaoin shrdlu, by David Loeb Weiss, The Museum of Modern Art Circulating Film Library, 1980. 16mm color film, 29 minutes

July 1, 1978, now here been a ho-hum news-day at The New York Times — fighting in Lebanon, a Manhattan explosion, plans for the upcoming Fourth of July — but in the paper's composing room, things were far from routine. On that summer Saturday evening, the next day's early editions of the Times were being printed for the last time from hot type cast from molten lead, below the night

was through, the changeover to cold type set by electronic computer was final and com-plete. David Loeb Weiss, a member of the New York Typographical Union and a former proofreader at the Times had the foresight to record that historic transition on film, and to ask Carl Schlesinger, a typesetter and an au-thority on the printing trades who retained Times printers by the operation of the new equipment, to narrate the story. This onetime, operational document is the result.

With the clock on the wall sweeping all too quickly through the fifty-six minutes to the first edition's 9pm deadline, the camera observes the noisy old reliable Linotypes on their final job, recording in loving detail how molds of letters are cast from 536-degree liq-uid lead, how the type is set in molds, how the lines are spaced and spread onto columns of full-page newspaper forms on steel tables, or "printers stones" how engravings, rules, and headlines are made by hand; how page plates are stereotypes, are placed on mine identical presses in the next edition, are fixed on the "stones", and, not least, how typeset-ting errors are signaled to the proofreader by striking the first twelve keys of the Linotype keyboard, "etaoin shrdlu" — a convention that gives the documentary its title of final farewell.

The process began with Gutenberg, the narrator reminds us — indeed, the mechan-ics of work seem to be uncharged and unmod-fied, used for parts of a kind that has for the past hundred years remained virtually un-changed — and on this night, when the Lino-type operator discards the last lead line at the end of the last story and gives his old machine a final run, when he turns out the lights and closes the door on the suddenly silent room as one comes to a close. All of the knowledge acquired by the operator in a lifetime of work is now laid to a complete farewell.

But the film is more than an appreciation of the mechanical past: it is also a celebration of the electronic future. Briskly, the cam-era moves on to the next edition, being put together in late-like, noise-free, temperature-controlled quarters, where seasoned printers (who have been retrained) orchestrate func-tions and magnetic tapes, magically trans-ferring paste-ups to flexible plastic plates on high-speed presses via electron impulse in a laser beam. If the process seems cold, it more wary than one, perhaps it is because the more measurable senses of personal con-nection — the page roller and layout man with hands together, rounding the type into the form, the sharp many dead printers work-ing to one another in sign language: the pride of the operators and "musketeps" in meeting the deadline one last time — have come be-fore. Certainly, the leap in production is fast enough: 1,000 lines of type a minute, or more than seventy times the speed of the process it replaced.

Even now, though, in its state of techni-cal obsolescence, the genius of the Linotype concept is no less astonishing than that of its automated successor. And to witness the end of one revolution and the beginning of the next is to be struck anew by the awesome reach of human inventiveness in our urge to communicate. (OC)

This article first appeared in the Columbia Journalism Review, July/August 1982.

PICTURE AN IMAGE OF A PHOTOGRAPH

TIVOLI NY — Picture a man caught in a dispute between drug gangs in Mexico. This image appeared in Foto magazine, August 28, 2000. He is lying dead in the street, sur-rounded by a group of onlookers. Bystanders are taking photos of the body with video, digital, phone-cameras. The number of peo-ple in the picture taking a photo of the body almost outnumbers those who are not. To understand the economy of this image re-quires knowing that a piece of information (a photograph) is a unit of exchange in which our attention, and the attention of others, is accorded value. We don't know the fate of these pictures but some likely have been posted on the Internet to become tokens of exchange via blogs, on-line communities and chat lines. We are all involved in an informa-tion economy each time we log on to MySpace, send an e-mail of wherever the circu-lation of information heightens our visibility. The image-economy is founded on our activ-ity as self-performing subjects, feeling back and exchanging information in order to im-prove our stake within this media feedback loop — "the social studio."

Still from Farewell, etaoin shrdlu, a 1980 film chronicling the last day of hot metal typesetting at The New York Times.

Something funny's here nowaday, perhaps you have noticed it, too. You know what theists and onlineists and on-and-the-mobile-masters and Dieseists and documentarists of every stope want for themselves? They want search who they tell you were no longer want, sex politics, overweight, dumindexed. Kindle reader. They want whose bones ridiculists on reader sales in the middle of researchs on nill those obvious. (You can click your bottle of water series. Change er) They want to go shopping on Sunday after noon on the Avenue. Victor Happi; they want the pages of their New York Times all kind of proses from account smacks and butter at a café table in Aspen; they want to see their names as lead copy in the "New Establishment" zone of Vanity Fair, they want a homework/science bookshop, they want to see the plate in London, they want to float down the Nile in a felucca; they want free-trade and sector and yet once start-up aqua and cores of the park. And in or-der to narrow these things for themselves they will plug up your ears and scar eyes and your mouth, and if they can figure out a way to pump episodes of The Sopranos through the Askcrump corridors of your brain or you register (acne to someone, can), they will do it.

From "First Edition" by Richard Rodriguez, Harper's magazine, November 2000

1 The Medium Is the Message 2 Media Hot & Cold 3 Reversal of the Overheated Medium 4 The Gadget Lover: Narcissus as Narcosis 5 Hybrid Energy: Les Liaisons Dangereuses 6 Media as Translators 7 Challenge and Col-lapse: The Nemesis of Creativity 8 The Spo-ken Word: Flower of Evil? 9 The Written Word: An Eye for an Eye 10 Roads and Pa-per Routes 11 Number Profile of the Crowd 12 Clothing: Our Extended Skin 13 Hous-ing: New Look and New Outlook 14 Money: The Poor Man's Credit Card 15 Clocks: The Scent of Time 16 The Print: How to Dig It 17 Comics: Mad Vestibule to TV 18 The Printed Word: Architect of Nationalism 19 Wheel, Bicycle, and Airplane 20 The Photo-graph: The Brothel-without-Walls 21 Press: Government by News Leak 22 Motorcar: The Mechanical Bride 23 Ads: Keeping Upset with the Joneses 24 Games: The Extensions of Man 25 Telegraph: The Social Hormone 26 The Typewriter: Into the Age of the Iron Whim 27 The Telephone: Sounding Brass or Tinkling Symbal? 28 The Phonograph: The Toy That Shrank the National Chest 29 Movies: The Reel World 30 Radio: The Tribal Drum 31 Television: The Timid Giant 32 Weapons: War of the Icons 33 Automa-tion: Learning a Living (MM)

In 1785 the English philosopher Jeremy Bentham designed the panopticon, a prison that allowed an observer to observe all pris-oners without the prisoners being able to tell whether they are being watched. Although many were built as prisons Bentham envi-sioned many other uses for the panopticon, as French Philosopher Michel Foucault sug-gests, "Bentham thought that the panop-ticon apparatus could be used to construct metaphysical experiments on children, being taught something right from birth and putting them in a panoptic system, even be-fore they have begun to talk or be conse-of anything —different things could be taught to different children at a different cost; we could teach no matter what to no mat-ter which child, and we would see the result. In this way, we could teach children to com-pletely different practice, or even systems in-compatible with each other, some would be taught the Newtonian system and then oth-ers would be got to believe that the moon was made of cheese — and then we could wait again until they would finally see what they would be put together for discussions."

Bentham's idea of the totally regimented subject (and regimented society) didn't come out of the blue, the notion that the blank slate of the human could could be interfered with any number of designs had been posited in Aristotle and the notion of the fab-ula rasa was re-introduced by John Locke et al. 'It' is a child means is perceived of by us as a white paper void of all char-acters without any ideas. How comes it to be furnished with the almost endless variety that the human hand on it has lodged on it with the busy and boundless fancy of man has painted on it with an almost endless va-riety? Where has it all the materials of rea-son and knowledge? To this I answer, in one word, from experience.' (JL)

PUBLICK OCCURRENCES BOTH FORREIGN AND DOMESTICK

BOSTON — It is designed, that the Coun-trey shall be furnished once a moneth (or if any Glut of Occurrences happen, oftener,) with an Account of such considerable things as have arrived unto our Notice.

In order however, the Publishers will take what pains he can to obtain a *Faithful Re-lation* of all such things; and will particu-larly make himself beholden to such Persons in Boston whom he knows to have been for divers years the diligent Observers of such matters.

That which is herein propose, is, First, That Memorable Occurrents of Divine Provi-dence may not be neglected or forgotten, as they too often are. Secondly, That people every where may better understand the Cir-cumstances of Publique Affairs, both abroad and at home; which may not only direct their Thoughts at all times, but at some times also to assist their Businesses and Negotiations.

Thirdly, That some thing may be done towards the Curing, or at least the Charm-ing, of that Spirit of Lying, which prevails amongst us wherefore nothing shall be en-tered, but what we have reason to believe is true, repairing to the best fountains for our Information. And when there appears any material mistake in any thing that is col-lected, it shall be corrected in the next.

Moreover, the Publisher of these Occur-rences is willing to engage; whereas there are many False Reports, maliciously made, and spread among us, if any well-minded person will be at pains to trace any such false Report so far as to find out and Convict the First Raiser of it he will in this Paper (unless just Advice be given to the contrary) expose the Name of such person, as A malicious Raiser of a false Report. It is suppos'd that none will dislike this Proposal, but such as intend to be guilty of so villainous a Crime.

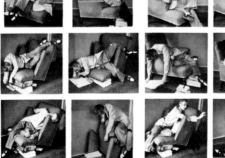

Farewell etaoin shrdlu, chronicling the last day of hot metal typesetting at The New York Times.

The Last Whole Earth Catalog

Updated

A Reconstruction of the Newspaper Industry in 5 Easy Afflictions

THE FIRST / LAST NEWSPAPER
DEXTER SINISTER

BLANK SL8

COMMISSIONED
BY PERFORMA
IN PARTNERSHIP
WITH THE TIMES
SQUARE ALLIANCE
AND THE FASHION
CENTER BID

CURATED BY
DEFNE AYAS WITH
VIRGINIE BOBIN

Opposite: Front page of the first issue of Dexter Sinister's THE FIRST / LAST NEWSPAPER, 2009. Courtesy the artists.

Below: View from the window of Dexter Sinister's THE FIRST / LAST NEWSPAPER, 2009. Photo by Paula Court.

At Performa's invitation, publishing imprint and self-described Lower East Side "pamphleeters" Dexter Sinister (designers and writers David Reinfurt and Stuart Bailey) transformed Blank SL8—a "pop-up" hosting space facing the *New York Times* building and adjacent to the Port Authority Bus Terminal—into a fully functioning newspaper office, where they and their guest collaborators (writers, artists, and designers including Steve Rushton, Jan Verwoert, Rob Giampietro, Dan Fox, Walead Beshty, Jason Fulford, Will Holder, Tamara Shopsin, and Angie Keefer) wrote, edited, designed, printed, and distributed six issues of a biweekly broadsheet during the three weeks of the biennial: *THE FIRST / LAST NEWSPAPER*, which was to reflect "as much the current state of news media as anything else."

The editorial team worked daily in the vast storefront space, which was filled with large glass tables enclosing back issues of the paper. Three thousand copies were printed every Wednesday and Saturday and dispatched across the city, both distributed by hand and pasted on six "street readers": eight-foot-high plywood structures placed at public sites such as Port Authority and Cooper Union. A program of screenings (including two showings of *Farewell Etaoin Shrdlu*, a 1980 tribute to the last edition of the *New York Times* to be set using the hot metal printing process), talks (including one by former *New York Times* lino-

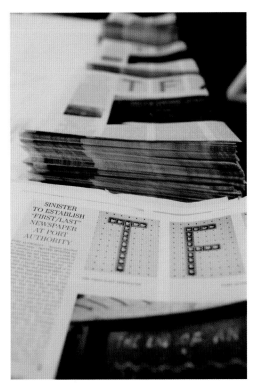

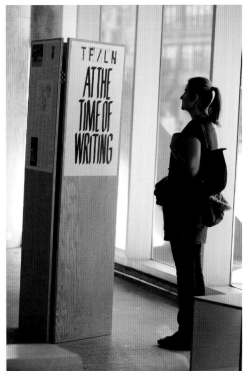

Above, left: Dexter Sinister, THE FIRST / LAST NEWSPAPER, *2009. Installation view. Photo by Paula Court. Right:* THE FIRST / LAST NEWSPAPER *"street reader" in the Performa Hub, 2009. Photo by Paula Court.*

Opposite: Dexter Sinister, THE FIRST / LAST NEWSPAPER, *2009. Installation view. Photo by Paula Court.*

type operator Carl Schlesinger), and workshops (such as a "one-day production project" led by artist Walead Beshty) added to the ongoing activity at this new expression of Dexter Sinister's "Just-in-Time" production policy. For the closing-night party, fish and chips were served in folded issues of *THE FIRST / LAST NEWSPAPER* while artist Gareth Spor's version of Brion Gysin's seminal *Dreammachine*—a light-based flicker device first made in the early '60s and said to induce a hypnotic trance—projected an aphorism by Gysin himself: "Illusion is a Revolutionary Weapon." The contents of all six issues were reprinted in *Dot Dot Dot* #19, available at dextersinister.org.

—*Virginie Bobin*

THE PIGEON-LIKE UNEASE OF MY INNER SPIRIT
AHMET ÖĞÜT

BIDOUN
MAGAZINE SPACE

COMMISSIONED
BY PERFORMA

CO-PRESENTED
BY BIDOUN
MAGAZINE AND
PERFORMA

CURATED BY
DEFNE AYAS

Ahmet Öğüt, The
Pigeon-Like Unease of
My Inner Spirit, *2009.
Performance view.
Photo by Paula Court.*

On January 19, 2007, in broad daylight, charismatic Turkish Armenian journalist Hrant Dink was shot and killed in Istanbul in front of the building where he worked as founding editor-in-chief of the weekly newspaper *Agos*. His final column, "The Pigeon-Like Unease of My Inner Spirit," published the morning of his assassination, outlined his prosecution by ultra-nationalist lawyers for "denigrating Turkishness" and the death threats that he and his family had received. Dink's legacy as an outspoken advocate for Turkish-Armenian reconciliation, and as one of the few Armenians in Turkey who broke the taboo on discussing the 1915 genocide of Armenians in the Ottoman Empire, was the subject of Ahmet Öğüt's first live performance in New York, titled after Dink's last article.

Öğüt, himself part of the Kurdish minority in Turkey, created an homage to Dink that also evoked the years of darkness obscuring the fate of the Armenian Turks: He commissioned the legally blind artist Devorah Greenspan to sit with him in a pitch-dark space over a three-day period and paint a portrait of Dink based on their discussions about Dink's philosophy and beliefs, his dreams and fears. The performance took place in a downtown storefront. Viewers were given a flashlight upon entering, and made their way to the far end of the space, where Öğüt and Greenspan sat talking at her easel. With the darkness suggesting a state between wakefulness and dreaming, the atmosphere was one of somber tribute to a relentless crusader for justice.

—Defne Ayas

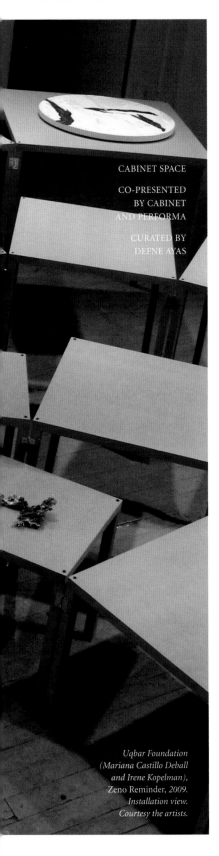

*Uqbar Foundation
(Mariana Castillo Deball
and Irene Kopelman),
Zeno Reminder, 2009.
Installation view.
Courtesy the artists.*

ZENO REMINDER

UQBAR FOUNDATION (MARIANA CASTILLO DEBALL AND IRENE KOPELMAN)

In Jorge Luis Borges's 1940 short story "Tlön, Uqbar, Orbis Tertius," the narrator tries to determine whether or not a place called Uqbar is real. A postscript, itself added by characters within the fictional story, reveals that Uqbar is indeed imaginary. Inspired by this and other writings by Borges, artists Irene Kopelman and Mariana Castillo Deball formed Uqbar Foundation in 2006 to create work drawing from diverse fields including epistemology, science, and literature. For *Zeno Reminder*, they traveled to the International Center for the Study of Futurism at the MART museum in Rovereto, Italy, to examine the dynamic shapes of artist Fortunato Depero. Their installation—a wooden, table-like structure spiraling through *Cabinet* magazine's Brooklyn exhibition space—merged Depero's innovations, Borges's tantalizing ideas about the mazelike nature of the mind (as elaborated in his 1941 stories "The Garden of Forking Paths," which intertwines book and labyrinth, and "The Library of Babel," which describes the universe as a library of interlocking hexagonal rooms), and their own favorite patterns in sacred Islamic architecture. This striking structure became the set for an exhibition of small sculptures, drawings, and paintings by Kopelman and Castillo Deball; a libretto reading by University of Pennsylvania professor Reinaldo Laddaga; and a screening of Castillo Deball's film *Nobody Was Tomorrow* (2007), a Borgesian "children's story." Visitors walking around the structure negotiated a labyrinthine environment in which both the design of the table and the esoteric objects on view both acted as conversation-starters and alluded to possible paths into the Uqbar Foundation's imaginary worlds.

—*Defne Ayas*

BAREFOOT IN THE HEAD: FUTUROLOGICAL POETRY READING

THE BRUCE
HIGH QUALITY
FOUNDATION
UNIVERSITY

CURATED BY
MARK BEASLEY,
JOHN RUSSELL,
AND ALUN
ROWLAND

Barefoot in the
Head: Futurological
Poetry Reading, *2009.*
Performance view.
Photo by Paradise
Gonzalez.

Barefoot in the Head was a series of presentations inspired by the 1969 prose and poetry novel of the same name by the British science-fiction writer Brian Aldiss (b. 1925). Aldiss's book, considered his most experimental work, reflects the shattering of language under the influence of drugs, with narration and dialogue turning into mutated phrases, puns, and allusions in a deliberate echo of James Joyce's *Finnegans Wake* (1939). The artists and musicians invited to respond to Aldiss's hallucinogenic vision created poetic textual works that were performed at the Bruce High Quality Foundation University in Lower Manhattan; a resultant publication, published by Article Press, was stored for perpetuity at the Brian Aldiss archive at England's Reading University.

The "futurological poetry reading" was staged in two makeshift lecture rooms split over two floors, with a bar in the upper room and crowds of people throughout. Writer and musician Dan Fox opened the evening with a satiric address and an introduction to Aldiss's work. In the presentations that followed, writer and editor Will Holder read a text simultaneously on both floors; designers and publishers Dexter Sinister gave a spoken-word recitation via a ventriloquist's dummy; artist Amelia Saul intoned the stage directions of Samuel Beckett's *Happy Days* (1961), in which a woman is buried in a giant mound of earth; a video performance by Susanne Clausen examined the relationship between mother and child; psychedelic projections and heavy rock guitar by musician Rose Kallal accompanied by Mark Beasley and members of the Bruce High Quality Foundation reading from an Aldiss text; and music duo Blanko & Noiry mixed melodramatic pop songs, electronic sounds, and poetic lyrics. Throughout the evening, artist and educator John Russell sat with his back to the audience, declining to look—a reminder that the ear, unlike the eye, cannot be shuttered; it makes poetry of all things.

—*Mark Beasley*

3 LECTURES + 1 STORY = 4 EVENINGS
ALEXANDRE SINGH

WHITE COLUMNS

PRESENTED BY
WHITE COLUMNS
IN PARTNERSHIP
WITH PERFORMA

CURATED BY
MATTHEW HIGGS

Alexandre Singh, The Assembly Instructions, *2009. Performance view. Photo by Paula Court.*

Following spread: Notes for Alexandre Singh's "Ikea," part of The Assembly Instructions, *2009. Courtesy the artist.*

In his modern epic *The Alkahest*, Alexandre Singh recounts three interwoven stories in which monks, golems, parrots, and historical characters such as Kurt Schwitters, Richard Wagner, and Alfred Barr are searching for the mythical cure-all "alkahest," which alchemists have sought for centuries. Throughout the evening-length telling of this tale, the artist, wearing his trademark black suit, paced around an overhead projector—to him, a contemporary version of the crackling fire—on which he placed colored acetate sheets and props such as a glowing glass of soy milk (representing "The Holy Grail") and a burning glove ("The Invention of Fire"), to the enchantment of the audience, seated in a circle around him. Three and a half hours long, *The Alkahest* was a physical marathon for both artist and audience: of the 150 people present at the beginning, only 20 braved it to the end.

On the following three evenings, Singh performed episodes from his lecture series *The Assembly Instructions*, which combines rhapsodic academic-style presentations with more meandering discussions on various tangents. With the audience this time sitting in rows facing images beamed from a pair of overhead projectors, Singh moved smoothly back and forth between the projectors, slipping on and throwing off hundreds of black-and-white acetates of photocopied collages. "Tangential Logick" and "Tangential Magick" explore structures of thought and illusion through unexpected images; "Ikea" focuses on the Memory Palace mnemonic technique; and "An Immodern Romanticism" confronts contemporary romanticism through television heroines Carrie Bradshaw (*Sex and the City*) and Meredith Grey (*Grey's Anatomy*). As he always does in his performances, Singh embroiled his tales in the surrounding architecture; on this occasion, White Columns (and its director, Matthew Higgs) became part of the intricate narrative. On these four fascinating evenings, Singh joined elements from all the disciplines in which he works with his abiding interest in combining reality and fiction to question our systems of gathering knowledge.

—*Stefano Collicelli Cagol*

9.

FIND YOUR LOCAL IKEA STORE.

Conveniently you are never too far from an ikea store.

10.

For an IKEA Store might perhaps be of all current RETAIL environments, best serve our purposes as a MEMORY PALACE.

"Information is encoded into a static field of furniture and household objects.

11.

Ingvar Kamprad. — The Architect of our Architectonic System of Knowledge.

Architectonic Systematisation of knowledges esp. of ARISTOTLE + KANT. of ALL KNOWLEDGE.

12.

The Circuitous path, THE LONG NATURAL WAY, Collection — recollection.

13.

Read — Write. Experiment on WHITE MICE in a maze The act of learning = the act of discovering THAT IS equivalent to WRITING.

All other is simply READING.

Young mind is like an empty store.

15.

Knowledge is accumulated like possessions.

(16) The IKEA store can be read. Like a girl through OSMOSIS. One can even wander about absorbing the information without conscious machination.

— like Reading the MUSIC, written word.

— Self service item [19] [7] will bring the mind immediately to that shelf and to that idea. That in 495AD, in Britain, there were 14 churches and 8 bishops.

(17) PLAN OF IKEA, follow the path, learn

— LIVING ROOMS

— WALL UNITS + MEDIA STORAGE (LOGIC / LANGUAGE)

(18) PAX " Right where you put it ".

— Plants → Shoes ROOTS, family 884 sub-groupings of plants.

19 Plan of all Knowledge

20 Monerans.

(21 + 22) — Folded Duvet = COELENTRATES
Jelly fish, sea anemones,
Animals. corals, Portugese mans of war.

koilos = hollow Hollow More Complex.
enteron = GUT GUT. Folded material.

FUTURIST LIBRARY
SERGE BECKER

SWISS
INSTITUTE

Serge Becker,
Futurist Library,
*2009. Installation
view. Courtesy Swiss
Institute.*

It is quite unlikely to find a round bookcase in a library— presumably because most books, like most rooms, are rectangular. The Swiss Institute's Reading Room was furnished with a one-of-a-kind *Futurist Library* created by Swiss-born graphic and interior designer Serge Becker, who is also a creative entrepreneur on downtown New York's restaurant scene. Becker thought it would be interesting to build a bookcase using unconventional means that also contained a secret inner life. Constructed out of wood and Mylar, and inspired by the architecture of skyscrapers and Op art, the bookcase held publications on several circular levels, occasionally interrupted by an oval peephole in the gray wall of the central cylinder. These peek-a-boos teased the curiosity of the visitors and afforded a vertigo-inducing view into the inside of the bookcase, where a funhouse-style mirror riddled with the reflected faces of other viewers peering in added a fourth dimension to the structure— which was sometimes confusing and irritating, and sometimes as enjoyable as the rabbit hole in *Alice in Wonderland*. During Performa 09, rather than hardcover books, the shelves held dozens of copies of the fantastic Futurist reader edited by Performa that was used as a jumping-off point for the biennial.

—*Gianni Jetzer*

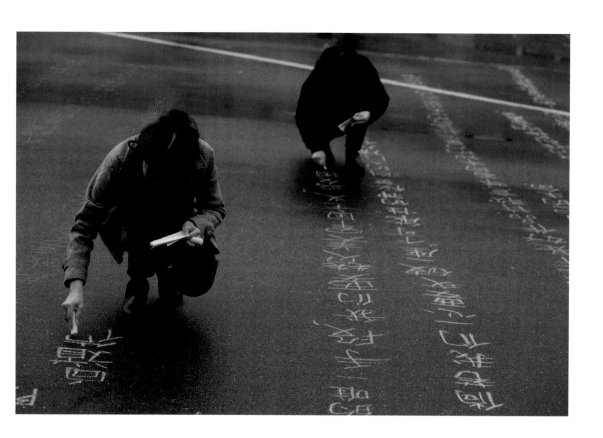

LITTWITCHALK

TAN LIN

P.S. 2
PLAYGROUND

Tan Lin,
LitTwitChalk, *2009.*
Performance view. ©
Nisa Ojalvo 2010.

It was a drizzly day when we all met on the playground of P.S. 2 on the Lower East Side for Tan Lin's *LitTwitChalk* performance. A few days before, I had received instructions, as one of about forty New York City poets invited to participate in the event, to bring content gathered from social networking feeds like those on Twitter and Facebook. When we got to the playground, Lin and several volunteers distributed colorful chalk to the participant/performers, who included Chris Alexander, Bruce Andrews, Anselm Berrigan, Robert Fitterman, Kristen Gallagher, and Paolo Javier as well as Performa 09 audience members and random bystanders. Lin told us to "feed" the material we had gleaned from the Internet into chalkings, which ranged from statements about corporate branding, to poems by favorite authors, to Luddite responses to Twitter ("I hate Twitter"; "When I see you I don't think of Kilowatt hours"). Other participants were chalking translations of the Futurist Manifesto into Chinese—a nod to the biennial's centennial celebration of that document and the playground's location in Chinatown—as well as the fact that Lin would introduce the Chinese American poet John Yau later that afternoon at the Museum of Chinese in the Americas. Through pure luck, the rainfall that day added vibrancy to the chalkings, deepening their colors and artfully smudging the text. It also, eventually, washed them away, emphasizing the ephemeral nature of both chalking and tweeting as forms of writing.

—Thom Donovan

SPEED READING

DEFINITIONS
GYM

PRESENTED
BY CABINET
MAGAZINE

Speed Reading, *2009.*
Performance view.
Photo by Paradise
Gonzalez.

On November 14, 2009, twenty-four intrepid artists and writers assembled at dusk at a temple dedicated to the pursuit of physical perfection—the downtown branch of New York's Definitions Gym—to participate in the world's first literary relay race. Conceived by *Cabinet* magazine, *Speed Reading* took the 100th anniversary of the Futurist Manifesto as an occasion to recover speed, now imagined primarily as a tool for increasing productivity, in its radical avant-garde guise as a disruptor of complacent subjectivity. Taking turns on a pair of side-by-side treadmills, the participants astonished the assembled hundreds by courting disaster—much like Marinetti as he hurtled down the dark road before his legendary automobile accident—as they ran and read short excerpts from novels, manifestos, poems, philosophical treatises, children's stories, timetables, recipes, parables, scientific experiments, instructional manuals, and dictionaries. In contrast to Futurism, however, the organizing principle of Cabinet's event was less a celebration of the *fast* than a consideration of *pace* in all its various manifestations.

The event included a full range of velocity-inspired writings, from the plaque text commemorating the great Boston Molasses Disaster to Harvey Cohen's "Amphetamine Manifesto," from the founding document of the Slow Sex Movement to Formula One Grand Prix commentary, from Alfred Jarry's "The Crucifixion Considered as an Uphill Bicycle Race" to J. G. Ballard's "The Assassination of JFK Considered as a Downhill Motor Race." The marathon concluded with a truly heroic recitation of the chariot race sequence from Homer's *Iliad*, performed by a prominent academic running at a frenzied pace while weighed down by dumbbells and various other pieces of gym equipment. As in Marinetti's original manifesto, the gouty onlookers crowded terrified around this and the other marvels offered by *Speed Reading*, and felt the red-hot poker of joy deliciously pierce their hearts. And then runners and spectators, both covered in useless sweat and celestial grime, retreated to the libations table to drink deep into the night.

—*Jeffrey Kastner and Sina Najafi*

BRIGHT FUTURES

JOHN MALPEDE

During the early months of the financial crisis in late 2008, actor, activist, and writer John Malpede was in residence at MIT's Center for Advanced Visual Studies. In response to the crash, Malpede developed the lecture-performance *Bright Futures* from two found sources: a "business-school pep talk" that he attended, in which nervous students were reassured by reliable sources that the crisis was just a blip in an otherwise fail-safe system; and MIT economist Simon Johnson's article "The Quiet Coup," published in the *Atlantic Monthly* in May 2009, which argued that the banks and financial institutions that caused the economy's collapse were actively impeding its recovery. The contradictory texts were presented in a small lecture theater at NYU by three actors, mediated by Malpede, with additional interruptions and contradictions provided by plants in the audience, in an event intending to call out the arrogance of Wall Street and its "business as usual" policies.

—*Mark Beasley*

MICHELSON THEATRE, TISCH SCHOOL OF THE ARTS

CURATED BY MEG ROTZEL

PRESENTED BY MIT'S CENTER FOR ADVANCED VISUAL STUDIES AND NEW YORK UNIVERSITY

THE FUTURISMS OF AMERICAN POETRY: A READING BY CHARLES BERNSTEIN AND JOHN YAU

Charles Bernstein and John Yau came together to read work that upset traditional notions of what poetry is—Bernstein by giving a spirited recantation of his own poetry, and Yau by speaking in a hybrid language that might be called Chinglish, or, in Yau's formulation, "Engrish." In his reading of "Recantorium" (2009), Bernstein, a poet best known for his work with the Language poets, implicated poetry in the work of regulating good taste, "the canon," and ideals of beauty, thus exposing the myriad ways that poetry performs in the social sphere. In Yau's reading, the poet and critic recited poems containing broken syntax, poor pronunciation, racist stereotyping, "Charlie Chan English," and other failed forms of communication, suggesting the ways in which mastery of a language is suffused with judgments about social and economic success. —*Tan Lin*

MUSEUM OF CHINESE IN AMERICA

CURATED BY TAN LIN

VOCABULARY LESSON
CORO COLLECTIVE

SWISS
INSTITUTE

Known for transforming public spaces into the settings for performances that feel like live music videos, CORO Collective used voguing, a dance style popularized at gay clubs in the 1980s and later immortalized by Madonna, to play with the relationship between dance and architecture in their New York debut. Derived from 1930s ballroom dance, voguing is a modified form of miming in which imaginary geometric shapes, like a box, are outlined through movement. When visitors to *Vocabulary Lesson* arrived at the Swiss Institute, on the third floor of 495 Broadway, the elevator doors opened on a dark hallway blocked by the three female members of CORO Collective (Egle Budvytyte, Goda Budvytyte, and Ieva Miseviciute), who had wedged themselves in the gallery's front door and were striking poses alternating between pillar-like stoicism and stylized fashion shapes. Thumping techno beats drew visitors past the performers into the gallery, where full-wall projections showed a multi-channel music video in which CORO Collective, dressed in angular costumes with pyramidial shoulder pads and cylindrical headdresses, clicked their torsos into sharp, staccato permutations in front of the Vilnius Sports Palace, a now-defunct arena in Lithuania featuring startlingly geometric concrete architecture that became a symbiotic backdrop for the women's shape-focused choreography.

—*Piper Marshall*

FUTURIST MANIFESTOS

Futurist Manifestos was an exhibition that presented the first editions of many of the original Futurist manifestos, including "The Founding and Manifesto of Futurism" (F. T. Marinetti, 1909), "Let's Murder the Moonshine" (Marinetti, 1909), "The Manifesto of Futurist Musicians" (Balilla Pratella, 1912), "The Plastic Foundations of Futurist Sculpture and Painting" (Umberto Boccioni, 1913), "Futurist Manifesto of Men's Clothing" (Giacomo Balla, 1913), and "The New Religion—Morality of Speed" (Marinetti, 1916). The first page of each manifesto was also photocopied and handed out by volunteers and ICI staff to passersby walking along Park Avenue in front of the ICI's building, so that as many people as possible could have a piece of these revolutionary documents that the Futurists intended to be a mosaic for rebuilding the universe.

—*Renato Miracco*

ITALIAN
CULTURAL
INSTITUTE

CURATED BY
RENATO MIRACCO

FUTURISM AND WOMEN AND FUTURISTE: WOMEN IN ART AND LITERATURE

Futurism and Women was a panel discussion held during the opening of the exhibition *Futuriste: Women in Art and Literature,* which showcased paintings, drawings, and first-edition books by prominent female Futurist artists and writers of the early twentieth century, including Benedetta Cappa Marinetti, Ruzena Zatkova, and Olga Biglieri Scurto, a pilot whose pseudonym "*Barbara dei colori*" (Barbara of the colors) described her aerial-view paintings. Moderated by art historian Ara H. Merjian, who spoke about the protagonist of F. T. Marinetti's 1909 novel *Mafarka le Futuriste,* a man whose twenty-foot penis becomes the mast of a ship—the perfect example of the Futurists' male-centric worldview—the panel included Liza Panzera, Giancarlo Carpi, and Christina Poggi, all of whom shed light on the question of women's role in Futurism, and why, despite their contributions, the feminized word "*futuriste*," as Merjian pointed out, "still spills strangely from the tongue." —*Lana Wilson*

CASA ITALIANA
ZERILLI-MARIMÒ

BEYOND FUTURISM: F. T. MARINETTI, WRITER

TEATRO OF THE
ITALIAN ACADEMY
AND THE ITALIAN
CULTURAL
INSTITUTE

PRESENTED BY THE
DEPARTMENT OF
ITALIAN, COLUMBIA
UNIVERSITY

ORGANIZED BY THE
ITALIAN ACADEMY
FOR ADVANCED
STUDIES IN AMERICA
AT COLUMBIA
UNIVERSITY AND
THE ITALIAN
CULTURAL
INSTITUTE IN
NEW YORK

This two-day symposium devoted to the father of the Italian avant-garde, Filippo Tommaso Marinetti, was the first part of a conference that continued with *Futurismo/Futurizm*. Marinetti's granddaughter Francesca Barbi, daughter of the late Luce Marinetti Barbi (1932–2009), to whom the event was dedicated, kicked off the proceedings with a reading of "The Futurist Manifesto" in the sumptuous Teatro of the Italian Academy at Columbia University. Italian Cultural Institute director Renato Miracco then joined Barbi onstage for a histrionic reading of some Futurist "words in freedom." At the symposium the next day, the presentation of academic papers alternated with lively literary readings. The poetic readings—frequently performed with great dramatic flair—included Marinetti's final poem, written on the very day of his death, "Quarto d'ora di poesia della X Mas" (Quarter Hour of Poetry of the Xth Mas). As Marinetti wrote in "The Futurist Manifesto," "Standing tall on the roof of the world, yet once again, we hurl our defiance at the stars!" —*Paolo Valesio*

FUTURISMO/FUTURIZM:
THE FUTURIST AVANT-GARDE IN ITALY AND RUSSIA

THE BEINECKE
RARE BOOK AND
MANUSCRIPT
LIBRARY, YALE
UNIVERSITY, NEW
HAVEN

PRESENTED
BY THE
DEPARTMENTS OF
ITALIAN, SLAVICS,
AND FILM
STUDIES AT YALE
UNIVERSITY

This two-day event in New Haven, Connecticut, the second part of the international conference that began with *Beyond Futurism*, opened with Marjorie Perloff's keynote speech (which explored connections between the Italian and Russian avant-gardes, focusing on Marinetti's visit to Moscow and St. Petersburg in 1914) in the beautiful setting of the Beinecke Rare Book and Manuscript Library, which preserves a treasure trove of Marinetti-related materials as well as a range of important European and Russian modernist art documents. The day after, a dense roster of scholarly papers addressed various aspects of Italian and Russian Futurism, in the tradition of Italian Futurism's broad notion of what constitutes a text—thus ranging from the verbal to the visual. —*Paolo Valesio*

THE POLYEXPRESSIVE SYMPHONY

CAPTURED ON FILM

The scant cinematic output of the Futurists was put to impressive use in Performa 09's film programs, which included "city symphony" movies shown outside with a live score, a retrospective of rare Futurist-related films, and a fiery "Futurist film funeral" in three parts. Gorgeous moving-image work by Tacita Dean, paying tribute to the process and aesthetic of choreographer Merce Cunningham, and the extraordinary Performa TV platform, which drew three million visitors to Performa's website in November with exciting clips from each day's performances, heightened and enriched the biennial's wide-ranging media program.

CRANEWAY EVENT
TACITA DEAN

DANSPACE
PROJECT

A PERFORMA
PREMIERE

CO-PRESENTED
BY DANSPACE
PROJECT AND
PEFORMA

Opposite and following spread: Tacita Dean, Craneway Event, *2009. Film stills. Courtesy the artist and Marian Goodman Gallery.*

Tacita Dean made *Craneway Event* at the invitation of the late choreographer Merce Cunningham, whose company was then rehearsing at the Craneway Pavilion, a former Ford assembly plant overlooking San Francisco Bay. Using two cameras, Dean shot seventeen hours of 16 mm footage over three days, then spent six months editing the footage into a feature-length film.

The anamorphic (or widescreen) projection captures the dancers preparing for a public performance. Characteristically, Dean's film is ruminative and non-narrative, and like the other portraits she has made of great artists, the admiration of her subject is overt. Here, however, Dean's affection is echoed by the palpable reverence the dancers feel for their teacher, a master artist who, at age 89, exhibited extraordinary lucidity and verve. As such, *Craneway Event* is a poignant study of a community, and an intimate window onto Cunningham's working process.

The performance being rehearsed falls into a category that Cunningham termed "Events," in which excerpts from preexisting pieces are woven together to form new compositions, and dancers occupy multiple stages simultaneously. Such synchronicity creates marvelous juxtapositions and layers, but also denies the audience a holistic experience: when watching, one is attuned to having chosen a particular vantage point. Similarly, Dean's distinctive style—long, motionless shots rather than jump cuts and pans—makes the viewer acutely aware of the off-frame activity that is perpetually out of reach. This is evident in *Craneway Event*, where non-action (the play of light and shadow across the glass-enclosed building, the path of an errant pigeon wandering the sprung floor, a passing tanker) features as prominently as the company itself. Such commitment to detail and context, however, befit Dean's subject, who shared her passion for simple, straightforward gestures and ordinary happenings. As Cunningham noted, "Stillness is just as much a part of dancing as moving."

Craneway Event was the second and last work the two artists

made together—Cunningham died while Dean was editing. She has written eloquently about finishing the piece without him, and the cathartic sensation of feeling his "directional force" as she worked. Premiered in New York in November 2009, some three months after his death, it was experienced by many as a kind of eulogy. Fittingly, the screening was held at St. Mark's on the Bowery, an arts-centric parish where Cunningham had danced many times before. —*Katie Sonnenborn*

CITY SYMPHONIES OUT OF DOORS
TEXT OF LIGHT

THE HIGH LINE

CO-PRESENTED
BY FRIENDS OF
THE HIGH LINE
AND PERFORMA
WITH ROOFTOP
FILMS

CURATED BY
LANA WILSON
AND ESA NICKLE

I'm not much for watching movies out of doors on blustery, wet fall evenings, but this double bill screened on the High Line, the old elevated railway that runs through Chelsea that has recently been refurbished into a public park, was so smart, evocative, and compelling that it was worth withstanding the cold. The program paired Charles Sheeler and Paul Strand's eleven-minute film *Manhatta* (1921) with Walter Ruttman's feature-length *Berlin, Symphony of a Great City* (1927), the latter accompanied live by Text of Light, an ensemble that performs improvised music to avant-garde films with a somewhat rotating cast of musicians; for this event, the group comprised composer and saxophonist Ulrich Krieger, guitarist and composer Alan Licht, turntablist and visual artist Christian Marclay, and Sonic Youth cofounder Lee Ranaldo.

Reflecting its creators' primary art forms (for Sheeler painting, and Strand photography), the series of tableaux that make up *Manhatta* suggest a set of stills, or paintings of the city rendered in film. It opens with footage of the Staten Island Ferry docking in Lower Manhattan. As the deck gate is pulled back, morning commuters rush into the canyons of the Financial District, an image emblematic of how the film portrays New York's citizens as either a mass, a single entity like the thronging ferry passengers, or antlike pedestrians scrambling in the streets, as viewed from the rooftops and windows of skyscrapers. They serve for scale and are dwarfed by the mass and height of buildings, and it's the buildings—their majestic towers, their broad facades and the steeple-like massing of their tops—that are celebrated, not the people. Highlighted, framed, lingered over lovingly in long shots, they are almost frozen, monumentalized as geometric forms much as each of the two artists treated buildings (such as factories, farms, and skyscrapers) in their usual mediums.

Berlin, Symphony of a Great City also presents an imaginary day in the life of the titular metropolis. At sixty-five minutes, it's much longer than *Manhatta* and far more experimental, representing the culmination of the "city symphony" films that

Text of Light, City Symphonies Out of Doors, 2009. Performance view. All photos this section by Paula Court.

emerged in the 1920s and sought to capture urban life through a mixture of documentary footage, abstract visual compositions, and rhythmic editing. Because Berlin was a low-rise city before the Second World War, most of the footage was shot at street level (although there are a few sequences from or of passenger planes). In part because of this point of view, but mostly because the film concentrates on the actions of its denizens, Berlin comes off as a city of its people. Its streets, cafés, buses, trains, restaurants, dancehalls, offices, factories, and stores are thronged. Its day is a ceaseless scrum of activity bookended by scenes of empty sidewalks at dawn and midnight. Shots of whirring machines taken from oblique angles, close-ups of typists' fingers whizzing across keys and images of clerks opening roll-top desks suggest the influence of Soviet photography and Futurist dynamism; but the underlying mood is not celebratory. Rather, it's somewhat sad. Much of Berlin, as seen, is working class or poor. Beggars are pictured. A mother with two ragamuffins sits on the curb. The looks from dancers in cafés seem tinged with weariness. People seem to be going about their business and pleasure with a face-to-the-wind earnestness, except for the rich, who are chic, svelte, and satisfied. It's a vision inflected by Neue Sachlichkeit, Käthe Kollwitz, and George Grosz's biting social barbs.

Text of Light's noise score was a perfect complement. Beginning with all four performers up front and center behind four Futurist *intonarumori* noise machines, whose grinding industrial sounds slowly built in volume, and then leading to the musicians moving outward to other instruments on stage, including a turntable set for Marclay, their clipped, urgent, rushing cascades of screeching noise and whining guitars matched the visual rhythm of the film and captured the frenetic, almost frantic pace of the Berliners as they rushed about their days. In the same way that the film was not entertaining, but compelling for its directness and energy, the music was compelling for its dense overlay of sounds, its masterful pacing, and its suggestion of both the order and chaos, vigor and misery of the lives lived in the Berlin of the film. All this was rendered in the idiom of the sounds of a city, rather than some swollen mood-movie music, and in direct contrast to the florid original orchestral score that accompanied *Manhatta*.

Text of Light, City Symphonies Out
of Doors, *2009. Performance view.*

When it was over, each attendee received a coupon for a 50
percent discount on a cup of organic hot cocoa, redeemable a
couple of blocks further along the High Line. Which goes to
show how much things have changed, and how much not. As
I walked home alone along the raised right-of-way and saw the
Empire State Building glowing purple in the mist, I could, for
that moment, have been in *Manhatta*: as proud of its possibili-
ties and rough beauties as was Walt Whitman—whose texts were
interspersed in the film—when he lived here. —*Joshua Mack*

This article was originally published on ArtReview.com *on December 10, 2009.*

FUTURIST FILM FUNERAL (FFF !!!)
BRADLEY EROS

ISSUE PROJECT
ROOM

COMMISSIONED
BY PERFORMA

CO-PRESENTED
BY ISSUE PROJECT
ROOM AND
PERFORMA

Bradley Eros, Futurist
Film Funeral (fff !!!),
*2009. Performance
views. Photos by Paula
Court.*

Rumor has it that the Futurists, with their love of danger and destruction, may have actually incinerated some of their own films. Inspired by this idea, Performa commissioned artist and curator Bradley Eros—best known for his expanded cinema works that push the physical limits of film to extremes, and for his all-night festivals of projection and performance—to create his own "Futurist film funeral." At ISSUE Project Room, in the semi-desolate Gowanus neighborhood of Brooklyn, the evening began with part one of the three-part evening, "Synthetic History": a screening of *Trans Trans: Transformers Transformed,* a twelve-minute video in which Eros and Tim Geraghty juxtaposed layers and layers of CGI giant mechanical men from the recent action blockbuster *Transformers: Revenge of the Fallen* to approximate the aesthetic of Umberto Boccioni's Futurist paintings, accompanied by a propulsive sound track featuring German industrial noise band Einstürzende Neubauten; followed by a live drum and vocal duet performed by Brian McCarthy and Rachelle Rahme as a call-and-response between Marinetti's "Futurist Manifesto" and a contemporary countertext by the anarchist Bifo. In part two, "Plastic Dynamism," musicians TwistyCat (Lea Bertucci and Ed Bear) performed a noisy, free jazz–inspired set on reed and electronic instruments behind the projection screen while Eros melted and destroyed 16 mm film and gels in the projector gate, so that the silhouetted musicians were seen through colorful layers of bubbling, burning film stock.

The audience was then led outside to ISSUE's concrete courtyard, where the culminating event of the evening—"Sirens of Destruction," the much-anticipated "sacrificial incineration of the cinema apparatus," as Eros put it—commenced with artists Tony Conrad and Marie Losier throwing rotten tomatoes at Eros and his projection equipment, crying "Fascist! Fascist!" Eros ignored them and made his preparations, dousing the projector and screen with lighter fluid. A beat-up white pickup truck idled eerily nearby, headlights aimed directly at the setup;

ARIES MAR 21 — APR 19

Do you miss high school even a bit? I know the hor-rid mix of hormones, cruelty and trenchfoot grease made for some awful, humiliating moments, but wasn't there a kind of bittersweet abandon to youth? A quicksilver torrent of opportunity and vitality? Or maybe my memories are off. Maybe I'm the one with the problem, Aries. Maybe you're right to just bury all the sad nostalgia. Maybe.

TAURUS APR 20 — MAY 20

Do you know that Alan Alda almost wasn't Alan-ish? It's true. On his way to audition for the role of George Plimpton in *Paper Lion*, he ran into an old high school acquaintance. He chatted a bit, rapt with reminiscence, and Alda bought him coffee. It wasn't until the old flame noticed she was late for an appointment — her florist that Alda recalled his audition. Flowers everywhere, Taurus.

GEMINI MAY 21 — JUNE 20

I was driving around upstate New York last week, and the frequency of road kill was a real bummer: deer, raccoons, cats, ground hogs, a possum, a real estate agent, two Jehovah's Witnesses and the entire line-up of the 1994 Washington Generals. All of them, dead, just wandered out into the road like they're dead. It reminded me, Gemini, that life is precious, so we must live it.

CANCER JUNE 21 — JULY 22

Castles in Scotland are way overrated. Sure, they might appear glamorous and romantic, all those kilts and knotted brows, the mighty stags and mist-shrouded highlands, the sabers and the whiskey, but those places are *cold and damp. Not sexy.* It's like trying to get busy inside a giant stone fish. You can do better than that, Cancer. Spanish-style luxe, baby. Luxe is the new hotness.

LEO JULY 23 — AUG 22

The image of Virginia Woolf's suicide is particu-larly haunting, among all the sad lady writer suicides (Sylvia Plath, Anne Sexton). One can very easily see her, proper and quiet in her London overcoat filled with stones: a quick indrawn breath as she steps into the cold River Ouse, walks slowly against the current, head held up, eyes straight ahead. And then gone. Now I am sad, Leo.

VIRGO AUG 23 — SEP 22

The big question, Virgo, is whether or not you should cut your hair. I, for one, think you should. Further to that, you should consider yourself lucky that that's the most pressing thing you have to worry about at the moment. What if you had to decide whether or not you'd fly into space to save the Earth from an asteroid? That would be tough. *Bruce Willis* tough. Are you that tough?

LIBRA SEP 23 — OCT 22

"Stone Temple Pilots, they're elegant bachelors/ They're foxy to me, are they foxy to you..." Steve Malkmus had a whole treasure-trove of free-as-sociated lyrics plucked from the corn-syrup bin of his subconscious, but that one was always my favorite. Because, Libra, though I always hated their music and liked STP, sometimes, just sometimes, we need misdirection.

SCORPIO OCT 23 — NOV 21

Greater men have given in to temptation than you, Scorpio. I admire your resolve, your flinty ability to ignore your corporeal desires, your tenacious dedication to prudence and propriety. But are you really having fun with your life? Fun is not something you can plan for. Occasionally you have to be available to its particular spontaneity. OR YOU WILL DRY UP AND DIE!

SAGITTARIUS NOV 22 — DEC 21

We've all dreamed at one time of owning a flying bicycle. Some of you have thought to use your imaginary flying bikes for good (saving kittens, delivering ice cream to people in highrises), while others choose to plan for mischief (putting kit-tens in trees, stealing ice cream from highrises). What will you do, Sagittarius? With great power (or a flying bike) comes great responsibility.

CAPRICORN DEC 22 — JAN 19

The Solstice is nigh! King Arthur shall awake and smite the enemies of the British Kingdom! Faer-ies and fauns shall flounce over the Manhattan avenues! Mead! Thou shalt drink mead! And the flowers will rise up and march across the Man-hattan Bridge in row upon row of bouquet! This is my favorite time of year, Capricorn. The sun never sets and crazy shit happens. Woot.

AQUARIUS JAN 20 — FEB 18

Crazy ups and downs are what you're all about, Aquarius — that pretty much goes with your sign. The key to surviving that roller coaster ride, though, is remembering this duality *at all times.* So when you're flying high, you're always aware that things could crash and, more importantly, when things look grim, they eventually turn around. If you can really internalize this, you'll be fine.

PISCES FEB 19 — MAR 20

Step on a crack, break your mother's back. I had a brief week-long run in the fall of my seventh year when I pretty firmly believed this to be a true fact about the world. So each day, as I walked to and from school, I danced along the sidewalk avoiding all the cracks. Until Jason Richie knocked me into Pam Dawber (no relation). My mother was fine when I got home. Stay rational, Pisces.

soon a mournful composition of siren sounds by artist Lary Seven began emanating from its speakers. Eros started the projector and then tossed a match, causing it to burst into flames, the shadows of which were cast across the screen. He moved over to the screen and burned that down, too, until nothing remained but a pile of ashes. The mood of the audience was anarchic and jubilant, as though they had all been part of a secret ceremony that might never be performed again.

—*Lana Wilson*

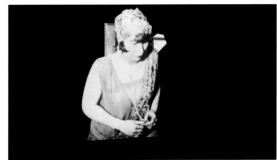

WAKE UP

NEW YORK CITY

NEW YORK CITY

● PERFORMA 09

PERFORMA TV

MANHATTAN
NEIGHBORHOOD
NETWORK
AND WWW.
PERFORMA-ARTS.
ORG

COMMISSIONED
BY PERFORMA

PERFORMA TV
COMMISSIONS
CO-PRESENTED
BY MANHATTAN
NEIGHBORHOOD
NETWORK AND
PERFORMA

CURATED BY
TAIRONE BASTIEN

Video stills from
Performa 09 intro
animation by Georg
Scherlin, 2009.
Courtesy the artist.

Performa TV, inaugurated in 2007, is an Internet-based video broadcast and commissioning program that provides a live, open, and public platform for the artists and organizers of the biennial. During Performa 09, the Performa website provided three million visitors with a front-row seat to exclusive biennial content, from performances to interviews with artists and curators. A team of videographers, led by Performa TV co-founder Pierce Jackson, covered all 150 events of the biennial, collecting hundreds of hours of material, which was edited and posted online within twelve hours. As Jackson said of this material, "It spread Performa 09 around the world almost instantaneously." It also now forms the basis of Performa's permanent media channel.

Performa TV also commissioned artists' projects that were broadcast on the Manhattan Neighborhood Network. *Circular File Channel* comprised three half-hour programs including work by Alex Hubbard, Fatima Al Quadiri, Uri Aran, and Takeshi Murata, as well as members of the Circular File Collective. Lucy Raven's *This Is a Test* consisted of five thirty-minute programs based on tests of the Emergency Broadcast System. Broadcast live from MNN on consecutive afternoons, they focused on a single setup: a small fire engine bathed in red or green light that gave the appearance of being at some times life-size, and at other times a toy, while the emergency tone was replaced by a recording of Tony Conrad's *From the Side of Man and Womankind* (1973), in which a violin's hypnotic drone is backed by a slow and steady drumbeat. Finally, Katie Paterson's *Ancient Darkness TV* transmitted an image of a starless void from the furthest point of the observed universe, formed 13.2 billion years ago, shortly after the Big Bang and before Earth existed. On the last day of the biennial, at 11:59 p.m., New Yorkers were invited to tune into MNN to stare into the darkness and look back in time for a single minute. —*Tairone Bastien*

Compilation of video stills from Circular File's This Is Our Tsunami, *directed by Josh Kline, Tatiana Kronberg, and Greg Edwards for Circular File, 2009. Courtesy the artists.*

Top: Taping in progress of Lucy Raven's This is a Test, *2009. Courtesy the artist.*
Bottom: Lucy Raven, This is a Test, *2009. Video still. Courtesy the artist.*

Broadcast of Katie Paterson's Ancient Darkness TV, *2009, at the home of Performa director RoseLee Goldberg. Courtesy the artist.*

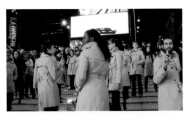 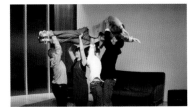 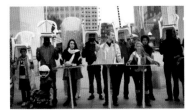

Arto Lindsay, SOMEWHERE I READ

Oliver Herring, 3 Day Weekend

Marcello Maloberti, The Ants Struggle on the Snow

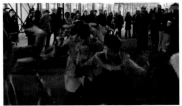

Martí Guixé, Mealing

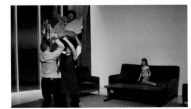

Dragan Živadinov, Dunja Zupančič, and Miha Turšič, Postgravity Art :: Syntapiens

Loris Greaud, The Snorks, Concert for Creatures [Trailer]

Darius Miksys, Artists' Parents Meeting

Video stills from Performa TV, produced and directed by Pierce Jackson, 2009.

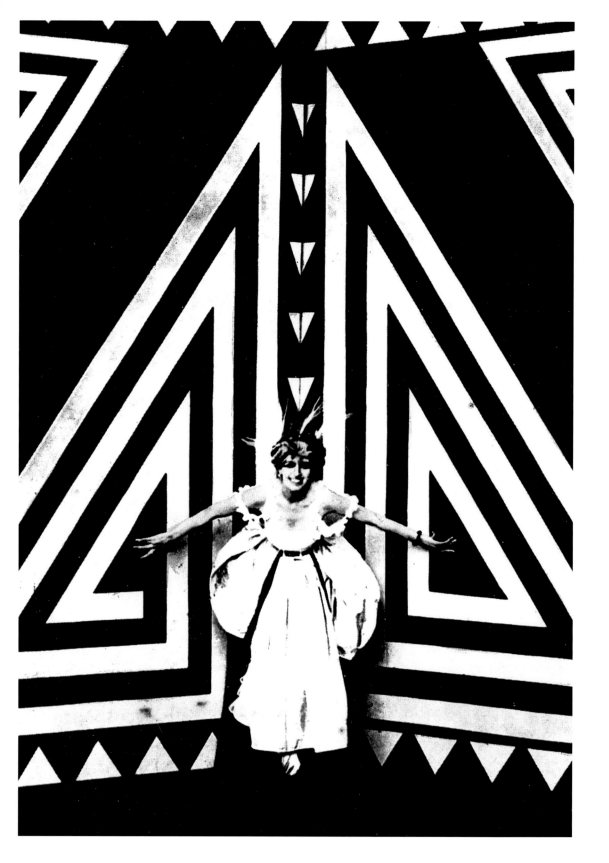

THE POLYEXPRESSIVE SYMPHONY:
FUTURISM ON FILM

ANTHOLOGY
FILM ARCHIVES

PRESENTED BY
PERFORMA

CURATED BY
LANA WILSON

*Anton Giulio
Bragaglia,* Thaïs, *1917.
Film still. Courtesy
George Eastman
House Motion
Picture Department
Collection.*

"The Futurist Cinema" manifesto of 1916, written by F. T. Marinetti, Bruno Corra, Emilio Settimelli, Arnaldo Ginna, Giacomo Balla, and Remo Chiti, declared that film was "the expressive medium most adapted to the complex sensibility of a Futurist artist." Though few Futurist films were made (and many of those were lost or destroyed during World War II), the ideas in the manifesto—such as using images drawn from outside the story world to create "cinematic analogies," and expressing states of mind through abstract shapes and movement—were highly influential on the burgeoning community of filmmakers in the early twentieth century. *The Polyexpressive Symphony* was a four-program film series showcasing existing Futurist films along with groundbreaking early works affected by Futurist ideas.

The Futurist Canon presented the US premiere of a partially surviving feature-length Futurist film, *Thaïs* (1917), a seemingly conventional Italian "diva" picture that builds to an experimental final sequence, in which geometric paintings by Futurist artist Enrico Prampolini transform into three-dimensional shapes that strangle a woman to death. *Thaïs* was shown alongside *Stramilano* (1929), a vibrant "city symphony" film of a day in the life of bustling Milan, and *Speed* (1930), another look at city life made by Futurist painter Pippo Oriani and Futurist writers Tina Cordero and Guido Martina featuring rhythmic editing and stop-motion animation.

Futurist-Related Performance on Film included *Pedestrian Love* (1914), the only filmed record of Futurist "reductionist performance," in which the story of a love triangle is told through shots of the characters' shoes; *Feet and Hands* (1915), a French film inspired by *Pedestrian Love* but showing performers' hands in addition to their feet; *Excelsior* (1914), an adaptation of the nineteenth-century ballet celebrating technology and progress, in which up to eight different planes of performers were laid out in stunning wide-angle tableaux; and *News Item* (1923), a surreal French short starring theater icon Antonin Artaud.

Two other film programs focused on the Futurist obsession

with the "mechanical man" and locomotives. *Man and Machine* featured *March of the Machines* (1929), an abstract mechanical symphony with a score written by Futurist artist Luigi Russolo (an interpretation of which was performed live on one of Performa's reconstructed *intonarumori* by Luciano Chessa); *The Belly of the City* (1932), an exhilarating look at the industrial food cycle, beginning with the butchering of cattle and ending with an infant drinking its mother's milk; and *The Mechanical Man* (1921), a rare fantasy-horror epic in which a colossal robot runs wild. *Trains, Trains, Trains* included the lyrical train station short *Impressions of Life #1: Railway Station Rhythms* (1933), the abstract film *Play of Reflections and Speed* (1925) by "pure cinema" leader Henri Chomette, and *The Steel Beast* (1935), a German film paying tribute to the Nurmburg-Furth railroad line that was later banned by the Third Reich for "decadent aesthetics."

Most of these films were silent, and accompanied live by composer and pianist Pete Drungle improvising scores on an electric keyboard, blending his gorgeous, richly textured musical language with his own impressions as a viewer to form another, deeply personal layer of cinematic analogy. —*Lana Wilson*

Gaston Ravel and Jacques Feyder, Des pieds et des mains (Feet and Hands), *1915. © GAUMONT.*

UNTITLED PERFORMANCES
EMMA HART AND BENEDICT DREW

In their first collaborative event in New York, London-based artists Emma Hart and Benedict Drew presented three performances from an ongoing series. For *Untitled 1.* (2005), the sound of a projector's fan played through a speaker filled with laundry powder, while the projector transmitted an image of the jumping granules. For *Untitled 2.* (2006), a loop of film leader scored with splices ran through a projector and the strings of an electric guitar Drew stood holding by the screen, each splice strumming a metallic *krrang*. In *Untitled 6.* (2009), a stretch of leader to which helium balloons were attached was strewn on the floor so that as the film ran, the balloons proceeded one by one toward the lens, throwing colored shadows. Here, as in *Untitled 2.*, the corridor of space perpendicular to the screen became the site of performance. As the audience members stood to either side, their focus shifted away from the screen onto the complex mechanisms of projection itself.

—*Ed Halter*

LIGHT INDUSTRY

CURATED BY
THOMAS BEARD
AND ED HALTER

Emma Hart and Benedict Drew, Untitled Performances, *2009. Performance view. Photo by Marten Elder.*

ENTANGLEMENTS FOR FOUR PROJECTORS

SANDRA GIBSON AND LUIS RECODER WITH BEN OWEN

LIGHT INDUSTRY

CURATED BY
THOMAS BEARD
AND ED HALTER

*Sandra Gibson
and Luis Recoder
with Ben Owen,
Entanglements for
Four Projectors,
2009. Performance
view. Photo by
Michael Galinsky.*

For *Entanglements for Four Projectors*, Sandra Gibson and Luis Recoder ran film loops of variously abraded 16-millimeter black leader through multiple projectors positioned on utility tables across one side of the large performance space, then created hypnotically elaborate images using simple means, such as setting the lenses at various degrees of focus, spraying mist onto plexiglass squares in front of the beams, or turning the projectors on their sides so that the film ran horizontally. "The footage is not what interests us per se," the artists wroite in a related statement, "but the effect it has in dispersing and/or scattering the projected light itself." Gibson and Recoder thus dissolved the typical square frame of projection in favor of ever-shifting sequences of spectral shapes, pulsating lines, and light-spot constellations. These visual elements were accompanied by audio signals generated by the film loops running over the projectors' optical sound readers, processed live by artist Ben Owen.

—Ed Halter

THE FUTURIST IMPULSE AFTER FUTURISM

ANTHOLOGY
FILM ARCHIVES

CURATED BY
ROBERT HALLER

Amy Greenfield,
Wildfire, *1994. Film
still. Courtesy the
artist and Anthology
Film Archives.*

In 1912, F. T. Marinetti embraced the motion picture as celebrating the values of the Futurist revolution—speed, progress, the energy of the machine, the "dematerialization of bodies"—and indeed, though very few Futurists made films, cinema proved in many ways to be the heir of Futurism. In *The Futurist Impulse After Futurism*, an evening-length film program, I focused on films that were made in the spirit if not in the name of Futurism. Francis Thompson's film *N.Y., N.Y.* (1957), in which some buildings curl up and float free of the ground, echoes Fortunato Depero's *Mechanical-Kinetic Set for the Ballet New York New Babel* (1929–30), in which all the buildings lean in different directions. Hilary Harris's film *Highway* (1958), with its hurtling cars on expressway ramps, evokes Marinetti's racing cars and Umberto Boccioni's *Forces of a Street* (1911). The dream of Futurist brothers Arnaldo Ginna and Bruno Corra—who, as early as 1911, made abstract "chromatic music" films by painting color directly onto film stock—was realized in the 1960s and '70s by Paul Sharits's color "flicker" films (including *Declarative Mode*, 1976). Bruce Elder's *Sweet Love Remembered* (1980) recalls Valentine de Saint-Point's "Futurist Manifesto of Lust" (1913) through its multiple-exposure depiction of nude women caressing and clasping each other. The program also included Henri Chomette's *Jeux des reflets et de la vitesse* (1925); Ralph Steiner's *Mechanical Principles* (1931); Wheaton Galentine's *Treadle and Bobbin* (1954); and Amy Greenfield's *Wildfire* (2003), in which footage of dancers was edited into thousands of images flowing forward and backward, on top of and through each other, creating an aesthetic (unintentionally) suggestive of Futurist paintings like Alessandro Bruschetti's *The Vortex* (1932), Giacomo Balla's *The Spell is Broken* (1923), and Gino Severini's *Sea = Dancer* (1914). —*Robert Haller*

NUTS AND BOLTS: MACHINE MADE MAN IN FILMS FROM THE COLLECTION

THE MUSEUM OF
MODERN ART

ORGANIZED BY
ANNE MORRA IN
COLLABORATION
WITH PERFORMA

Marcel L'Herbier,
L'Inhumaine, 1924.
Production still.
Courtesy The Museum
of Modern Art.

In "The Founding and Manifesto of Futurism" (1909), F. T. Marinetti breathlessly announced that in the coming Futurist revolution, the heretofore-dark night would be "illuminated by the internal glow of electric hearts." His veneration of a machine age continued in "War, the World's Only Hygiene" (1911–15), wherein he averred that automobiles, trains, and vast machines driving the technology of the day possessed "personalities, souls or wills." Inspired by the centenary of the founding of Futurism, and in celebration of Performa 09's programming, *Nuts and Bolts* presented twenty-one films from MoMA's collection that reflected Marinetti's vision of the mechanical being in the machine age: endlessly energetic and productive, free from sentimentality, immune to disease and death, yet somehow reflective of the human condition.

While *Nuts and Bolts* was expansive in its inclusion of a wide variety of films reflecting Futurist dogma—from *La Marche des machines* (1928) and *Metropolis* (1926) to *The Legend of John Henry* (1991) and *Terminator 2: Judgment Day* (1991)—Marinetti's radical political and aesthetic vision perhaps most acutely came to life onscreen in Marcel L'Herbier's *L'Inhumaine* (1924), a tragedy of unrequited love in which a scientist's laboratory of machines is run by leather-clad assistants moving more like robots than men, on a striking modernist set designed by Fernand Léger. This film was preceded by the 1934 short *Rhapsody in Steel*, which was produced for the Ford Motor Company and presents the automaker's now-ubiquitous contribution to modern industrial society—the mechanized assembly line. In *Rhapsody in Steel* cars assemble themselves with the magic of trick photography, in an idealistic veneration of the factory that dovetails with Marinetti's prophetic appeal to divest the world of a weakened humanity and develop a vigorous, imperturbable cadre of mechanical beings.

—*Anne Morra*

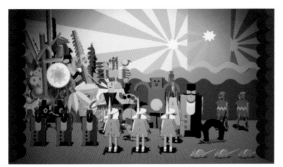
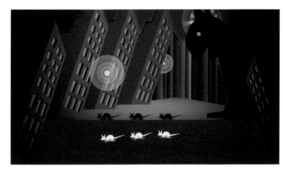
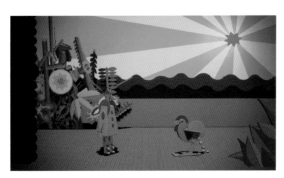

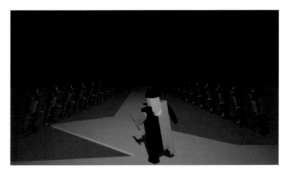

BALLI PLASTICI

MUSEUM OF ARTS
AND DESIGN

PRESENTED
BY CARNEGIE
MELLON
UNIVERSITY'S
ENTERTAINMENT
TECHNOLOGY
CENTER

Video stills from
Balli Plastici, *as
reconstructed by
Depero Futuristi, 2009.
Courtesy Carnegie
Mellon University's
Entertainment
Technology Center.*

In 1917, the Futurist painter, writer, sculptor, and graphic designer Fortunato Depero conceived of a ballet in which machinelike puppets would replace actors and dancers, emphasizing the Futurist glorification of technology as a way to transcend human limitations. Within a year, Depero had produced a collection of marionettes and set designs and enlisted four composers—Alfredo Cassella, Lord Berners, Béla Bartók, and Gian Francesco Malipiero—to arrange music for the four short acts of the show. In its 1918 premiere at the marionette theater Teatro dei Piccoli in Rome, *Balli Plastici* was performed eleven times, and featured clowns, a ballerina, mustachioed men, a blue bear, a monkey, and one vignette depicting savages and an evil green snake. It was considered novel and daring by critics and audiences at the time, but *Balli Plastici* was never repeated, and the puppets were eventually lost or destroyed. In 1981, the Autunno Musicale di Como music festival undertook a revival of the ballet, reconstructing the puppets according to Depero's original drawings, photographs, and production notes from his journals. In 2009, a team of graduate students at Carnegie Mellon University's Entertainment Technology Center, working under the collective name Depero Futuristi, reimagined *Balli Plastici* for the twenty-first century. Just as the Futurists had incorporated the latest technology into their work, Depero Futuristi translated Depero's puppets into digital figures. The result was a 1918 ballet transformed into an animated movie through specially developed computer software—which Depero Futuristi also made available on an interactive DVD, allowing users to create Futurist-inspired ballets of their own.

—Don Marinelli

VITAL SIGNALS: JAPANESE AND AMERICAN VIDEO ART FROM THE 1960S AND '70S

When the consumer-grade Sony "Portapak" was introduced in the mid-1960s, artists and non-artists alike entered a fertile period of creative experimentation with video recording. Presenting key early videos from the archives of EAI, the leading international resource for video and media art, which also provided curatorial guidance, this program traced analogous developments in Japanese and American video art in the '60s and '70s—such as the new artist communities that grew out of the medium's accessibility; an interest in manipulating and distorting footage; and an ongoing exploration of how physical and emotional gestures resonate differently in performances created for the camera. Including work by Shigeko Kubota, Katsuhiro Yamaguchi, Fujiko Nakaya, and Nobuhiro Kawanaka from Japan, and Vito Acconci, Chris Burden, Gary Hill, Allan Kaprow, Paul McCarthy, and Nam June Paik from the United States, the daylong, marathon-format program comprised three screening sessions (*Open Television, The Language of Technology,* and *Body Acts*) plus a discussion on avant-garde filmmaking featuring Japanese experimental filmmaker and artist Takahiko Iimura, New York–based multimedia artist Mary Lucier, and MoMA associate curator of media and performance art Barbara London—all of which made clear that the inquisitiveness and innovation that these video pioneers shared would impact generations of artists to come. —*Yoko Shioya*

JAPAN SOCIETY

CO-PRESENTED BY JAPAN SOCIETY AND ELECTRONIC ARTS INTERMIX (EAI)

Above, left: Takahiko Iimura, Observer/Observed, *1975–76. Video still. Courtesy the artist. Center: Katsuhiro Yamaguchi,* Image Modulator *(Document of the installation), 1966. Video still. Courtesy the artist. Right: Norio Imai,* Digest of Video Performance 1978–1983, *1978–1983. Video still. Courtesy the artist.*

MUSEUM FUTURES: DISTRIBUTED
NEIL CUMMINGS AND MARYSIA LEWANDOWSKA

PARSONS THE
NEW SCHOOL FOR
DESIGN (KELLEN
AUDITORIUM)

PRESENTED
BY THE NEW
SCHOOL'S VERA
LIST CENTER
FOR ART AND
POLITICS IN
COLLABORATION
WITH PERFORMA
AND PARSONS
THE NEW
SCHOOL FOR
DESIGN

It so happened that Parsons The New School for Design pro-
vided a telling setting for the US premiere of London-based
artists Neil Cummings and Marysia Lewandowska's 2008 film
Museum Futures: Distributed, as the recently inaugurated Kel-
len Auditorium, designed by Lyn Rice, renders the university's
ambitions in suitably futuristic architecture. Set in 2058, *Mu-
seum Futures* purports to be a promotional media feature on
the newly appointed director of Moderna Museet in Stock-
holm, Sweden, and her plans for the museum. In the course of
an interview between her and a student, questions arise about
the value, power, and meaning of cultural institutions within a
global market economy and, just as provocative, the nature of
individuality in a homogenized world. The impression that the
actors themselves might actually be cyborgs can never quite be
shaken. Like past projects by Cummings and Lewandowska,
in which they work in banks, galleries, schools, and other or-
ganizations, Museum Futures and the panel discussion that
followed (which featured Lewandowska with Parsons faculty
members Jamer Hunt and Christiana Paul) examined the risks,
benefits, and transformative potential of powerful institutions
in a globalized world.

—*Carin Kuoni*

A SLAP IN THE FACE OF PUBLIC TASTE

PUSHING THE AUDIENCE

The Futurists were controversial for many reasons—their wild stage shows, challenging aesthetics, and, later, reactionary politics chief among them. "A Slap in the Face of Public Taste" collects some of the biennial's most confrontational shows, including both historic sensations—like *parades & changes, reenactment,* which revisited a groundbreaking Anna Halprin work previously banned in the United States—and modern-day face-offs, such as *Symphony No. 1,* which ended with the audience and performers in a spirited game of dodgeball in the theater. Forgetting the "filthy stigmas" of common sense and good taste, to the Russian Futurists, at least, was the only road to risk-taking and the achievement that accompanies it.

I° DECENNALE DELLA FONDAZIONE DELLA R. AERONAVTICA 28 MARZO I / XI

SHOCK AND AWE: THE TROUBLING LEGACY OF THE FUTURIST CULT OF WAR

HUNTER COLLEGE (THE KAYE PLAYHOUSE)

ORGANIZED BY EMILY BRAUN WITH THE SUPPORT OF THE ROOSEVELT HOUSE PUBLIC POLICY INSTITUTE AND THE HUNTER COLLEGE DEPARTMENT OF ART

Postcard designed by Latini for the tenth anniversary of the founding of the Regia Aeronautica in 1933, used as part of the invitation for Shock and Awe: The Troubling Legacy of the Futurist Cult of War, *2009. Courtesy Hunter College.*

During the centenary celebration of Futurism that took place in cities around the world in 2009, *Shock and Awe: The Troubling Legacy of the Futurist Cult of War* may have been the only symposium to address the dismaying alliance of Futurist aesthetics and Fascist politics. The audience was unusually large and wide-ranging for an academic conference, comprising more than three hundred artists, art historians, environmentalists, journalists, art patrons, political, military, and cultural historians, museum curators, and graduate students from various New York institutions and abroad—demonstrating that the concerns of the symposium went far beyond the ivory tower.

Focusing on the second phase of Futurism between the two world wars, which has long been neglected in the scholarship and the museum world, the ten multidisciplinary papers presented in two consecutive four-hour sessions discussed the avant-garde's culpability in touting the "beauty" of modern war, with a particular interest in connecting WWII military strategies to those still in use today. From a roster of international scholars (see a full list of participants on page 395), one learned of the direct links between Futurist *aeropittura*, *aeromusica*, and *aerodanza* and the strategic bombing doctrine issued by an Italian military theorist, Giulio Douhet. Several papers dealt with the ambiguous ideological position of modernist artists such as Bruno Munari and filmmaker Roberto Rossellini and the ways in which Futurist imagery was used in aerial propaganda to increase popular support for the Fascist regime. The presentations generated animated questions and comments from the audience—some of it politically loaded or contentious, but with unanimous gratitude for bringing so much new material to light.

—*Emily Braun*

SYMPHONY NO. 1

ALTERAZIONI VIDEO AND RAGNAR KJARTANSSON

PS122

CO-PRESENTED BY PS122 AND PERFORMA

CURATED BY BARBARA CASAVECCHIA AND CAROLINE CORBETTA

Opposite: Alterazioni Video and Ragnar Kjartansson, Symphony No. 1, 2009. Performance view. Photo by Paula Court.

Below: Preparatory sketch for Alterazioni Video and Ragnar Kjartansson, Symphony No. 1, 2009. Courtesy the artists.

"It will be a pretty long, crazy, frenzied performance with stunts of stupidity. We are planning to dig into some Dionysian energy," wrote the collective Alterazioni Video and artist Ragnar Kjartansson about their *Symphony No. 1*, in true Futurist style. Presented as an absurd talent show, the forty-five-minute piece in four "movements," which took place in PS122's black-box theater for one night only, parodied clichés of endurance-based performance while also referring to the Futurists' 1913 manifesto for "The Variety Theater" ("destroying the Solemn, the Sacred, the Serious, the Sublime of Art with a Capital *A*").

The five tuxedo-clad members of Alterazioni Video (who have worked together since 2004) performed their repetitive antics on a stage littered with props—soccer balls, buckets, a stepladder, mirrors, a TV monitor, a VCR—and ringing with sound effects, including the rapid-fire of ping-pong balls being thrown at objects, a laundry rack being played as a stringed instrument, cocktails being poured from one container to another, and wild declamations by one of the performers standing at a microphone, speaking in Italian and using only words beginning with the letter *p*. Four equally absurd video segments by Kjartansson set the tempo for each section, and the piece ended in a hilarious finale, with the entire cast kicking and throwing soccer balls at the set, each other, and the audience, who returned them in kind.

—*Barbara Casavecchia and Caroline Corbetta*

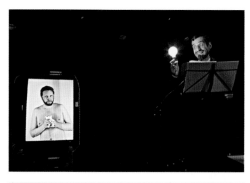

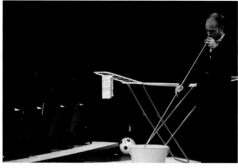

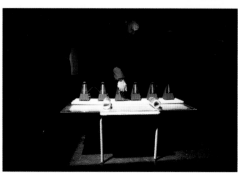

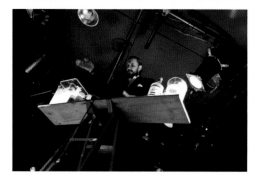

*Alterazioni Video and Ragnar
Kjartansson,* Symphony No. 1, *2009.
Performance views. Small image, third
from top: Photo by Paula Court. All
other images: Photos by Luca Babini.*

IF I SING TO YOU
DEBORAH HAY

SPIRALING DOWN
YVONNE RAINER

BARYSHNIKOV
ARTS CENTER

CO-PRESENTED
BY BARYSHNIKOV
ARTS CENTER
AND PERFORMA

Top: Deborah Hay, If
I Sing to You, *2009.
Performance view.
Photo by Paula Court.*

*Bottom: Yvonne
Rainer,* Spiraling
Down, *2009.
Performance view.
Photo by Paula Court.*

Sharing the stage for the first time in over twenty-five years, two legendary old friends—postmodern dance icons Deborah Hay and Yvonne Rainer—presented new hour-long performances that revealed both their shared intellectual heritage and their diverging choreographic approaches.

Hay's *If I Sing to You* began with its five female performers standing awkwardly pressed together, nervously humming and muttering to themselves. Some wore men's clothing or facial hair appliqués, confusing their gender identities. As they engaged in a series of frequently absurd, strangely entrancing activities—scampering around on tiptoe, crawling, barking, spouting gibberish, humping the floor, wrestling, shaking, embracing—their movements created a sense of unfettered release that was both confounding and exhilarating.

Language and the body were equally important in Rainer's *Spiraling Down*, whose four dancers were also all women. The piece began with Rainer reading excerpts from Haruki Murakami's book *What I Talk About When I Talk About Running* (2008), framing the dance as an intellectual exercise drawing connections between body and brain. Borrowing physical and textual language from a mélange of sources, including old movies, newspapers, novels, ballroom dance, and soccer, the piece ruminated on subjects from war and technology to male impotence and sports through a pastiche of movement, pre-recorded text, and live readings that jumped haphazardly from one source to another, creating a melancholic and often silly fragmentation that reflected broadly on the passage of time.

Through the highly pedestrian, fractured, and referential vocabulary of the postmodern dance that they both helped shape, Hay and Rainer expressed the mutability of the body and the self. If dance is understood as an event, already in the process of becoming a memory, their work rendered a painful awareness of one's precarious relationship to time. —*Hong-An Truong*

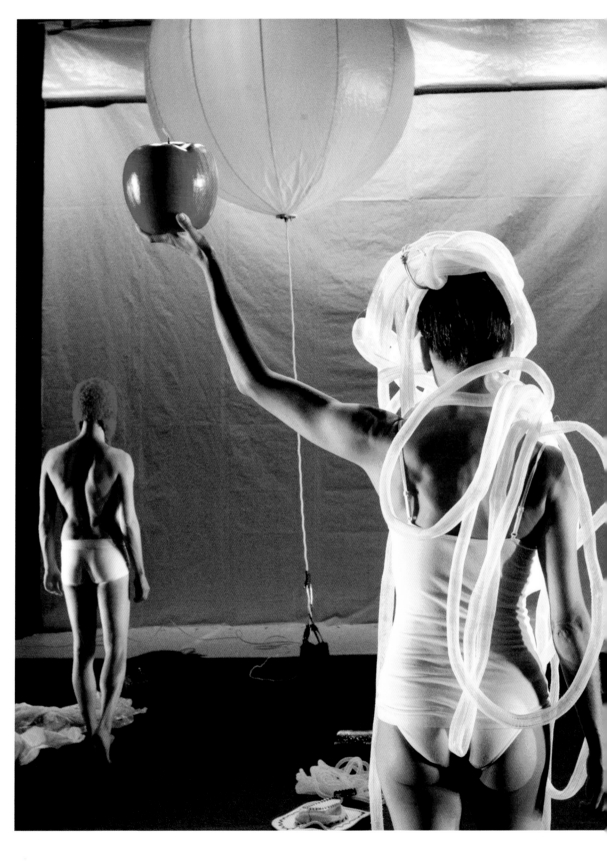

*Anna Halprin,
Morton Subotnick,
Anne Collod &
guests,* parades
& changes,
reenactment,
*2009. Performance
view. All photos
this section by
Yi-Chun Wu.*

PARADES & CHANGES, REENACTMENT
ANNA HALPRIN, MORTON SUBOTNICK,
ANNE COLLOD & GUESTS

Anna Halprin, the legendary teacher of post-modern choreographers—Yvonne Rainer, Trisha Brown, Steve Paxton, and Meredith Monk were among the many students who flocked to her famed "redwood deck" in Northern California in the 1950s and '60s for her lessons in improvisation and composition—shook the dance world in 1965 with the New York premiere of her performance *Parades & Changes*. Because of its extensive nudity, *Parades & Changes* was banned in the United States and had not been seen in this country since 1967—until French choreographer Anne Collod, in dialogue with Halprin and original composer and electronic music pioneer Morton Subotnick, restaged the seminal work in 2009, first in Paris at the Centre Pompidou and then on four evenings in New York for Performa 09.

The six American and European dancers in this iteration—Boaz Barkan, Nuno Bizarro, Alain Buffard, Anne Collod, D. D. Dorvillier, and Vera Mantero, all accomplished choreographers—were joined onstage by Subotnick, now in his seventies, who returned to mix his compositions live. Structured as a series of interchangeable "cell blocks" around task-based, improvisational scores for action, *parades & changes, reenactment* allowed for considerable variation from one performance to the next. The evening began with the dancers speaking from the audience in French and English, describing experiences from the 1960s, before moving onto the stage, where they formed a single line across the center and removed their clothes, very slowly, one item at a time, folding and placing them in a pile on the floor in front

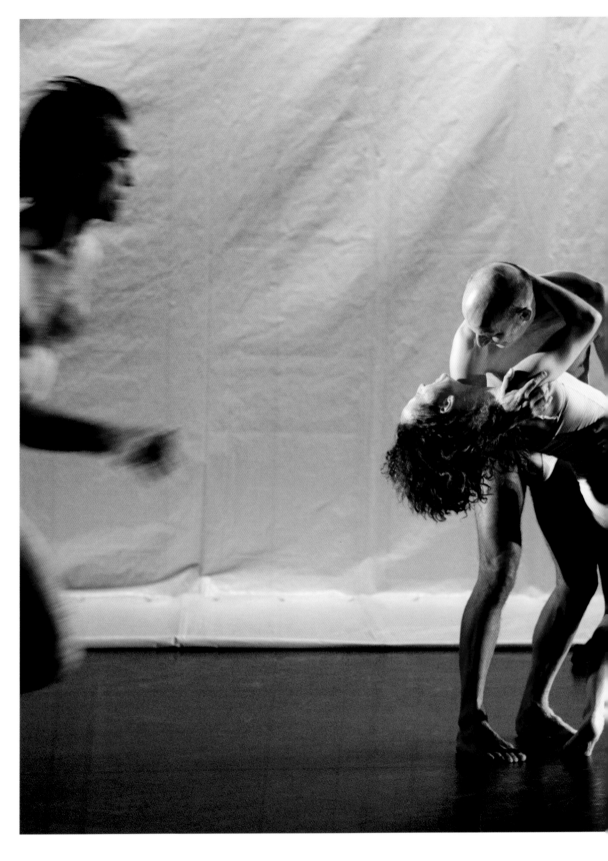

of them. They then dressed themselves again, also very slowly, and proceeded to repeat this methodical sequence of dressing and undressing three times, all the while staring at the audience, as though daring each person to confront the fact of their nudity. The dancers then moved through a series of "scores," from stomping on wooden platforms to shredding enormous sheets of brown paper. In the finale of the ninety-minute performance—or "ceremony of trust," as Halprin called it—the entire company worked together to dress two dancers, using every piece of a large selection of materials laid out on the stage—life vests, fantastical hats, industrial tubing, silver foil, balloons, etc. Weighed down by these imposing new identities and adornments, the two dancers then walked up through the audience and made their way out into the New York night.

—*Alexis Clements*

Anna Halprin, Morton Subotnick, Anne Collod & guests, parades & changes, reenactment, *2009. Performance views.*

AUF DEN TISCH! (AT THE TABLE!)
AN IMPROVISATION PROJECT
CURATED BY MEG STUART

In Baryshnikov Arts Center's Howard Gilman Performance Space, a cast of artists sat around an enormous table that filled most of the room, with the audience sitting in rows of chairs encircling it. First presented in Berlin in 2005, *Auf den Tisch! (At the Table!)* was conceived by American-born, Brussels-based choreographer Meg Stuart to be performed by a different set of artists in each location to which it traveled. In New York, the cast comprised a diverse group of improvisers, performers, thinkers, and writers: Trajal Harrell, Keith Hennessy, Janez Janša, Jean-Paul Lespagnard, Jan Maertens, Yvonne Meier, Anja Müller, Vania Rovisco, Hahn Rowe, George Emilio Sanchez, David Thomson, and Stuart herself.

The huge table literalized the idea of providing a democratic "platform" for the performers, who could ignite or disrupt the flow of action however they chose, putting any issue that might arise "on the table." They could speak into one of four

BARYSHNIKOV
ARTS CENTER

CO-PRESENTED
BY BARYSHNIKOV
ARTS CENTER AND
PERFORMA

Auf den Tisch! (At the Table!), *a performance project curated by Meg Stuart, 2009. Performance view. All photos this section by Paula Court.*

microphones on the table, jump up onto the table to talk or dance, even invite members of the audience to join in the discussion, either verbally or through movement. Topics ranged from history to politics to improvisation itself; at one point, Yvonne Meier asked into a microphone, "Do soldiers in Afghanistan improvise?" Janez Janša completely undressed himself, announcing that he was paying homage to Richard Schechner's attempt, as an audience member, to incite the rest of the audience to action at a performance of the Living Theater's *Paradise Now* (1968). Meg Stuart stood on the edge of one side of the table, silently looking into the eyes of each spectator facing her.

By giving all of the performers (and, by extension, the audience) freedom to explore whatever they wanted, and to criticize or change what was happening, *Auf den Tisch!* exposed the politics involved in collective decision-making, illuminating the potential for transformation as well as the vulnerability for failure inherent in all kinds of improvisation.

—*Cristiane Bouger*

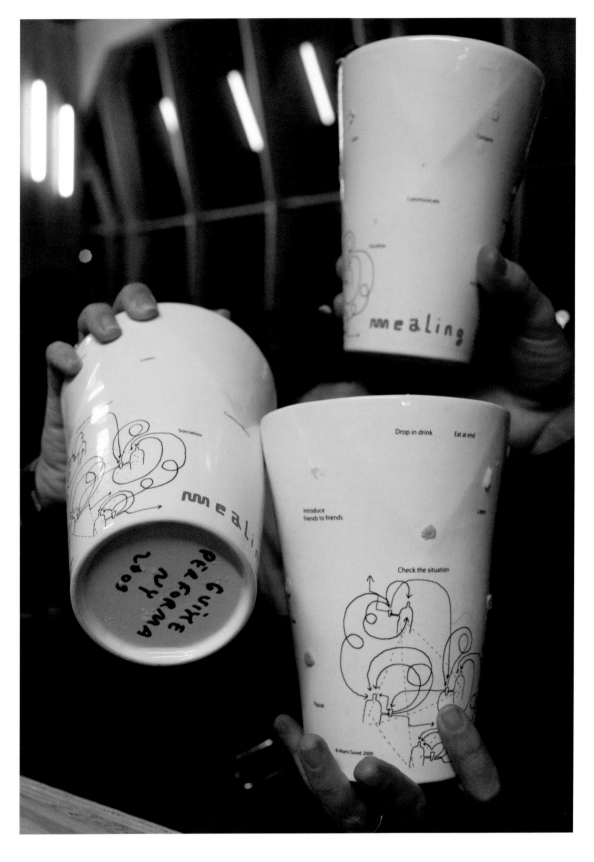

MEALING

MARTÍ GUIXÉ

PERFORMA HUB

COMMISSIONED
BY PERFORMA

CURATED BY
ESA NICKLE

Mugs for Martí Guixé's Mealing, *2009. Photo by Paula Court.*

F or Catalan designer Martí Guixé—who started out in interior and industrial design but proclaimed himself an "ex-designer" in 1997, turning to theoretical questions about the culture of products and the design of food—"mealing" describes both the act of eating a meal and the concept of a meal as a social activity. Inspired by the Futurists and their view of food as a platform for social engineering, Guixé created *Mealing* as a three-hour "meal-in-motion" for fifty people. Ticket-holders arrived at the Performa Hub at 6 p.m., and Guixé explained the rules for the evening. Then each person was given a large ceramic cup covered with tiny snacks (a sunflower seed, a goji berry, a raw cacao bean) and filled with one of four specially constructed cocktails. Next to the spot where each snack was adhered to the cup, instructions were printed: "Meet new people," "Conspire," "Act unexpectedly." One longer text read, "These statements help you to create connections, interact, and relate to other participants. . . . Please report any changes in your life after performing *Mealing*." Guixé announced each phase of the performance. "Introduce friends to friends!" he cried at one point. "Now find the 'drop in drink' snack and . . . drop it in your drink!" he shouted later. The participants took Guixé's instructions to heart, eating, mingling, and perhaps even making new friends, well into the night. —*Esa Nickle*

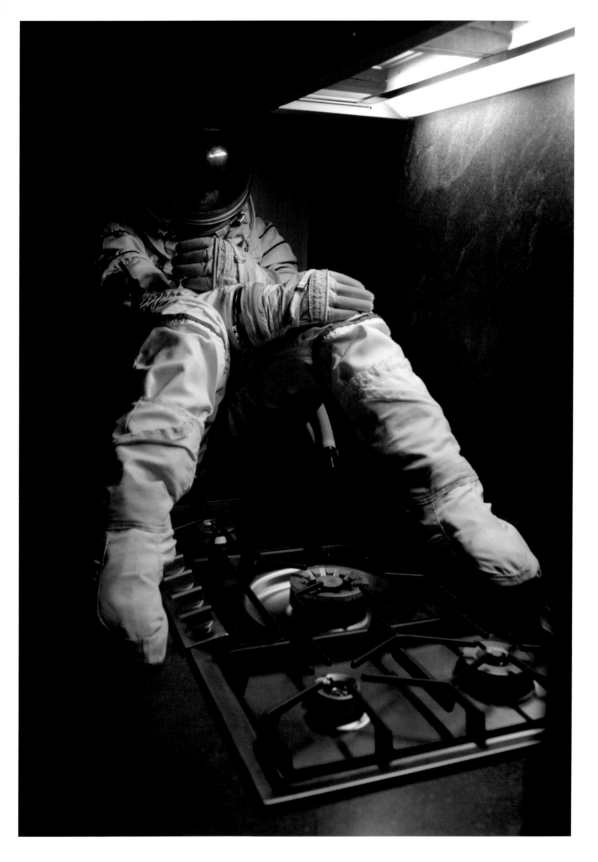

LOST ASTRONAUT

ALICIA FRAMIS

APF LAB AND
VARIOUS
LOCATIONS

A PERFORMA
PREMIERE

PRESENTED BY
ART PRODUCTION
FUND AND
PERFORMA

CURATED BY
DEFNE AYAS

Alicia Framis, Lost
Astronaut, *2009.*
Performance view.
Photo by Paula Court.

Prior to her arrival in New York, Barcelona-born, Amsterdam-based artist Alicia Framis began exploring what it might be like to live on the moon, at a time when life on that distant satellite, some two hundred million miles away, seems increasingly feasible. For New York, she created a character, the Lost Astronaut, as a symbol of a feminist mission as well as the potential achievements of a "failed" mission. Wearing full space gear—her jumpsuit, helmet, and accoutrements were worn by a real Russian astronaut in 1973—Framis used New York as her base camp. For three weeks, she lived in a SoHo storefront amid drawings and models for housing on the moon, designed by architect Uriel Fogué. Each day she followed instructions written by authors and artists whom she had invited to guide her wanderings: she moonwalked in Times Square (Matthew Licht), bowed to the marble lions on the steps of the New York Public Library (Brian Keith Jackson), and sang "Fly Me to the Moon" at karaoke bar Planet Rose (Michael Schulman). She also went to Penn Station "to buy a ticket to a place you have never been" (Marina Abramović), traveling to Babylon and back in a day. After leaving New York, she collaborated with artists and designers to create more than fifteen items to take on a lunar trip—including a compass that would always point to Earth (made with Paula Ampuero and Maria Serret), an updated Chinese moon calendar (Pan Jianfeng), and an ultra-low- frequency fireplace (Tao G. Vrhovec Sambolec and Brian McKenna). With her ironic and carefully orchestrated program, Framis staked her claim for women's presence on the moon.

—*Defne Ayas*

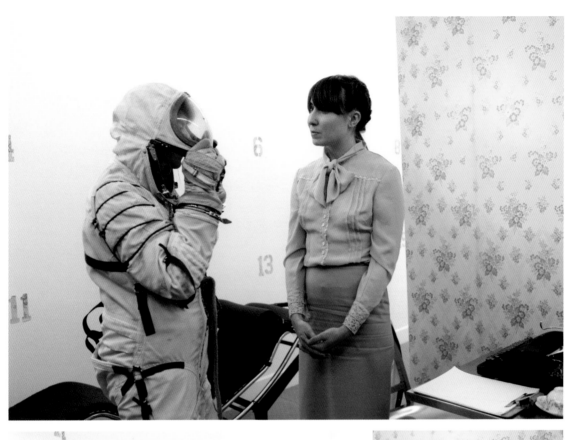

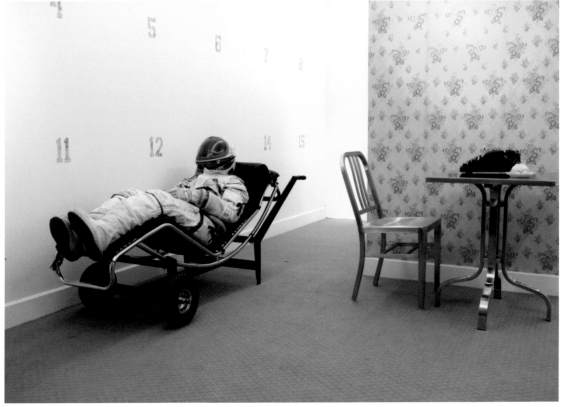

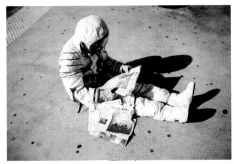 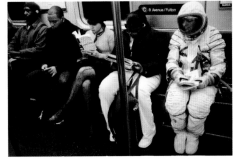

Alicia Framis, Lost Astronaut, *2009. Performance views. Courtesy the artist.*

Alicia Framis, Lost Astronaut, *2009. Performance views. Photos by Paula Court.*

Alicia Framis, Lost Astronaut, *2009. Exhibition views. Photos by Paula Court.*

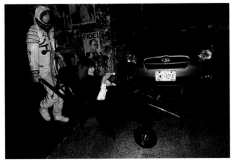 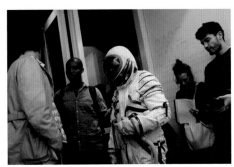

Alicia Framis, Lost Astronaut, *2009. Performance views. Left: Photo by Grace Kim. Right: Photo by Paula Court.*
Opposite: Alicia Framis, Lost Astronaut, *2009. Performance views. Photos by Paula Court.*

ART HISTORY WITH BENEFITS
THE BRUCE HIGH QUALITY FOUNDATION

The Bruce High Quality Foundation, a collective of seven to twelve anonymous young men (depending on the project), founded the Bruce High Quality Foundation University on September 11, 2009, as a free university conceived in counterpoint to the dominant system of expensive art schools, and devoted to formulating "new histories of art," or parallel accounts of recent work, using irony and criticism as methodological tools. The BHQFU presented one such "history" at X Initiative as a half-hour lecture staged twice in a row on one evening. Slides were projected on a wall behind a small stage, on which three men sat—all wearing jeans and matching aviator sunglasses—and took turns reading from an accompanying text to the crowded room of 150-plus people. The text was a personal recollection of the relationships between artists and their patrons, intertwined with case studies and quotations taken from various sources, ranging from retail researcher Paco Underhill's *Why We Buy: The Science of Shopping* (2000), to German playwright Georg Büchner's politically charged *Danton's Death* (1835), to congressional records from the NEA debates of the late '80s. The projected images alternated art icons with pop culture: we saw Peggy Guggenheim and Jean-Michel Basquiat, and Andrea Fraser and Robert Mapplethorpe, but also Mariah Carey and George Michael. Toward the end, music started to play, and the performers began singing along to Michael's "Father Figure"—"I will be your father figure / Put your tiny hand in mine / I will be your preacher teacher / Anything you have in mind"—in this setting, an ironic hymn to art and its intrinsically commercial nature.

—*Cecilia Alemani*

The Bruce High Quality Foundation, Art History With Benefits, *2009. Performance view. Photo by Michelle Proksell.*

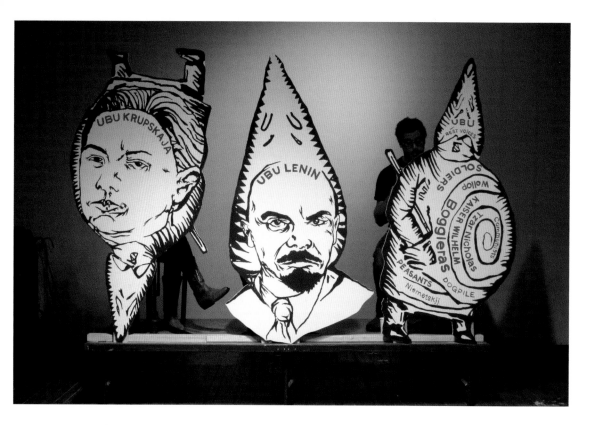

UBU LENIN

RAINER GANAHL

SWISS
INSTITUTE

The possibility that Vladimir Lenin and his wife Krupskaya may have seen the notorious Alfred Jarry play *Ubu Roi* (1896) at Cabaret Voltaire in Zurich in 1916 served Austrian-born artist Rainer Ganahl as the pretext for rewriting *Ubu Roi* as *Ubu Lenin*. At the reading of the new play at Swiss Institute, the actors—Matt Raines, Nicole Kontolefa, and Ganahl himself—hid behind Jarry's original illustrations of the characters. The new text retained Jarry's exquisite use of nonsense, but was adapted to fit contemporary America, with a mention of President George W. Bush and his weapons of mass destruction, and an appearance by former Fed chairman Alan Greenspan—both, from Ganahl's perspective, masterminds behind Ubuesque investment schemes that led to the 2008 downfall of the global financial system. —*Gianni Jetzer*

Rainer Ganahl,
Ubu Lenin, *2009.*
Performance view.
Courtesy the artist.

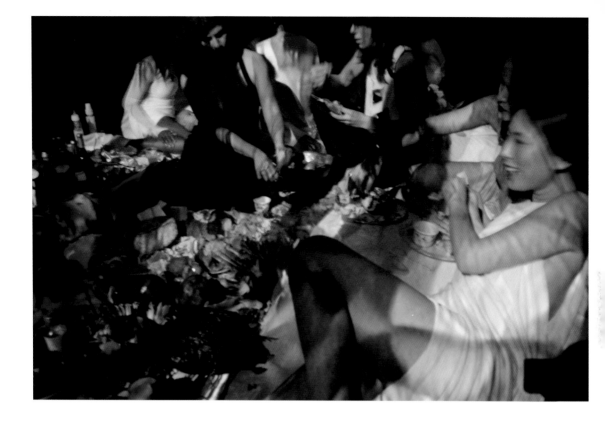

FAMILY DINNER IN A PARALLEL UNIVERSE
MAI UEDA

EMILY HARVEY
FOUNDATION

CURATED BY
LIUTAURAS
PSIBILSKIS

Mai Ueda, Family
Dinner in a Parallel
Universe, *2009.*
Performance view.
Photo by Liutauras
Psibilskis.

Japanese-born artist, performer, singer, and poet Mai Ueda set up *Family Dinner in a Parallel Universe* as a glamorous indoor picnic. The artist—who works in media from ring tones to painting—had invited friends to dine with her on the gallery floor, and the audience moved around them in the half-lit space to the quiet cracking of lobster shells, tinkling of wine glasses, and whispers between the performers. The women were dressed in white clothes, designed by Wayne Lee, that served as the backdrop for an uncanny meta-effect: real-time video images of the event projected back onto the performers. In the specific context of the Emily Harvey Foundation, an organization associated with the Fluxus movement, Ueda's group self-portrait took on additional significance through its connection to 1960s food performances, but retained its own very contemporary, image-conscious edge. —*Liutauras Psibilskis*

ABRONS ARTS
CENTER

PRESENTED
BY FRANKLIN
FURNACE

Performance of Guy de Cointet's Two Drawings *at Franklin Furnace, 1978. Courtesy Franklin Furnace.*

Honoring Guy de Cointet (1934–1983), a French artist known for his encrypted works on paper, theatrical productions, and readymade language, *History of the Future II* mixed live performances by some of today's emerging stars (both reconstructions of historic works and brand-new creations) with videos of related performance works that have changed cultural discourse during the last three decades.

As audience members approached the Abrons Arts Center, they saw artist and poet Adam Pendleton speaking and musician Alicia Hall Moran singing *Two Scenes,* a heartfelt piece about discrimination against gay people. Inside the theater, the program began with performance artist Nao Bustamante making her way through the audience to the stage for *Silver and Gold,* a memorial for Jack Smith that took place in front of a hilarious erotic film. Other performances included *Bags* by the devilishly funny Jibz Cameron (aka Dynasty Handbag), in which the artist related to the different personalities of several bags on the floor; playwright and performance artist Deb Margolin's *Oh Yes I Will (I Will Remember the Spirit and Texture of This Conversation),* which took us on a twenty-minute joyride through a moment in her personal history; and choreographer Neal Medlyn's *That Ever Elusive Kudo,* a humorous reenactment of the famous music video for Alanis Morrisette's 1995 song "Thank You," where she strolls naked through an oblivious city, occasionally patted on the shoulder by passersby (all of whom, in this case, were played by Farris Craddock). Interspersed among the performances were videos providing relevant historical context, including works by Susan Mogul, Linda Montano, Matt Mullican, Andrea Fraser, David Leslie, John Malpede, Jennifer Miller, dancenoise, and John Kelly. Historical film footage of a 1978 Franklin Furnace presentation of one of Guy de Cointet's key performances, *Two Drawings*—in which one woman recounts to another her detailed and strange reaction to a drawing she finds in a Los Angeles shop—concluded the program. —*Martha Wilson*

EVERY GENERATION MUST BUILD ITS OWN CITY

THE PERFORMA HUB AND URBAN ACTIVISM

Ideas of radical urbanism, the "festival as think tank," and performance activating an entire city were all central to Performa 09, which launched Performa's first-ever architecture program. Centered around the Performa Hub, a performance and gathering space that seemed to magnetically draw people to its multi-use interior, whether in New York or Santiago, to which it later toured, Performa's architecture and urban activism program enlisted participants to design posters, follow the sound of sirens, and make their own pasta, among other activities, all of which emphasized the importance of individual action in a collective environment.

*nOffice, Performa Hub,
2009. Installation view.
Photo by Paula Court.*

PERFORMA HUB
NOFFICE

Performa launched its first architectural commission in 2009: the Performa Hub, a three-dimensional realization of the conceptual underpinnings of the organization that functioned as Performa's headquarters throughout the biennial. Designed by Berlin- and London-based architectural practice nOffice (Markus Miessen, Magnus Nilsson, and Ralf Pflugfelder), whose work is "situated at the crossroads of critical architecture, urban intervention, and the art world," the Hub was a truly "live" space capable of responding to the constantly shifting functional demands of the biennial: a multi-use, hand-built "machine" with fold-down walls, amphitheater seating, and a movable bookcase that was also a hidden door to a back office. Located in the brand-new Cooper Union building on the Bowery that had opened its doors two months earlier, the Hub provided a meeting point, lounge, information and ticketing kiosk, exhibition space, workshop, radio and TV recording studio, projection booth, and boardroom, allowing for press conferences, solo concerts, public conversations, and more. It also became a drop-in center for visitors from abroad and students from Cooper Union and New York University.

The Hub was designed for travel as a self-contained Performa module that would adapt to new venues according to the demands of different environments. It was presented in October 2010 in Santiago, Chile, as the centerpiece of *SCL 2110*, an exhibition at the Museo de Arte Contemporáneo, and will continue to travel with future Performa projects.

—*RoseLee Goldberg*

Interview

MARKUS MIESSEN AND MAGNUS NILSSON

MODERATED BY ROSELEE GOLDBERG

ROSELEE GOLDBERG (RLG): Markus, we met at a cocktail reception in New York, and from our brief conversation, I liked your ideas so much that I commissioned you to design the Performa Hub with Magnus Nilsson and Ralf Pflugfelder, your partners in nOffice. Then you returned to Berlin. How did you begin the process? What were the conversations between the three of you?

MARKUS MIESSEN (MM): I was really excited that you had asked us to think about how to concretize Performa's first architectural commission, the Hub. It was clear from the start that it would be a challenging brief, as the budget was very limited, but the operational and content-related tasks that the architecture had to perform were quite serious. At the same time, the brief was in many ways an almost direct response to a number of issues that we at nOffice are really concerned

about and interested in, like the spatial repercussions of archives, how you can "stage" discourse, and how space can be used to activate audiences. We tend to think of these relationships as one thing stimulated by what we call "enablers" and "disablers"—a set of physical components that sometimes facilitate, and sometimes produce friction or conflict. When Magnus, Ralf, and I talked about the Performa Hub back in Berlin, it was pretty clear that we would approach the project in this way.

In our practice, talking is the main design tool. We develop projects through ongoing conversation. We rarely draw—in part because we have different backgrounds and responsibilities within the office, but also because that has led, for us, to a very helpful apparatus: conversation as productive practice. When we talk, we develop space around content and vice versa, only toward the end

starting to visualize it. We're not interested in preconceived modes of production fueled by formal language, style, or physical aesthetics. For Performa, our ambition was to stage discourse in a way that realized the spatial potential for social processes and encounters, creating what Hans Ulrich Obrist would call "contact zones."

MAGNUS NILSSON (MN): The initial emails with you, RoseLee, and Performa were also very productive. We first gave you a proposal for what we originally wanted to do, which was more of a freestanding, autonomous intervention. Then you wrote back with a bunch of criticisms of that proposal, which was great, because that's a bit like how we work among ourselves, so you became an external part of the design process.

MM: We like to interrogate each other's minds constantly. That's why ongoing conversation is so helpful. Also, the advantage of only starting to visualize at the end of a process is that nothing is ever considered "fixed." It's in a constant state of flux.

RLG: So I became part of your larger group discussion about the project.

MN: Absolutely. I think that really helped move things forward. It was also challenging that we didn't know where the actual space would be until much later, just six weeks before the Hub opened. We had to generate a design concept without knowing where it would ultimately be realized, to make a proposition that was both generic and specific. That was actually quite productive, because we weren't so focused on the end result. In that sense, the design process was like juggling a bunch of "known unknowns." Obviously, in the end we had to drop some of our initial ideas, but there were also many that we kept and developed.

RLG: Like what?

MN: First there was the basic idea of making the Performa Hub a space where you constantly form new relations, a space that is always being made and remade while you use it. So the interaction between people was key.

MM: It was our attempt to make a setting in which the roles of audience and producer would start to blur: to create a space in which the participant becomes part of the overall scheme, which is really what Performa does. We understand that Performa is a platform for

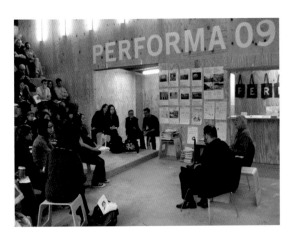 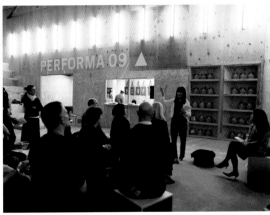

nOffice, Performa Hub, 2009. Top left: During The Universe Will Be Our Vocabulary: Futurist Film, Music, and Literature. *Photo by Joanne Cheung. All other images: Insallation views. Photos by Paula Court.*

artistic representation, but even more, it's an activator, an agent that produces diverse audiences and manages to unearth audience relationships that simply have not existed before. It was our aim to try to turn this ambition of Performa into the micro-setting of Performa's temporary headquarters during the biennial: the Hub.

RLG: You created a space that turned out to be a kind of construction set that I found myself wanting to play with. There's a real desire to engage with the various parts, which is really quite different from any other life-size building I know.

MN: I think it's a bit like an Advent calendar, that toy you use to count down the days until Christmas, with little doors or windows that you open to reveal surprises on each day.

MM: At the same time it has seriousness to it. There was a clear ambition from the start to produce a setting that would allow for multiple uses and programs to unfold and overlap, so that there would never be just one thing happening at any moment, but a plethora of overlapping things. The outcome was what we

started to call a "spatial bastard"—a typology that collides many different programs into a single space without withdrawing the individual programs' abilities to function for distinct audiences or users. If you want, you could call it an institution in a large room.

RLG: Yes, it does have those qualities. And the material is so simple and yet so elegant. We did have a tight budget, but you made it work.

MN: The budget was certainly constrained, but that just meant that we had to use inexpensive materials in a very efficient way, and base everything on a strict grid in order to minimize labor and material waste.

MM: We are generally very fond of challenging briefs. They stimulate a certain kind of productivity and generate a lot of energy. As a result of the many conversations among ourselves at nOffice that happened before you chose the final site, the ground floor of the new Cooper Union building in the East Village, we managed to come up with decisions fairly quickly once the site was chosen. As Magnus said, at that point, also because of the incredibly tight schedule, we had to be very

efficient. The result was that we used a given reality, which was a drop in ceiling height more or less in the middle of this huge space, to cut the space in half, produce a single wall with a single material, and generate the programs and activities around this surface, from either side.

RLG: I was very happy with the fact that the space still felt like a raw space, with concrete floors and exposed ceilings, yet you integrated the plywood structure in such a way that it all worked together beautifully. There were strong visual lines from the front doorway into the space, and onto the street. In one sense the design seemed to come from a very conceptual place, but it also had a sensorial richness to it. And a rhythm. Your eye would move from different shaped cut-outs, to a line of vertical lights, up and down the stairs, and sweeping across the space in such a way as to really arouse one aesthetically. People could roam through the space and feel like it was almost a part of their body.

MN: Yes, I think that sensorial qualities are sometimes a bit forgotten by people who work more conceptually. Their projects often tend to be concepts laid bare, a sort of skin-and-bone architecture. I'd like to see more flesh. From the beginning, it was very clear to us that we didn't want the Hub to just appear like a temporary installation. We wanted it to feel like an architectural project in its own right.

MM: Totally. An architectural project based on the premise of building something of architectural scale for a huge audience while facing no time for construction and hardly any budget to do so. This is not meant to sound negative, because it actually produced an unprecedented energy.

MN: And it looked different depending on where you stood. A few times we stood across the street, to see how it looked from there. Once, we saw someone magically appear from behind the bookshelf. That continuous wall, which partially unfolds, acted both as background and foreground. As a discreet background it enables certain acts to take place in front of it, while it simultaneously had a strong presence, acting like a billboard for Performa to the outside.

RLG: That wall is so great. And the bookshelf

that folds out is wonderful—it's like a secret passageway in a nineteenth-century novel.

MN: Exactly. We're great fans of Sir John Soane's museum in London.

MN: Our early renderings had all this furniture that you could pull out and move around. It really looked more like a dollhouse. In the end, we really had to simplify, because of budget, and because we knew that whoever was actually building it was going to have minimal supervision, so it had to be a design robust and consequential enough that it couldn't be screwed up, if you know what I mean. In the end, we were lucky enough to have our friend and architect Nate Lindsey to oversee the construction.

RLG: And he did a fantastic job. To me, the Performa Hub is about how a space can perform and be transformed through use. We had a panel discussion in the Performa Hub about the ideal performance space, and for me, the Hub is it. It's quite raw, but that's also what's so great about it—every person who uses it can make it work for themselves. We used it for so many different things—the mini-gallery

in the back, designed as a space for video projections, was turned into a conference room, a meeting place for conversations, for example. If you think of those stairs in the main space, and covering them with white pillows, or lining the wall with paper and filling the space with balloons, it would be completely transformed again. It was like a blank theater drop that any artist could turn into something else. And above all, it's a piece of architecture. I think of it as "instant architecture"—just add water!

MM: I fully agree. For us, it also demonstrated the importance of the user and those protagonists who program and deal with the space on a daily basis. Without trying to sound like a romantic hippie, the user is still the one force in architecture that is, over time, the most powerful. This is not to say that architecture itself is not powerful, but from our point of view, good and interesting architecture should provide a complex stage for events, actions, inhabitation, and life to all unfold.

RLG: I tell everyone who comes in here, it's not a bookstore, it's not a café—it's a place for ideas. That's what it is.

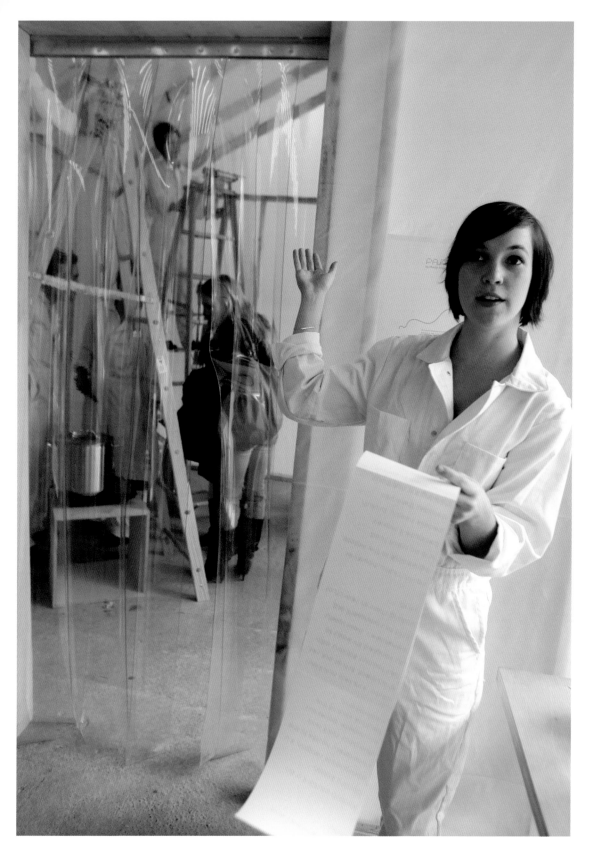

PASTA SAUNA

PROEF (MARIJE VOGELZANG)

PERFORMA
HUB

COMMISSIONED
BY PERFORMA

CURATED BY
ESA NICKLE

*Opposite: Proef
(Marije Vogelzang),
Pasta Sauna, 2009.
Performance view.
Photo by Paula Court.*

*Below: Preparatory
drawing for Proef's
Pasta Sauna, 2009.
Courtesy the artist.*

"No more pasta, as it causes lassitude, pessimism, and lack of passion," wrote F. T. Marinetti in *The Futurist Cookbook* in 1931. Thwarting Marinetti's declaration against pasta—as well as the similar advice of some present-day nutritionists—the Amsterdam-based "eating designer" Marije Vogelzang, who also goes by the name of her design studio and restaurant Proef, created a "Pasta Sauna" in the middle of the Performa Hub. The idea was for the Pasta Sauna to boil enough pasta water to become filled with steam, so that visitors stepping into it could have "the chance to be as lazy and un-energetic as they want." Open during lunchtime for three days, the sauna itself was a small wooden hut with plastic flaps in the doorway. Visitors, while waiting for their turn to enter, were given a small bowl of balled pasta dough to share, and watched one of the Pasta Sauna assistants shouting and singing Futurist mottos and statements about cooking. Once inside, Pasta Sauna assistants—clad in jumpsuits painted with Futurist slogans, and standing atop tall ladders—took the bowl from each participant and

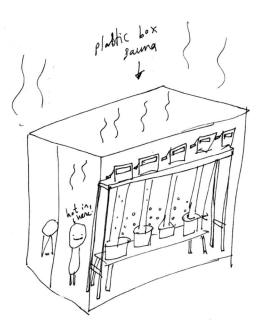

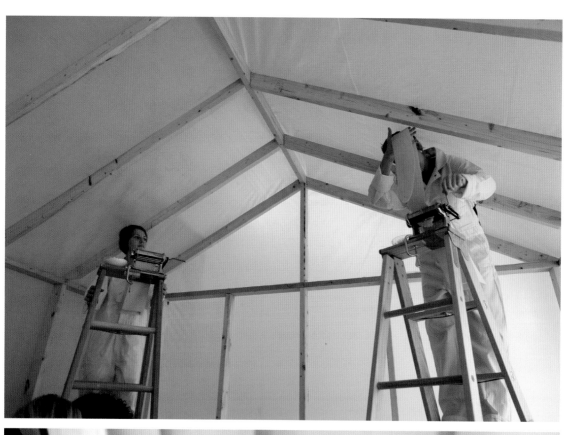

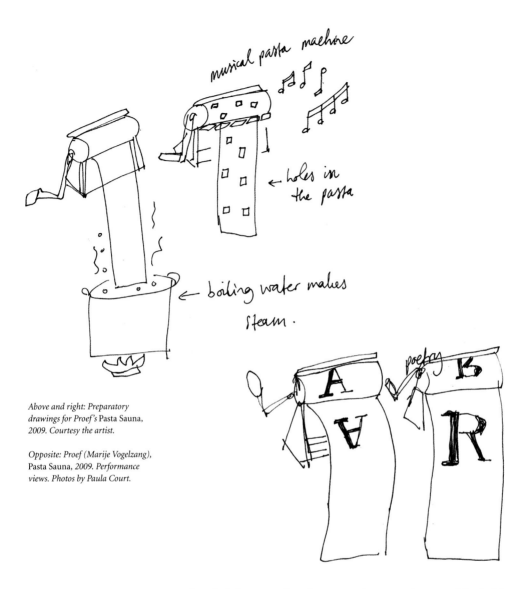

musical pasta machine

← holes in the pasta

← boiling water makes steam.

poetry

Above and right: Preparatory drawings for Proef's Pasta Sauna, *2009. Courtesy the artist.*

Opposite: Proef (Marije Vogelzang), Pasta Sauna, *2009. Performance views. Photos by Paula Court.*

handed the pasta dough to an assistant at the top of the ladder, who then rolled it flat through a pasta machine, which was also a music box that played a song as the handle was cranked. The pasta dropped almost six feet below into a pot of boiling water, and after cooking for two minutes, was placed in the original bowl and returned to the visitor. Outside, a table was spread with olive oil, parmesan, lemon, and herbs for dressing. Many visitors went back for seconds.

—*Esa Nickle*

SIRENS TAKEN FOR WONDERS

PAUL ELLIMAN

PERFORMA
HUB AND THE
VAN ALEN
INSTITUTE

COMMISSIONED
AND PRESENTED
BY PERFORMA

CURATED BY
DEFNE AYAS

Paul Elliman, Sirens
Taken for Wonders,
*2009. Performance view.
All photos this section by
Alex Maubrey.*

Taking New York City to be a gigantic petri dish of urban crises, *Sirens Taken for Wonders* set out to explore the coded language of sirens, from the distress signals of emergency vehicles to their haunted echoes in the deadly song of the mythological creatures of *The Odyssey*. The project took a double form: a series of walks across Lower Manhattan and a radio panel discussion at the Van Alen Institute, broadcast live on AIR (Art International Radio).

The radio panelists included Dr. Arline Bronzaft, chair of the Noise Committee for the mayor's Council on the Environment of New York City; Raviv Ganchrow, a sonologist based at the Royal Conservatory, The Hague (Netherlands), specializing in sound-forming technologies; Laura Kurgan, director of the Spatial Information Design Lab (SIDL) at Columbia University's Graduate School of Architecture; and Lázaro Valiente, a musician and sound artist based in Mexico City, whose lecture "How To Make Music With Police Cars and Get Away With It" refers to his *Police Car Quartet*, performed in 2008 as a concert at Mexico City's Palacio de Bellas Artes. Chairing the discussion, I wanted to introduce a range of siren themes. These included the powerful new super-siren known as the Rumbler; more a weapon than a signal, it vibrates the ground within a two-hundred-foot radius, and is currently (and controversially) deployed by a number of New York City police cars. I also wanted to get a better sense of how the canyons of the city establish a network of reflecting surfaces across which the sirens rebound. We then spoke about the psychological impact of sirens on the urban population and the varying levels of siren activity in different areas and demographic zones of the city. Finally, we had a few exchanges about the prototyping of a system of intelligent sirens designed for New York by artist Max Niehaus in the 1980s—what they sounded like, and why they were so quickly dismissed by city officials at the time.

The siren walks began with my introduction to the five key siren tones likely to be heard: the wail, yelp, phaser, manual,

and air-horn blast. New York–based operatic singer Daisy Press helped by embodying these tones in a sequence of vocal warm-up exercises. Each of the siren patrols numbered about twenty people, notebooks in hand, and before setting off I also went over the emergency response codes used by dispatchers when briefing ambulance drivers: from Code 1 for an EDP (emotionally disturbed person) situation (no lights or sirens) to Code 7 for cardiac or other traumatic arrest (high speed with lights and sirens on full).

The first siren walk left the Performa Hub at 4 p.m. on a windswept Tuesday afternoon, heading north to Fourteenth Street, west via Union Square, then north again, along sections of Sixth and Seventh Avenues toward Times Square. Artist and pirate radio broadcaster Max Goldfarb brought along a powerful set of radio scanners, and we listened to several emergency transmissions. We tried to stake out the rush-hour traffic along both major avenues. Curiously, there were no sirens, resulting in an intensified desire to hear them, as well as comments about how wrong their absence felt. The closest thing to a siren encounter was a spectacular sighting of a large red-tailed hawk on the lower branches of a tree in Union Square, reminding us of the earliest references to sirens in Greek literature: creatures that were half-woman, half-bird. At 6:54 p.m., a sudden dramatic burst of police sirens in Times Square was taken as a signal for the end of the first walk.

The second group left the Performa Hub at 10 p.m. on a Friday night, heading into the busy East Village and then back along Houston Street toward Lafayette and Broadway. On this walk we were joined by Natalie Jeremijenko, artist and director of NYU's xDesign Environmental Health Clinic. Natalie, one of the few people I know who won't leave home without her digital bat detector, talked about the impact of sirens on the city's animal and bird species. This walk covered a smaller area of the city but presented us with far more intense siren activity, which was met by dramatic shifts in the feelings of the group: from jubilant cheers at the sound of the first siren of the evening (a wail and yelp heard at 10:27 p.m. on the corner of St. Marks Place and First Avenue), to a mix of keen-eared spectatorship,

Paul Elliman, Sirens Taken for
Wonders, *2009. Performance view.*

consternation, and guilt, as a broken-down EMS vehicle care-
fully transferred its injured passenger to another ambulance on
the corner of Houston and the Bowery. The second ambulance
then jumped into the busy intersection with lights blazing and
phaser siren blaring, and the small crowd moved on, not en-
tirely undaunted by the mixed emotions of urban life.

—*Paul Elliman*

TEN DAYS FOR OPPOSITIONAL ARCHITECTURE: TOWARDS POST-CAPITALIST SPACES
AN ARCHITEKTUR

GAIR BUILDING NO 6

COMMISSIONED BY PERFORMA

PRESENTED BY STOREFRONT FOR ART AND ARCHITECTURE AND PERFORMA

ORGANIZED BY OLIVER CLEMENS, KIM FÖRSTER, SABINE HORLITZ, AND ANITA KASPAR

An Architektur, Ten Days for Oppositional Architecture: Towards Post-Capitalist Spaces, *2009. Conference view. Courtesy the artists.*

Following spread: An Architektur, The Preliminary Charter of Oppositional Architecture, *2004-05. Courtesy the artists.*

Organized in the midst of the global financial crisis by Berlin-based architecture collective An Architektur, *Ten Days for Oppositional Architecture* represented the culmination of two previous events: their *Camp for Oppositional Architecture* conferences in Berlin in 2004 and in Utrecht in 2006, in which dozens of architects, researchers, and theorists gathered to explore the possibilities for socially committed architecture in an age of rampant corporate expansion. For Performa 09, An Architektur translated this concept for New York.

Ten Days took place in a newly vacant storefront in Brooklyn's rapidly gentrifying Dumbo neighborhood. Four members of An Architektur temporarily rebuilt the space as a venue for presentations and community gathering, and as living quarters for themselves and a few friends. Eventually the space housed an exhibition on community design, a collage of An Architektur magazine issues, a reading corner, a provisional kitchen and bar, and a huge, irregularly shaped conference table made of desks from another performance.

The program for *Ten Days* included an evening series of public talks along with film screenings and performances. An Architektur invited a range of academics—economists, historians, geographers, architects, and activists in housing, organized labor, and the arts—to present their ideas and work, followed by discussion and dinner prepared and served by An Architektur. Local artists and architects also curated film screenings, performances, and presentations of interactive planning models. All of these events were linked by the questions and tasks necessitated by the current economic crisis and the search for strategies to decommodify and reappropriate the city, challenging the dominance of—and hopefully even offering an alternative to—the capitalist production of space. —*An Architektur*

Participants: Brett Bloom, common room, Janelle Cornwell, Teddy Cruz, Veronica Dorsey, James deFilippis, David Harvey, Ashley Hufnagel, David Kotz, Peter Linebaugh, Lize Mogel, Max Rameau, Rob Robinson, Neil Smith, SLO architecture, and Esther Wang.

The Preliminary Charter of

Berlin-Wedding 2004/2005

This is a dynamic Charter that is developing in the context of the Camp for Oppositional Architecture. This edition contains several versions and some comments, each indicated by a different color. The current state will be published and updated under: www.oppositionalarchitecture.com. Here you also can sign the Charter.

0 Architecture is a process that includes research, design, construction, and the use of space that is deeply involved in social and political issues*. Thus we declare:

*social, cultural and political issues

An organization to promote an Oppositional Architecture will have to unite all workers, activists, and users involved in making and transforming our environment – that is not just architects, but construction workers, tenants, user groups and other social movements that are challenging the capitalist hegemony. Until such an organization exists to further the collective struggle for an Oppositional Architecture:

1 We shall do no harm.

Prof. Marcuse introduced this first issue in his lecture at the Camp: ethics. I would argue that without ethics architecture couldn't be achieved.

Indeed paragraph 1. was controversial in Berlin already. It was brought to the fore by Peter Marcuse but questioned by Patricio del Real: the paragraph "We shall do no harm" is taken from the oath of the Hippocrates, which is sworn by doctors. That is also where it makes sense, because treating "individual entities" doctors can avoid doing harm to their clients without doing harm to anyone else. The sanity of one person does not affect the sanity of another. With architecture and urban space, however, it is different. Architects find themselves in a struggle involving the conflicting interests of different stakeholders. Doing a favor to one will harm another. Architecture is cutting space into pieces, defining barriers to access and inclusion. We distribute space among various interest groups. We do not treat an individual entity but always have to find a balance between the different interests. Doing harm to some may become necessary to achieve goals for the weak. A suggestion: We shall treat socio-spatial structures that we find with respect.

We do not support or accept architectures of war, racism, sexism, capitalismn or civilian occupation.

Delete: We shall do no harm.

2 We fight all manifestations of socio-spatial inequality*, exploitation and deprivation.

*Delete "inequality", or it should be more explained.

I am committed to fighting all manifestations of socio-spatial inequality, exploitation and deprivation. I will produce critical works and design ideas that promote a radical social and political rethinking of how we make and experience buildings and cities.

3 We shall pursue a critique of capitalist and authoritarian forms of production and use of the built environment.

We stand against* all capitalist** and authoritarian*** forms of production and use of the built environment.

*better: oppose, **should be more specified, ***should be more specified

Maybe another remark on the anti-capitalistic issue: it might be worth reconsidering a strong criticism to capitalism as this questions the fundamentals of most western societies. It seems "slippery" to argue against Lutheran and Calvinist philosophy.
I do agree that under the name of capitalism irreparable damages have been done to humankind. But writing a capitalism critical paragraph in the Charter would require bringing the issue under another perspective (such as the limit of its validity) while considering other cultures that are unable to assimilate it and open the gate to an alternative. So, I suppose the capitalist issue needs to be replaced in a more global context instead of simply being oppositional.

I oppose capitalist and authoritarian production and use of the built environment.

4 We intervene in the production of space through knowledge and its mediation, socio-political engagement and the processes of planning and building. Architectural research should be involved from the outset in the definition of the spatial conditions which contribute to learning, healthcare, social services, communication and knowledge.

I will engage in the production of emancipated space through the means of research, education, socio-political engagement, planning, design, and construction.

We intervene in the production of space through* research, information, socio-political engagement, planning and building.

*research, information, development of methods for acquiring knowledge, documentation, performance, fiction, socio-political engagement, planning and building.

Paragraph 4. is quite weak, because it describes actions nearly everybody is involved in.

5 The definition of needs and programs has to be generated through a process of radical democracy, taking into account collective memory and local context.

We ask for the definition of needs and programs through a process of radical democracy.
The main approach of Oppositional Architecture that relies on the idea of a radical democracy should be to accept conflict as the driving force of democratic communication. The designer should not rely on a predefined notion of the users needs nor should there be a need to follow the common neoliberal stories. He should get involved in a collective process articulating individual and common needs and desires to transgress the given situation, to provoke alternative needs, offer possibilities or appropriate produced desires and connect existing desires to other goals. Do not design a solution for anybody and for everything! Open up conflicts, collect expressions of desire, serve the process!

We challenge the definition of needs and programs through a process of radical democracy, which also challenges topographical contexts as well as contexts of cultural production.

Oppositional Architecture

▓▓ The Original Provisional Charta, Berlin 6/2004, ▓▓ Workshop "Radical Democracy Design", Berlin 6/2004 ▓▓ Bernard Cherix ▓ Saskia Draxler ▓ Ifau

▓▓ Workshop "Social Engagement", Berlin 6/2004 ▓▓ An Architektur ▓▓ Ulrich Doenitz ▓ Florian Haydn

▓▓ Workshop "Cooperation", Berlin 6/2004 ▓▓ Allan Atlee, Judith Barber, Florian Kossak, Tatjana Schneider ▓ Lars Fisher ▓ Birgit Schlieps

With whom can you cooperate to search for the client, to find the needs of a client? Practical point: to build up public pressure and public interest, to be used in the negotiation process
with a developer, we have to organize publicity. We have to think of new forms of powerful
negotiation. We have to convince them. Build up values in order to stay in the process.
Keep your values. Don't compromise too soon in a negotiation strategy. Find a surplus value with which to bargain. Always try to stay one or two steps ahead. But is it always a one on one discussion? Or do we also need to understand the values of the developer?

6 We need passionate and fundamental participation of the manifold users of space.

We ask for the passionate and fundamental participation of the manifold users and producers of space (participation and cooperation).

But who are the users? Engage yourself in a practice in which the user arises in the dialogue. Create users, let them reinvent themselves in the social context. Invent yourself. Engage in real time-processes with open results. It's not about representation! Realize sensitization for context, relations, situations. Creating a sense of community, let people define what their common property is. What they want to share and what they do not. Produce social situations!

7 We appreciate conflicts and aim at endless negotiations.

We support continuous negotiations of space.

Comment on paragraph 7.: From our point of view the word "endless" should be erased. Endless negotiations become meaningless in a way.

8 We offer advice and services to individuals and social groups engaged in struggles to transform their environment.

We support individuals and social groups engaged in struggles to transform their environment.

I aim to offer advice and assistance to individuals and social groups engaged in struggles to transform their environment.

I am committed to the dissemination of my ideas to as wide an audience as possible, exploring a broad range of communication techniques.

How can we work for those outside the market? How to resist to market-realism? What about illegal practices? What could be a possible subversion? How can we use/misuse commercial forces? How to deal with consumer attitudes? Should we try to change the system from within or look for an alternative? What could be a vision beyond the existing? How to create collective spaces? How to cooperate to change the situation? How to form group-processes in times of individualism?

Other points to be developed on the themes:
labor process, production*
radical ecology, materials**

9 *We do not accept depriving working conditions of any persons included in the design- and construction-processes.

10 **The second issue is sustainability. Here I think that the Charter needs to address the current issues that every professional is dealing with at the present time. In our industrialized countries almost all political foundations and most governmental research funds are dealing with sustainability. As I do not think that a timeless Charter would be of any use I firmly believe that we need to integrate contemporary questions in it.

11 As the current condition proposes only one way of making society, we want to push the border of collective imagination and use the language of architecture to propose and communicate different ways of shaping society.

We intend to push the border of collective imagination and propose alternative ways of shaping society by architecture.

12 I subscribe to the political principles of collective self-management and ownership of ideas*.

*for an open-source and anti-copyright principle of information against the private property of ideas.

X The following Dogma of Oppositional Architecture adds a codex to the Charter of Oppositional Architecture to evaluate ways of production, to qualify the deriving results, and to lend them a seal of approval. For this reason it is helpful to acknowledge the critical attitude of Dogme 95 (http://www.dogme95.dk/menu/menuset.htm) and its hassle with the representation of reality. This does not mean to take over the set of rules thoughtlessly. It is rather considered as a challenge to an open and critical debate not only about definitions, but also about attitudes to the impact of political decisions upon the built environment. 1. Architecture must be done on location.Interiors and typologies must not be brought in. 2. The program must never be produced apart from the building or vice versa. (Atmosphere must not be generated artificially. It occurs where the site is.) 3. The building must be custom-made. Any movement or immobility attainable in the process is permitted. (Architecture must not take place where your office is; architecture must take place where the user is.) 4. Architecture must be in true material only. Special lighting is not acceptable. (If there is too little light for exposure provide some more windows.) 5. Fake facades are forbidden. 6. Architecture must not contain superficial action. (Murders, weapons, etc. must not occur.) 7. Temporal and geographical alienation are forbidden. (That is to say that architecture takes place here and now.) 8. Genre architecture is not acceptable. 9. The architectural format must be Dogma OA. 10. The architect must not be credited. Furthermore I swear as an architect to refrain from personal taste! I am no longer an artist. I swear to refrain from creating a "work", as I regard the instant as more important than the whole. My supreme goal is to force the truth out of my characters and settings. I swear to do so by all the means available and at the cost of any good taste and any aesthetic considerations. Thus, I make my vow of chastity.

crowds

capitalS arSenalS
 workShopS

railway StationS factorieS

 bridgeS

 SteamerS

LocomotiveS

aeroplaneS

 crowdS.

ART MUST MOVE: A COLLABORATION WITH KHATT FOUNDATION

PERFORMA HUB

PRESENTED BY
PERFORMA

ORGANIZED
BY HUDA
SMITSHUIJZEN
(KHATT
FOUNDATION)
AND DEFNE AYAS
(PERFORMA)

Images from Art
Must Move: A
Collaboration with
Khatt Foundation,
*2009. Courtesy Khatt
Foundation.*

Inspired by the Futurists' embrace of typography and graphic design as well as the influence of Ottoman calligraphy on Futurism founder F. T. Marinetti, who spent his childhood in Egypt, Performa developed a dialogue with the nonprofit Khatt Foundation, which is dedicated to design research in the Middle East and Arab world with the goal of building cross-cultural creative networks and rethinking the visual and emotional impact of international alphabets. Featuring designers Max Kisman (Netherlands), Naji El Mir (Lebanon/France), and Hisham Yousef (Egypt/United Arab Emirates/United States), a typography exhibition was created to explore concrete poetry and visual "noise" in public urban space. The bilingual fonts developed for the exhibition played on the monumental Kufic Arabic lettering that can be found integrated into the mosaics of Arab architecture as well as on the streets of Arab cities in the form of graffiti. Based on a modular grid that accommodated both Arabic and Latin letters, the fonts were designed so that both scripts could almost be read as one, suggesting a cultural *rapprochement.* The exhibition consisted of twenty-two posters: half with a play on words in English; the other half with the same text in Arabic. For bilingual readers, these variations ended up sounding like haiku poetry, while the letters' visual arrangement created a bold graphic design from one poster to the next. Exhibited at the Performa Hub, the posters were also distributed across the city to Performa's eighty-plus consortium venues.

—*Defne Ayas*

ARTISTS' PARENTS MEETING
DARIUS MIKSYS

For *Artists' Parents Meeting*, a project that Lithuanian artist Darius Miksys first realized in an early form at the 2008 Lyon Biennial, more than thirty parents of artists crowded into e-flux's small downtown storefront space. "I've noticed there's a huge difference between authoritarian parents and non-authoritarian parents," one woman remarked. "Artists have an attitude of not knowing what's going to happen, while some parents want to know that if their children act in a certain way, they'll turn out good." Pioneering feminist artist Martha Rosler attended the event with her grown son, acclaimed graphic novelist Josh Neufield, and toddler granddaughter. Rosler held up drawings that her son had made at age four and said, "I knew from an early age that he had no choice!" When Neufield was asked about his own daughter, he laughed: "It's too early to tell."

—*Raimundas Malasauskas*

E-FLUX

CO-PRESENTED BY E-FLUX AND PERFORMA

CURATED BY RAIMUNDAS MALASAUSKAS

Drawing made by Jesse Cohen during Darius Miksys's Artists' Parents Meeting, 2009. Courtesy the artist.

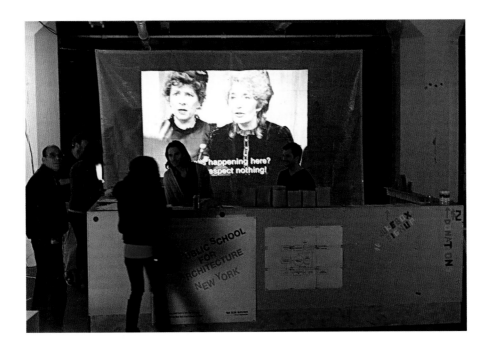

THE PUBLIC SCHOOL (FOR ARCHITECTURE) NEW YORK

NYC.THEPUBLIC-
SCHOOL.ORG

ORGANIZED
BY COMMON
ROOM AND
THE TELIC ARTS
EXCHANGE IN
COLLABORATION
WITH PERFORMA

The Public School (For Architecture) New York at An Architektur's Ten Days for Oppositional Architecture: Towards Post-Capitalist Spaces, *2009. Courtesy An Architektur.*

The Public School (for Architecture) New York, a self-organizing educational program for which the general public is invited to propose the curriculum and schedule, collaborated with Performa to present three events as part of its fall curriculum during the biennial: *Actions Propaganda* (page 378), Paul Elliman's *Sirens Taken for Wonders* (page 366), and *Not For Sale: Ideal Performance Space* (page 382). The Public School's programs were also listed on Performa 09's calendar, so that audience members could visit its website to create and sign up for other architecture-related courses, as part of the Public School's abiding goal of creating a public for architecture while opening up architecture for the public. *—Defne Ayas*

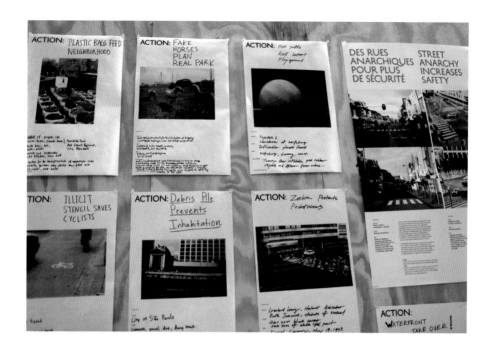

ACTIONS PROPAGANDA

Inspired by *Actions: What You Can Do With the City*, a 2008 exhibition at the Canadian Centre for Architecture in Montreal that solicited and presented ninety-nine projects to instigate positive change in cities around the world, *Actions Propaganda* was a morning workshop led by CCA's Daria Der Kaloustian and Adam Michaels of the New York–based design studio Project Projects. The twenty-odd architects, writers, and passersby in attendance were given colored markers and 11x17-inch poster paper on which to detail their ideas for improving New York's urban experience. The finished drawings—including proposals to install metal bars on the sides of parking signs as "urban rest stops," to defy rush hour by standing still on a street corner, and to build a zip line across the East River to Brooklyn—were then taken to a local copy shop and run off as hundreds of posters, which were pinned up around the Performa Hub and taped on walls and telephone poles all around the city.

—*Defne Ayas*

PERFORMA HUB

CO-PRESENTED BY THE CANADIAN CENTRE FOR ARCHITECTURE (CCA) AND PERFORMA AS PART OF THE PUBLIC SCHOOL (FOR ARCHITECTURE) NEW YORK

Posters created during Actions Propaganda, 2009. Photo by Paula Court.

FLAGS
ARAHMAIANI

PERFORMA HUB

CURATED BY
DEFNE AYAS

Arahmaini, Flags, 2009. Production still. Photo by Esa Nickle.

Raised by an Islamic-scholar father and a Hindu-Buddhist mother, West Javanese artist Arahmaiani has spent much of her life navigating different cultural landscapes, making performances, pictures, and installations that encourage collective thinking beyond cultural difference. Recently she has been using Jawi, an adapted Arabic alphabet for writing the Malay language. "Jawi embodies an important cultural heritage that is still alive in Southeast Asia's Muslim world," Arahmaiani explains, but points out that the script's meaning is now being distorted by both radical Islam and the Western media, who each "connect it to terror and fear." Arahmaiani has used Jawi to deliver a variety of messages all over the world; for Performa 09, she sent two flags to the Performa Hub: an orange flag with blue text reading "*Nyali*" ("Courage"), and a red flag with yellow text reading "*Aqual*" ("Mind"). —*Defne Ayas*

VIVA FUTURISM! REVOLUTION, VANGUARDIA, AND THE MODERN METROPOLIS
NICKY ENRIGHT

Nicky Enright, Viva Futurism! Revolution, Vanguardia, and the Modern Metropolis, 2009. Performance view. Photo by Carucha L. Meuse / clmvisuals. com. All rights reserved by El Museo del Barrio.

Multimedia artist Nicky Enright led an hour-long audio-visual experience rooted in the concept of the "revolutionary vanguard" at El Museo del Barrio. After walking through several video meditations on New York's urban landscape, displayed in El Museo's lobby, the audience gathered on one side of the space and took their seats for a poetry reading drawing on several traditions of manifestos. Enright himself began with a straightforward reading of the original Futurist manifesto in English and French, followed by poet Ernesto Gomez reading manifestos from the Brazilian Modernistas, Argentine Martín Fierristas, and Mexican Estridentistas, gradually mingling his own original manifesto into the texts, so that by the time he finished, his own words had attained the same level as the historical prose. Mariposa, an award-winning poet, educator, and activist, dressed in a crisp white suit and black fedora, then performed her *Mujerist Manifesto*. After leading the audience in a "rhythm lesson," inviting everyone to clap along to Francis Picabia's experimental composition *La Nourrice Americaine* (1920), Enright ended the evening with a modern tango performed by two women, which he framed as giving physical form to the questions he had proposed from the start—namely, "When do we bow to tradition, and when do we break with it? Where is the balance between respecting the past and building the future?"—reflecting upon the power of this idea in relation to early twentieth-century Latin American art and intellectualism.

—*Jocelyn Meade Elliott*

NOT FOR SALE: IDEAL PERFORMANCE SPACE

PERFORMA HUB

PRESENTED BY
THE PUBLIC
SCHOOL (FOR
ARCHITECTURE)
NEW YORK AND
PERFORMA

Christian Wassmann,
Endless Space, *2009.*
East Village Radio
Station installation view.
Courtesy the artist.

In sync with Performa 09's focus on New York City itself—with commissioned projects exploring architecture, design, urban planning, and public space, turning the city into an evolving platform for public engagement—*Not For Sale: Ideal Performance Space* brought six New York–based architects and designers together on the biennial's final day to discuss their own projects and to brainstorm about the ideal performance space, in particular a space ideal for Performa. The speakers gave presentations on their favorite venues, ranging from historical examples of Greek and Roman arenas to experimental spaces such as Frederick Kiesler's *Endless Theatre* (1926) and contemporary constructs such as Zaha Hadid's *Chanel Mobile Art Container* (2008).

Artist and architect Didier Faustino called for architecture that would materialize on the fringes of the city or in vacant lots, while architect Florian Idenburg (cofounder of Solid Objectives—Idenburg Liu) showed examples of his own playful architectural projects. Interactive media artist Dana Karwas presented her *Party Dress* (2007–08), a "pavilion" made from the skirt of a giant evening gown worn simultaneously by five women on ladders, seamlessly injecting fashion into architecture. Carlos J. Gómez de Llarena, a media architect, shared his prototype for *Urballoon*—a balloon equipped with a projector and wifi that "broadcasts" images or text e-mailed to it onto the street surface below. Eric Liftin of MESH, who sees physical and virtual design as part of a continuous whole, discussed the design process of Dumbospace, a 350-seat concert space in Brooklyn, while Shohei Shigematsu, director of the New York office of OMA, presented Taipei's Performing Arts Center, envisioned as three theaters embedded in a central cube, set on stilts over the lively Shi Lin Night Market. Finally, Christian Wassmann described his temporary architectural installations, such as his design for East Village Radio, a storefront radio station on First Avenue lined with mirrors that reflect and refract infinitely, creating a sense of endlessness within a very small space. —*Defne Ayas*

THE UNIVERSE WILL BE OUR VOCABULARY: FUTURIST FILM, MUSIC, AND LITERATURE

PERFORMA HUB

"The mountains, seas, woods, cities, crowds, armies, squadrons, aeroplanes will often be our formidable expressive words: the universe will be our vocabulary," F. T. Marinetti proclaimed in "The Futurist Cinema" manifesto of 1919. An event inspired by this statement, *The Universe Will Be Our Vocabulary: Futurist Film, Music, and Literature* brought together two experts in the Futurist avant-garde—composer, performer, and musicologist Luciano Chessa, and York University professor and Italian aesthetics scholar John Picchione—to present two mini-lectures on how the Futurists exploded the possibilities of artistic representation across every imaginable discipline. As Marinetti wrote, "We want to give a sensation of strange cheerfulness: we show a chair cover flying comically around an enormous coat stand until they decide to join. We want to give the sensation of anger: we fracture the angry man into a whirlwind of little yellow balls." Picchione, who specializes Futurist film, poetry, and visual art, provided a broad historical context for the Futurists' innovations, and Chessa, an expert on the *intonarumori,* or Futurist noise machine (which he was in charge of reconstructing for *Music for 16 Futurist Noise Intoners*), spoke specifically on the thought process underlying some of the Futurist composers' findings in the arena of sound art—together providing the intellectual underpinnings of this dramatic revolution. —*Lana Wilson*

CITY OF TOMORROWS

JENIFER KAMINSKY, LIZE MOGEL, AND STEPHANIE ROTHENBERG

STOREFRONT
FOR ART AND
ARCHITECTURE

CO-PRESENTED
BY STOREFRONT
FOR ART AND
ARCHITECTURE
AND PERFORMA

CURATED BY
DEFNE AYAS

A building facade, a subway-station entrance, and a broken water fountain were a few of the sites where *City of Tomorrows*—a performance workshop organized by urban planner Jenifer Kaminsky, interdisciplinary artist Lize Mogel, and multimedia artist Stephanie Rothenberg—took place on the Lower East Side on a cold, sunny Saturday afternoon. Mixing urban geography, guerilla street theater, and science fiction, this three-hour event kicked off in the narrow concrete gallery space of the Storefront for Art and Architecture with a group of twenty pre-registered participants, including a biologist/artist, an affordable-housing developer, a geographer, several community organizers, a group of art educators, a criminal defense lawyer/alternative circus performer, and, of course, many sci-fi fans. The group was divided into four teams, each of which was assigned a topic for a skit to perform later that day. The four topics—labor, the environment, mobility, and housing—were to be considered in relation to New York City's political, spatial, and social futures, and the scripts that resulted were imaginative and entertaining. In the "environment" skit, for example, a nanotechnology-based solution for increasing dwindling water supplies began to have strange effects on New Yorkers, giving them temporary euphoria followed by sudden death whenever they had a drink.

Once the scripts were ready, the teams spread out in the neighborhood and performed, each drawing an impromptu crowd. The performers went out of their way to directly involve audience members, whether by throwing them into the maw of a "people-eating building" (in the "housing" skit) or by leading them in a chant of "Smile—you have a job!" (in the "labor" skit). Combining theatrical vignettes with the language of politics and the amateurish charm of street performance, *City of Tomorrows* created a playful space where people could work together toward a common goal, reminding us of the power of activism when it is imbued with fantasy and creativity. —*Defne Ayas*

WRITING LIVE

Writing Live, a program presented during every Performa biennial, brings together an international group of critics, curators, and artists to generate written material related to the biennial. An intensive writing laboratory led by professional writers, artists, and critics, including poet Charles Bernstein, critic and historian Richard Kostelanetz, artist Alexander Singh, and Performa director RoseLee Goldberg, took place throughout the three weeks of the biennial. The writing was posted on the Performa website, with some appearing in subsequent Performa publications. A public seminar, "Writing About Performance," led by the Writing Live fellows, took place at the Performa Hub and was attended by many practicing critics, including Jerry Saltz of *New York Magazine* and Claudia La Rocco of the *New York Times.* —*Rachel Lois Clapham and Mary Paterson*

PERFORMA HUB

PRODUCED BY OPEN DIALOGUES, THESPACE BETWEENWORDS, AND PERFORMA

Performa 09 Writing Live fellows included Rebecca Armstrong, Rachel Lois Clapham, Tyler Coburn, Ryan Tracy, Patricia Milder, Mary Paterson, Kenny Ulloa, and Peter Walsh.

TESLA: DESPITE HISTORY
BRACO DIMITRIJEVIC

Braco Dimitrijevic, who gained an international reputation in the 1970s with his *Casual Passer-by* series, in which gigantic photo portraits of anonymous people were displayed on prominent facades and billboards in European and American cities, pointed his camera toward his own history by focusing on a well-known hero of the former Yugoslavia, also the birthplace and current home of the artist. Written, directed, and narrated by Dimitrijevic, the forty-five minute film *Tesla: Despite History* examined the influence of inventor and engineer Nikola Tesla (1856–1943), offering an artist's take on this eccentric and remarkable man. —*Performa*

PERFORMA HUB

THE FUTURE IN FIVE SENSES: ECHOES OF ITALIAN FUTURISM IN NEW YORK ARCHITECTURE AND DESIGN

CASA ITALIANA
ZERILLI-MARIMÒ,
NEW YORK
UNIVERSITY

PRESENTED
BY NEW YORK
UNIVERSITY AND
CASA ITALIANA

ORGANIZED BY
ARA H. MERJIAN

For the "heroic" avant-gardes of the early twentieth century, perhaps no metropolis invited the projection of more utopian aspirations than New York. While the Futurists drew on the city's dynamic example mostly from afar, the movement's broad aesthetic legacies have filtered into New York's spaces, textures, and architectural innovations and can still be sensed both nowhere in particular and everywhere at once. *The Future in Five Senses* looked at New York's place in the history of Futurism as evidenced by its architecture and design, with an emphasis on how the city is experienced through the five senses. Each of the participants was assigned one sense on which to focus a twenty-minute presentation—Rodolphe el Khoury had smell, David Humphrey had touch, André Lepecki had sight, and Ted Sheridan had sound. (In light of the spate of Futurist food-related events during the centenary, I decided to leave taste to the chefs.) In line with Futurist directives, the speakers were encouraged to incorporate performance elements into their talks. Lepecki's presentation began with the pre-recorded voice of his wife and collaborator, Eleonora Fabiao, talking about the relative lack of female presence in Futurism, and Humphrey's talk made use of a fake snow machine and a giant blow-up snowman that swelled to fill the room, threatening to overwhelm the audience via the senses, rather than academic sensibility.

—*Ara H. Merijian*

POSTSCRIPT

SCRATCH THE GRAND FINALE

An experimental musical ensemble founded in London in 1969 by Cornelius Cardew, Michael Parsons, and Howard Skempton, the Scratch Orchestra reflected Cardew's philosophy at the time: it was open to everyone, they would use graphic scores (rather than traditional sheet music), and improvisation was key. Its first meeting was announced by a "Draft Constitution" published in the June 1969 issue of *The Music Times* inviting participants and laying out four categories of musical activity: Improvisation Rites, Popular Classics, Compositions, and Research Projects. Many of the fifty-odd original members came from the experimental music class that Cardew taught at London's Morley College, and their performances with the Scratch Orchestra ranged from relatively conventional musical concerts, presenting work influenced by John Cage and Fluxus, to interventionist outdoor performances, in which the group would, for example, silently walk through a meadow performing patterns of hand claps, or stare into a shop window from the street while humming intensely.

Performa 09's closing-night party, *Scratch the Grand Finale*, adopted a similar approach, inviting artists, musicians, and poets to present work related to the disparate themes of Dining on Radio Waves, Lust is a Force, Between Noise and Silence, Songs for Architects, and Motion and Magic. Featured artists included Ari Benjamin Meyers with Chris Spencer (Unsane), Luciano Chessa, Davide and the Balulalas, Didier Fiuza Faustino, Nick Hallett, Xiao He, Jonas Mekas, Kalup Linzy, Kay Merryweather, Katie Paterson, Shannon Plumb, Daisy Press, Zhang Shouwang, Beau Sievers, Mai Ueda, and Imani Uzuri with Marika Hughes, and the night ended with a dance party.

—Performa

(LE) POISSON ROUGE

PRESENTED BY PERFORMA

About Performa

Performa, a nonprofit multidisciplinary arts organization established by RoseLee Goldberg in 2004, is dedicated to exploring the critical role of live performance in the history of twentieth-century art and to encouraging new directions in performance for the twenty-first century. In 2005, Performa launched New York's first performance biennial, Performa 05, followed by Performa 07 (2007), and Performa 09 (2009).

PERFORMA STAFF
RoseLee Goldberg,
Founding Director and Curator

Esa Nickle,
General Manager and Producer

Dougal Phillips,
Manager of Curatorial Affairs

Defne Ayas,
Curator

Mark Beasley,
Curator

Lana Wilson,
Publications Manager and Film Curator

Ashley Tickle,
Press and Marketing Manager

Adrienne Edwards,
Strategic Development

Shelley Gross,
Assistant to the Director and Special Events

Craig Hensela,
Special Projects and Development

Marc Arthur and Jess Wilcox,
Research Assistants

Lillie De Arnon,
Production Coordinator

Thibaud Losson and Leonor Torres,
Production Assistants

Sara Campot,
Press and Archival Intern

Livia Carpeggiani and Sarah Stout,
Development Interns

Trevor Martin and Clara Toubould,
Interns

PERFORMA BOARD OF DIRECTORS
Laurie Beckelman
Irving Benson
Todd Bishop
Julie Blakeslee
Amy Cappellazzo
Wendy Fisher
Stephanie French
Amanda Fuhrman
Jeanne Greenberg Rohatyn (Chair)
RoseLee Goldberg
Ronald Guttman
Barbara Hoffman
Michael Kantrow
William Kornreich
Toby Devan Lewis (Honorary Chair)
David Orentreich
David Raymond

PERFORMA VISIONARIES
STEERING COMMITTEE
Karen Boyer
Anne Dayton
Zoe Jackson
Jennifer Joy
Esther Kim
Candice Madey
Kate Robinson
Jeremy Steinke (Chair)
Burcu Yuksel

PERFORMA CURATORIAL
ADVISORY COUNCIL
Marina Abramović
Massimiliano Gioni
Yuko Hasegawa
Jens Hoffmann
Chrissie Iles
Joan Jonas
Lois Keidan
William Kentridge
Joseph V. Melillo
Paul D. Miller aka DJ Spooky
Meredith Monk
Hans Ulrich Obrist
Lisa Phillips
Octavio Zaya

PERFORMA 09 CREDITS

PERFORMA 09 CONSORTIUM
Abrons Arts Center
Anthology Film Archives
Art in General
Art Production Fund
Artists Space
Asia Society
Asian American Writer's Workshop
Baryshnikov Arts Center
Bidoun Magazine Space
Blank SL8
The Bronx Museum of the Arts
Brooklyn Museum
The Bruce High Quality Foundation
University
Cabinet
Casa Italiana Zerilli-Marimò
Chashama 679
China Institute
Columbia University
The Cooper Union
Creative Time
Dance Theater Workshop
Danspace Project
e-flux
El Museo del Barrio
Emily Harvey Foundation
Eyebeam
Forever & Today, Inc.
Goethe-Institut
The High Line
Hunter College
ISSUE Project Room
Italian Cultural Institute
Japan Society
Judson Memorial Church
The Kitchen
La MaMa
Light Industry
Manhattan Neighborhood Network
Martin E. Segal Theatre Center
The Museum for African Art
Museum of Arts and Design
Museum of Chinese in America
The Museum of Modern Art
National Arts Club
New Museum
The New School's Vera List Center for Art
and Politics
New York University
Park Avenue Armory
Parson's The New School for Design
PARTICIPANT INC.

The Performance Project @ University
Settlement
PS122
The Performing Garage
P.S.1 Contemporary Art Center
Rental
Rhizome
Salon 94
SculptureCenter
Scaramouche
SFMOMA
Storefront for Art and Architecture
The Studio Museum in Harlem
Swiss Institute
Teatro of the Italian Academy
Van Alen Institute
White Box
White Columns
X Initiative
Yale University

PERFORMA 09 CURATORS
Chief Curator:
RoseLee Goldberg

Performa Curators:
Defne Ayas
Tairone Bastien
Mark Beasley
Esa Nickle
Lana Wilson

Stefano Albertini
Sarina Basta
Jonathan Berger
Sally Berger
Klaus Biesenbach
Virginie Bobin
Emily Braun
Barbara Casavecchia
Luciano Chessa
Caroline Corbetta
Deborah Cullen
Lia Gangitano
Robert Haller
Matthew Higgs
Anthony Huberman
Eungie Joo
Mike Kelley
Lynda Klich
Andrew Lampert
Maria Lind
Raimundas Malasauskas

Ara H. Merjian
Renato Miracco
Anne Morra
Lara Pan
Michael Portnoy
Liutauras Psibilskis
Meg Rotzel
Alun Rowland
John Russell
Jenny Schlenzka
Adrien Sina
Meg Stuart
Sarah Wilson

PERFORMA 09
FOUNDATION SUPPORT

Performa Commissions and the Performa 09 biennial were supported by grants from The TOBY Fund; the Rockefeller Foundation's New York City Cultural Innovation Fund; The Andy Warhol Foundation for the Visual Arts; the Starry Night Fund of Tides Foundation; the David & Elaine Potter Charitable Trust; the State Corporation for Spanish Cultural Action Abroad; the Peter Norton Family Foundation; The Orentreich Family Foundation; The French-American Fund for Contemporary Art; the Graham Foundation for Advanced Studies in the Fine Arts; The New York City Department of Cultural Affairs, in partnership with the City Council; the New York Council for the Humanities; The Polish Cultural Institute in New York; The Trust for Mutual Understanding for Polish and Russian Artists; Artis Contemporary Israeli Art Fund; Étant DonnésThe French American Fund for Performing Arts, a Program of FACE; The Map Fund, a program of Creative Capital, supported by the Doris Duke Charitable Foundation and the Rockefeller Foundation; Flanders House, the new cultural forum for Flanders (Belgium) in the United States; The Korea Foundation; the Mondriaan Foundation; Lower Manhattan Cultural Council; New York State Council on the Arts; Pro Helvetia Swiss Art Council; Culture Ireland; The National Endowment for the Arts; The Kadist Foundation; Office of Cultural Affairs, Consulate General of Israel; the Moon and Stars Project; and The Foundation for Contemporary Arts.

Tacita Dean's *Craneway Event* was a Performa Premiere co-presented by Performa and Danspace Project. It was supported by Marian Goodman Gallery.

Alicia Framis's *Lost Astronaut* was a Performa Premiere presented by Performa and Art Production Fund. Production assistance was provided by Virginie Bobin. Participating writers and artists were Marina Abramović, Mark Beasley, Virginie Bobin, Kim Ann Foxman, Brian Keith-Jackson, Shelley Jackson, Angie Keefer, Matthew Licht, Rita McBride, John Menick, Katie Paterson, Silvia Prada, Frances Richard, Michael Schulman, and Katrina Sieverding. It was supported by the State Corporation for Spanish Cultural Action Abroad. Special thanks to Pera Mediterranean Brasserie, TBD Wines, and Voss Water.

Loris Greaud's *The Snorks, A Concert for Creatures [Trailer]* was a Performa Premiere commissioned by Performa and co-commissioned by Fabrice Bousteau for the symposium-show *Art, Talks, and Sensations*, part of Abu Dhabi Art. It was presented in cooperation with the Times Square Alliance and supported by Étant Donnés.

Joan Jonas's *Reading Dante* was a Performa Premiere supported by Performa Producers Circle member Shane Akroyd.

William Kentridge's *I Am Not Me, the Horse Is Not Mine* was a Performa Premiere presented by Performa. It was supported by Marian Goodman Gallery and Performa Producers Circle member Liza Essers.

ADDITIONAL CREDITS

Alterazioni Video and Ragnar Kjartansson's *Symphony No. 1* featured Alterazioni Video members Paololuca Barbieri Marchi, Alberto Caffarelli, Matteo Erenbourg, Andrea Masu, and Giacomo Porfiri. Sound design was by Christopher McDonald.

An Architektur's *Ten Days for Oppositional Architecture* was supported by the Graham Foundation and Two Trees.

Barefoot in the Head: Futurological Poetry Reading featured Die Störung, Amelia Saul, Polly Fibre, Blanko & Noiry, Dan Fox, Rose Kallal & Mark Beasley, Susanne

Clausen, Dexter Sinister, Will Holder, John Russell, Virginie Bobin & Duo, Daniel C. Herschlein & Trio, the Bruce High Quality Foundation, Jason Martin, and Jennie Hagevik Bringake.

Beyond Futurism: F. T. Marinetti, Writer was sponsored by Fondazione Cassa di Risparmio in Bologna and the *Italian Poetry Review*.

Brody Condon's *Case* was organized by Lauren Cornell for Rhizome and the New Museum, with support from the Performa Production Fund. The cast was Rad Radtke (Case), Sasha Grey (Molly), Lionel Maunz (Armitage), Sto (Panther Moderns), Tony Conrad (Julius Deane), Sindri Eldon (Finn), Peter Segerstrom (AI), Melissa Baxter (Zionites), Rachid Outabia (Riviera), Emily Mahoney (Lady 3Jane), Brandon Stosuy (Ratz), Jee Young Sim (Hideo); Guil R. Mullen (Ashpool), Brody Condon (Wage/Zone), and Mallory Blair (Linda Lee/Cath). The crew was Brandon Stosuy (script), Breanne Trammell (printmaking), Peter Segerstrom (sound design), Ray Radtke and Brandon Stosuy (casting), and Ariel Abrahams, Ross Condon, and Ariel Zakarison (production assistance).

For Brody Condon's *Without Sun*, the text by Sally Berger is © The Museum of Modern Art, 2010. Gratis one-time use of the text was granted to Performa solely for use in *Performa 09: Back to Futurism*.

Youri Dirkx and Aurélien Froment's *In Order of Appearance* was supported by Étant Donnés and the Kadist Art Foundation. Models, props, and artworks were courtesy of Aurélien Froment and Motive Gallery, Amsterdam. The dramaturgy consultant was Myriam Van Imschoot. Co-production by Playground, Stuk Art Centre, Leuven, and If I Can't Dance, I Don't Want To Be Part of Your Revolution, Amsterdam, 2009.

Paul Elliman's *Sirens Taken for Wonders* had coordination support provided by Virginie Bobin and Griffin Frazen.

Tamar Ettun and Emily Coates's *Empty is Also* was supported by the Office of Cultural Affairs, Consulate General of Israel; and the Performa Production Fund.

A Fantastic World Superimposed on Reality featured Luigi Russolo's *Risveglio di*

una città (1913) conducted by Luciano Chessa; Steve Reich's *Pendulum Music* (1968) performed by Alex Waterman, Lee Ranaldo, Alan Licht, James Moore, and Mark Beasley; Karlheinz Stockhausen's *IT* (1968) performed by Lee Ranaldo, Alex Waterman, Alan Licht, and Okkyung Lee; Rodney Graham's *Lobbing Potatoes at a Gong (1969)* (2009) performed by Mike Kelley; Fred Frith's *Stick Figures* (1987) performed by James Moore and Taylor Levine; John Zorn; Thurston Moore, Ryan Sawyer, and Daniel Carter; Z'EV; Arto Lindsay; Jad Fair and Lumberob; Thee Majesty; Rhys Chattham's *Two Gongs* performed by David Shively and Alex Waterman; Max Neuhaus's *Fontana Mix Feed—John Cage* (1965), performed by David Shively; Alison Knowles's *Nivea Cream Piece* (1962), performed by Alex Waterman; George Brecht's *Solo for Violin* (1962), performed by Tom Chiu; Tony Conrad; Joan La Barbara; Shelley Hirsch and Christian Marclay; John Duncan's *The Grateful* (2009); Airway; Destroy All Monsters; and Bruce Nauman's *Violin Tuned D.E.A.D.* (1968), performed by Dana Lyn.

Fischerspooner's *Between Worlds* was presented in conjunction with MoMA's Performance Exhibition Series. It was organized by Klaus Biesenbach, Director, MoMA PS1 and Chief Curator at Large, The Museum of Modern Art; and Jenny Schlenzka, Assistant Curator for Performance, Department of Media and Performance Art. The Performance Exhibition Series is made possible by MoMA's Wallis Annenberg Fund for Innovation in Contemporary Art through the Annenberg Foundation. Additional support for this exhibition was provided by John and Amy Phelan.

The Futurisms of American Poetry: A Reading by Charles Bernstein and John Yau was sponsored by the Asian American Writers Workshop, the Museum of Chinese in America, and the Asian/Pacific/American Institute at New York University. Kristen Gallagher and Chris Alexander provided introductions for John Yau and Charles Bernstein, and Defne Ayas introduced the subject of Futurism and China.

Maria Hassabi's *SoloShow* was co-produced and co-presented by the Portland Institute for Contemporary Art, PS122, the French

Institute Alliance Française (FIAF), and Performa 09. *SoloShow* received funding from the National Performance Network Creation Fund, the Performa Production Fund, and the National Performance Network Creation Fund, and the Manhattan Community Arts Fund supported by the NYC Department of Cultural Affairs, administered by the LMCC and The Brown Foundation, Inc. of Houston. It was created, in part, while in residence at Herberger College of the Arts, Arizona State University, Tempe, AZ, and at Performing Arts Forum in St. Ermes, France.

For *History of the Future II*, participating artists were Nao Bustamante, Jibz Cameron (aka Dynasty Handbag), Deb Margolin, Shelly Mars, Neal Medlyn, Alicia Hall Moran, Adam Pendleton, and Cathy Weis with Jennifer Miller. Video footage of performances by David Cale, Guy de Cointet, Dancenoise (Lucy Sexton and Annie Iobst), Mary Ann Duganne, John Kelly, David Leslie, John Malpede, Robbie McCauley, Jennifer Miller and Circus Amok, Susan Mogul, Linda Montano, Rashaad Newsome, Diane Torr, Johanna Went, and Jane Zingale was also shown.

James Hoff's *How Wheeling Feels When the Ground Walks Away* was produced by Mike Skinner and James Hoff. Sound design was by Mike Skinner and James Hoff.

Nuts and Bolts: Machine Made Man in Films From the Collection was organized by Anne Morra, Associate Curator, Department of Film, The Museum of Modern Art

Bruno Jasieński's *Mannequins' Ball* featured the Company of CounterPoint, staged by Allison Troup-Jensen, Marek Bartelik, Professor of Art History, Cooper Union, and installations and an intervention by Krzysztof Zarebski. Costumes were by Samantha Sleeper and David Destafano at the Martin E. Segal Theatre Center, Graduate Center CUNY.

JODI and Jeff Crouse and Aaron Meyers's *Performing the Web* was supported in part by the Mondriaan Foundation and Consulate General of the Netherlands.

For Mike Kelley's *Extracurricular Activity Projective Reconstruction #32, Plus*, the music was by Mike Kelley and Scott

Benzel, the choreography was by Kate Foley, the score was by Devin McNulty, and the Lead Curator and Producer was Mark Beasley.

Sung Hwan Kim's *One from In the Room* was commissioned by Hyunjin Kim and supported by Arts Council Korea (ARKO) and Korean Cultural Service, New York.

For Arto Lindsay's *SOMEWHERE I READ*, the choreographer was Lily Baldwin, the architects were Bureau V, and the Lead Curator and Producer was Mark Beasley.

LitTwitChalk was sponsored by the Asian American Writers Workshop, the Museum of Chinese in America, the Asian/Pacific/American Institute at New York University, and the Chinese American Association for Poetry and Poetics.

For *Not For Sale: Ideal Performance Space* and *The Public School for Architecture (New York)*, coordination was provided by Griffin Frazer.

Ahmet Öğüt's *The Pigeon-Like Unease of My Inner Spirit* was curated by Defne Ayas with assistance from Ozge Ersoy.

For Performa TV, Circular File collective members were Josh Kline, Anicka Yi, Jon Santos, Thomas Torres Cordova, Tatiana Kronberg, Allyson Vieira, Patrick Prince, Greg Edwards, Lanneau White, and Jeremy Fisher; other participating artists included Michele Abeles, Fatima Al Quadiri, Uri Aran, Luke Calzonetti, MV Carbon, Anne Eastman, Debo Eilers, Loretta Fahrenholz, Alex Hubbard, Shana Moulton, Takeshi Murata, Ken Okishi (Interference), Georgia Sagri, Trevor Shimzu, Brina Thurston, and W.A.G.E. Katie Paterson's *Ancient Darkness TV* was co-curated by Defne Ayas and Tairone Bastien.

Proof (Marije Vogelzang)'s Pasta Sauna was supported by Mondriaan Foundation and the Dutch Consulate.

The Prompt was co-produced by Chris Martino and Mary Rinebold. Documentation was provided by Lucy Raven with Cliff Borress, Amy Harrington, Corin Hewitt, and Jessie Stead.

Yvonne Rainer's *Spiraling Down* was commissioned by the J. Paul Getty Museum, Getty Research Institute, and World Performance Project at Yale. Additional

support was provided by the Performa Commissioning Fund.

For *Shock and Awe: The Troubling Legacy of the Futurist Cult of War*, participants were Laura Beiles, Department of Education, The Museum of Modern Art; Ruth Ben-Ghiat, Professor of Italian Studies and History, NYU; Emily Braun, Distinguished Professor, Hunter College and the Graduate Center, CUNY; Ernest Ialongo, Assistant Professor of History, Hostos College, CUNY; Lynda Klich, Assistant Professor of Art History, Hunter College, CUNY; David Lewis, The Graduate Center, CUNY; Robert Lumley, Professor of Italian Cultural History, University College London; Maria Antonella Pelizzari, Associate Professor of Art History, Hunter College, CUNY; Lucie Re, Professor of Italian and Women's Studies, UCLA; and Elihu Rose, Adjunct Associate Professor of History, NYU.

For *Speed Reading*, participants were Sasha Archibald, Fia Backström, Jimbo Blachly, David Brody, D. Graham Burnett, Alexandra Cardia, Jenny Davidson, Jeff Dolven, Julia Feldman, Paul Fleming, Matt Freedman, Lizzie Harper, Shelley Jackson, Julia Jacquette, Craig Kalpakjian, Jeffrey Kastner, Gabriel Larson, Claire Lehmann, George Makari, Sina Najafi, Lytle Shaw, Jude Tallichet, Christopher Turner, Aleksandra Wagner, and Kristofer Widholm.

Text of Light's *City Symphonies Out of Doors* was sponsored by Viper Studios.

Guido van der Werve's *Nummer Elf: The King's Gambit Accepted, the Number of Stars in the Sky & Waiting for an Earthquake* was supported by Juliette Jongma, Amsterdam, Monitor Gallery, Rome, Marc Foxx, Los Angeles, the Consulate General of the Netherlands, and the Performa Production Fund.

Yemenwed's *Bedroom w TV and Woman Lays w Aide* was written by Gloria Maximo and choreographed by Megha Barnabas. It featured a stage set by Shawn Maximo, sculpture by Paul Kopkau, costuming by David Toro and Solomon Chase, additional costuming by Jason Farrer, and stage make-up by Melissa Ip. It was performed by Shannon Funchess (vocals), Fatima Al Qadiri (keyboards), and Tim Dewitt (drums), with additional performers including Gerlan Marcel, Busy Gangnes, and Telfar Clemens.

Book Contributors

RoseLee Goldberg

Cecilia Alemani
Paul Amitai
An Architektur
Defne Ayas
Laura Barlow
Sarina Basta
Tairone Bastien
Mark Beasley
Naomi Beckwith
Jonathan Berger
Sally Berger
Claire Bishop
Virginie Bobin
Justin Bond
Cristiane Bouger
Emily Braun
Shane Brennan
Stefano Collicelli Cagol
Barbara Casavecchia
Travis Chamberlain
Kristin Chappa
Rachel Lois Clapham
Alexis Clements
Tyler Coburn
Caroline Corbetta
Lauren Cornell
Thom Donovan
Christoph Draeger
Melissa Dubbin
Anne Ellegood
Paul Elliman
Jocelyn Meade Elliott
Didier Faustino
Lia Gangitano
Daniel Gerould
Jeanne Gerrity
Sarah Giovanniello
Robert Haller
Trajal Harrell
Frank Hentschker
Oliver Herring
Nina Horisaki-Christens

Carol Hsin
Gianni Jetzer
Jeffrey Kastner
Scott Keightley
Carin Kuoni
Tan Lin
Scott Lyall
Raimundas Malasauskas
Don Marinelli
Piper Marshall
Kevin McGarry
Ara H. Merijian
Joel Mesler
Renato Miracco
Anne Morra
Sina Najafi
Esa Nickle
Lara Pan
Mary Patterson
Armelle Pradalier
Liutauras Psibilskis
Domenico Quaranta
Ruth Sacks
Jenny Schlenzka
Silvia Sgualdini
Yoko Shioya
Adrien Sina
Persis Singh
Katie Sonnenborn
Rob Teeters
Julie Trotta
Hong-An Truong
Paolo Valesio
Lilly Wei
David Weinstein
Lana Wilson
Martha Wilson
Linda Yablonsky

Index

Acknowledgements

The Performa biennial is teamwork of the highest order. With a full-time staff of only five, which expands to more than a dozen with additional assistants in the final months leading up to the biennial, we deliver an action-packed three weeks, all realized with the incredible oversight and steady goodwill of general manager and producer extraordinaire Esa Nickle. The many-sided parts of the biennial—the commissions, exhibitions, and educational programs—as well as its creative scope, are the work of a highly calibrated curatorial team, Defne Ayas, Tairone Bastien, Mark Beasley, Esa Nickle, and Lana Wilson, and production manager Mike Skinner, each of whom I cannot thank enough for their knowledge, generosity, and grace. The Performa Consortium, and the twenty-five-plus curators who represent it, are equally essential to the success of the Performa biennial. It is inspiring to collaborate with them year after year. Paula Court's photographs and Pierce Jackson's videos document the unfolding of events hour by hour, storing and sorting our memories so that we may revisit experiences over time, and for history. David Weinstein and Alanna Heiss of AIR (Art International Radio) capture the voices of participants in ways that make our archives as close to three-dimensional as they can be. APFEL (A Practice for Everyday Life) in London sets the tone of our printed matter each year with an elegance and understanding of visual messaging that we value enormously.

Turning all of the above into book form is the work above all of editor Lana Wilson. Holding the hundreds of different parts in her hand, coaxing texts and notes from artists and writers, and working with our endlessly inventive book designer Stacy Wakefield, consulting editor Nell McClister, research assistant Marc Arthur, and my invaluable assistant on all Performa matters, Shelley Gross, Lana creates an atmosphere that makes the entire process of book-making an exuberant and wondrous affair. Thank you also to Sharon Gallagher and Elisa Leshowitz of D.A.P./Distributed Art Publishers, our publication distributors.

Finally, this teamwork begins with the support, as emotional as it is everything else, of our founding patron Toby Devan Lewis and our extraordinary Board of Directors, led by Board Chair Jeanne Greenberg Rohatyn, whom I thank each day for their commitment, enthusiasm, and belief, as well as the Producers Circle, the Performa Visionaries, and all of our remarkable supporters and fans. As always, my deepest and most deeply moved thanks to my family, Dakota, Zoë, and Pierce Jackson.

—*RoseLee Goldberg*